atlas of GRAPHIC designers

atlas of
GRAPHIC designers

MAIA FRANCISCO

BEVERLY MASSACHUSETTS

ROCKPORT PUBLISHERS

Copyright © 2009 by **maomao** publications
First published in 2009 in the United States of America by
Rockport Publishers, a member of
Quayside Publishing Group
100 Cummings Center
Suite 406-L
Beverly, MA 01915-6101
Telephone: (978) 282-9590
Fax: (978) 283-2742
www.rockpub.com

ISBN-13: 978-1-59253-493-7
ISBN-10: 1-59253-493-7

10 9 8 7 6 5 4 3 2 1

Publisher: Paco Asensio
Editorial coordination: Anja Llorella Oriol
Editor: Elena Stanić, Corina Lipavsky
Text: Corina Lipavsky
Art director: Elena Stanić, Emma Termes Parera
Layout: Raquel Marín Álvarez
English translation: Heather Bagott

Editorial Project:
maomao publications
Tallers, 22 bis, 3º 1ª
08001 Barcelona, Spain
Telephone: +34 93 481 57 22
Fax: +34 93 317 42 08
www.maomaopublications.com

Printed in China

Contents

Mapping Contemporary Graphic Design

"Finally the journey leads to the city of Tamara. One enters the city through streets which are filled with insignia protruding from the walls. The eye only sees images of things which mean other things... Your gaze scans the streets as though they were written pages: the city says everything that's in your mind, it makes you repeat its message... What the city is really like under this tight cover of signs, what it holds and what it conceals is never unveiled as you leave Tamara without having found out..."

Italo Calvino. *Invisible Cities.*

An atlas is traditionally a book of maps – cartography. It is a system of projections that reinterprets a space and provides possible routes. This *Atlas of Graphic Design* is an invitation to travel, to explore the territory of current graphic design by way of a selection of outstanding graphic work carried out over the last decade around the world. It is a compilation which covers the diversity of areas apparent today in the field of graphic design – taking the town, production, and consumption as a starting point. It is a panoramic vision which invites us to consider the possible relations that exist between design and the context in which it has been produced.

In the first decade of the twenty-first century we are witnessing how cities are re-establishing themselves as centers of power. In a sort of medieval – course and recourse – turn, we can see how the idea of the "city" is reaffirmed above that of nation-state and thus retakes its former status of world-city, of cosmogony, of a center which generates signs and feelings. The contemporary city unfurls itself before us like a book, a space full of information and codes whose interpretation determines our comprehension of reality and which acquires form, generally, as a result of graphic design.

Bremen, Germany
Breslau, Poland
Brighton, UK
Brisbane, Australia
Bristol, UK
Brno, Czech Republic
Bucaramanga, Colombia
Bucharest, Romania
Budapest, Hungary
Buenos Aires, Argentina
Campobasso, Italy
Cape Town, South Africa
Caracas, Venezuela
Chengdu, China
Chicago, USA
Ciudad Quezón, Philippines
Clermont-Ferrand, France
Cologne, Germany
Columbus (Ohio), USA
Copenhagen, Denmark
Culebra, Puerto Rico
Curitiba, Brazil
Denpasar, Indonesia
Dijon, France
Dortmund, Germany
Drammen, Norway
Dubrovnik, Croatia
Duisburg, Germany
Durban, South Africa
Düsseldorf, Germany
Eagle Rock (Calif.), USA
Edam-Volendam, the Netherlands
Edinburgh, Scotland
Edmonta, Canada

To inform, educate, and persuade are the three basic premises on which this discipline is founded, whose beginnings date back to the fifteenth century with the invention of the printing press – the first medium of mechanical reproduction and the second greatest machine that would radically transform our perception of the world after the clock. Since then it has evolved on a par with technological development. In 1922, having inherited the values of the industrial revolution, the graphic designer William Addison Dwiggings used the term "graphic design" to designate the organization of elements (letter type, blank spaces, ornaments, and images) which were to be reproduced on paper. As with all visual expression that involves a machine based on reproduction, on series and in the times of the "lost aura," graphic design has been submitted, since its beginnings, to the constant pressure of opposites: art/profession, form/function, medium/process, style/content…

In the same manner as technological development, and the changes of paradigm that this generates, the theme of contemporary graphic design, understood today as visual communication, does not seem to focus on the confrontation of traditional opposites, but rather on the reconsideration of graphic design itself, restoring its value as an

Emmerich, Germany
Espoo, Finland
Essen, Germany
Frankenberg, Germany
Frankfurt, Germany
Freiberg, Germany
Givors, France
Gloucester, Australia
Göttingen, Germany
Gold Coast, Australia
Gothenburg, Sweden
Guangzhou, China
Haenam, Korea
Hamburg, Germany
Hanau, Germany
Hanover, Germany
Helsinki, Finland
Hilden, Germany
Hokkaido, Japan
Hong Kong, China
Honolulu (Hawaii), USA
Horw, Switzerland
Inverness, UK
Ipswich, Australia
Istanbul, Turkey
Johannesburg, South Africa
Kashan, Iran
Krefeld, Germany
Lausanne, Switzerland
Leeds, UK
Leipzig, Germany
Lillehammer, Norway
Lillestrom, Norway
Lisbon, Portugal

expressive idea, experimenting with the context of its practice and expanding its margins and reaches. This transformation is apparent in the figure of the multidisciplinary designer who may be at times an illustrator, at other times a typographer, or an artist, musician, photographer, or editor. Likewise, it is apparent in ethical aspects which have led many designers to explore beyond the commercial effectiveness of their work, incorporating elements extracted from their immediate reality, with a critical voice in social and political matters. In addition, one can implicitly observe a more fun approach to "productive" work, new ways of working together, un-hierarchical structures, trans-geographic communities, and the infinite number of applications which have converted this discipline into a fundamental part of contemporary life.

Ljubljana, Slovenia

London, UK

Lons-le-Saunier, France

Lorenskog, Norway

Los Angeles, USA

Luang, Laos

Lucerne, Switzerland

Lyon, France

Maastricht, The Netherlands

Madison (Wisc.), USA

Madrid, Spain

Maffra, Australia

Manchester, UK

Mbabane, Swaziland

Medellin, Colombia

Melbourne, Australia

Mexico City, Mexico

Midland (Texas), USA

Milan, Italy

Montbéliard, France

Montreal, Canada

Montreuil, France

Moscow, Russia

Munich, Germany

Narvik, Norway

Neckarsulm, Germany

Neenah (Wisc.), USA

New York, USA

Newcastle, UK

Nimega, The Netherlands

Nish, Serbia

Nova Gorica, Slovenia

Oakland (Calif.), USA

Oaxaca, Mexico

Contrary to the homogenized aesthetic that was foretold for the global world, a more local strategy is being demanded which promotes the development of made to measure personalized communication. "Customized" messages are being substituted instead of mass production, a unique communication for a society of subcultures instead of a mass culture. There are values of multiculturalism and diversity which respond to the specific interests of subgroups, new tribes which demand more diverse and particular visual languages. These are times of individualism and a boom in vernacular pop.

Based on these considerations and taking the city as the primary context, this *Atlas of Graphic Design* compiles outstanding work from all four corners of the globe that possess unique visual languages, and graphic dialects which are today on the fringes of global hegemony. Primarily it concerns projects designed for printed material although other applications are included. Posters, books, magazines, and flyers constitute the principal imagery of each map. It mostly explores projects developed for clients on the culture and arts scene – privileged spaces that are better prepared for audacity, experimentation, and innovation.

Orlando (Fla.), USA
Ørsta, Norway
Oslo, Norway
Ostrava, Czech Republic
Paris, France
Park Ridge (Utah), USA
Perpignan, France
Pforzheim, Germany
Pinvin, UK
Poeldijk, The Netherlands
Ponta Delgada, Portugal
Prague, Czech Republic
Pretoria, South Africa
Pristeg, Croatia
Québec, Canada
Raleigh (N.C.), USA
Rancho, India
Ravena, Italy
Reykjavik, Iceland
Rio de Janeiro, Brazil
Rochester (N.Y.), USA
Rome, Italy
Rosenheim, Germany
Rotterdam, The Netherlands
Sacramento (Calif.), USA
Saint Paul (Minn.), USA
San Diego (Calif.), USA
San Francisco (Calif.), USA
Santiago de Chile, Chile
São Paulo, Brazil
Sapporo, Japan
Saragossa, Spain
Sarajevo, Bosnia and Herzegovina
Semnan, Iran
Seoul, Korea

Two coordinates serve as a guide in each journey: the first, of geographical nature, is the birthplace, place of residence, and connecting town of each designer, thus outlining a network of places and links, suggesting limits and influences. The second, in the way of a mental map, consists of two images; one is a photograph, showing us how each designer perceives their immediate surroundings – their exterior as seen from inside. The other is a blank page, an open space where each designer was invited to develop a personal piece. It forms an interior landscape which completes the description of each project, thus contextualizing it beyond the geographical limits.

This *atlas* offers many different journeys, as though it were a map within a map, which, more than just marking boundaries or defining territories, establishes relations and celebrates differences. It gives an insight into the most contemporary graphic imagery, which is an open journey as much for delight as for interpretation.

Shanghai, China
Shenzhen, China
Singapore, Republic of Singapore
Southampton, UK
Springfield (Mo.), USA
St Albans, UK
Stockholm, Sweden
Strasburg, France
Sursee, Switzerland
Sydney, Australia
Szeged, Hungary
Taipei, Taiwan
Tehran, Iran
Tel Aviv, Israel
The Hague, The Netherlands
Togliatty, Russia
Tokyo, Japan
Toledo (Ohio), USA
Trenčín, Slovakia
Treviso, Italy
Tübingen, Germany
Turin, Italy
Ulm, Germany
Utrecht, The Netherlands
Vancouver, Canada
Varanasi, India
Venice, Italy
Vienna, Austria
Vitebsk, Byelorussia
Warsaw, Poland
Willisau, Switzerland
Yangjiang, China
Zadar, Croatia
Zagreb, Croatia
Zurich, Switzerland

Taipei, Taiwan
Hong Kong, China

Singapore, Republic of Singapore

:phunk studio

Alvin Tan, Melvin Chee, Jackson Tan and William Chan
www.phunkstudio.com
info@phunkstudio.com

Birthplace: Singapore, Republic of Singapore
Residence: Singapore, Republic of Singapore
Connecting cities: Singapore, Republic of Singapore / Taipei, Taiwan / Hong
Kong, China

FOUR MALAYSIAN AND CHINESE artists/ designers are the members comprising :phunk, a multidisciplinary studio which operates in Singapore.

This group is one of the most active Asian contemporary art and design collectives and has been classed as "the champion of the Singapore graphic scene," "the hottest agency in Asia," and "iconic heroes of the new wave of young Asian creators." Books such as *Tres logos* and *Graphic Design. A New History* feature some of its

work. In 2007, it published *Universality*, a monograph which is a compilation of its most recent work.

This prolific group tends to mix and reinterpret the broadest of influences. In each of their projects they combine elements that find inspiration as much in Chinese folklore and craftwork, cheap Hong Kong novels, Japanese manga and the *otaku* subculture, as in Western pop culture. Their aim is to reflect their own identity and the multiculturalism

of their surroundings. The concept of "universality" in the contemporary global era is a recurring theme throughout their work.

The members of :phunk studio approach each project from a multidisciplinary perspective, experimenting with new visual styles. The projects they develop include art exhibitions, graphic and editorial design, music, cinema, and interactive design.

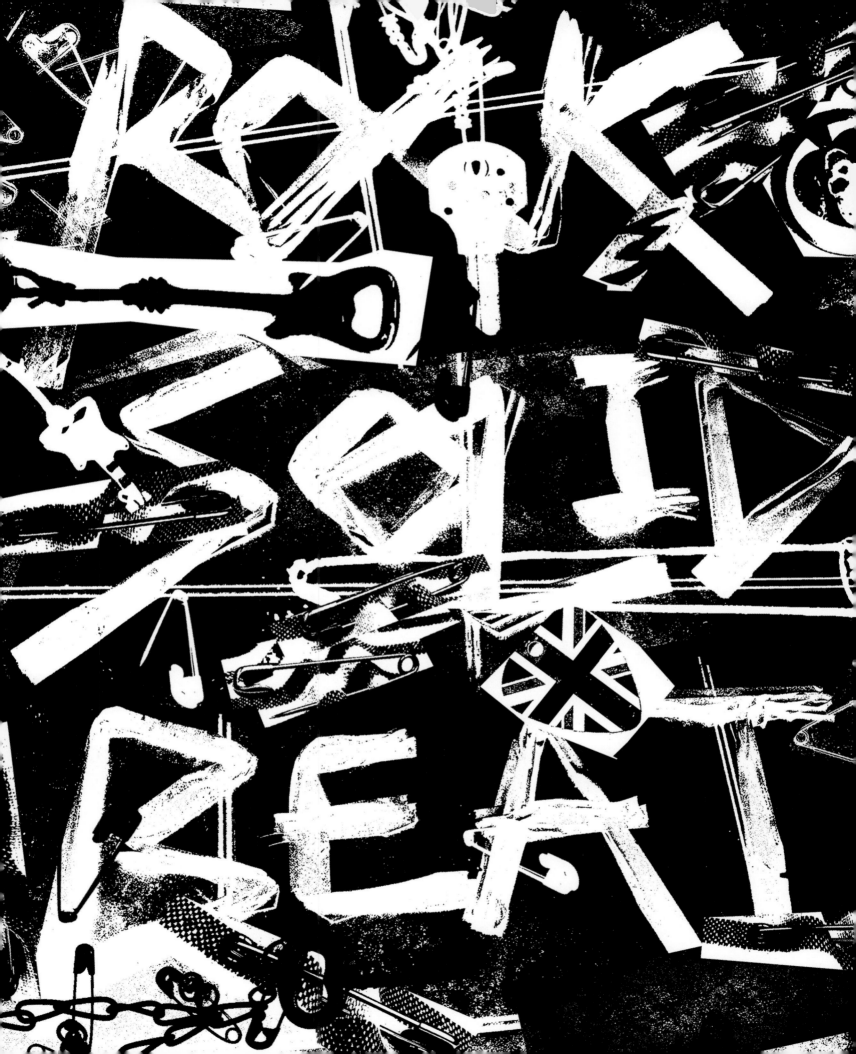

Treasure of Social Pleasures/Poster/Illustration/2006

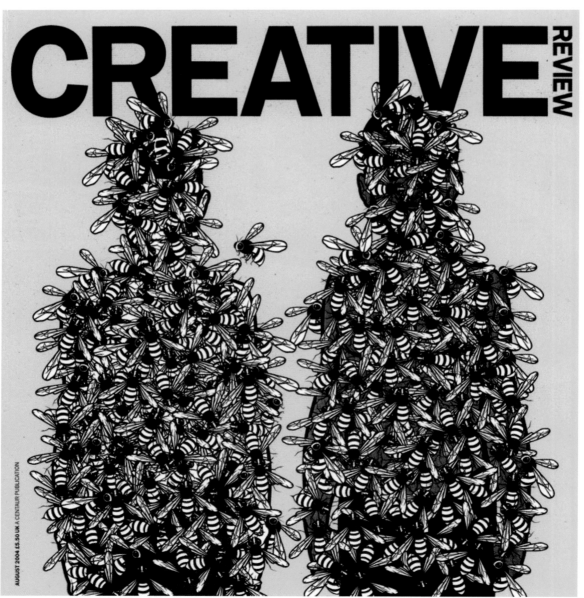

The Bees/Editorial illustration/2004

Music is .../Poster/Collage/2003

Rock & Roll/Editorial illustrations/2003

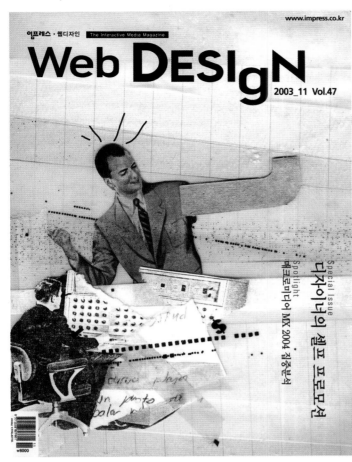

Web Design/Magazine cover/Illustration/2003

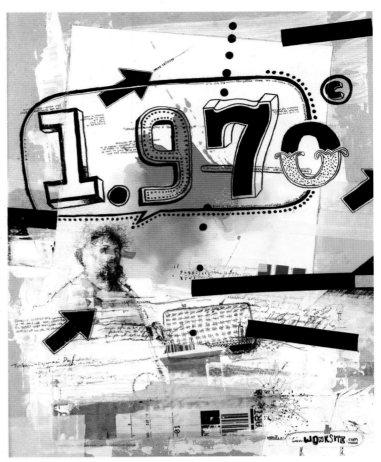

1970/Illustration/Hand drawn/2008

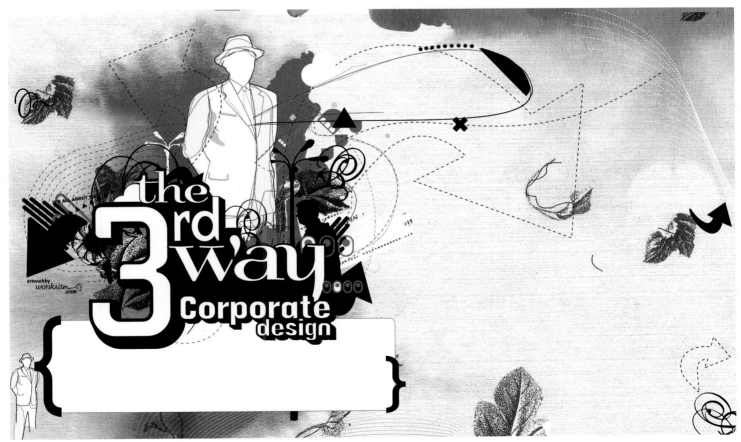

The 3rd Way/Magazine illustration/2007

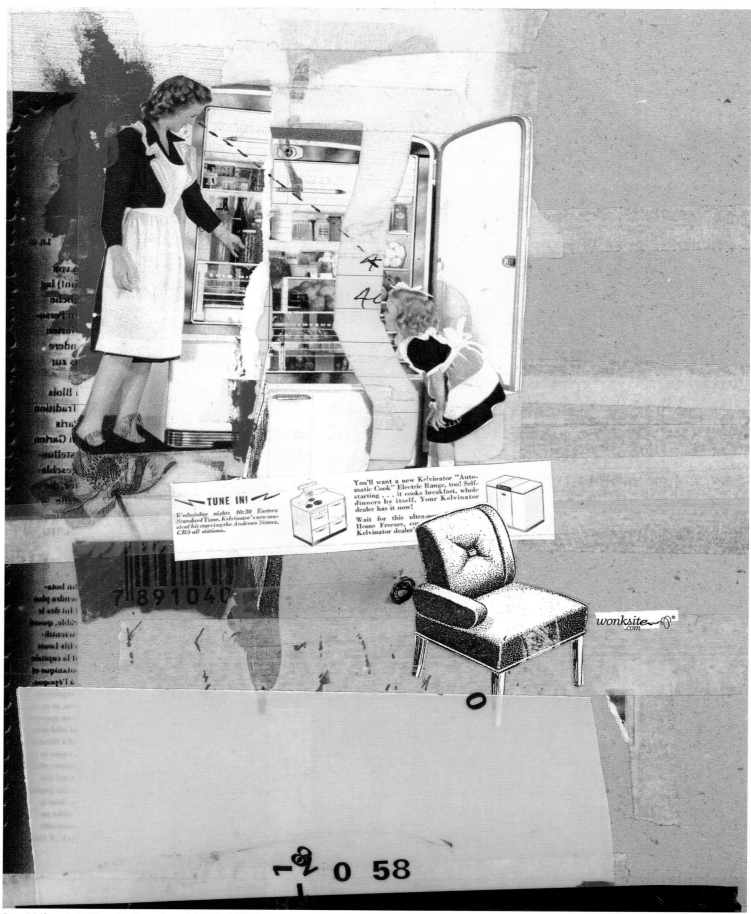

Burn Mother, Agite Magazine/Experimental project/2003

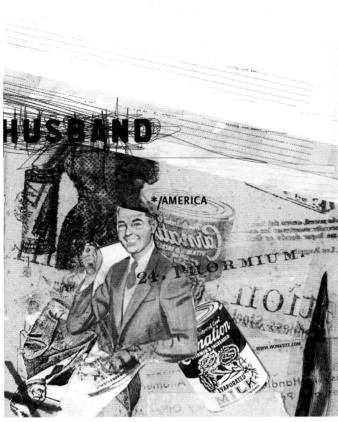

Husband & Wife Series, Tartart Wife/Magazine illustrations/2004

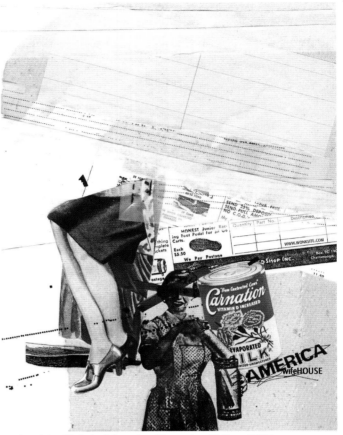

Husband & Wife Series/Magazine illustration/Collage/2004

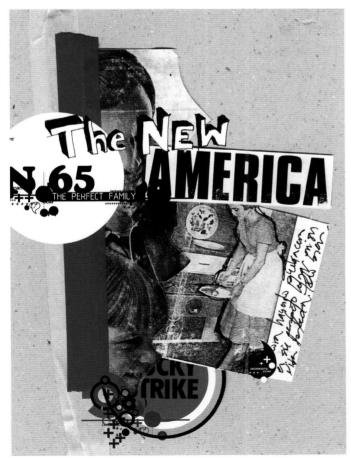

The New America/Magazine illustration/Collage/2004

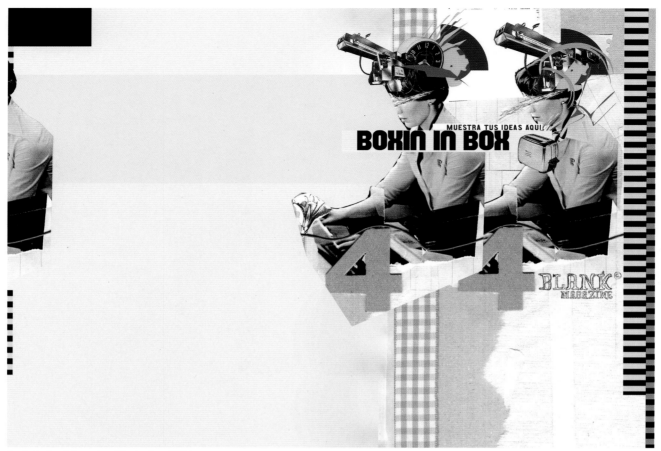

Boxin in Box/Magazine illustration/2004

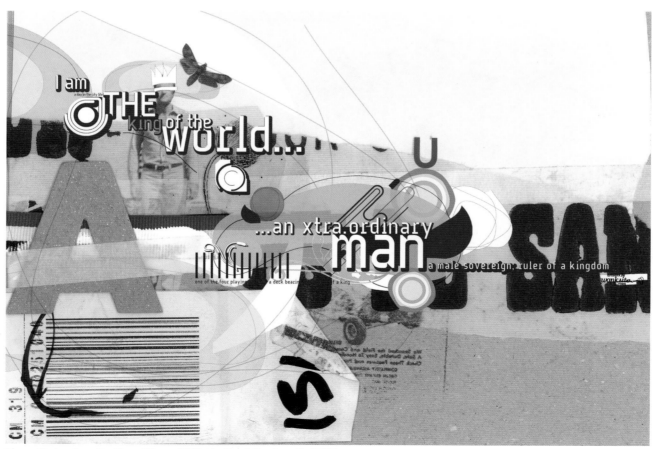

Theocy Design: I am the King of the world/Illustration/Mixed media/2007

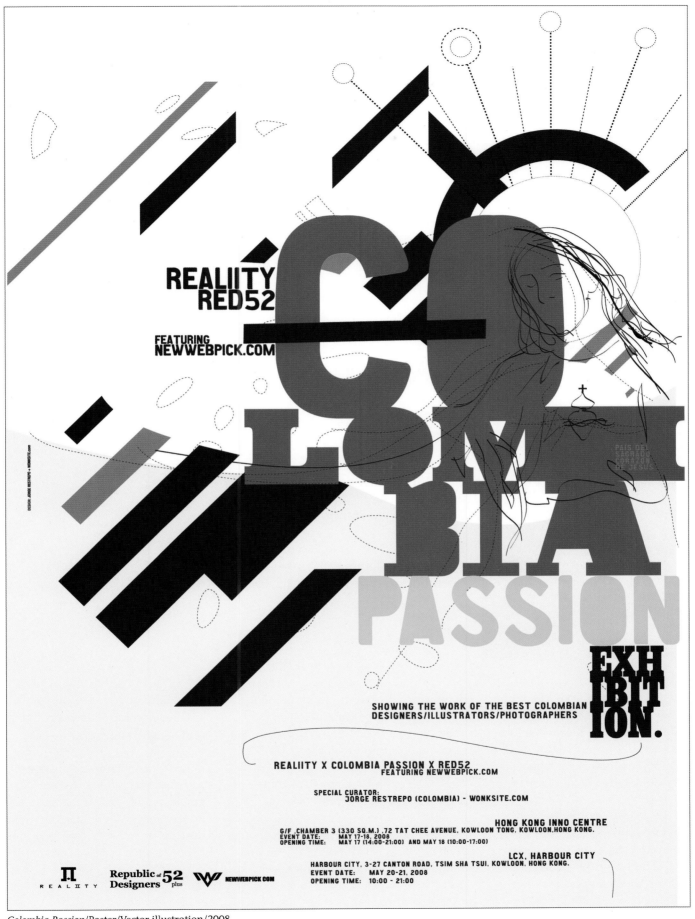

Colombia Passion/Poster/Vector illustration/2008

Stockholm, Sweden

Berlin, Germany

New York, USA

25ah

Dana Bergquist and Jacqueline Jacoel
www.25ah.se
dana@25ah.se/jacqueline@25ah.se

Birthplace: Stockholm, Sweden
Residence: Stockholm, Sweden
Connecting cities: Stockholm, Sweden/New York, USA/Berlin,
Germany

STOCKHOLM, CONSIDERED a "gamma level global city," is home to the design studio 25ah made up of Jacqueline Jacoel and Dana Bergquist – a duo dedicated to creating graphic solutions for editorial design, exhibition design, and visual identity.

Since 2004 this creative Swedish team has developed a great variety of projects, from posters and flyers for small clubs on the underground scene, to attractive invitations for shops and large scale museum exhibitions for multinational clients, such as The Human Journey exhibition, carried out at the Swedish Museum of Natural History.

The studio rethinks the modern traditions of graphic design and aims to create innovative communication pieces which are simultaneously classic and timeless. Their objective is to produce a clean and balanced visual language that never goes out of fashion. Their affection for modern Swedish minimalism and functionality is evident throughout their graphic projects, as is the importance they give to the handling of typography.

These designers draw great inspiration from music for most of their work. Bergquist is also one of the most active and recognized dj's on the Stockholm house music scene. He performs alongside big names such as Steve Lawler, Deep Dish, Dj Hell, Roger Sanchez, and Tiga among others.

cocktail club presents

music sound better with you

alan braxe
kris menace

thursday february	downstairs: alan braxe, france kris menace, france dana bergquist	forthcoming	winter/spring '07 andré galuzzi scsi-9 michael mayer apparat john dahlbäck dinky stefan bodzin troy pierce
8	upstairs: putte ponsbach luciano leiva		
	grodan cocktail club grev turegatan 16 www.cocktailclub.se		

cocktail club presents

matthew dear /audion
spectral, ghostly - detroit

friday june	downstairs: matthew dear aka audion, detroit jola bola	forthcoming	closing party '07 magda
9	upstairs: dana bergquist		
	grodan cocktail club grev turegatan 16 www.cocktailclub.se		

cocktail club opening party

miss kittin
presented by cocktail club and adam beyer

thursday august	downstairs: miss kittin nobodys bizzness, france	forthcoming in september:	downstairs: minilogue tomas andersson anders åkergren oliver huntemann neat tagteam surkim
31	new upstairs bar/lounge: dana bergquist joan east		
	grodan cocktail club grev turegatan 16 www.cocktailclub.se		upstairs: dana bergquist heads up joan east ida engberg

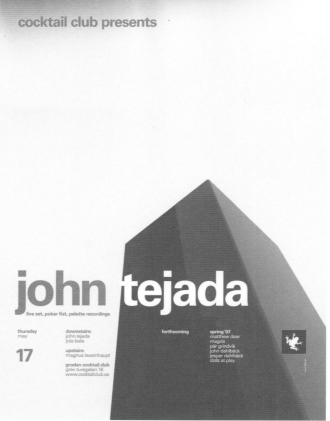

cocktail club presents

john tejada
live set, poker flat, palette recordings

thursday may	downstairs: john tejada jola bola	forthcoming	spring '07 matthew dear magda pär grindvik john dahlbäck jesper dahlbäck dollz at play
17	upstairs: magnus lewenhaupt		
	grodan cocktail club grev turegatan 16 www.cocktailclub.se		

Cocktail club/Posters/2004-2007

F12 TERRASSEN OPENING 05/25 2007

F12 TERRASSEN / SUMMER 2007 OPENING WEEK STARTING FRIDAY MAY 25TH. F12 TERRASSEN WILL BE OPEN SEVEN DAYS A WEEK UNTIL SEPTEMBER 1ST. WELCOME

MAY					25	26	27

F12/TERRASSEN

FREDSGATAN 12

· MON	21.00-03.00
· TUE	21.00-03.00
· WED	21.00-03.00
· THU	21.00-03.00
· FRI	17.00-03.00
· SAT	21.00-03.00
· SUN	21.00-03.00
···	80KR
····	100KR
AGE	23

F12.SE/TERRASSEN

28	**29**	**30**	**31**			
FICKS	🦅 CBB	**HOLIDAY**	**LOU**	eldbo	🙂	**Sunday**
TERRASSEN	**TERRASSEN**	**TERRASSEN**	**TERRASSEN**	**TERRASSEN**	**TERRASSEN**	**TERRASSEN**
KORNÉL	FREDRIK NILSSON	A. KOVACEVIC	ADAM BEYER	SÖNKE	ANDREAS HANSSON	B-LINE FEEL FINE
MAKODE	DANIEL ÖHRN	PUTTE PONSBACH	(DRUMCODE)	(SERIOUS PARTY)	ANDREAS HÖISTAD	MARC HYPE &
		ADAM HOLMBERG	**INDOOR**	ALBION (CBS)	JOAN EAST	JIM DUNLOOP (GER)
			HOT SCAMPI	**INDOOR**	**INDOOR**	
			CURRY COCONUT	SARA VARGA	KÄRLEKSJOHAN	

WWW.25AH.SE

F12 Terrassen/Poster/2006

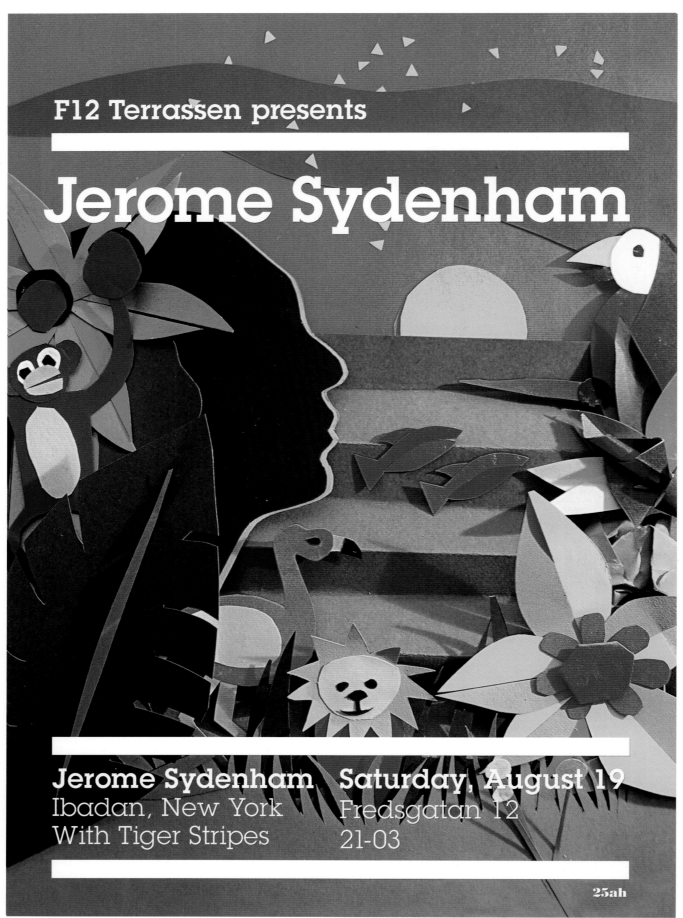

F12 Terrassen presents

Jerome Sydenham

Jerome Sydenham **Saturday, August 19**
Ibadan, New York Fredsgatan 12
With Tiger Stripes 21-03

25ah

F12 Terrassen/Poster/2006

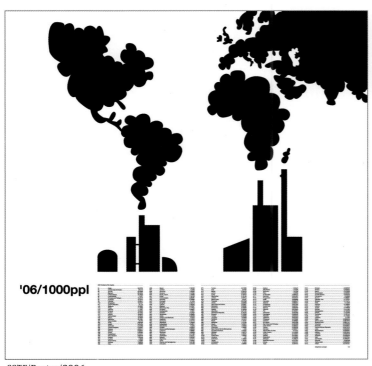

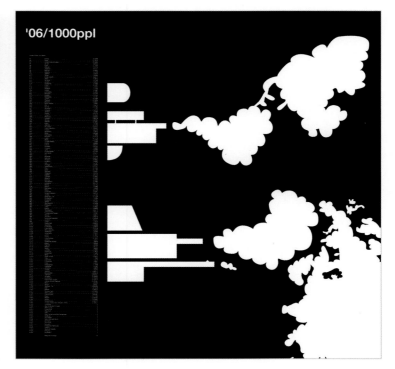

'06/1000ppl

'06/1000ppl

SSTF/Poster/2006

Frosbergs Skola/Posters/2006

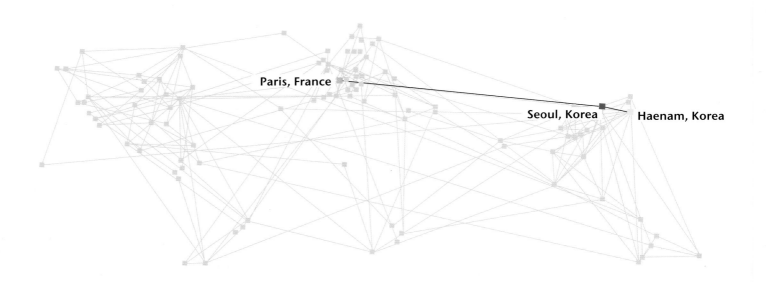

Paris, France

Seoul, Korea Haenam, Korea

601bisang

Park Kum-jun
www.601bisang.com
kj@601bisang.com

Birthplace: Haenam, Korea
Residence: Seoul, Korea
Connecting cities: Paris, France

THIS CREATIVE STUDIO is located in Seoul and was established in 1998 by the visual communicator Park Kum-jun who occupies himself by creating powerful and youthful designs. His intention is to develop designs based on the imagination, with strong messages transmitted in an original manner, with an infinitely liberal spirit and mentality.

He graduated with a degree in communication arts from Hongik University and completed a master's degree in advertising and public relations. He worked as a graphic designer and art director for various communication and advertising agencies in Japan until 1997. His projects have won a large number of prizes and distinctions from institutions such as the Art Directors Club, as well as the International Poster Biennales of Brno, Lahti, Warsaw, and Toyama, among many more.

The work of this creator, who is also passionate about teaching, has been exhibited in various spaces, such as the GGG Gallery in Osaka and Tokyo and has been included in compilation publications such as the *Graphis Poster Annual*. In addition, he has undertaken various editorial projects, such as the books *Calendars are culture, 2 note: time.space* and *601SPACE PROJECT*.

THE FOUNDING MASSAGE OF 601BISANG.1998

It would be easy to follow everyone else.
Continuing on with the usual is easy also.
Nothing will happen if you just do what you can or whatever is easy.

Then who will do "something new"?
Who will do "what has never been done?"
Who will manifest the ultimate vision of design?"

We are convinced that we can outdo ourselves.
If someone has to do it, why should it not be us?
If everyone visualizes it, why should anything stop us?

Let us consider what we will do rather than what we've done.
We'll focus on things that can't be done by anyone else,
things that have never been done before.
The hardest thing to do in this world is to do something differently.

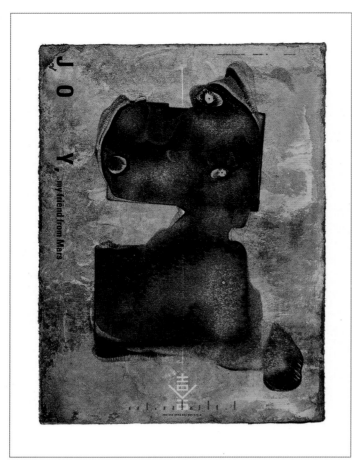
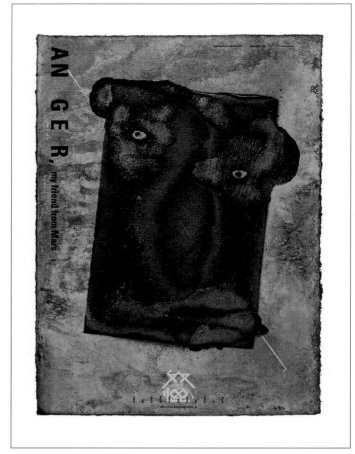
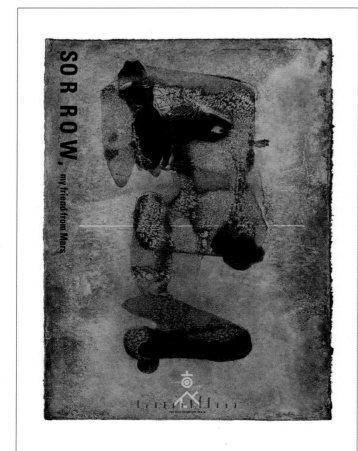
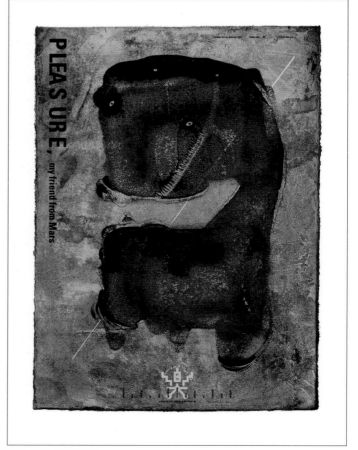

My friend from Mars: JOY, ANGER, SORROW, PLEASURE/Poster series/Designer: Park Kum-jun/2005

2 note: time.space/Book/Designer: Park Kum-jun, Nam Seung-youn, Lee Jung-won/2001

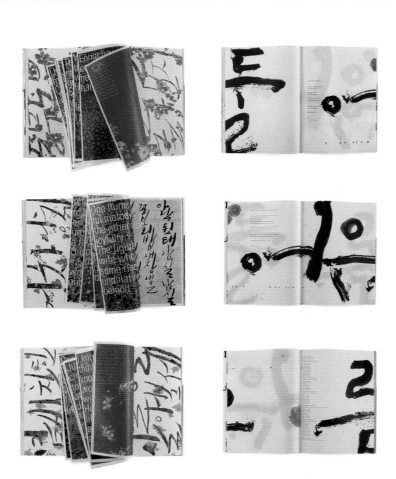

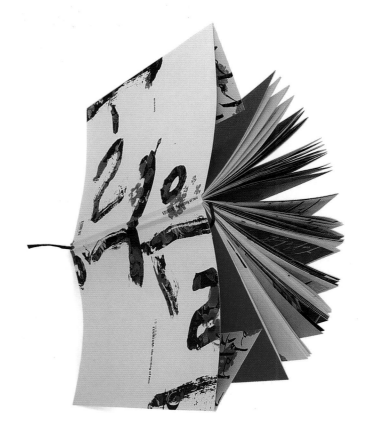

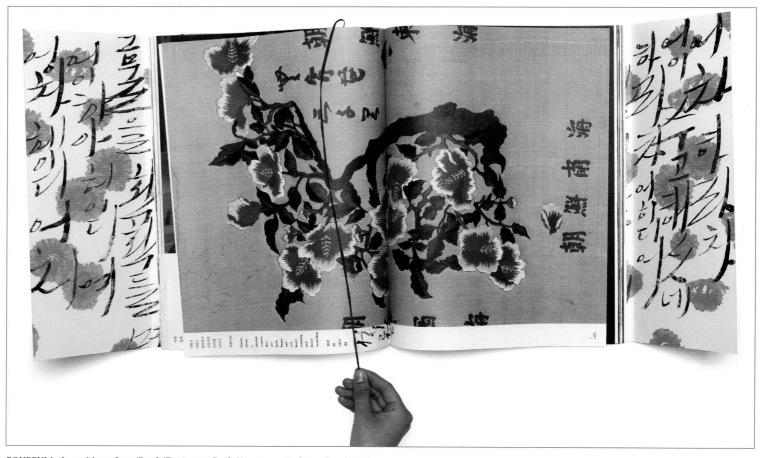

EOUREUM: the uniting of two/Book/Designer: Park Kum-jun, Park Jae-hee/2006

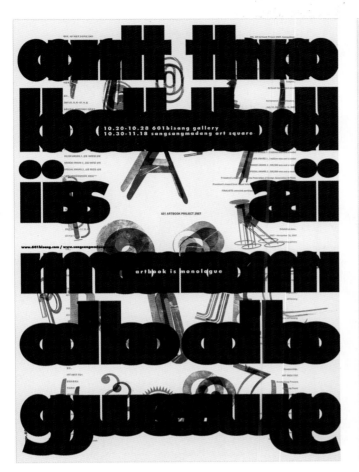

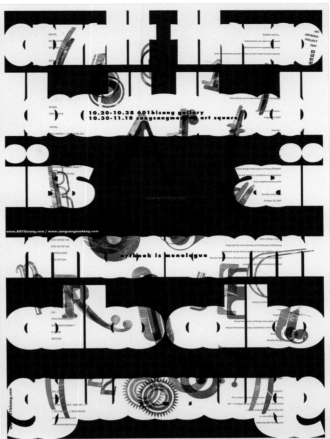

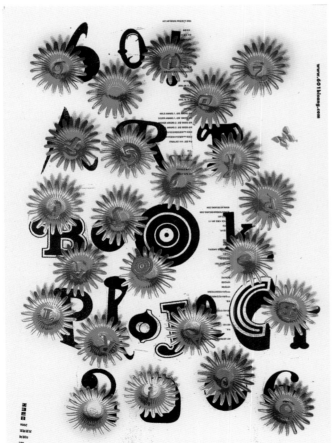

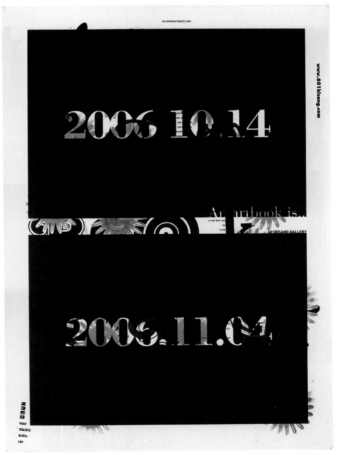

601ARTBOOKPROJECT 2006-2007/Poster/Designer: Park Kum-jun, You Na-won/2006-2007

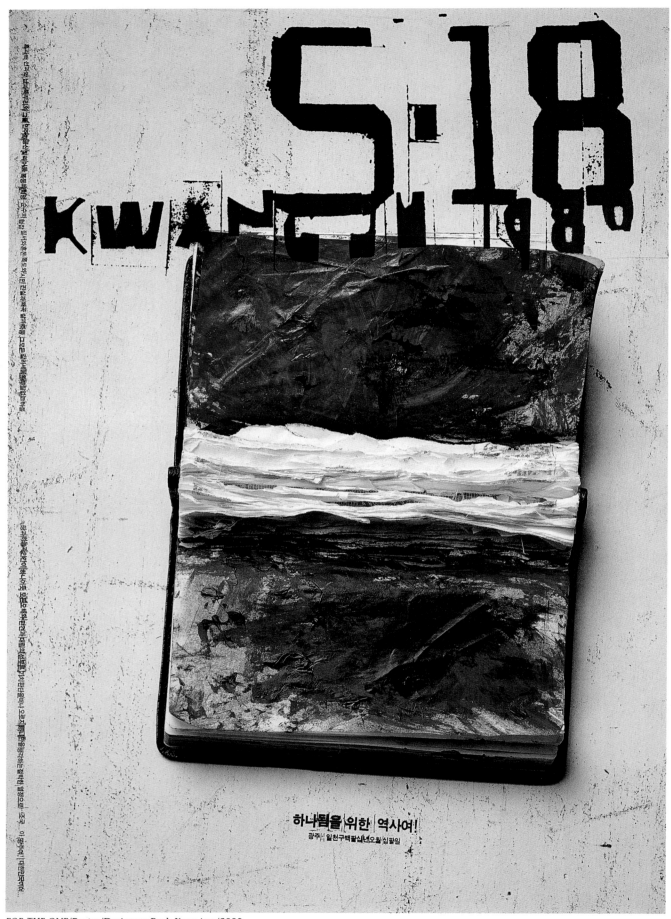

FOR THE ONE/Poster/Designer: Park Kum-jun/2000

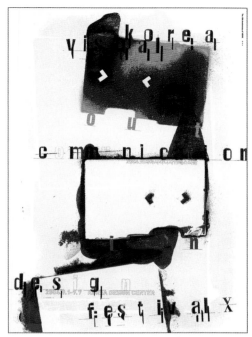

VIDAK 10th Anniversary Korea Visual Communication Design Festival 2004/Poster/Designer: Park Kum-jun/2004

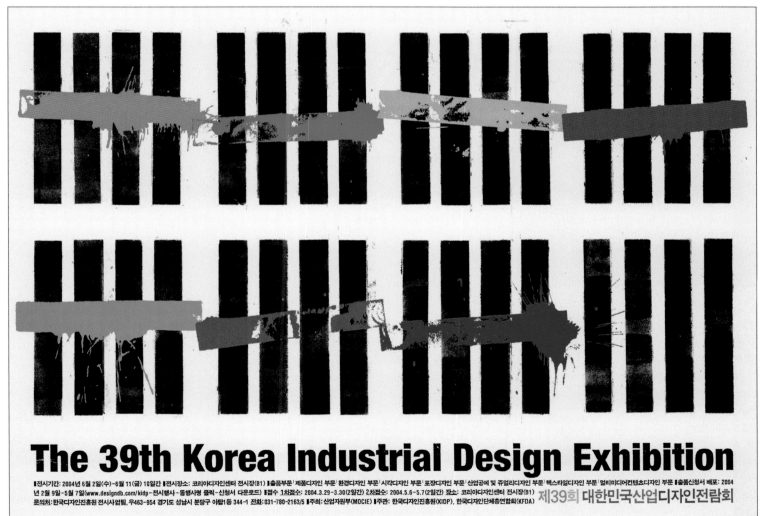

The 39th Korea Industrial Design Exhibition/Poster/Designer: Park Kum-jun/2004

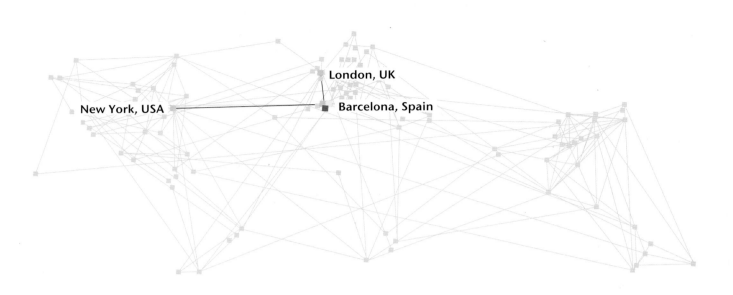

London, UK

New York, USA — Barcelona, Spain

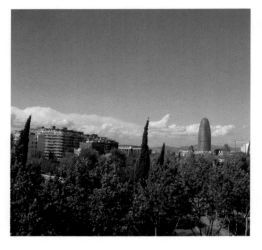

Alex Trochut

www.alextrochut.com
hello@alextrochut.com

Birthplace: Barcelona, Spain
Residence: Barcelona, Spain
Connecting cities: Barcelona, Spain / London, UK / New York, USA

ALEX TROCHUT LIVES and works in Barcelona, capital of Catalonia, on the shores of the Mediterranean Sea. This independent designer and illustrator has received great international recognition due to his excellence and creativity in typography and illustration.

He is the grandson of the famous Catalan typographer, Joan Trochut – who developed the Super-Veloz typography – and was born in Barcelona in 1981. He studied

graphic design at the Escuela Elisava and subsequently undertook a work placement in Berlin for the Moniteurs and Xplicit studios. On his return to Barcelona he worked for the design studio Toormix and for the renowned studio Vasava where he had ample space to experiment.

His work has been included in renowned publications such as *Computer Arts*, *Beautiful/Decay*, and the newspaper *The Guardian*. In 2005, he received the

Certificate of Excellence in Typography from the Type Directors Club of New York.

In his own words, his work is the expression of two great passions: typography and illustration. His style is expressive and his main interest is experimentation with new forms of writing and means of communication with the text, working at times solely with formal beauty and pure aesthetic pleasure more than content.

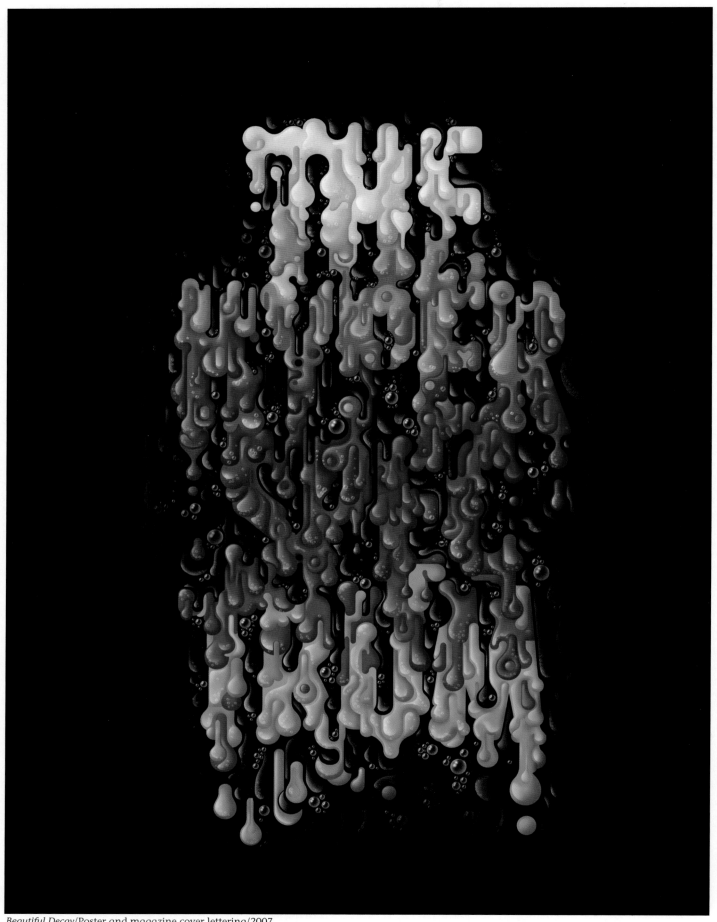

Beautiful Decay/Poster and magazine cover lettering/2007

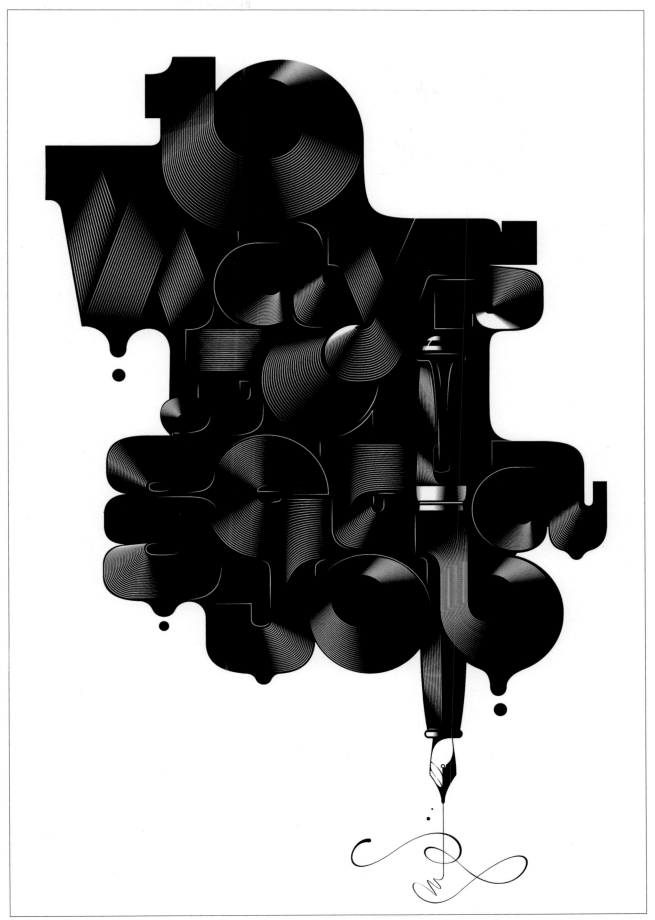

Computer Arts magazine/Type illustration/2007

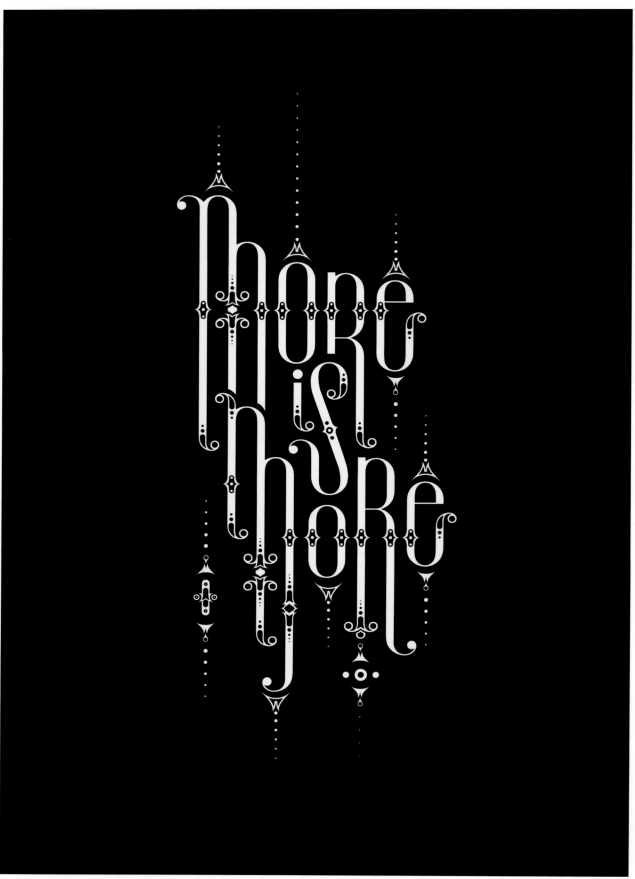

Modular systems untitled 01/Modular typography/Personal project/2005-2006

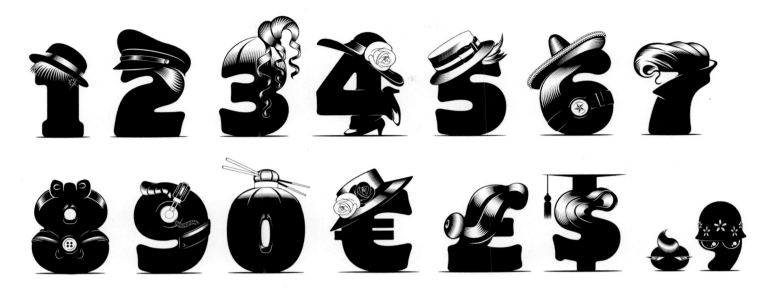

British Airways. Numeric Alphabet/Type illustration/International campaign commissioned by BBH (London) for British Airways/Art director: Nadine Akle; creative director: Adrian Rossi; art buyer: Julian Cave/2007

Liquid/Illustration/Personal project/2004

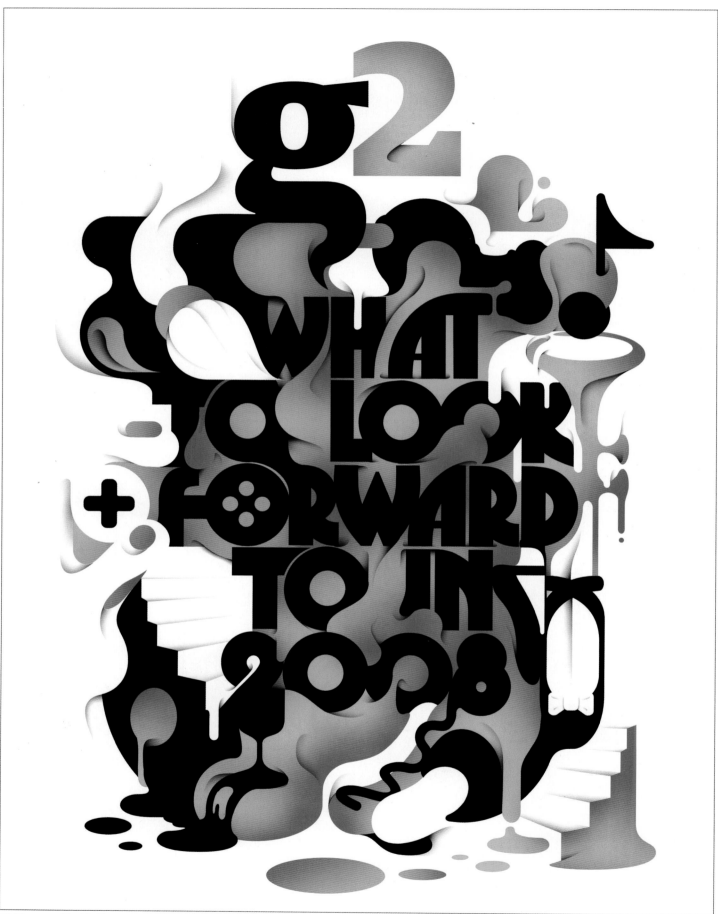

G2/Cover and inside illustration/2008

If you could/Poster/2008

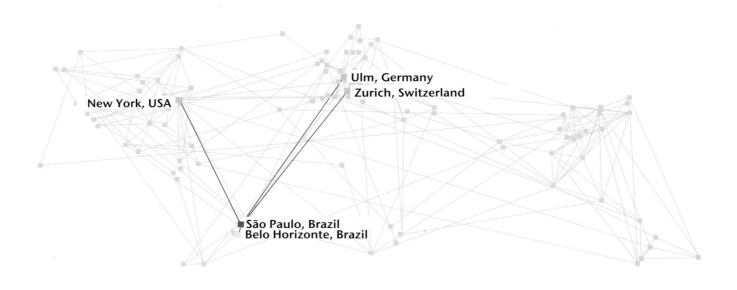

New York, USA

Ulm, Germany
Zurich, Switzerland

São Paulo, Brazil
Belo Horizonte, Brazil

Ana Starling

www.anastarling.com/www.bizu.bz
ana@anastarling.com

Birthplace: Belo Horizonte, Brazil
Residence: São Paulo, Brazil
Connecting cities: Zurich, Switzerland/Ulm, Germany/New York, USA

THIS BRAZILIAN DESIGNER works from her studio, Bizu Deisgn, a space she founded together with her husband, the musician and writer Roberto Guimarães, in São Paolo.

Her studio develops pieces where design and content are inseparable. "The design *with* content is always greater than design *plus* content." For them this implies a deep understanding of the uniqueness of each project and offering personalized

solutions that, as well as matching their client's expectations, have the capacity to surprise.

Ana Starling is a versatile graphic artist who has worked as illustrator and designer creating visuals for a wide range of media. Her influences are found in the worlds of art – surrealism, Dadaism, conceptual art and minimalism, music, and European design.

In the year 2000, she began to experiment in interactive projects. This new media had a big influence on her style and resulted in her using digital interfaces as graphic elements possessing great personality. From there she entered the motion graphics world and created a successful series of pieces in movement for which she has received important international mentions and prizes.

Animals/Opera scenario/Video animation/2007

Lolita/Magazine illustrations/2005

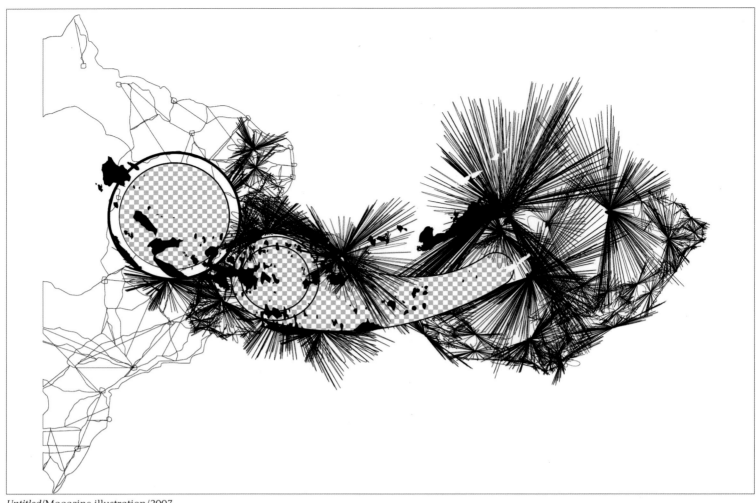

Untitled/Magazine illustration/2007

Box/MTV Artbreak/Video animation/2006

Rumos/DVD package/2006

Tree/Magazine type illustrations/2006

Amsterdam, the Netherlands
Berlin, Germany
Düsseldorf, Germany
Hilden, Germany

■Mexico City, Mexico

André Pahl

www.primeclub.org
andre@primeclub.org

Birthplace: Hilden, Germany
Residence: Mexico City, Mexico
Connecting cities: Amsterdam, The Netherlands/Berlin,
Germany/Düsseldorf, Germany

ANDRÉ PAHL IS a German graphic designer who has lived and worked in Mexico City since 2005. He graduated from Rietveld Academy in Amsterdam in 2004 and has worked for different clients in Europe and America ever since, in projects ranging from graphic design, illustration and Web design to installations, animations, and motion graphics.

Through the studio Musterfirma, with headquarters in Berlin (musterfima. org) which he runs with designer Ulrike Brückner, Pahl works for international clients for the most part in corporative, editorial, and printed design. In 2005, the website Musterfirma received the Red Dot Awards prize.

This versatile designer is one of the founding members of the record label *Los Nuevos Ricos de Mexico* and was also part of the band Thom Revolver

from 2003–2005. He is responsible for the–artistic direction, alongside Mexican Carlos Amorales and other invited artists, and is in charge of all the visual communication.

His work has also been selected to participate in various exhibitions and shows such as ARCO 2005, Musik Total at the De Appel Gallery, Casa America in Madrid, and the Yvon Lambert Gallery in Paris, among others.

"So white and Neardy"

This is my curtain.

I moved into my new place almost 4 month ago but due to a crazy about of jobs I didn't have time for any decoration and it's still a total improvised mess - I've been non-stop in front of the computer.

So my girlfriend generously dedicated this drawing to me, to get me in a better working mood and to always remind me who's the pale guy here.

When she discovered the tune with the same name on YouTube, performed by Weird Al Yankovic, she was so beside herself with joy that I was forced to watch it over and over - especially when the guy takes his laptop into the shower she was convinced that this is ME.

Which is kind of funny - and she didn't even know that story - because some years ago when I was graduating from art school in Amsterdam I managed the perfect nightmare: On the very day of the presentation of the end-exam I ran out of the shower in total stress and still wet because I realized that I forgot to hit the render button – and I short-circuited the keyboard with some few ridiculous drops. The computer was ready for the trash, I couldn't finish a couple of things for the presentation, I was 4 hours late, everybody got mad and the committee almost refused to let me pass the final exam. Of course, no one ever asked me afterwards for the holy diploma.

But back to the curtain.

So I'm the nerd, and I'm furthermore I'm a farmer she says, a "ranchero". Because I come from that little town called Hilden, German middle-class wasteland, which has 100 times less inhabitants than Puebla or Tlalpan or any other synonym for "stupid little village" over here.

I have to admit that I'm quite glad to have left the cows and chickens and I'm living now in the biggest town of the world instead. And that my girlfriend is from HOLLYWOOD. And that she's half Chilean, half Mexican, a little bit French and grew up in Los Angeles, later moved to the tongue-twister-town Guadalajara, and after studying in London headed straight on to Mexico City – just to meet ME, the farmer-boy, who is regrettably nothing but just boring-plain-German.

At least she misspelled "nerdy" !!!

Hilden must be proud of so much exoticism and my parents have their top story for the coffee klatch. My white & nerdy hometown, I send you all my best and aaaadiooooossss...
(nostalgic sigh)

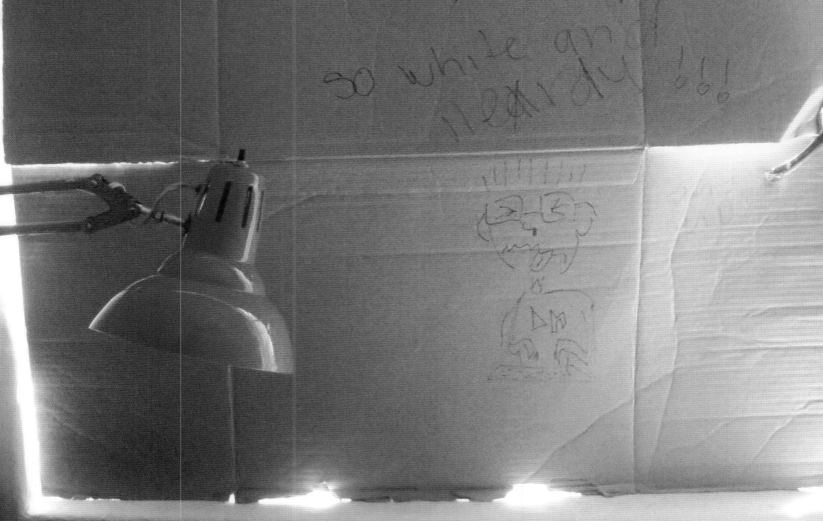

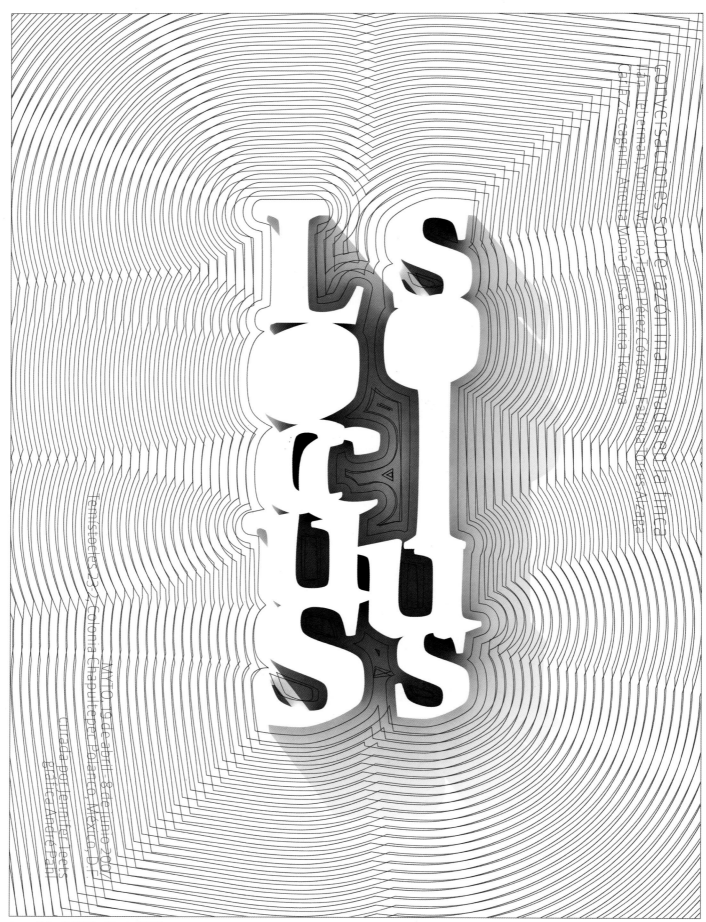

Locus Solus Exhibition/Poster/2007

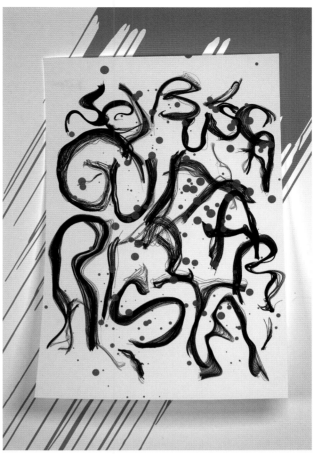
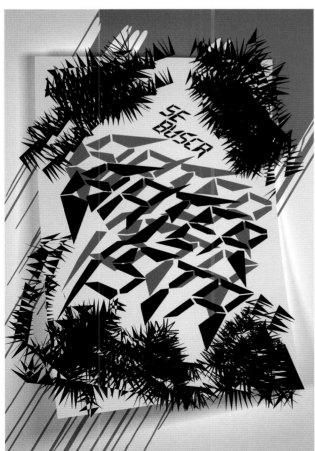
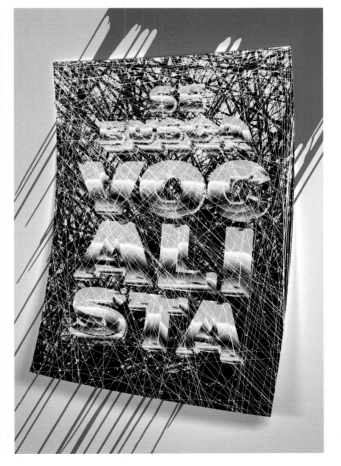

Nuevos Ricos/Poster/2007

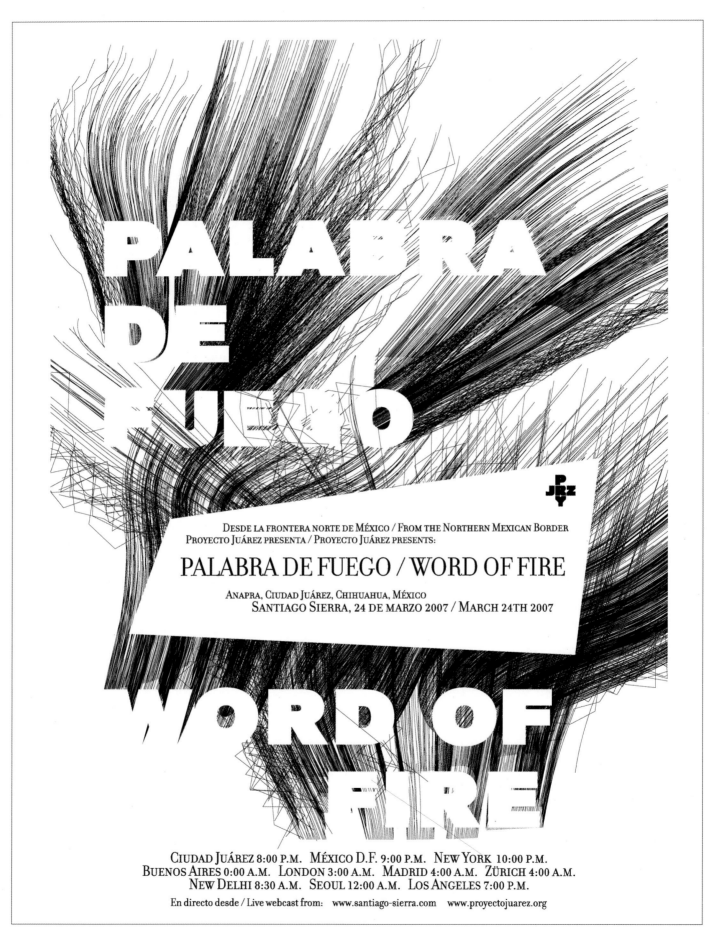

Proyecto Juarez, Santiago Sierra/Poster/2006

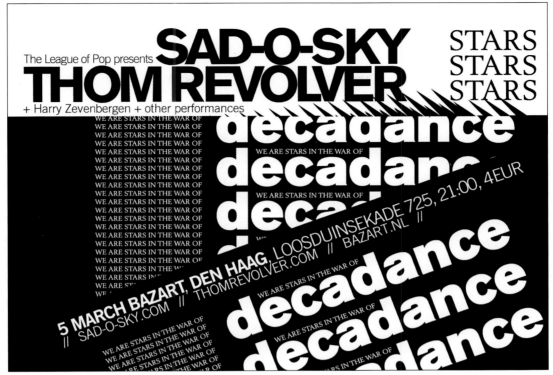

Thom Revolver/Flyer/2004

Proyecto Juarez, Paco Cao/Poster/2007

Thom Revolver/Poster/2003

Paris, France
Angers, France — Paris, France (Audiau)
Clermont-Ferrand, France (Warosz)
New York, USA

Antoine+Manuel

Antoine Audiau and Manuel Warosz
www.antoineetmanuel.com
c@antoineetmanuel.com

Birthplace: Paris, France (Audiau)/Clermont-Ferrand, France (Warosz)
Residence: Paris, France
Connecting cities: New York, USA/Angers, France

THIS DUO OF DESIGNERS met while they were studying at the school of Art in Paris and almost immediately began working together with the name of Antoine+Manuel.

Since 1993 they have carried out projects for cultural institutions such as the Museum of Tomorrow in Taiwan, the Yale University Art Gallery, and the Angers National Center of Contemporary Dance (CDNC). Their work has also been reviewed by publications such as *FORM* and *RES*. Antoine+Manuel run a space/

gallery where they commercialize some of their work, from screen prints to editorial projects such as the book *François-Xavier Courrèges*, which they designed in 2007.

They combine hand drawings and digital illustrations with the use of typography and their own photography. They both explore their favorite creative methods, which give results of coherent unity despite their diversity. By working in areas such as dance and fashion this creative studio has defined a unique graphic style.

"For each project we begin the design process by inventing a formal system with its own vocabulary and rules. In this conception phase we concentrate on form and the story we wish to tell. We focus on the fact that the objects we create are destined for a specific audience and our objective is to provoke emotions. Since we are the first people to see our own work, we need to understand what emotions our work provokes in us."

Pavane/Christian Lacroix's Fall-Winter 2006-2007 prêt-à-porter brochure/2006

38/Christian Lacroix's Spring-Summer 2006 haute couture brochure/2006

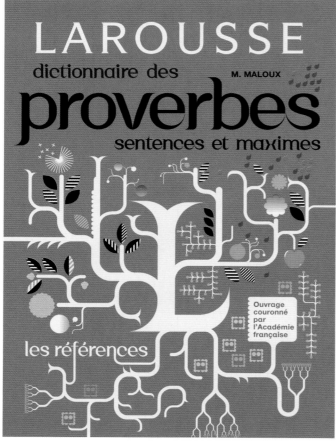

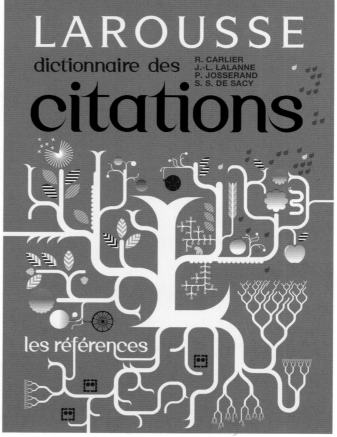

Larousse proverbes/Cover for a proverb dictionnary/2006

Larousse citations/Cover for a quotation dictionnary/2006

16——23 {JUIN} 2007

LOCATION : 04 66 03 15 39

www.uzesdanse.fr

LA VILLE D'UZÈS, LE CONSEIL GÉNÉRAL DU GARD, LE CONSEIL RÉGIONAL LANGUEDOC ROUSSILLON, LE MINISTÈRE DE LA CULTURE ET DE LA COMMUNICATION - DIRECTION RÉGIONALE DES AFFAIRES CULTURELLES LANGUEDOC ROUSSILLON, L'ONDA, LA SACD, LE CENTRE HOSPITALIER LE MAS CAREIRON, L'AGENCE RÉGIONALE D'HOSPITALISATION, LE GOETHE INSTITUT DE LYON, RÉSEAU EN SCÈNE LANGUEDOC-ROUSSILLON, LE MUSÉE DU BONBON HARIBO, L'ARCADE PACA, LES HARAS NATIONAUX D'UZÈS, LA CHARTREUSE DE VILLENEUVE-LEZ-AVIGNON - CENTRE NATIONAL DES ÉCRITURES DU SPECTACLE, LA FNAC DE NÎMES, VÉO LOCATION À AVIGNON, LA MÉDIATHÈQUE D'UZÈS, L'OFFICE DU TOURISME D'UZÈS, LE FORUM DANSE D'UZÈS, LE CCN DE MONTPELLIER LANGUEDOC ROUSSILLON, LE DANISH ART COUNCIL.

Uzès danse/Poster for a contemporary dance festival/2007

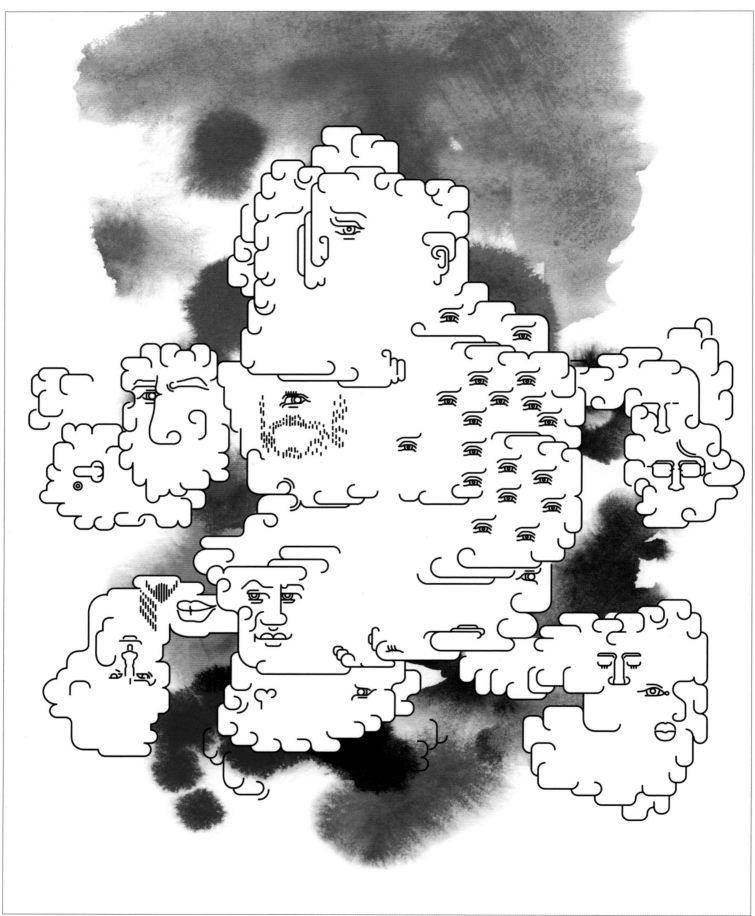

Res cover/Magazine cover/Illustration/2006

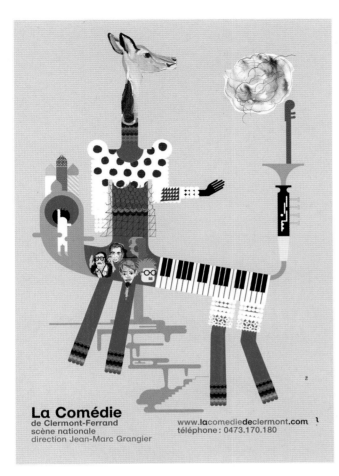

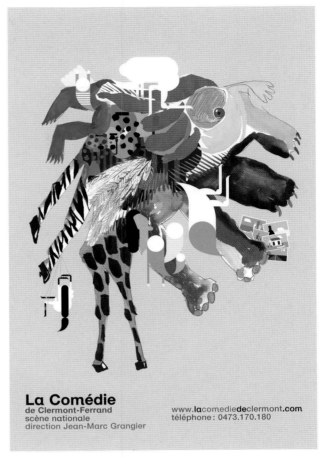

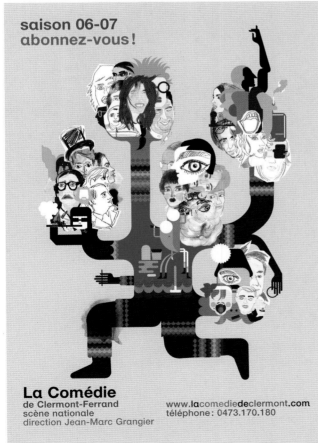

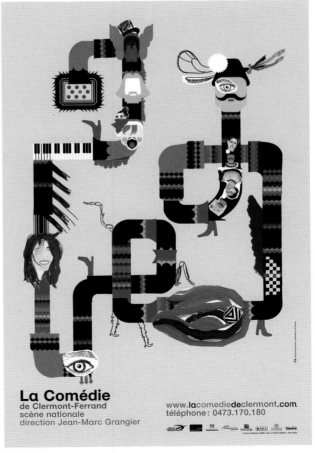

La Comédie de Clermont-Ferrand/Posters for a contemporary theatre/2006-2007

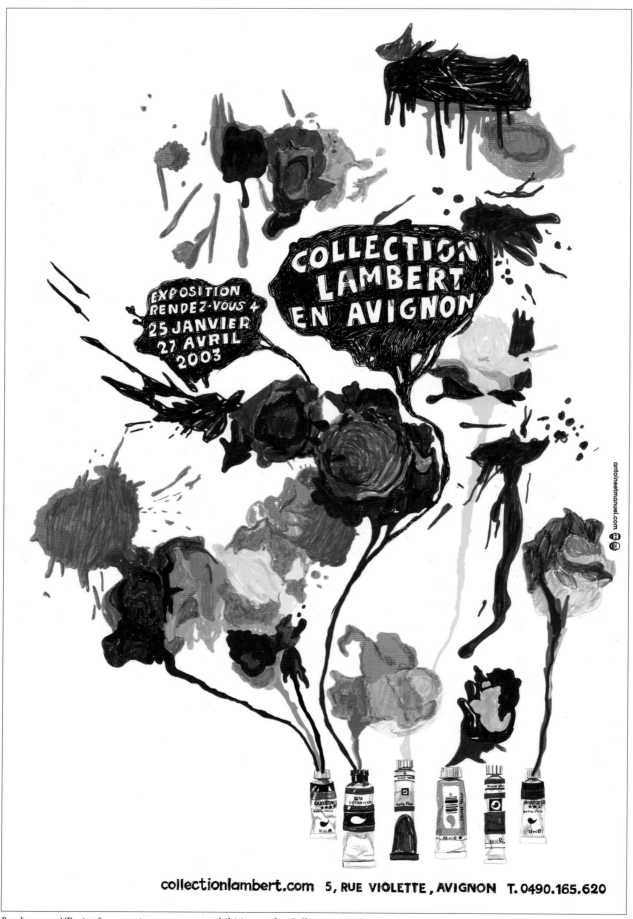

Rendez-vous 4/Poster for a contemporary art exhibition at the Collection Lambert en Avignon Museum/2003

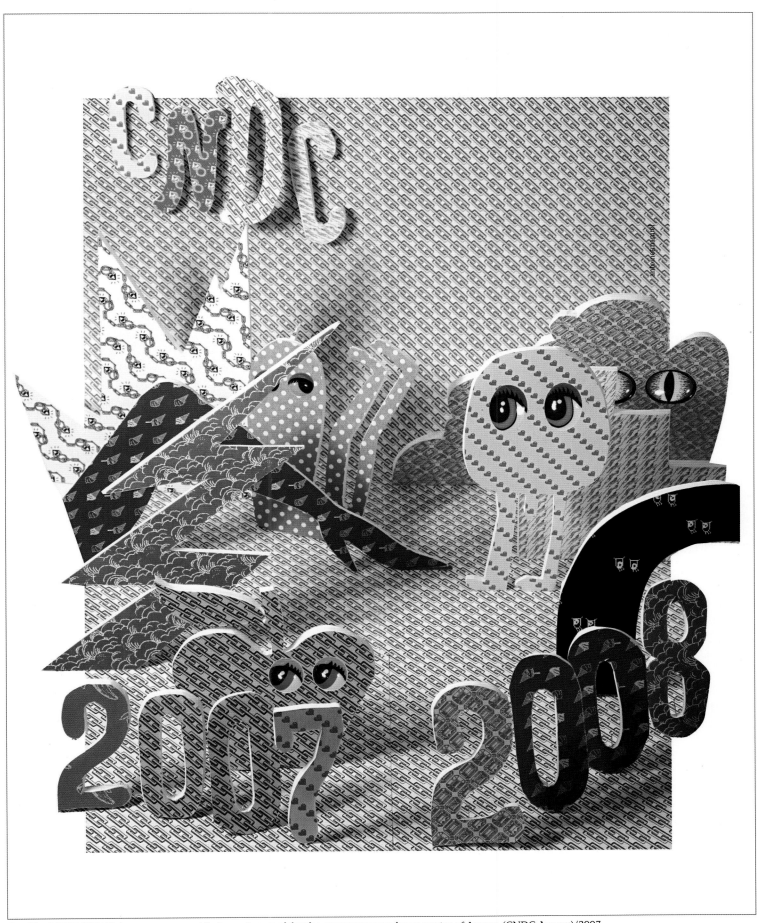

Good Look/CNDC07-08 dance season card/Information card for the contemporary dance center of Angers (CNDC Angers)/2007

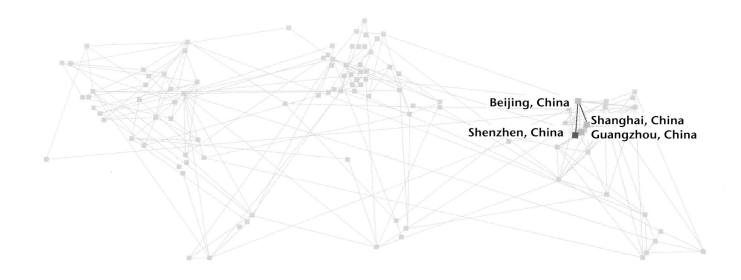

Beijing, China
Shanghai, China
Shenzhen, China
Guangzhou, China

Bai Design

Bai Zhiwei
www.baizhiwei.cn
art4bai@gmail.com

Birthplace: Shenzhen, China
Residence: Shenzhen, China
Connecting cities: Beijing, China / Shanghai, China / Guangzhou, China

SHENZHEN IS A TOWN in the south of Guangdong province in the People's Republic of China and the studio of Bai Zhiwei, Bai Design, is located here. It is a workshop where new forms of design are developed in each project using creative concepts which succeed in showing the value of commercial items.

Zhiwei was born in 1981. He studied art and design at the Shenzhen Polytechnic and since 2007 has managed his own studio. He is a member of the Art Directors Club (ADC) in New York and of the Shenzhen Graphic Design Association (SGDA).

His work has been rewarded with numerous local and international distinctions from important institutions, amongst which include: Art Directors Club of New York (NYADC), Type Directors Club (NYTDC) of New York, Type Directors Club (TDC) of Tokyo, The Taiwanese International Poster Biennale, Identity Best of the Best 2007, and the Beijing International Logo Biennale. He has also participated in diverse exhibitions and his work has been shown all over the world.

Zhiwei creates sophisticated universes which involve the balanced combination of the ornamental style of oriental calligraphy and the minimalist elegance of the Bauhaus style.

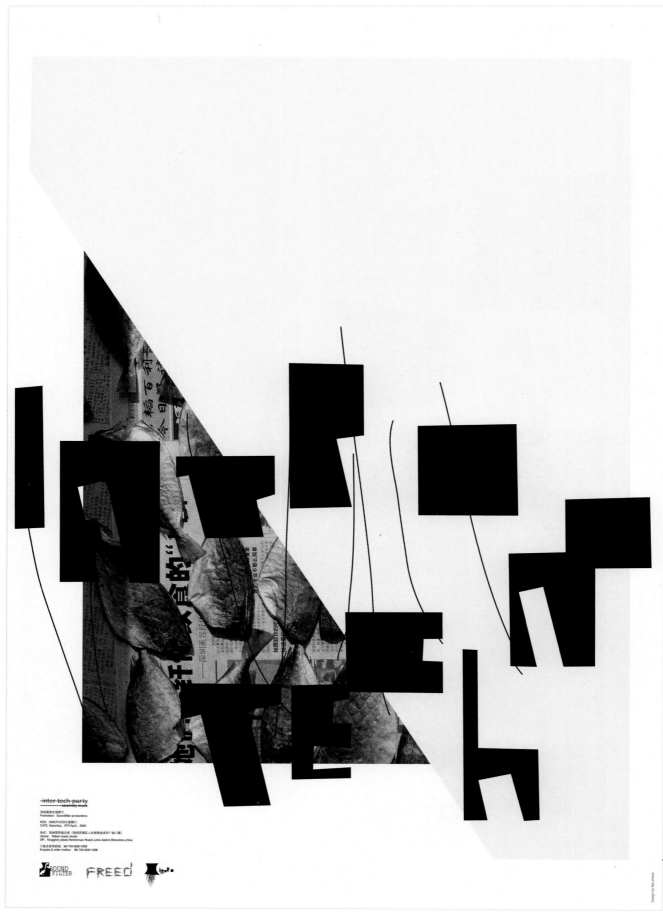

Intro tech DJ party/Poster/2006

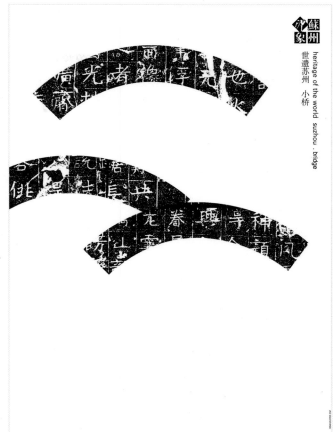

Suzhou image/Poster/2005

Intro tech DJ party/Poster/2006

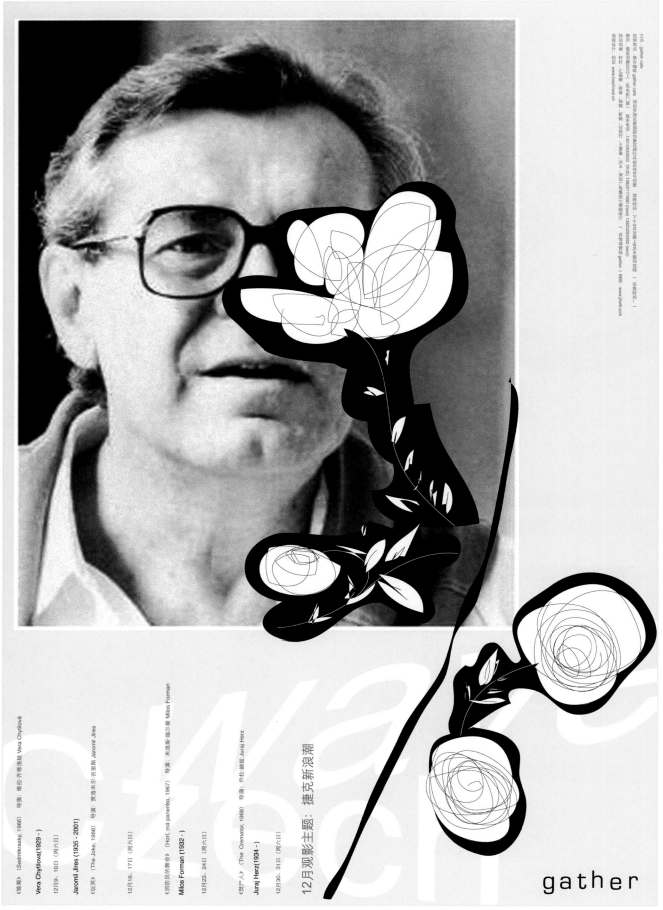

主办：gather cafe
放映地点：柔乐咖啡 gather cafe 深圳罗湖区翠竹路怡景花园怡乐阁北侧都会翠竹家园这些都是你所能分享的空间 放映须知：下午五时后座于咖啡厅内请持观赏通联系
费用：最低消费20元人（会员则一票一） 联系电话：13510633520（玲）13602177890（coco）13823292282（wen）
特别鸣谢：针针·上海楼·玲春·杨颖·新新·新颖·炫炫·任彦行·王嘉焱·火木·深圳电台DJ晓雨情人节礼厅 — 兴情信誉屋 gather BBS
海報设计：相文 针针·上海楼·玲春·杨颖·新颖·炫炫 www.bd01@163.net www.jbvd.com

《雏菊》（Sedmikrasky, 1966） 导演：维拉·齐蒂洛娃 Vera Chytilová

Vera Chytilová(1929 -)

12月9、10日（周六日）

Jaromil Jires (1935 - 2001)

《玩笑》（The Joke, 1968） 导演：贾洛米尔·吉瑞斯 Jaromil Jires

12月16、17日（周六日）

《消防员的舞会》（Hori, má panenko, 1967） 导演：米洛斯·福尔曼 Milos Forman

Milos Forman (1932 -)

12月23、24日（周六日）

《焚尸人》（The Cremator, 1968） 导演：乔拉·赫兹 Juraj Herz

Juraj Herz(1934 -)

12月30、31日（周六日）

12月观影主题：捷克新浪潮

gather

New Wave/Poster/2007

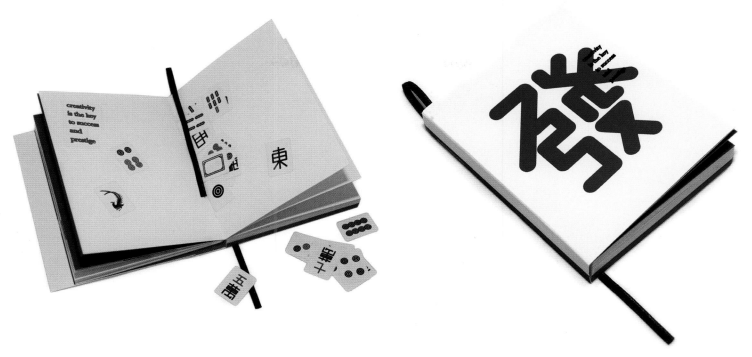

Mahjong book/Booklet/2007

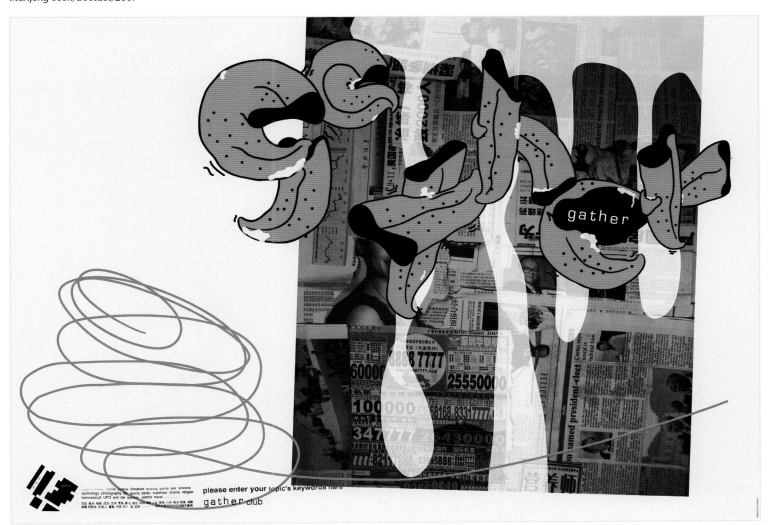

Gather/Poster/2006

Typographic/Typographic treatment/2006

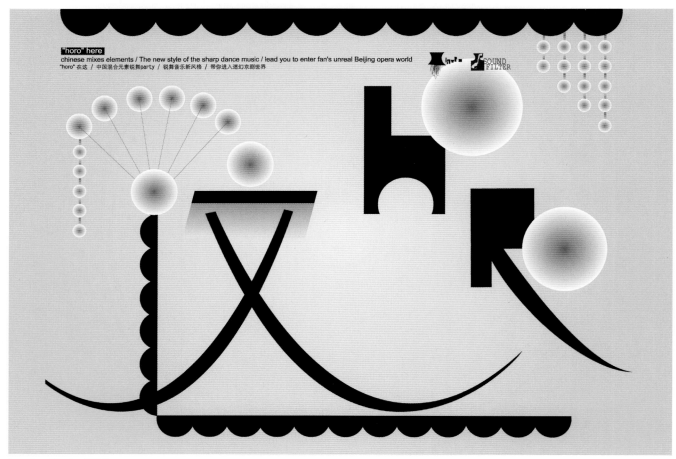

horo here/Poster/2005

wbread/Logo/2006

Pure/Logo/2006

Beijing, China
Baoding, China
Shenzhen, China
Shanghai, China
Hong Kong, China

Bi Xuefeng

www.imagram.com
info@imagram.com

Birthplace: Baoding, China
Residence: Shenzhen, China
Connecting cities: Hong Kong, China/Beijing, China/Shanghai, China

BI XUEFENG FOUNDED HIS STUDIO Imagram Graphic Design in 1997. It develops commercial projects and studies new design ideas, exploring graphics as an independent formal language.

He has received great recognition for his work on a national and international level. His creativity and distinction in graphic design is based on imagination and innovation along with the commercial values required by each one of his clients.

The work of this studio has won numerous prizes and distinctions, which include the Ken Cato Chairman of Judges, and Graphic Design in China, at The International Hong Kong Poster Triennial in 1997 and the Hong Kong Design Show among others. His posters have been exhibited on numerous occasions at the Toyama Poster Triennial in Japan and at the Poster Biennales in Helsinki, Brno, Warsaw, Mexico, and Hong Kong. He has also been selected, three years running, for the TDC Annual Awards.

Xuefeng has participated in exhibitions in Paris and at the Guangdong Art Museum in China. In 2002, he published the monographs *Speaking in visual language* and *The life and design of Bi Xuefeng*. His work has also been included in publications such as *Graphis Poster Annual 2001* and *All Men are Brothers: Designer's Edition*. In addition, he works as a curator, organizing exhibitions such as "French Modern Graphic Design in China" and an important show of one hundred international posters as a tribute to the master, Toulouse-Lautrec.

Graphic Design in China 05/Book/2005

巴黎国际艺术城

City International of Art/Poster/2005

OCT Magazine/Magazine covers/2007

Refreshing Breeze From Mountain Valleys/Book/2006

06+SZ+04/Invitation design/2004

Ljubljana, Slovenia
Zagreb, Croatia
Belgrade, Serbia
Sarajevo, Bosnia and Herzegovina

Bruketa&Zinic

www.bruketa-zinic.com
bruketa-zinic@bruketa-zinic.com

Birthplace: Zagreb, Croatia
Residence: Zagreb, Croatia
Connecting cities: Belgrade, Serbia/Ljubljana, Slovenia/Sarajevo,
Bosnia and Herzegovina

THIS INDEPENDENT AGENCY, which offers advertising services, was founded in 1995 by the designers Davor Bruketa and Nikola Zinic. Its portfolio spans an array of areas from the development of communication strategies, advertising campaigns, and branding to packaging design, signage, and interactive media. Bruketa&Zinic work with a team of around seventy graphic design and advertising professionals.

This well known communication agency has received various prizes at advertising festivals such as Epica, New York Festival, London International Awards, Art Directors Club New York, Cresta, and Clio, among others. Since 2004 the agency has been a member of Brandoctor, a company specializing in brand consultancy.

Many publications and specialist magazines have reviewed and included their work, such as *Grafik*, *Print*, *Design*

Evolution: Theory into practice and the *New York Times*. Also, the magazines *i-D Magazine* (2004) and *HOW* (2006) have named them "the best of the year."

Bruketa and Zinic have been invited to participate as jury members for various international prizes such as the D&AD in London, the Cresta Awards in New York, the Graphis Annual, and the London International Awards.

feed me

School/Visual identity/Creative Directors, art directors: Davor Bruketa and Nikola Zinic/2005

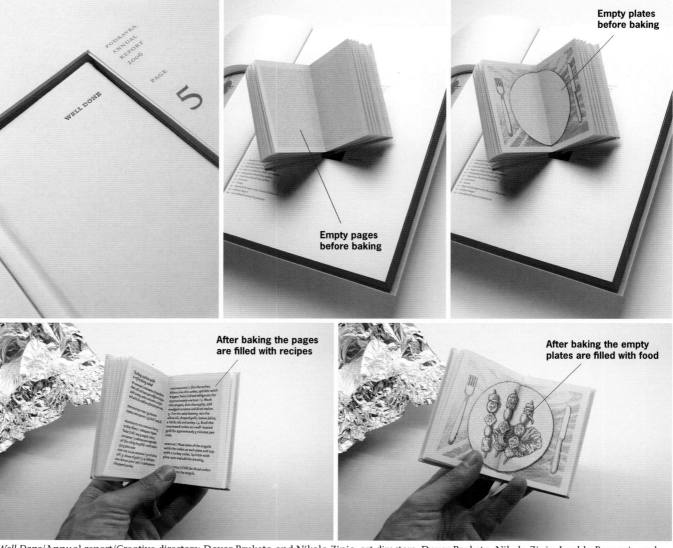

Well Done/Annual report/Creative directors: Davor Bruketa and Nikola Zinic; art directors: Davor Bruketa, Nikola Zinic, Imelda Ramovic and Mirel Hadzijusufovic; copywriters: Davor Bruketa and Nikola Zinic; typographer: Nikola Djurek/2007

KAUBOJI

www.teatarexit.hr

Cowboys/Visual identity/Art director, designer, illustrator: Tomislav Jurica Kacunic; creative directors: Davor Bruketa and Nikola Zinic/2008

Bum/Citylight/Creative director: Moe Minkara; art director: Martina Marinic and Krunoslav Franetic; copywriter: Daniel Vukovic/2007

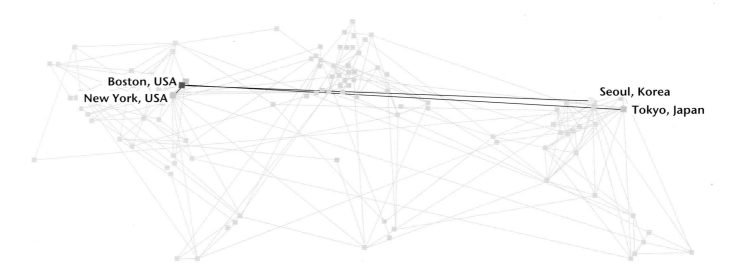

Boston, USA
New York, USA

Seoul, Korea
Tokyo, Japan

Byung-hak Ahn

www.designsai.com
ahn@designsai.com

Birthplace: Seoul, Korea
Residence: Boston, USA
Connecting cities: Tokyo, Japan/New York, USA/Boston, USA

BYUNG-HAK AHN IS a Korean graphic designer who currently lives in Boston, where he works for the Design Sai studio located in Seoul. Design Sai is a renowned Korean Graphic studio which specializes in editorial and printed projects, visual identity, signage, information design, and interactive design for important local and international clients.

He studied visual communication at the University of Hongik and has worked in graphic design and art direction for numerous projects, several of which have earned him international distinctions. In addition, he is actively involved as a professor and lecturer in an academic context.

"I oppose the characteristic distinction between design and art as creative activities. I am motivated by everything I find stimulating and I always aim to place myself at the frontiers of design and any other discipline. This is not somewhere with coordinated data, but a space in continual movement and the marks that this movement leaves behind. I call this 'Sai' in Korean and I believe that it is a place for creation and experimentation."

For Ahn and Design Sai the twenty-first century is a time for "diversity of thought and ideas," an historic moment where the celebration of differences and the appreciation of all things multicultural will see the blossoming of a new creativity.

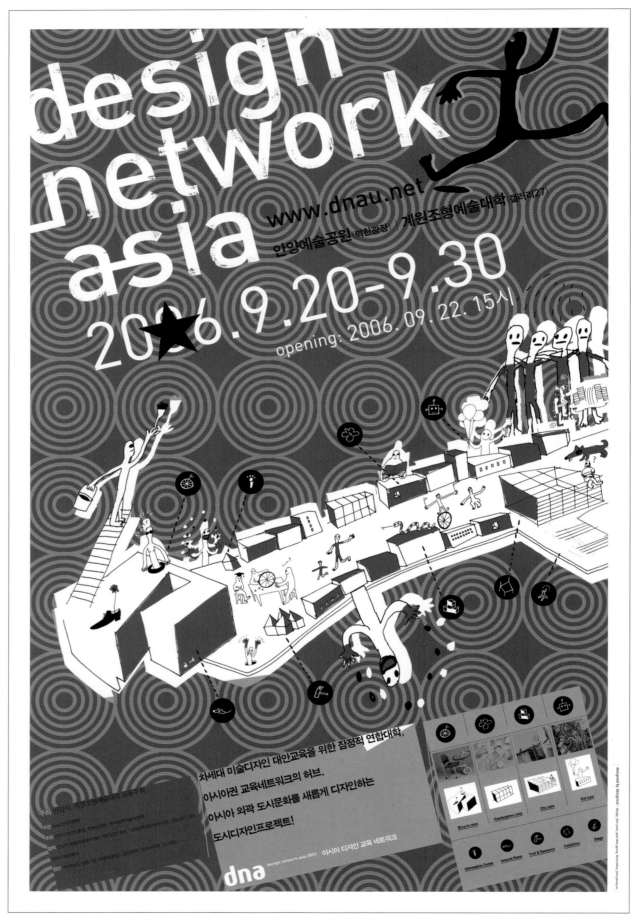

Design Network Asia/Poster/Designer: Yoon Kim, Woo-kyung Geel; illustrator: Young-soo Kim/2006

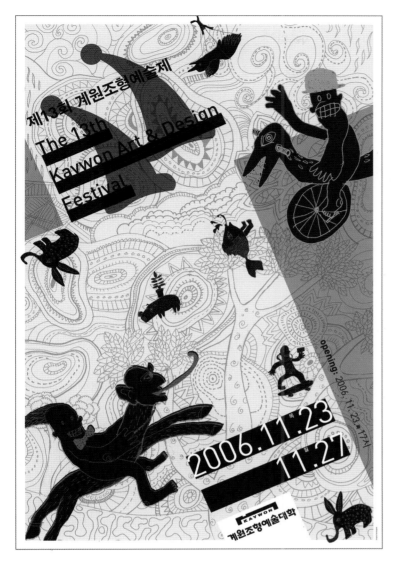

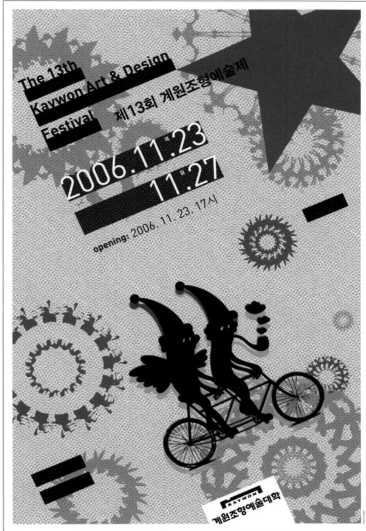

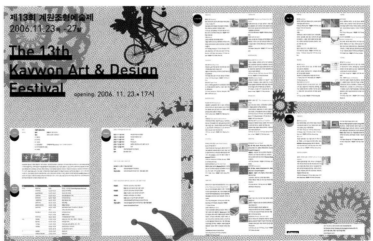

Kaywon Art & Design Festival/Poster No.1/Designer: Sun-soon Shin, Se-mi Yoon; illustrator: Young-soo Kim/2006

Kaywon Art & Design Festival/Poster No.2/Designer: Sun-soon Shin, Se-mi Yoon; illustrator: Young-soo Kim/2006

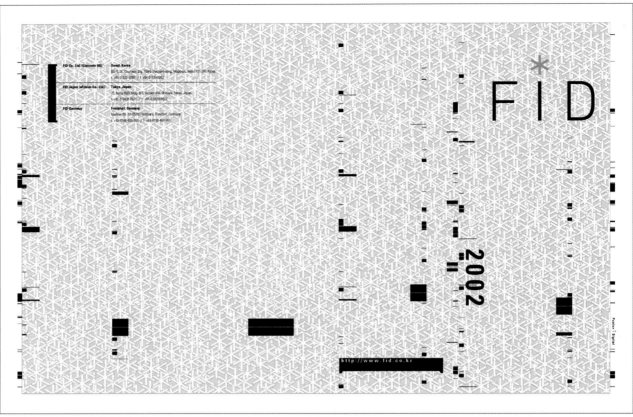

FID/Brochure/Designer: Byung-hak Ahn/2002

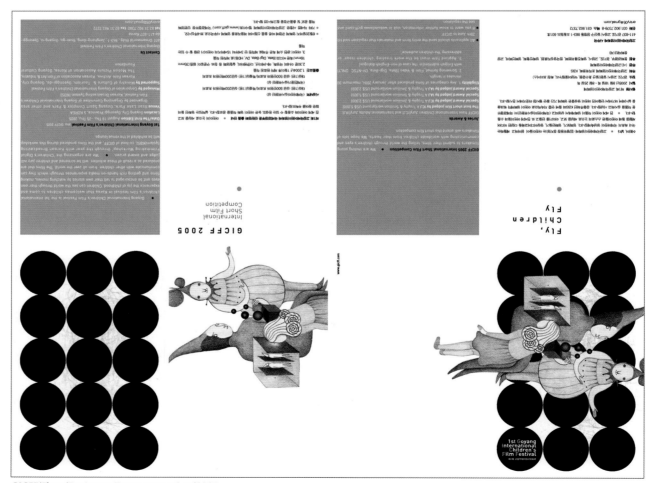

GICFF/Flyer/Designer: Dong-young Lee/2005

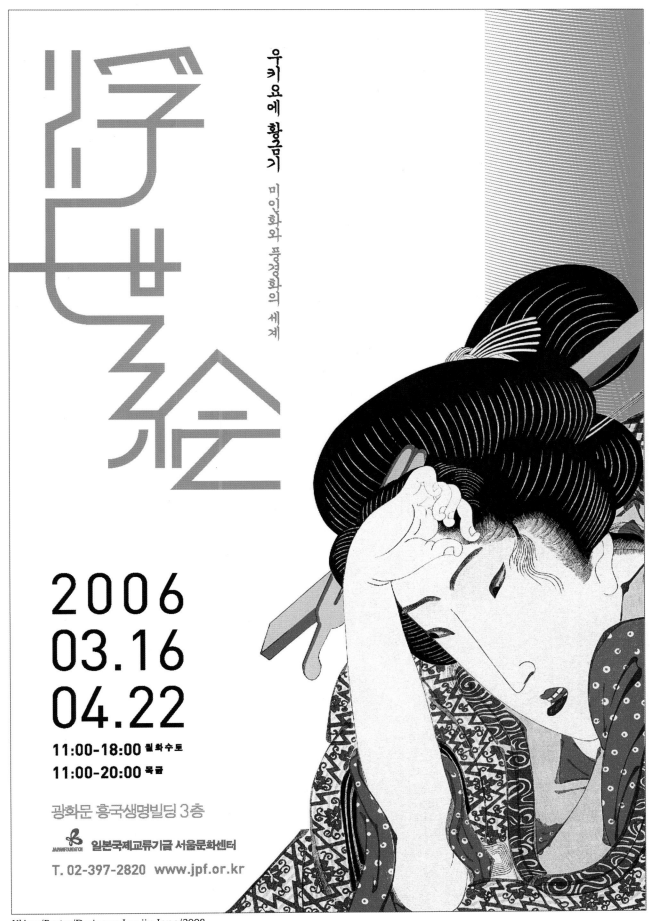

Ukiyoe/Poster/Designer: Lye-jin Jang/2008

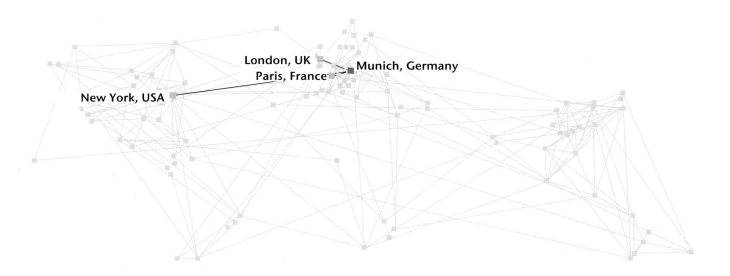

London, UK
Paris, France
Munich, Germany
New York, USA

C100 Studio

www.c100studio.com
hello@c100studio.com

Birthplace: Munich, Germany
Residence: Munich, Germany
Connecting cities: Paris, France/New York, USA/London, UK

C100 IS A MULTIDISCIPLINARY design studio devoted to the development of projects that are worked on from the conceptualization and creative direction to the illustration, graphic design, and art direction.

Based in Munich, this studio specializes in creating precise and inventive visual solutions. They embrace each project with great enthusiasm, dedication, and a unique style, which they hope to transmit to their work, vindicating the need to create personalized designs for audiences who are evermore visually educated and thus more demanding.

Largely influenced by the culture of extreme sports, graffiti, and street art, the work of this studio has been included in recent publications, such as *Young German Design*, *Zoom in Zoom out*, *Logology* and *Nice to meet you*. In 2008, they were selected for issue number 62 of Pyramid's "Design & Designers" series.

In 2003, they worked on the design and art direction of the book *The Art of Rebellion:World of Urban Activism* (www.the-art-of-rebellion.com), a compilation of urban art that comprised interventions by different artists and street practices from around the globe. They were again responsible for the design and art of a second edition in 2006.

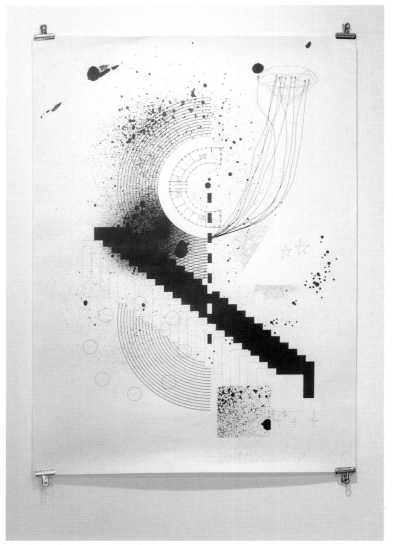

Glam/CD cover/2007

Zürich – High Contrast/Poster/2006

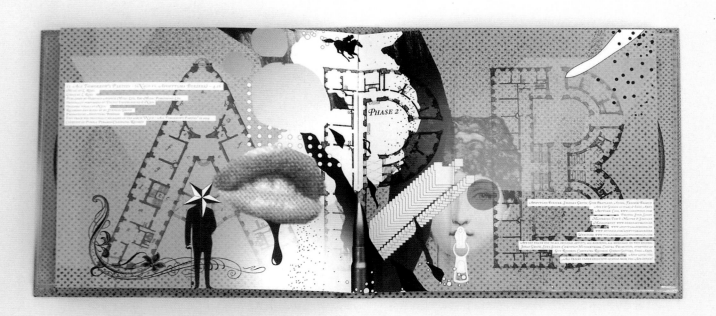

Apoptygma Berzerk/CD cover/2006

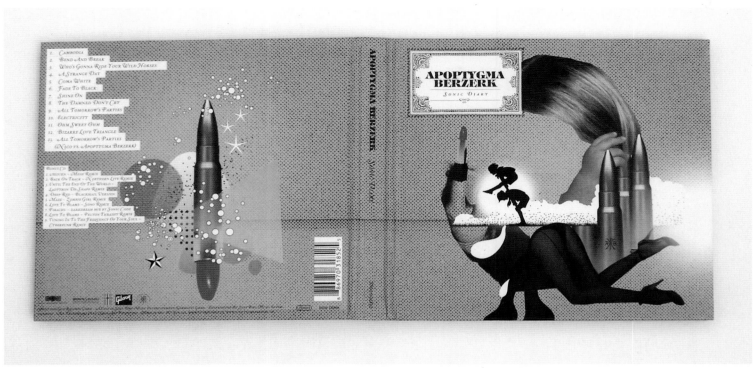

Apoptygma Berzerk/CD cover/2006

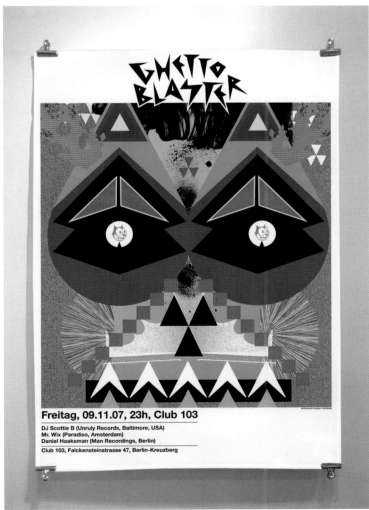

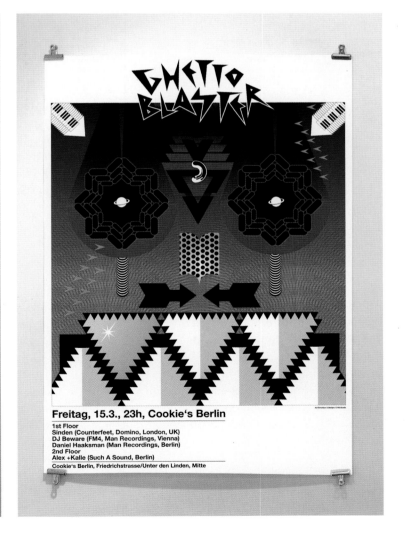

Man Recordings/Poster series/2007

Arnhem, The Netherlands (Gross)
Rotterdam, The Netherlands (Maltha)
San Francisco, California, USA
New York, USA
Aachen, Germany
Nimega, The Netherlands (Gross)
Hamburg, Germany (Maltha)

Catalogtree

Daniel Gross and Joris Maltha
www.catalogtree.net
mail@catalogtree.net

Birthplace: Nimega, The Netherlands (DG)/Hamburg, Germany (JM)
Residence: Arnhem, The Netherlands (DG)/Rotterdam, The Netherlands (JM)
Connecting cities: New York, USA/Aachen, Germany/San Francisco, California, USA

ARNHEM IS THE CAPITAL of the Province of Gelderland in the east of The Netherlands. Rotterdam, in the southeast, is the largest European port and the second biggest in the world after Singapore. Both cities serve as operational bases for the members of the Catalogtree studio – the designers Daniel Gross and Joris Maltha.

This creative duo work on the premise that form is equivalent to behavior, therefore, regardless of the media for which they design, the work of programming, typographical design and quantitative data visualization forms part of their daily routine.

Since their student days in Aachen they have shared an interest in generative systems and independent design. They began working together online with a space which served as a platform and somewhere to experiment with new ideas as well as exchanging technical knowledge and discussing projects.

The work of Catalogtree draws inspiration from architectural design, which they see as fundamental due to its unique capacity for programming human behavior. In each process of work they establish a set of rules where the content has special importance. This enables them to respond to the flow of dynamic information derived from new media and also to offer a refreshing viewpoint for the processing of content for traditional media.

↑ JAGUAR XJ6 UNDERGOING CRASH TEST 15TH APRIL 1969. ↓ BULLET THROUGH APPLE.

EXPERIMENTAL RASTER TYPES

A325

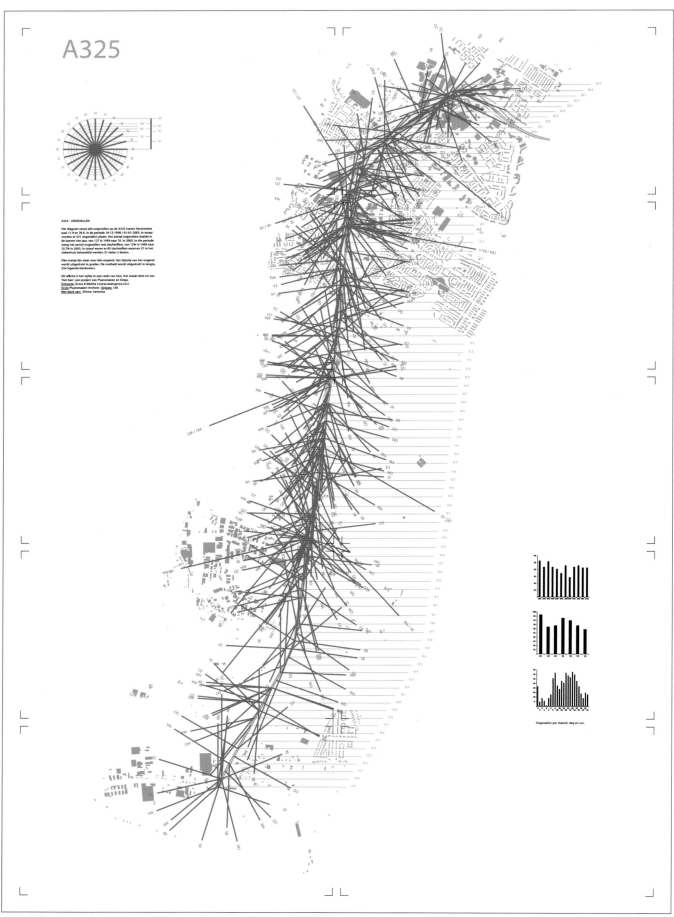

VINEC 005-006-008/Poster/Diagram showing all accidents on A325, location, speed, time, and day, between December 16, 1998, and January 1, 2003/2005–2006

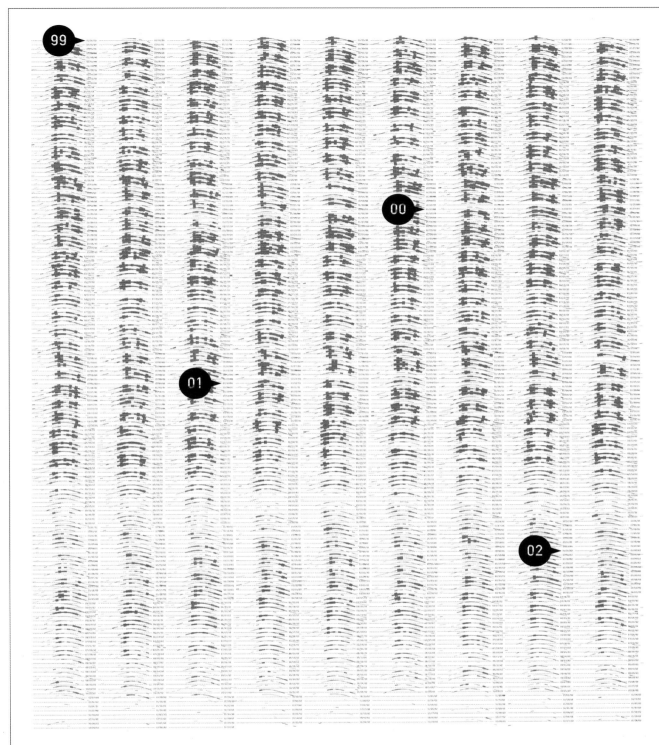

FLOCKING DIPLOMATS NYC 1999–2002

// VIOLATIONS/HOUR

Parking Violations by Diplomats / Hour in 1999 to 2002 in New York City. The violations are plotted in relation to the sun-position as seen from Central Park (LATITUDE 40° 47' N / LONGITUDE 73° 58' W).

ANNUAL TOTALS (YEAR: TOTAL (MAX / DATE))

1999: 42.542 (65 / 09-24) -- Security Council / Fifty-fourth Year, 4048th Meeting, Small Arms. Friday, 24 September 1999, 9.30 a.m.

2000: 38.338 (62 / 02-24) -- Security Council / Fifty-fifth Year, 4104th Meeting, The situation concerning the Democratic Republic of the Congo. Thursday, 24 February 2000, 11.30 a.m.

2001: 25.390 (56 / 02-12) -- Security Council / Fifty-sixth Year, 4276th Meeting, The situation along the borders of Guinea, Liberia, Sierra Leone. Monday, 12 February 2001, 3 p.m.

2002: 12.703 (33 / 04-23) -- Security Council / Fifty-seventh year, 4517th Meeting, The situation in Angola. Tuesday, 23 April 2002, 10.30 a.m.

SOURCES

- Based on data from: Ray Fisman and Edward Miguel, "Corruption, Norms and Legal Enforcement: Evidence from Diplomatic Parking Tickets", December 2007, Journal of Political Economy.
- Daylight Saving Time: http://sunearth.gsfc.nasa.gov/eclipse/SEhelp/daylightsaving.html
- Sun-position (method of calculation): http://answers.google.com/answers/threadview?id=782886 (L. Flores)
- Time of sunrise and dawn: http://aa.usno.navy.mil/data/docs/RS_OneYear.php
- New York City Department of Finance

DATA MINING / SCRIPTING / DESIGN

Catalogtree, January 2008

printed at Plaatsmaken, Arnhem, NL

FlockingDiplomats/Poster/Diagram showing parking violations by diplomats in New York City, 1997–2005/Data provided by: Ray Fisman and Edward Miguel/2007–ongoing

Post-it Poster/Poster/Screen print/2005

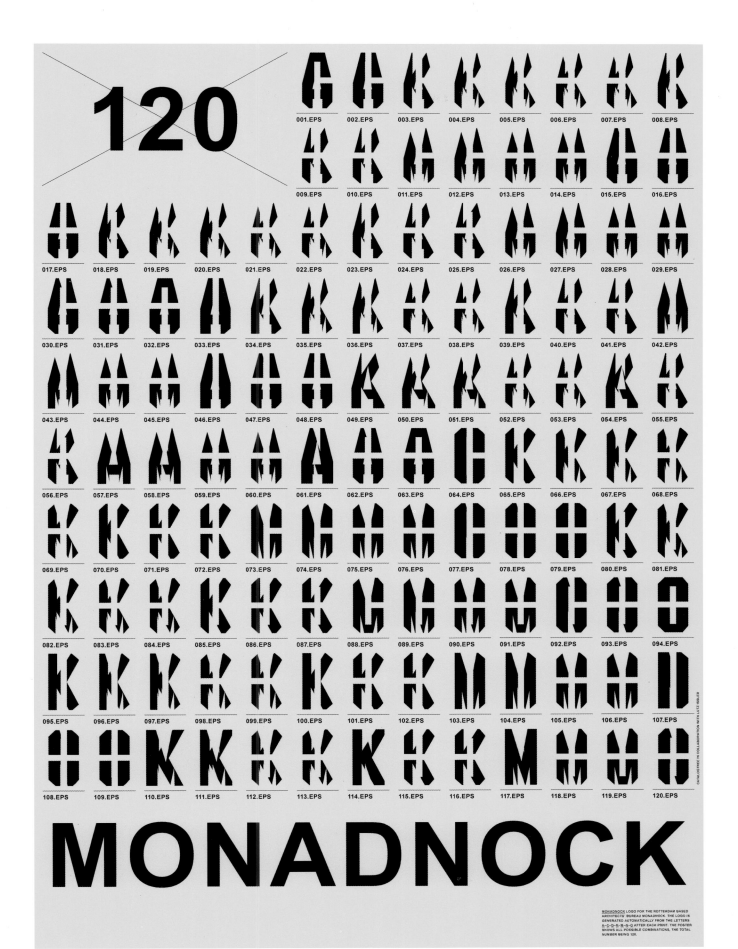

Monadnock Architects/Logo/In collaboration with Lutz Issler (postscript)/2007

Pushpin/Metropolis Magazine/2007

Talkshow 03-09-07

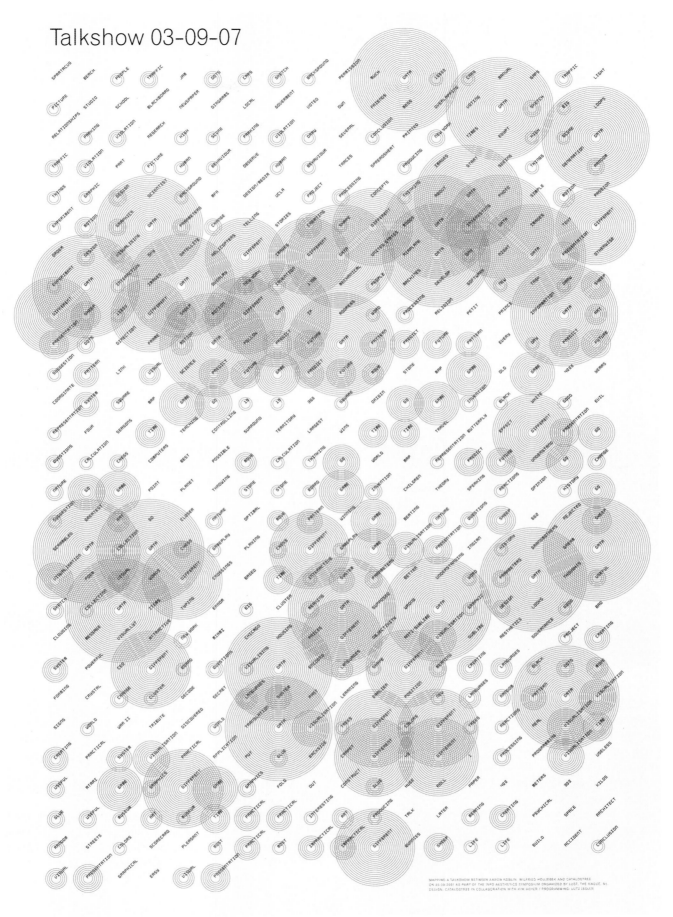

Talkshow/Poster/Mapping a talkshow with Aaron Koblin, Wilfried Houjebek and Catalogtree on 03-09-2007 as part of the Info Aesthetics Symposium organised by LUST/In collaboration with Lutz Issler (processing)/2007

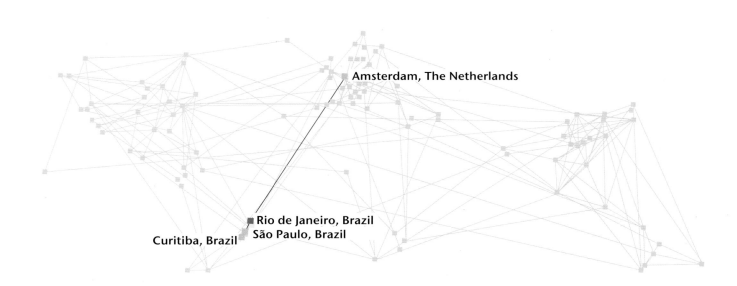

Amsterdam, The Netherlands

Rio de Janeiro, Brazil
São Paulo, Brazil
Curitiba, Brazil

Chacundum

Claudio Reston
www.chacundum.com
info@chacundum.com

Birthplace: Rio de Janeiro, Brazil
Residence: Rio de Janeiro, Brazil
Connecting cities: São Paulo, Brazil/Curitiba, Brazil/Amsterdam,
The Netherlands

CLAUDIO RESTON IS A BRAZILIAN graphic designer and illustrator who lives in the wonderful city of Rio de Janeiro. He is one of the four members of the motion graphics studio Visorama Diversões Eletrônicas (www.visorama.tv) and one of the designers of the fanzine *Design de Bolso*. He is a confessed lover of typography and on his webpage there is a wide selection of his personal typography projects.

The majority of this designer's work does not have a commercial aim, although this is not fundamental. His only real rule is, he says, "to be typographic, whether commercially or not, and to experiment with diverse languages just for fun."

He is inspired by everything that relates to typography – from the typefaces used in 1960s cartoons to street typography, calligraphy, art nouveau typefaces,

and Swiss typography. In fact, he says there is nothing in typography that does not inspire him – albeit simple or sophisticated. "Even the most elemental of things possess a kind of beauty when they are truly typographic."

It is paramount for Reston to try and identify exactly what it is that fascinates him and then transform this information into a personal language.

*Typographic fables series: Morbid Natur*e/In collaboration with Renato Faccini/2007

World Cup Exhibition at Rio de Janeiro: Brazilian National Anthem/Poster/
Illustration/Digital print/2006

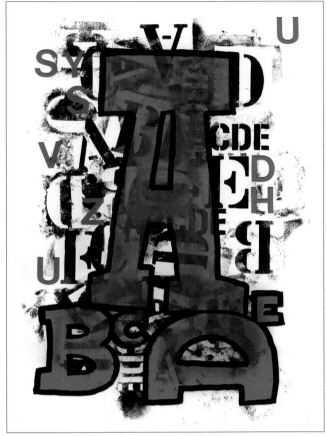

Imaginary alphabet series/Typographic illustration/Acrylic and let-
terset on pearl paper/2007

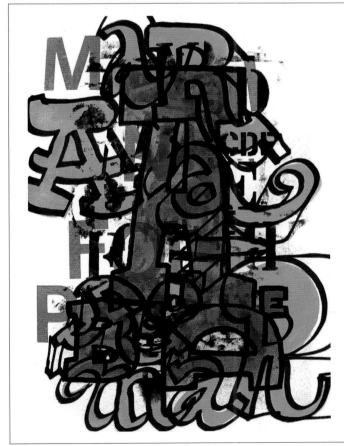

Mariana foi pro mar/Typographic illustration/Acrylic and letterset
on paper/2007

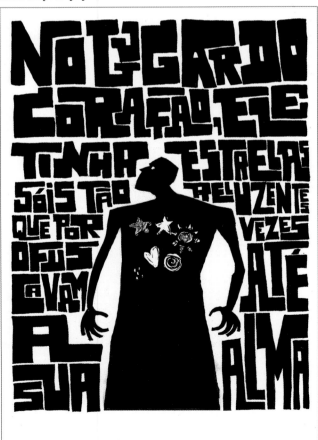

Typographic fables series: In the place of the heart, he had stars/In col-
laboration with Renato Faccini/2007

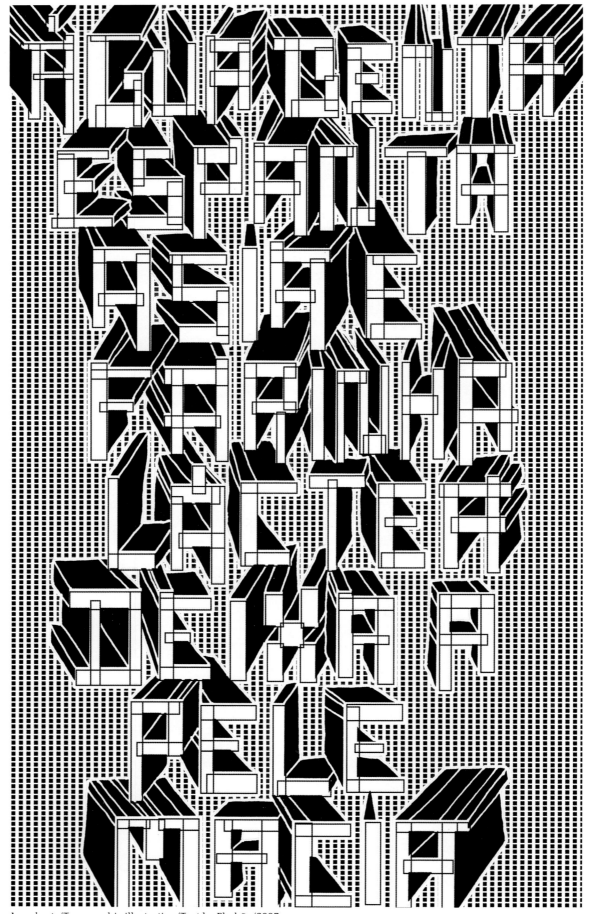

Agua benta/Typographic illustration/Text by Elesbão/2007

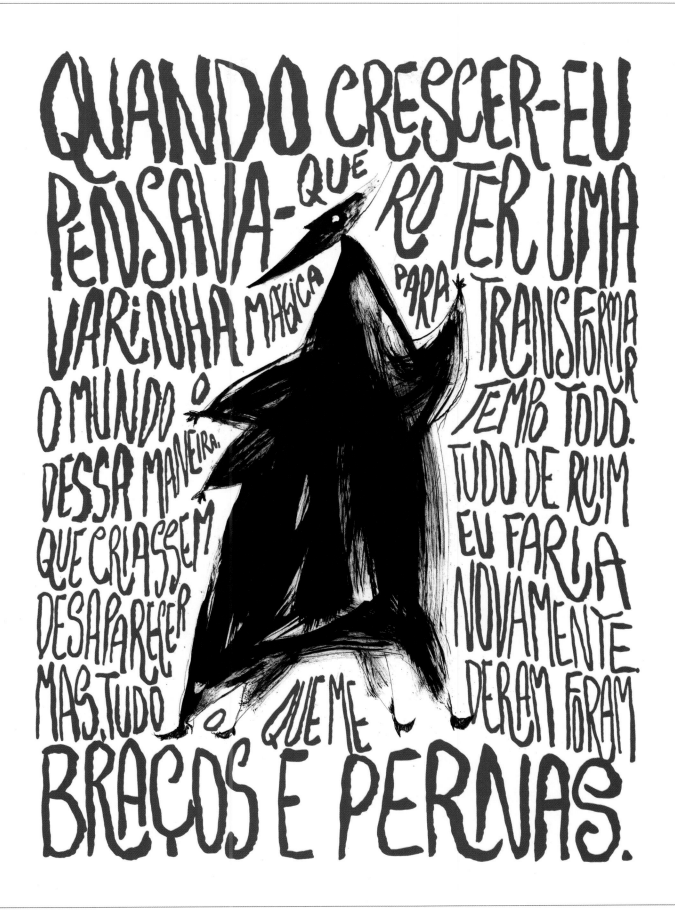

QUANDO CRESCER-EU PENSAVA-QUE ROTER UMA VARINHA MÁGICA PARA TRANSFORMAR O MUNDO O TEMPO TODO. DESSA MANEIRA. TUDO DE RUIM QUE CRIASSEM EU FARIA DESAPARECER NOVAMENTE MAS, TUDO O QUE ME DERAM FORAM BRAÇOS E PERNAS.

Typographic fables series: When I grow up/In collaboration with Renato Faccini/2007

Amsterdam, The Netherlands (RBB)
Amsterdam, The Netherlands
Paris, France
Zurich, Switzerland
Lisbon, Portugal
Ponta Delgada, Portugal (JA)

Change is good

José Albergaria and Rik Bas Backer
www.changeisgood.fr
pleasewriteus@changeisgood.fr

Birthplace: Ponta Delgada, Portugal (JA)/Amsterdam, The Netherlands (RBB)
Residence: Paris, France
Connecting cities: Lisbon, Portugal/Amsterdam, The Netherlands/Zurich, Switzerland

JOSÉ ALBERGARIA AND RIK BAS BACKER have worked together as a team since 2001. Lisbon-born Albergaria was cofounder of the Portuguese graphic studio "Bárbara says." Bas Backer has worked independently as graphic designer and art director for many years, contributing to various editorial projects and renowned publications such as the magazines *Étapes Graphiques, 81+, Creative Review*, and *Print*.

In 2003, they established a new space together, Change is good, an alternative to their unique independent work with two foreign names. The studio works for different types of clients, ranging from the beverage industry to contemporary art museums, fashion design firms, and art foundations. In 2004, they created the poster for the International Festival of Graphic Arts in Chaumont.

They create graphics with individual character, without a fixed style, by hand, and on the computer. They often work in conjunction with the designer Martijn, based in Amsterdam and with the typographers Marco Müller and Alex Meyer, who are based in Zurich.

"Change is good, and it is here to stay for good."

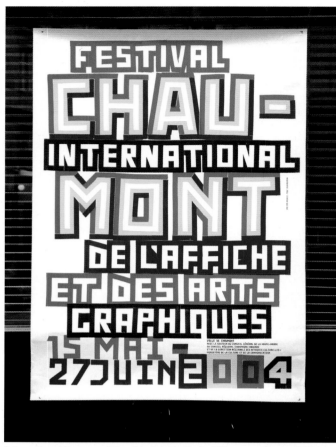

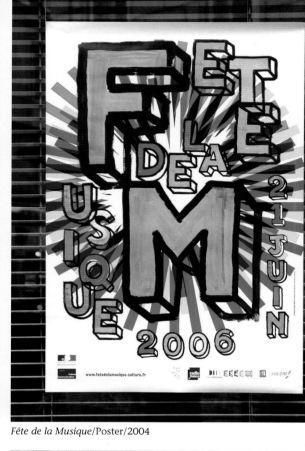

International Poster and Graphic Arts Festival of Chaumont/Poster/2004

Fête de la Musique/Poster/2004

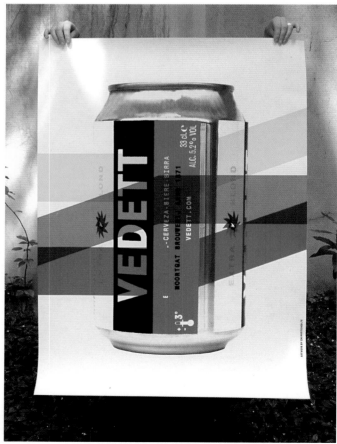

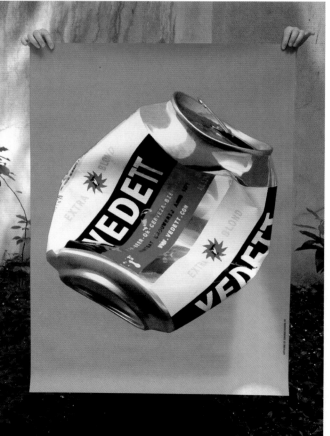

Vedett beer promotion/Poster/2008

Vedett beer promotion/Poster/2008

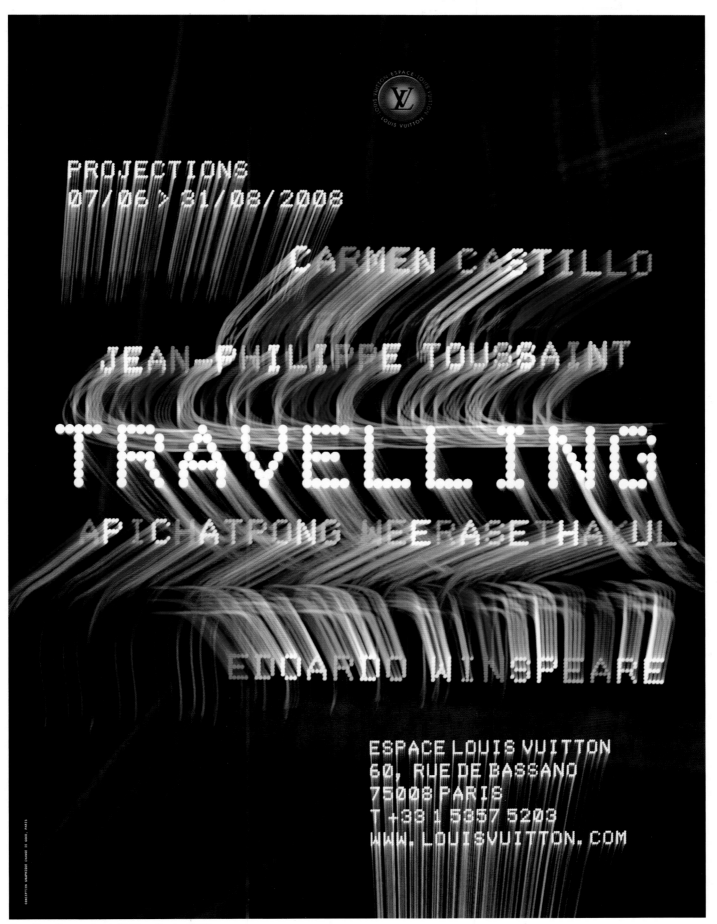

Travelling, Espace Louis Vuitton/Poster/2008

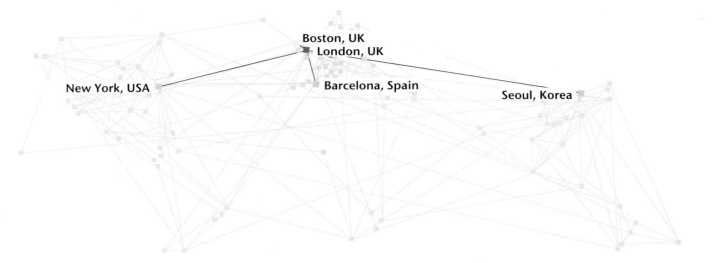

Boston, UK
London, UK
New York, USA
Barcelona, Spain
Seoul, Korea

Craig Ward

www.wordsarepictures.co.uk
info@wordsarepictures.com

Birthplace: Boston, UK
Residence: London, UK
Connecting cities: New York, USA / Seoul, Korea / Barcelona, Spain

"WORDS ARE PICTURES" is the pseudonym of Craig Ward, a designer and typographer based in London. He develops commercial projects for an advertising agency, his own personal projects of visual investigation, and other types of commissions.

He graduated in 2003 and went on to work mainly in the design of printed material and editorial work. He considers himself a typographic illustrator who aims to enliven titles through new treatments, continually exploring the idea of the word as an image.

The New York Times Magazine, *New York Magazine*, and *Time Out* have featured his work, as well as important specialist magazines such as *Computer Arts*, *Creative Review*, and *Bak*, among others.

In his experiments with typography he combines diverse materials such as ink, smoke, and hair. The City of London is his main source of inspiration. He considers the best typography that which first recognizes the rules, then reinterprets, and finally expands them. Scale and contrast are his two preferred attributes, which he uses to maneuver and transform a succession of letters into something different.

The Answers Are Not Found In The office/Digital type treatment/2008

What's Your Story?/Posters for Waterstone's bookshops/Typographic portrait/2008

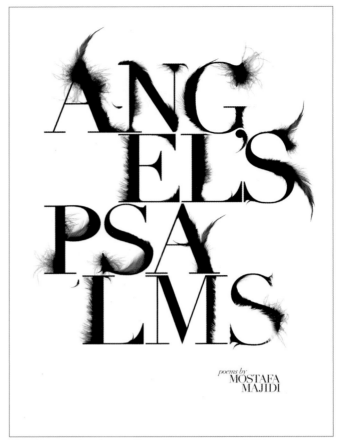

Angel's Psalms/Book cover/Digital type treatment/2008

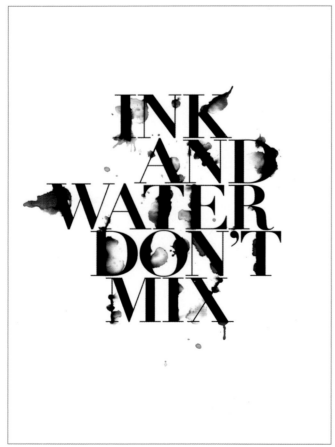

Ink And Water Don't Mix/Typeface proposal for Fontlab/Digital type treatment/2008

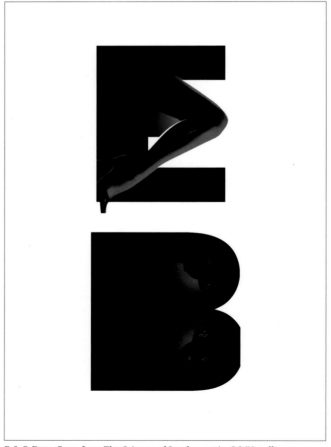

E & B Drop Caps from The Science of Sex feature in GQ/Headline treatment for GQ magazine/Digital type treatment/2008

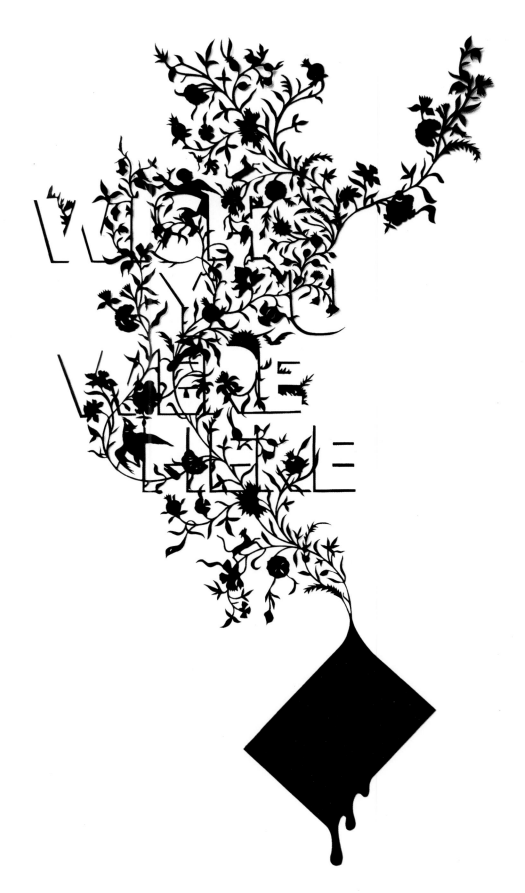

Wish You Were Here/Papercut illustration/Office decoration for advertising agency Elvis Communications/2008

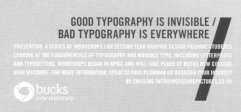

BADOOD
TYPOGR
GRAAPHY
IS IS
EVERYSI
BLWHERE

GOOD TYPOGRAPHY IS INVISIBLE /
BAD TYPOGRAPHY IS EVERYWHERE

PRESENTING, A SERIES OF WORKSHOPS FOR SECOND YEAR GRAPHIC DESIGN PATHWAY STUDENTS
LOOKING AT THE FUNDAMENTALS OF TYPOGRAPHY AND MOVABLE TYPE, INCLUDING LETTERPRESS
AND TYPESETTING. WORKSHOPS BEGIN IN APRIL AND WILL TAKE PLACE AT BUCKS NEW COLLEGE,
HIGH WYCOMBE. FOR MORE INFORMATION, SPEAK TO PAUL PLOWMAN OR REGISTER YOUR INTEREST
BY EMAILING INFO@WORDSAREPICTURES.CO.UK

bucks
new university

Bad Typography is Everywhere. Good Typography is Invisible/Type workshop poster/3D type on wall with digital type overlaid/2008

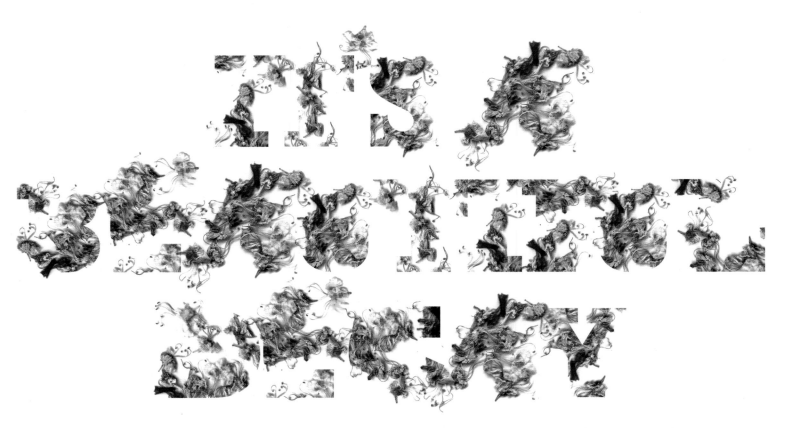

Fontlab 002/Blossomwell/Typeface proposal for Fontlab/Digital Type treatment/2008

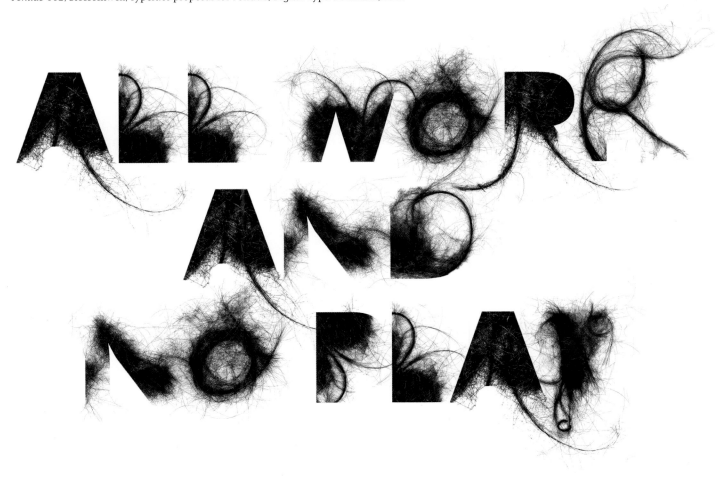

Fontlab 001/Hirsutura/Typeface proposal for Fontlab/Digital type treatment/2008

Columbus, Ohio, USA (AP)

San Francisco, Calif., USA (AP)

New York, USA (AP)

Barranquilla, Colombia (CJR)
Bucaramanga, Colombia (CJR)

Medellín, Colombia
Medellín, Colombia (CJR)
Bogotá, Colombia (CJR)

Cuartopiso

Alejandro Posada and Carlos J. Roldán
www.cuartopiso.com
info@cuartopiso.com

Birthplace: Medellín, Colombia
Residence: Medellín, Colombia (CJR)/Columbus, USA (AP)
Connecting cities: Bogotá, Colombia; Barranquilla, Colombia;
Bucaramanga, Colombia (CJR)/New York, USA;
San Francisco, California, USA (AP)

FOUNDED IN 2001, in Medellín, Cuartopiso is the studio formed by the designers Alejandro Posada and Carlos J. Roldán – a project which began with a passion for graphic design and visual art. Since then they have worked both together and independently, searching for unconventional design solutions in commercial and experimental work.

Some of their pieces have been included in publications such as *Logos* and *Tres logos*.

In 2003, they were invited to take part in the Place project – organized by the Barcelona studio, Vasava. In conjunction with other Colombian designers they were also featured in *IdN* magazine in a piece about contemporary graphic design in Colombia.

They have received the *Lápiz de Acero* (Iron Pencil) prize on various occasions in the category of Internet – one of the most important distinctions in Colombian

design. They were also nominated in the category of multimedia and identity design for the same prize. In 2006, they received a special mention at the Biennale of Latin Letters.

This design team is geographically dispersed and, thus, only meets up at certain times in order to develop "special projects, such as exhibitions, publications, competitions, and all that is challenging enough to warrant working over time."

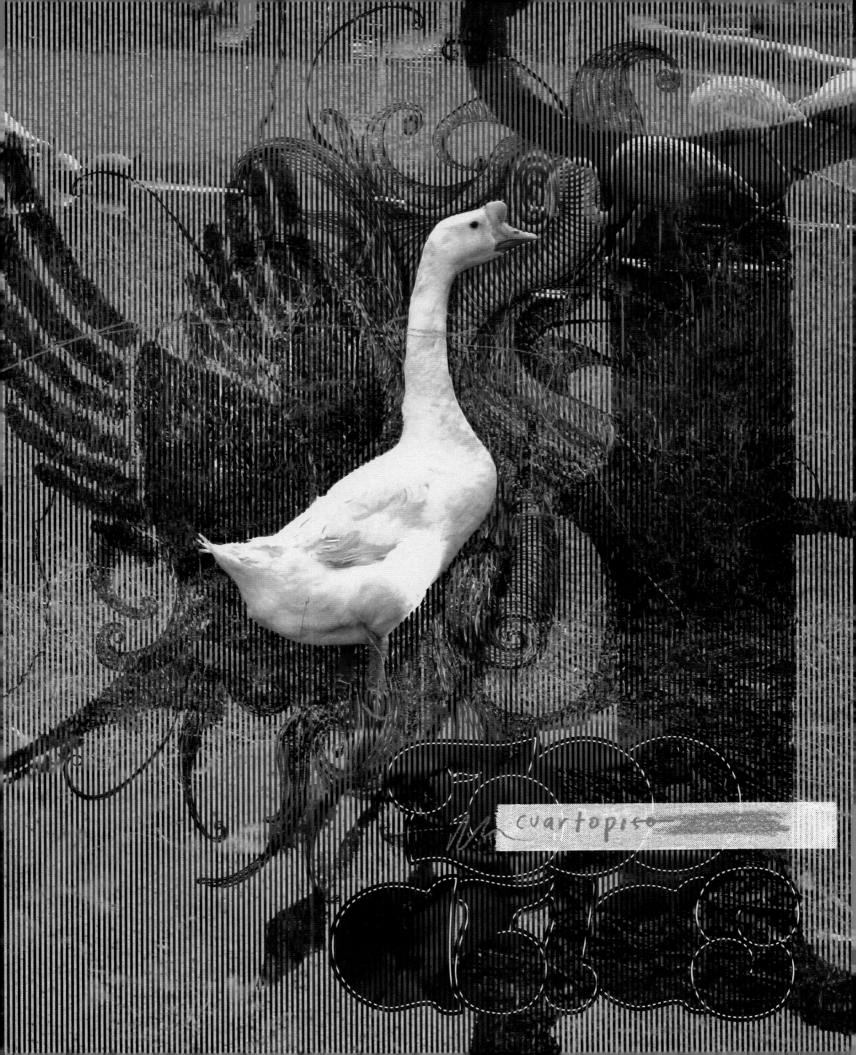

cuartopiso

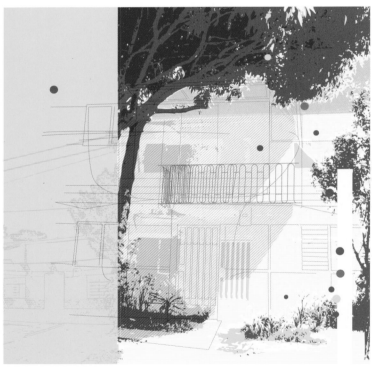

Vivir en El Poblado/Newspaper cover series/2006

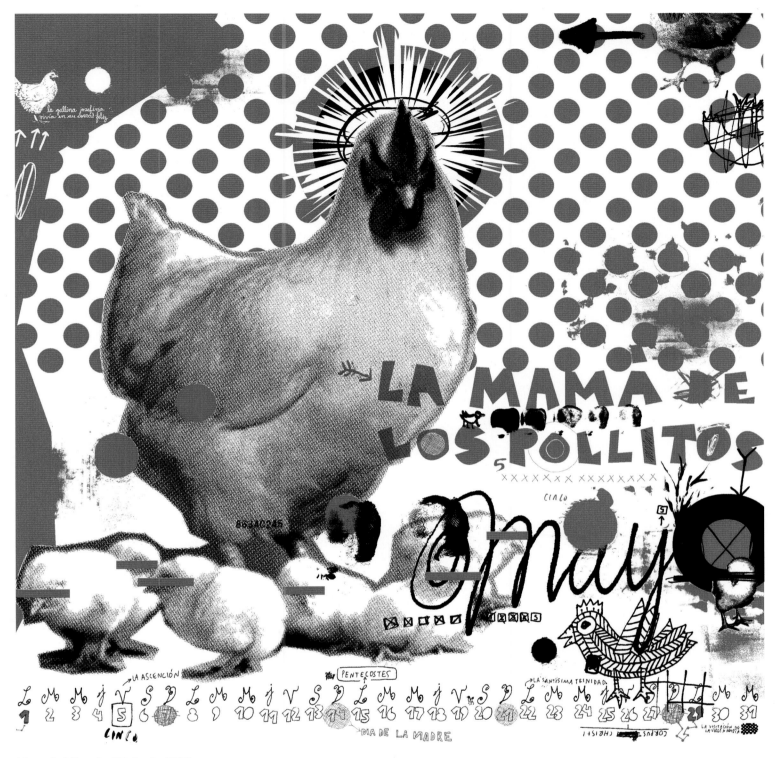

Mayo ¿Qué día es hoy?/Calendar/2005

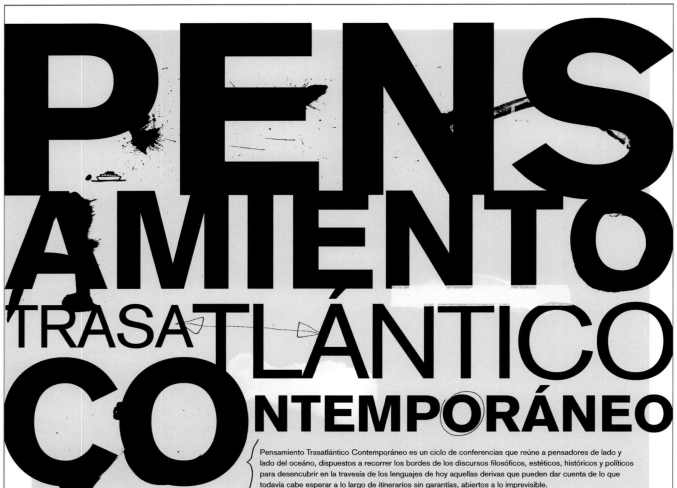

PENS AMIENTO TRASATLÁNTICO CONTEMPORÁNEO

Pensamiento Trasatlántico Contemporáneo es un ciclo de conferencias que reúne a pensadores de lado y lado del oceáno, dispuestos a recorrer los bordes de los discursos filosóficos, estéticos, históricos y políticos para desencubrir en la travesía de los lenguajes de hoy aquellas derivas que pueden dar cuenta de lo que todavía cabe esperar a lo largo de itinerarios sin garantías, abiertos a lo imprevisible.

Maurizio Ferraris (Universidad de Turín) **Encuentros Cercanos con Jacques Derrida** 24 DE ABRIL DE 2007 a las 6 pm.

Francisco Ortega y Bruno Mazzoldi (CES - U. Nacional de Colombia) y (U. de Nariño) **Seguridad Aterradora - A Propósito del IV Avatar de Vishnu** 14 DE MAYO DE 2007 a las 6 pm.

Félix Duque (U. Autónoma de Madrid) **Escatología Filosófica: La Paradoja del Idioma Universal** 5 DE JUNIO DE 2007 a las 6 pm.

Domingo Hernández (U. de Salamanca) **Hackers, Hacktivistas, Artivistas y Otras Especies Fronterizas** 26 DE JUNIO DE 2007 a las 6 pm.

CENTRO DE EVENTOS Y CONVENCIONES DE LA
BIBLIOTECA LUIS ÁNGEL ARANGO
BANCO DE LA REPÚBLICA, BOGOTÁ, D.C.

ENTRADA LIBRE

BOG

 Pensar dsñ: **CUARTOPISO**

Pensamiento Trasatlántico Contemporáneo/Poster/2007

OFFF/Catalogue/2007

IdN 15th Anniversary/Book contribution/2007

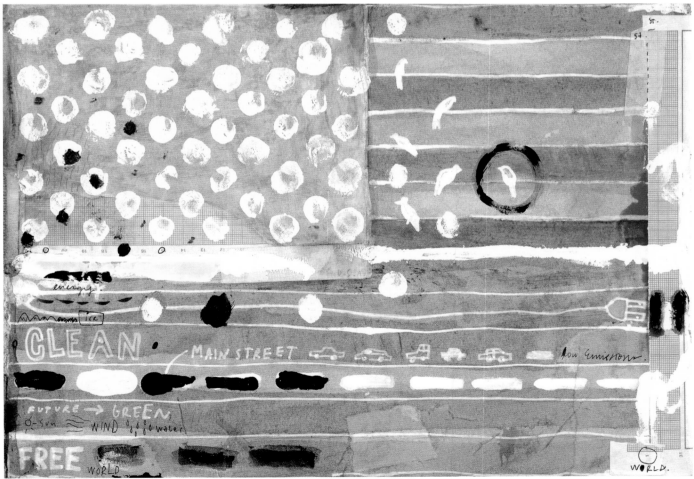

Green Flag/Magazine illustration/2007

Lillehammer, Norway

Oslo, Norway
Drammen, Norway

Bloomfield Hills, Mich., USA

Budapest, Hungary

Deconstructure

Halvor Bodin
www.deconstructure.com
halvor@bodin.no

Birthplace: Lillehammer, Norway
Residence: Oslo, Norway
Connecting cities: Budapest, Hungary/Bloomfield Hills, Michigan,
USA/Drammen, Norway

DECONSTRUCTURE IS HALVOR BODIN, a visual artist, graphic designer, and illustrator who lives and works in Oslo. His studio is a space which he shares with the designer Claudia C. Sandor and with whom he has worked on various projects, such as the award-winning magazine *NO*. They also form part of the network of graphic designers Superlow/Oslo Collective.

Bodin has made a name for himself thanks to his projects on the extreme music scene for black metal bands like Satyricon, Darkthrone, and Thorns, to his corporate graphics and his works for church altars – all without irony and disrespect.

This designer also stands out in the world of video, animation, and motion graphics with projects such as the opening credits for the film *Prozac Nation* and short films for the International Oslo Film Festival and Channel One News.

He has gained numerous prizes and mentions and is one of the most acclaimed Norwegian designers of the last decade. He has received honors at the European Design awards, the Visuelt Awards and the National Book Design Awards of Norway among others. He has also shown his audiovisual projects in important exhibition spaces such as the KonstMuseum in Malmö and the Green Naftali Gallery in New York.

Hydrophobia Series, Waterlow Park I/Public art piece (detail)/Hand drawn, digitally colored, print on aluminum/2006

Kaba Group/Annual Report and Prints/Pencil drawing and photographs reprocessed, vectorized and colorized/2007

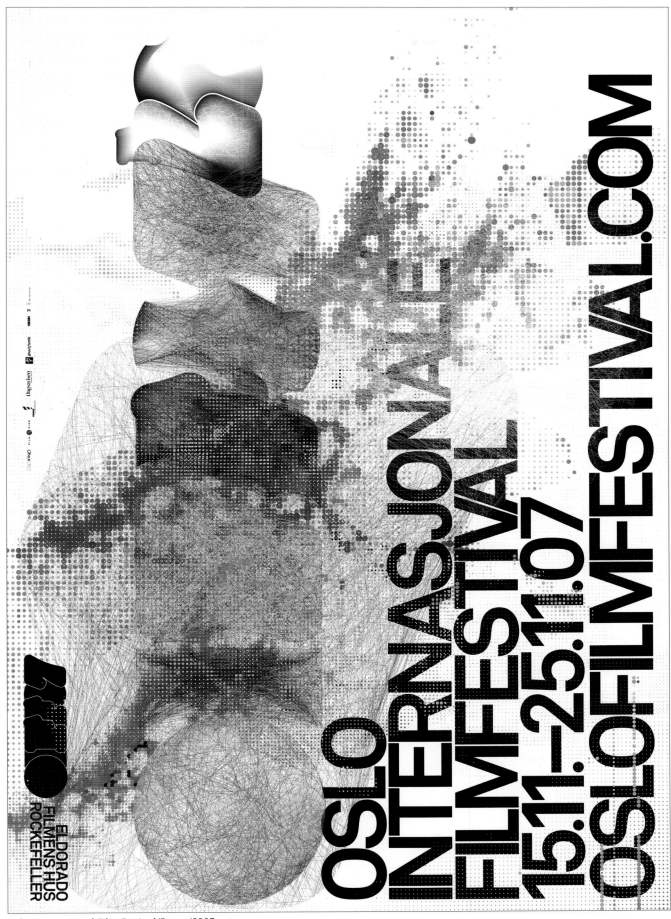

Oslo International Film Festival/Poster/2007

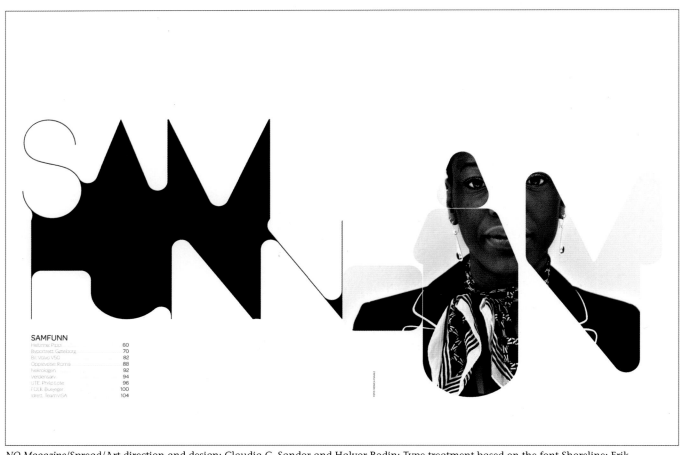

NO Magazine/Spread/Art direction and design: Claudia C. Sandor and Halvor Bodin; Type treatment based on the font Shoreline: Erik Hedberg/2008

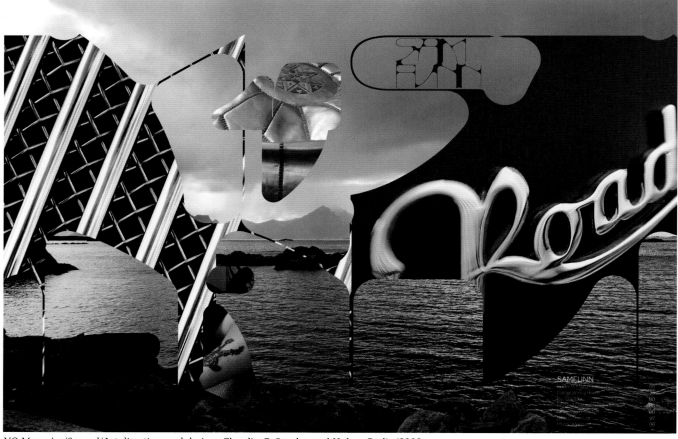

NO Magazine/Spread/Art direction and design: Claudia C. Sandor and Halvor Bodin/2008

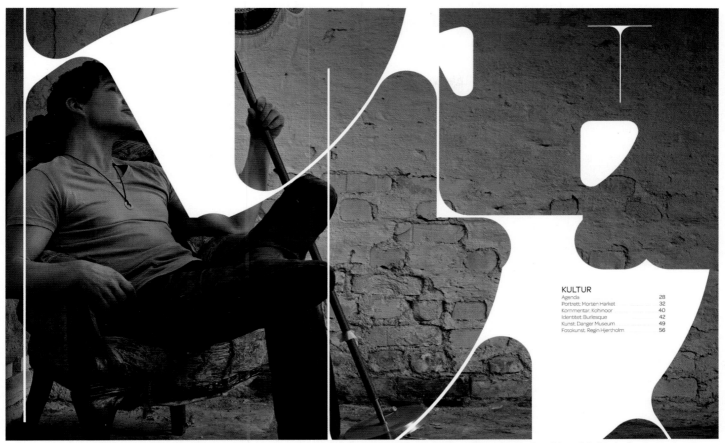

NO Magazine/Spread/Art direction and design: Claudia C. Sandor and Halvor Bodin/Photography of Morten Harket: Marcel Leliënhof (www.tinagent.com)/2008

Codpiece

Foto BILLY JIM
Styling DONALD LAWRENCE
Hår SEIJI YAMADA (Wallgroup)
Make-up YUKO MIZUNO (Pier NY)
Modell DIANA TOMAS (Fusion models NYC)
Stylingassistent SOFIA KRY

Sort skjorte: ISSEY MIYAKE

NO Magazine/Spread/Art direction and design: Claudia C. Sandor and Halvor Bodin/2008

Map labels:

New York, USA
Barcelona, Spain
Tokyo, Japan
Melbourne, Australia

Delaware

www.delaware.gr.jp
mail@delaware.gr.jp

Birthplace: Tokyo, Japan
Residence: Tokyo, Japan
Connecting cities: New York, USA / Barcelona, Spain / Melbourne, Australia

TOKYO, WITH A METROPOLITAN AREA of more than 34 million inhabitants, is the most populated city on the planet. This metropolis is the headquarters of Delaware, "a Japanese supersonic group that designs music and musics design." Its members consider themselves "artoonists" – a mixture of art and cartoon.

Comprised of designers Masato Samata, Aya Honda, and Morihiro Tajiri, this studio, since 1998, has participated in numerous exhibitions in galleries and art spaces. Many of its projects have been reviewed by important magazines and international publications. They have been invited as lecturers to professional gatherings such as AGI Ideas International, which took place in Melbourne, Australia. In 2004, the Barcelona Publishing House Actar published *Designin' In the Rain*, a monographic book about their work.

They work with multiple formats: audio recordings, visual installations, poetic texts and essays, Web, mobile telephone screens, posters, cross-stitch embroidery, and live performances. The square shape prevails in their work, enhancing their lack of delicacy and flexibility. Delaware promotes a *bitmap* aesthetic –"as simple as Lego" – which blends nonsense with spontaneity and diversion.

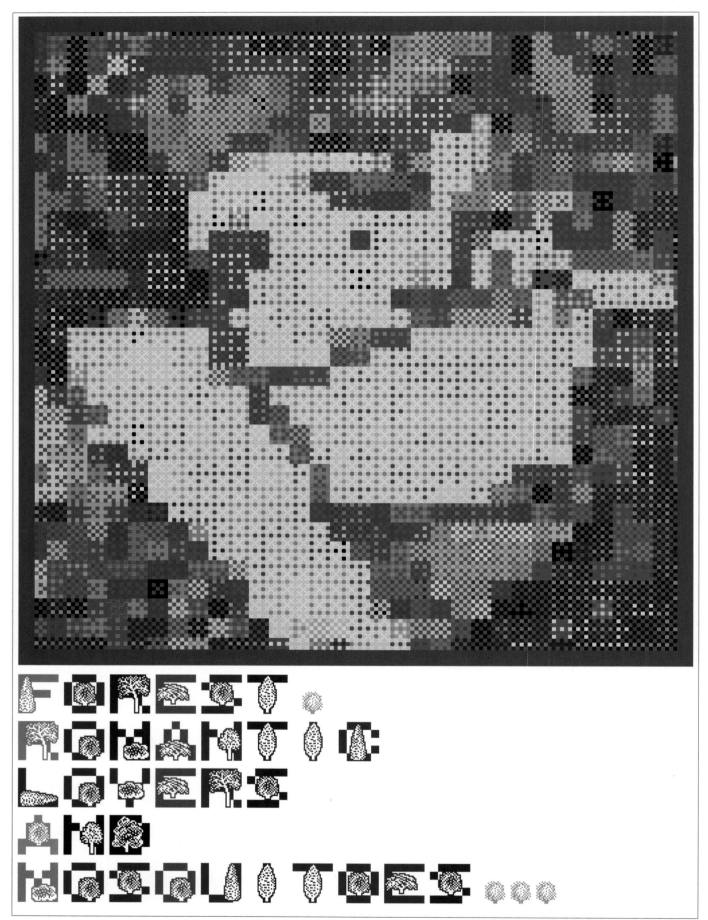

Forest, Romantic Lovers and Mosquitoes... /Illustration/2006

Forest/Illustration/2004-2008

The Beatles Tree/Illustration/2008

Green Park/Cross stitch/2004

Venus De Corgi/Argyle Sweater/2008

Cloud/Illustration/2007

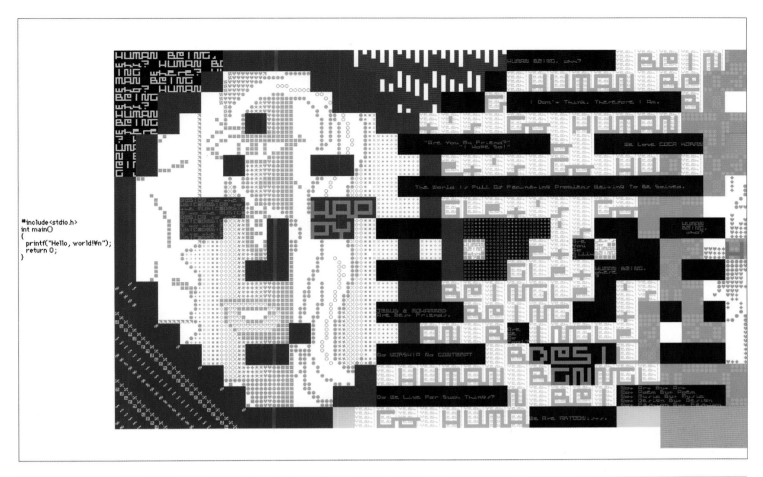

```
#include<stdio.h>
int main()
{
  printf("Hello, world!¥n");
  return 0;
}
```

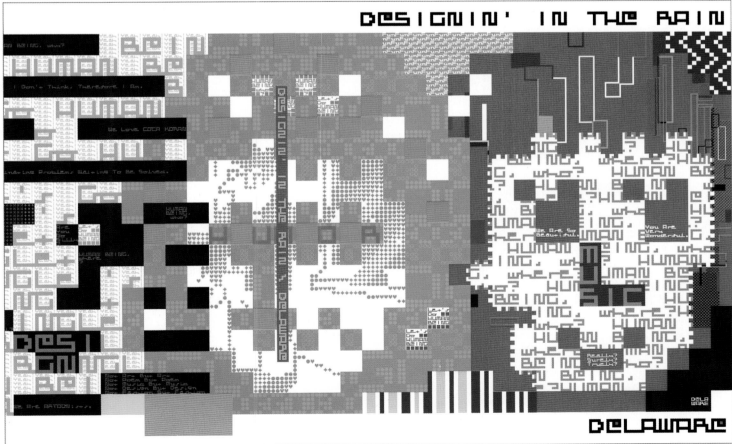

Designin' In the Rain/Book/2004

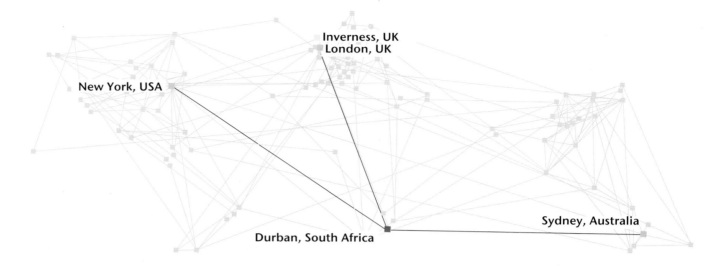

Inverness, UK
London, UK
New York, USA
Sydney, Australia
Durban, South Africa

disturbance

Richard Hart
www.disturbance.co.za
richard@disturbance.co.za

Birthplace: Inverness, UK
Residence: Durban, South Africa
Connecting cities: New York, USA/London, UK/Sydney, Australia

SUZIE AND RICHARD HART founded this South African design studio based in Durban in 1997. Currently, Roger Jardine is the third member of this group. According to Jardine, disturbance "has 11 members and 11 letters in its name. The studio address is 22 Prains Avenue – which is twice 11. All this is pure coincidence. However, disturbance believes in giving 110 percent in everything that it does."

It specializes in the development of illustration and graphic projects for editorial and printed work. It uses digital methods as well as traditional methods in its creations which range from industrial design, to T-shirts and interventions in space.

This agency is a small-scale company that offers a fresh and original approach in each of its projects. The variety of styles and its sense of humor are its most significant qualities, as well its objective in creating intelligent, committed, and relevant design.

It has won numerous local and international prizes and accolades, which include awards from institutions such as the D&AD, ADC, One Show, Communication Arts Design Competition, and Society of Illustrators. In addition to creating a fanzine, a restaurant, a gallery, and designing the fashion label Home Industries, disturbance has recently published a compilation of its favorite work in the book *These Are a Few of Our Favorite Things*.

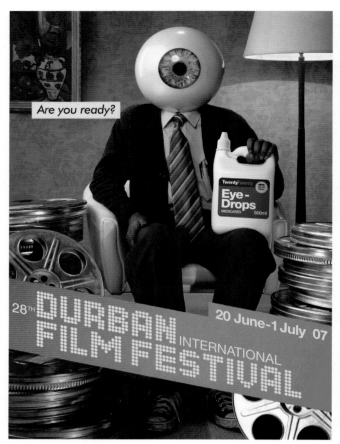

Durban Film Festival/Poster/2007

Durban Film Festival/Poster/2006

Durban Film Festival/Poster/2008

Durban Film Festival/Poster/2002

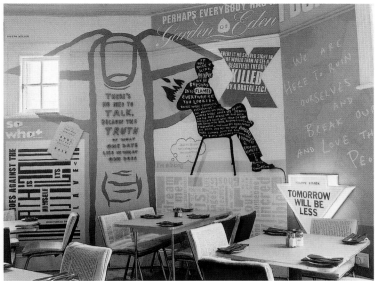
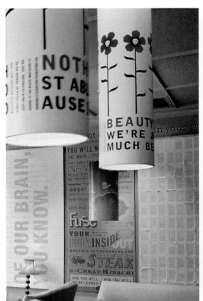
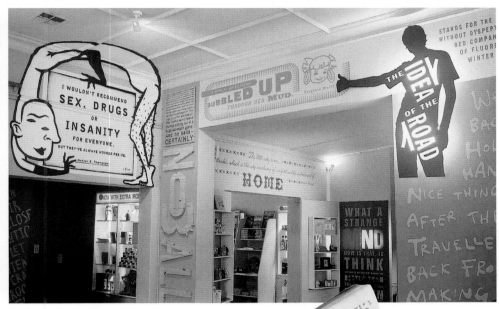
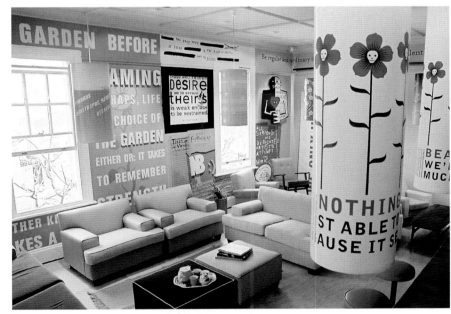

Home restaurant/Spatial intervention/2004

London, UK

Paris, France Dijon (MB)/Givors (EG), France

ÉricandMarie

Éric Gaspar and Marie Bertholle
www.ericandmarie.com
info@ericandmarie.com

Birthplace: Dijon, France (MB)/Givors, France (EG)
Residence: Paris, France
Connecting cities: London, UK

PARIS, CLASSED ALONGSIDE TOKYO, New York, and London as an "alfa/global" city, is the home to ÉricandMarie, composed by the designers Éric Gaspar and Marie Bertholle, who have worked together since 2002. After graduating with degrees in graphic design in France they set off for London where they both completed their studies, first at Saint Martins College of Art and Design and then at the Royal College of Art.

Each new project gives the designers an opportunity to explore new avenues in graphic design. In addition to their commercial work, the duo investigates a personal grammar of ideas and forms – a kind of "gym to keep them in shape," which they admit has been very useful.

ÉricandMarie have developed important projects for artistic and cultural institutions in Europe and have held educative workshops at Fabrica, Italy and at the Ecole Supérieure d'Art et de Design (ESAD) in Reims, France

Convinced that it is the idea that dictates form, Gaspar and Bertholle prefer to distance themselves from seductive images and put greater onus on the choice of materials and the processes of printing and production in each one of their projects. Experimentation is inherent in the whole process from the conception of an idea to the end product.

Amplifier skin/Leather/2000

Printed discs/Screen print on persplex/1999

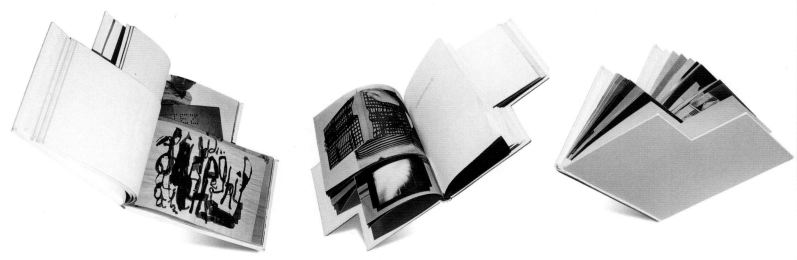

Portfolio book/Book/Manual binding/2000

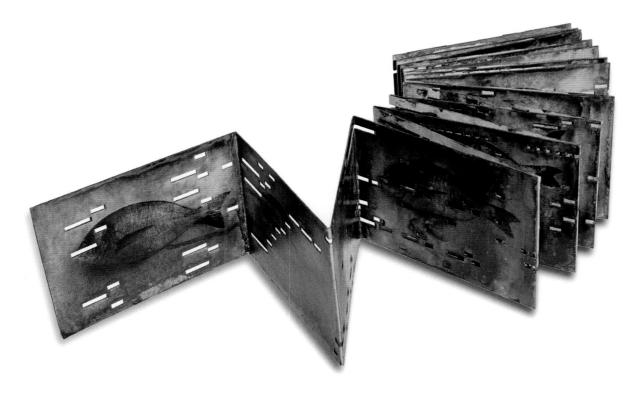

Fish book/Book/Photographic emulsion on mechanical music card/1999

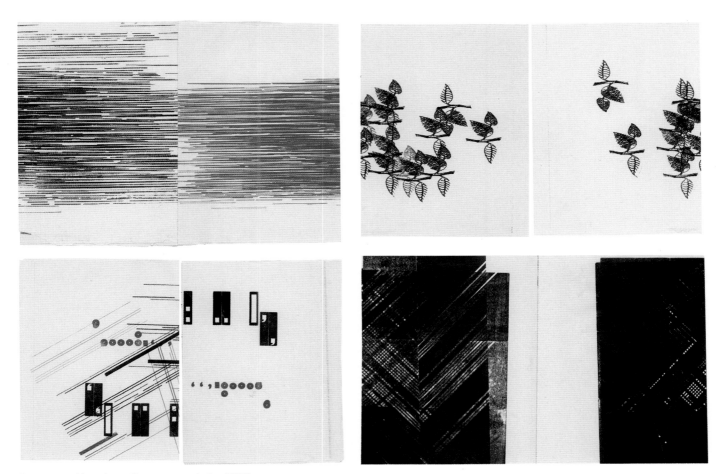

Letterpress without letters/Letterpress printing/2000

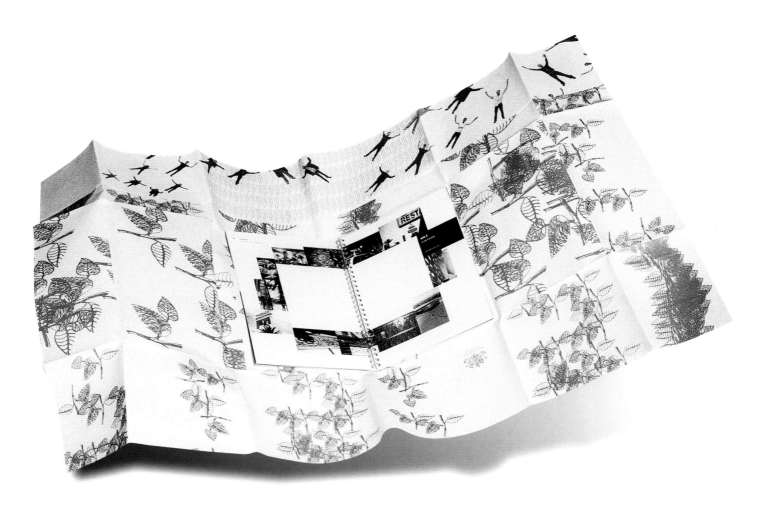

RCA Architecture/Offset/2001

Zoom Posters/Screen prints/1999

Zoom Posters/Screen prints/1999

Berlin, Germany

Zadar, Croatia ■ Zagreb, Croatia
Dubrovnik, Croatia

Fiktiv

www.fiktiv.hr
info@fiktiv.hr

Birthplace: Zagreb, Croatia
Residence: Zagreb, Croatia
Connecting cities: Zadar, Croatia/Berlin, Germany/Dubrovnik, Croatia

NOT EVERYTHING ABOUT Fiktiv is fictitious. Some things are just plain reality. For example, opposite the street where the Fiktiv studio is located, there is a small yellow grocery store. This is where the Fiktiv team goes whenever their energy levels begin to wane or the pixels start dancing.

The Fiktiv house is surrounded by eighteen rose trees, and four tall pine trees which make it a great hideout. The street itself, which winds its way up the hill through a peaceful neighborhood on the boundaries of the city center, is called Silvery – adding a touch of glamor to the whole concept. The studio is small and basic with three long white desks, three long benches to sit on, some books and a few plants in need of care. The space alters constantly – as does the team. The kitchen is rarely frequented.

The fiktivians spend most of their time chasing mice under their desks and hunting for online glory. During their brainstorming sessions some of them like surfing the Web, others like going out and chatting in the garden accompanied by Leni the dog. Fresh air and good news are always welcome. Lights go out at about 8 P.M.

f _ kt _ v
_ _ _ _ _ _

The Garden Zadar seasonal visuals/Print campaign and collateral/2005-2007

French Cuisine, Alif Tree/CD cover/2005-2006

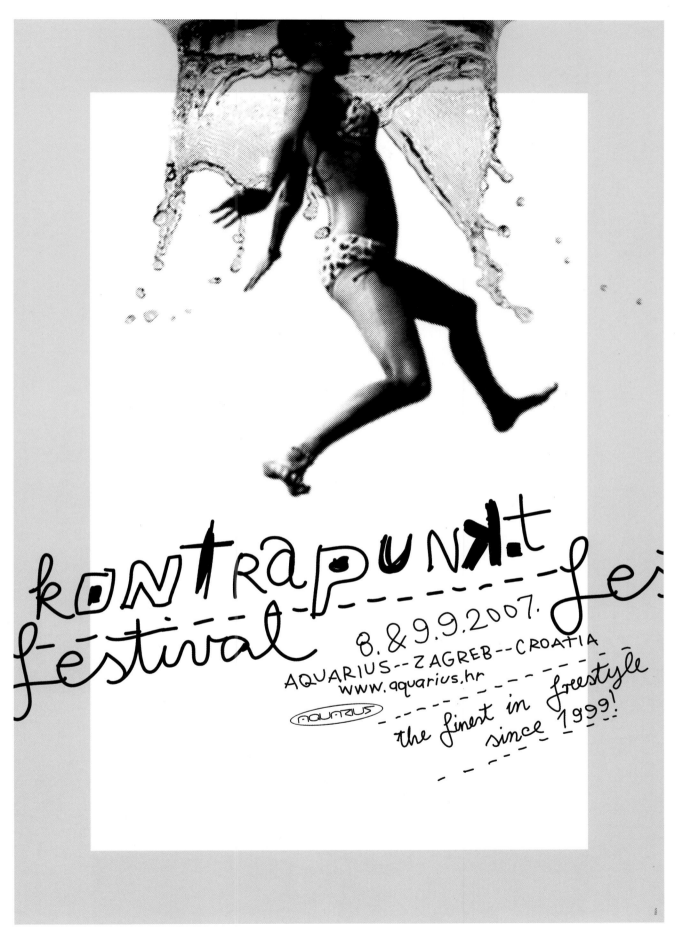

Kontrapunkt Festival/Poster/2007

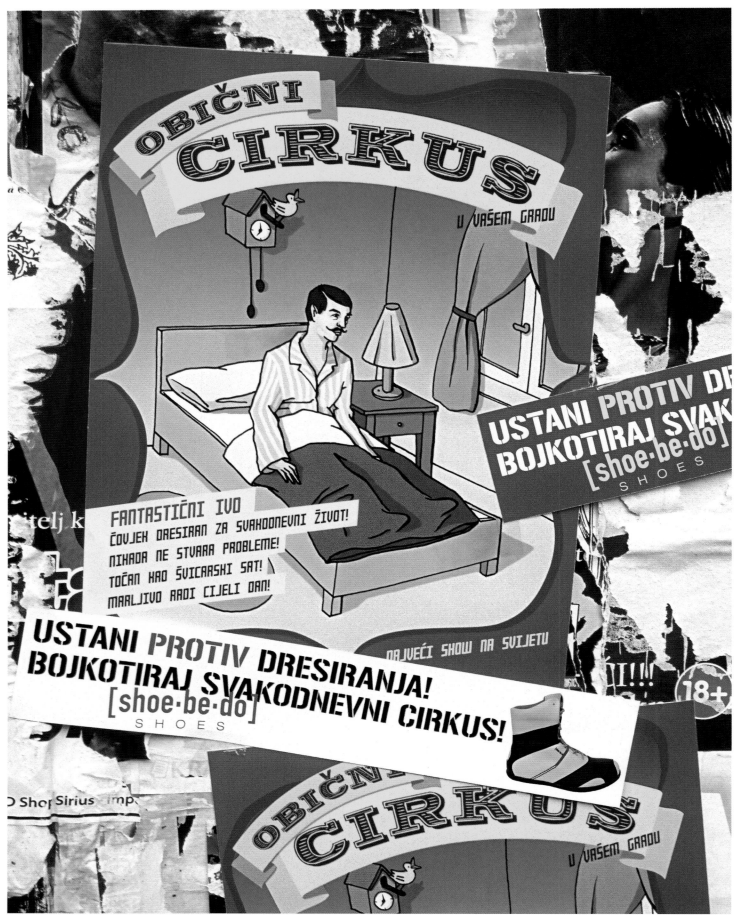

«Circus», *ShoeBeDo Shoes*/Advertising campaign/2004

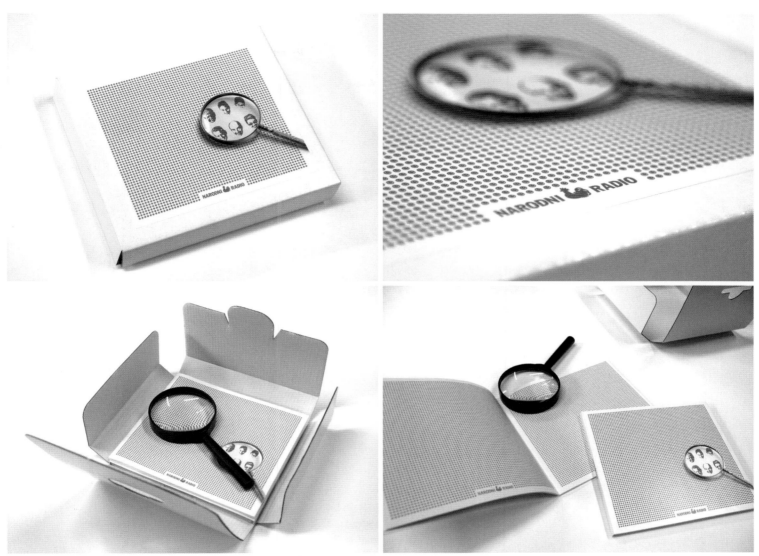

Narodni radio: One million listeners/Promo-pack/2002

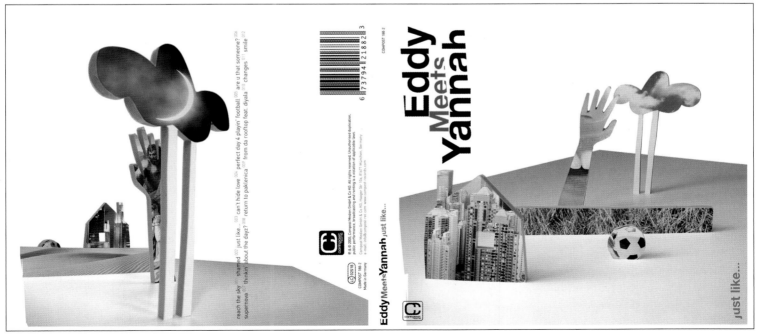

Eddy Meets Yannah: Just like…/CD cover/2005

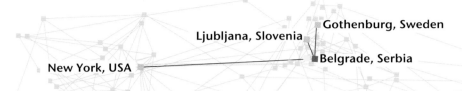

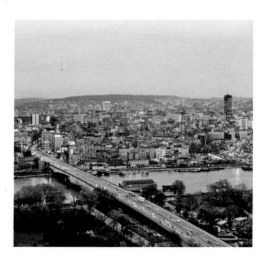

Futro

Slavimir Stojanović
www.slavimirstojanovic.com
slavimir@futro-icb.com

Birthplace: Belgrade, Serbia
Residence: Belgrade, Serbia
Connecting cities: Ljubljana, Slovenia/ New York, USA/Gothenburg, Sweden

THE FUTRO UNIT OF Creative Services of Ljubljana, Slovenia, was founded by Slavimir Stojanovic in the year 2003. Five years later it was relocated to the twenty-fourth floor of a tower with views over the converging Sava and Danube rivers, in the old village of Kalegmedan in Belgrade, Serbia.

Futro develops two lines of action – one is purely artistic and experimental and is displayed in the publications that its sister company, Futro Books, publishes. The

second is Futro ICB, a graphic design and branding agency, which collaborates with a team of more than ten young creative artists and directors.

In 2006, this studio was named one of the best 100 in the world. Stojanovic, a renowned designer, has received more than two hundred prizes such as Cresta, Clio, Epica, Art Director Club, Type Directors, Club and European Excellence Awards, among others. He has also been included on the list composed

by Rockport Publishers as one of the "20 New Poster Masters of the Next Century."

His work forms part of the collections at the Pompidou Art Center in Paris, the Hamburg Museum of Art und Reklame, the Poster Museum of Warsaw, and the Museum of Applied Arts in Belgrade. His work has been reviewed in numerous books and periodicals such as *Graphics*, *Communication Arts*, *Print*, *Creative Review*, *Icon*, and *Tipográfica*, among others.

665

(Almost Evil)

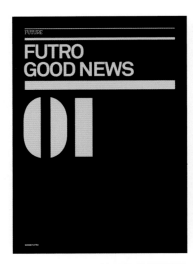
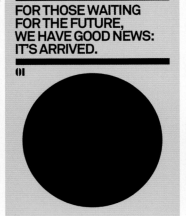

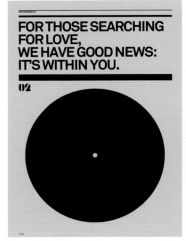
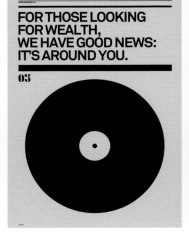

Futro Good News/Posters produced for U.G.F.I.A./2006

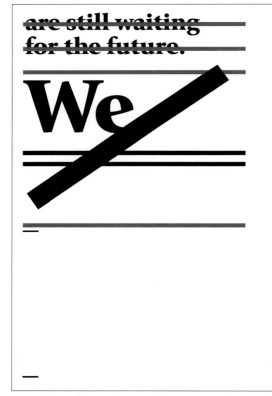

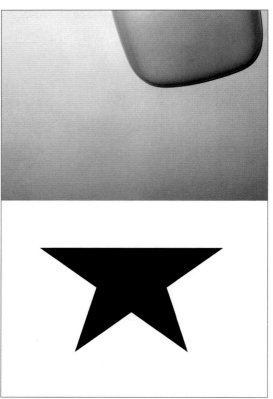

Waiting/Part of Future Retro exhibition/Digital print on plexiglass/2007

Private Public/Futro Fanzine No. 003/2004

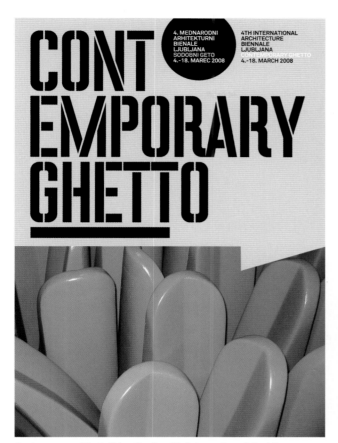

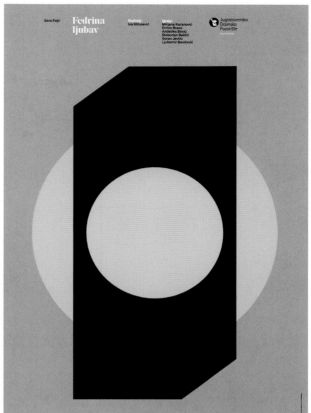

Contemporary Ghetto/Identity for 4th International Architecture Biennale Ljubljana/2008

Fedra's Love/Poster/2008

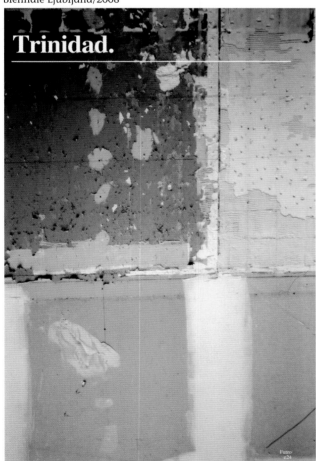

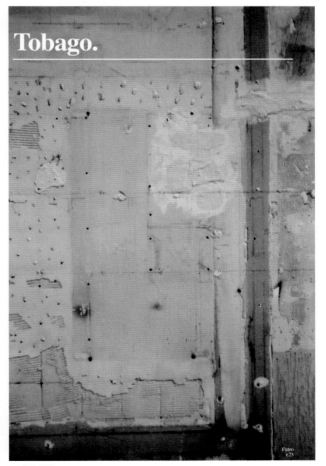

Trinidad & Tobago/Part of Future Retro exhibition/Digital print on plywood/2007

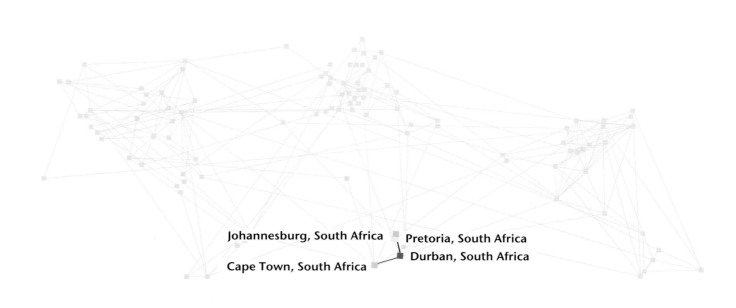

Johannesburg, South Africa Pretoria, South Africa
 Durban, South Africa
Cape Town, South Africa

Garth Walker

www.orangejuicedesign.net
www.ijusi.com/www.garthwalkerphotography.com
garth@oj.co.za

Birthplace: Pretoria, South Africa
Residence: Durban, South Africa
Connecting cities: Cape Town, South Africa/Johannesburg, South Africa

DURBAN, WITH 3.5 MILLION inhabitants, is South Africa's most cosmopolitan city where Zulu is the most popular mother tongue, followed by English, Afrikaans, and Hindi. It is also home to Orange Juice Design, an agency founded by the designer Garth Walker. It is a project that began "without clients, without employees and with a second hand computer"; a creative studio that remains focused on the development of "made-to-measure" graphic design projects. The desire for a new visual

language for South Africa prevails throughout his work. It is a unique aesthetic inspired by local elements in order to coexist with the international style inherent in contemporary graphic design. They also publish *I-jusi* (juice in Zulu) magazine, an experimental online publication where designers, photographers, and artists exchange ideas and perspectives on "Africanism" in their search for their own identities and character.

Orange Juice Design has received great local recognition and international distinctions from institutions such as the British D&AD, the Art Directors Club, and the Type Directors Club in New York among others. His work forms part of collections at the New York Modern Art Museum, the Victoria & Albert Museum, and the Smithsonian Institute, among others. He also frequently gives talks and workshops in more than twenty-five countries across five continents.

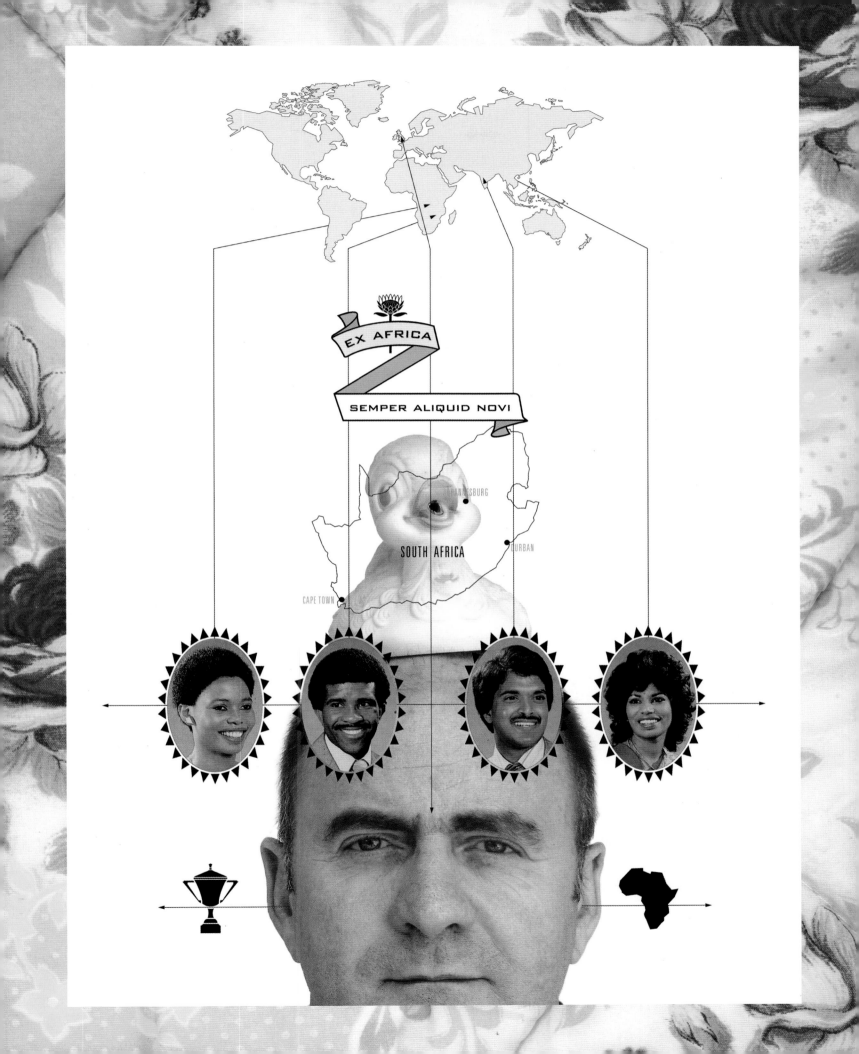

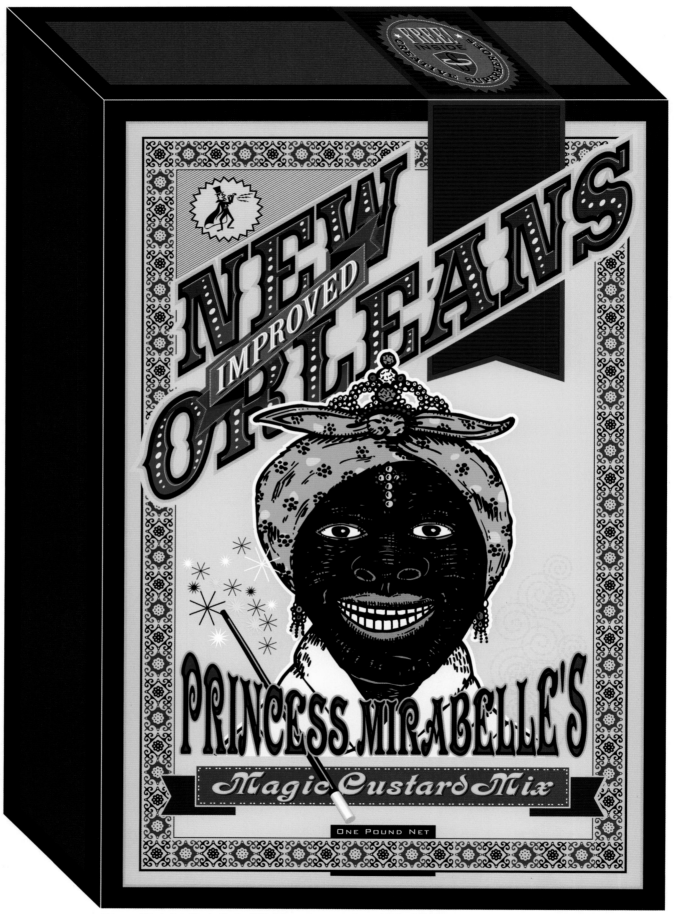

*Princess Mirabelle's Magic Custard Mix/*Magazine cover (unpublished)/2005

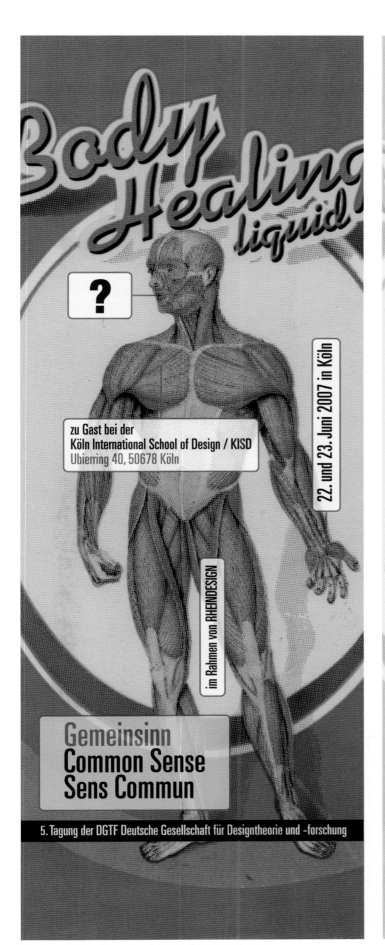

Gemeinsinn / **Common Sense** / Sens Commun

Freitag, 22. Juni: Gemeinsinn real

13:00 Registrierung

14:00 Meyer Voggenreiter (Meyer Voggenreiter Projekte, Köln): Begrüßung und gemeinsinnige Einführung

14:15 Michael Erlhoff (Professor für Designtheorie und -geschichte, Köln International School of Design/KISD) und Hans Ulrich Reck (Professor für Kunstgeschichte im medialen Kontext, Kunsthochschule für Medien, Köln): Streifzüge und Wegmarken im "Gemeinen"

15:30 Jörg Huber (Professor für Kulturtheorie/Institut für Theorie der Gestaltung, Zürcher Hochschule der Künste): Zur Einbildung von Gemeinsinn. Fallbeispiele kulturtheoretischer Forschung

16:45 Kaffeepause

17:15 Jakob Berndt (Strategische Planung, Jung von Matt, Hamburg): Deutschlands häufigstes Wohnzimmer

Moderation: Renate Menzi (DGTF-Vorstand, Dozentin Hochschule der Künste Zürich)

18:30 Abendvortrag (in englisch)
Garth Walker (Orange Juice Design, Durban, Südafrika): "If I live in Africa, why would I want to look like I live in New York?"
A Personal Journey towards a New Visual Language 1986-2007

Moderation: Uta Brandes (DGTF-Vorstandsvorsitzende, be design, Köln)

Samstag, 23.Juni: Gemeinsinn virtuell

10:00 Sabine Junginger (Dozentin für Produktdesign und Design Management, Lancaster University, England): Von Menschen für Menschen: Über Gemeinsinn, auf den Menschen bezogene Produktentwicklung und die Rolle des Design im öffentlichen Dienst

11:15 Sandra Buchmüller (User Experience Designerin, Deutsche Telekom Laboratories, Berlin): Common Sense in virtuellen Räumen

12:30 James Auger (Royal College of Art, London, Designstudio Auger-Loizeau): Common Sense and Critical Design (in englisch)

Moderation: Wolfgang Jonas (DGTF-Vorstand, Universität Kassel)

DGTF-Mitglieder: Forschungen zu "Gemeinsinn"

13:45 Robert Schwermer (Diplom Designer, Köln): Schulunterricht über, mit und durch Design

14:15 Johannes Uhlmann (Professor für Technisches Design, TU Dresden) und Christian Wölfel (Wissenschaftlicher Mitarbeiter) Gemeinsame Sache: Ein Ansatz zur Integration von Design- und Konstruktionsprozess bei der Produktentwicklung

Moderation: Lola Güldenberg (DGTF-Vorstand, Agentur für markenorientierte Trend- und Konsumentenforschung, Berlin)

15:00 Snacks & Ende der Tagung

Teilnahmegebühr:
Nicht-Mitglieder der DGTF: €100,- (Studierende: € 50)
DGTF-Mitglieder: € 50 (Studierende: € 30)

Anmeldung und weitere Informationen unter www.dgtf.de und e-mail: info@dgtf.de

T: +49(0)221-251297, F: +49(0)221-252149

Bankverbindung: Kreissparkasse Köln, Kto-Nr. 7728, BLZ 370 502 99

Nach Eingang der Teilnahmegebühr auf das Konto der DGTF erhalten Sie eine Anmeldebestätigung.

Postergestaltung: Garth Walker, Orange Juice Design, Durban

Der Druck wurde realisiert mit freundlicher Unterstützung der Druckerei Joost, Eckernförder Str. 239, 24119 Kronshagen. Für die Unterstützung der Tagung danken wir den Deutschen Telekom Laboratories.

Gemeinsinn / common sense

Kommt heute die Sprache auf den Gemeinsinn, dann entflammen schnell kleine Lagerfeuer des Entzückens an vergangene, vermeintlich gute Zeiten, und romantische Bilder von Politik und Gesellschaft steigen wärmend auf. Es scheint common sense, dass wir gegenwärtig auf diesem Globus nichts mehr entbehren als einen neuen Sinn für den Gemeinsinn. Der Unterschied ist fein und deutlich: als ein Sinn, der als allen gemeinsam vorausgesetzt werden muss, um zu wirken, ist der Gemeinsinn aufs Streitbarste mit der Urteilskraft des Einzelnen verbunden, während der common sense, gemeinhin als gesunder Menschenverstand bekannt, eine gesellschaftliche Übereinkunft postuliert, die in der Zeit ihrer Entstehung eine bürgerliche war und für eine Weile in der Watte des Konsens sich einrichten konnte. Neuerdings wird allerlei Watte woanders billiger produziert, man jammert gerne über deren mangelnde Qualität oder die Bedingungen der Produktion, aber es ist längst nicht mehr der Bürger, der wählt, sondern der Konsument.

Design nun ist in die globale Zirkulation der Watte ebenso verstrickt wie in die Widersprüche des Gemeinsinns. Im kontinuierlichen und auch choc-haften Prozess von Transformation arbeitet Design an der Herstellung von Gemeinsinn. Denn dieser ist nicht, er wird: er will ständig neu gestaltet werden und bringt dafür Objekte ins Spiel, auf die er sich zuvor geeinigt hat. Und dort, wo Transformation ins Stocken gerät und die Verhältnisse nicht mehr genügen wollen, interveniert Design kontrafaktisch und bringt die Transformation wieder in Fluss. Als pragmatischer Einspruch gegen das, was ist (und nicht läuft), steht Design in der Tradition der Skeptiker gegen jedweden Konsens, der über die Dauer seiner eigenen Rede hinausweisen will.

Wenn sich nun in den Zwischenräumen und virtuellen Falten sich selbst entpflichteter Gesellschaften ein neuer Sinn für Gemeinsinn regt, dann könnte es relevant sein, ebendieses Vermögen des Design zum Prozessieren temporärer Vereinbarungen, durch die Nutzen und Nutzung erst realisierbar werden – und je nach Relation durchaus different, aber mit einem hinreichend konsistenten Kern der Verständigung –, also dann könnte es relevant sein, die Produktion von Gemeinsinn, von sens commun und common sense als Voraussetzung, Aufgabe, Herausforderung und Widerspruch von Design neu zu untersuchen.

Body Liquid/Flyer/Found packaging illustration/2007

Son of Sam/Typeface inspired in prisoner graffiti/2003-2004

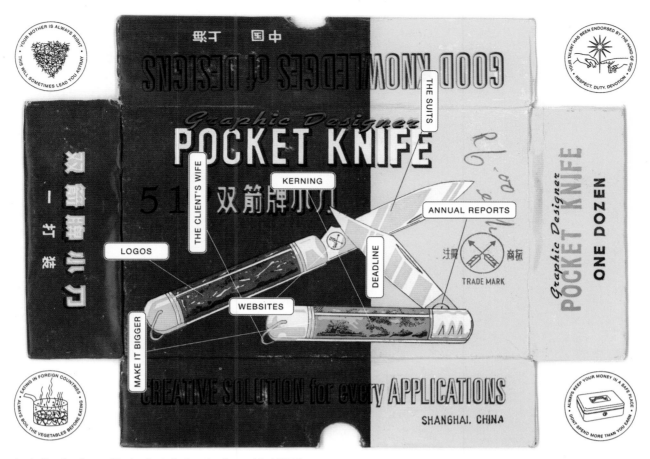

Australian Academy of Design/Installation (wall graphics)/2006

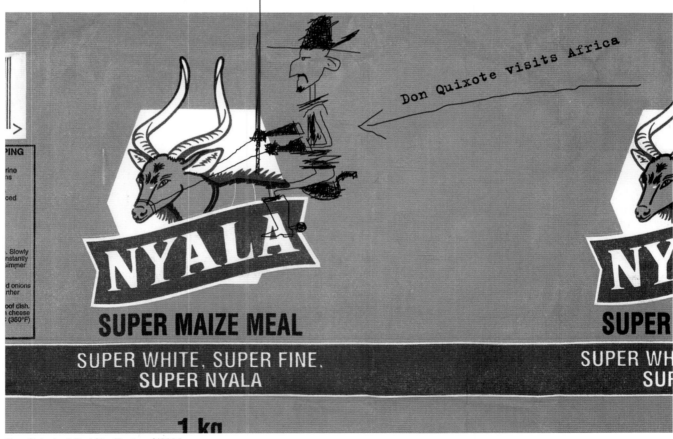

Don Quixote visits Africa/Postcard/2005

Ørsta, Norway (CSB)
Bergen, Norway
London, UK
Oslo, Norway
Drammen, Norway (MVM)
Arendal, Norway (MH)
Tokyo, Japan

Grandpeople

Christian Strand Bergheim, Magnus Voll Mathiassen and Magnus Helgesen
www.grandpeople.org
post@grandpeople.org

Birthplace: Drammen, Norway (MVM)/Ørsta, Norway (CSB)/Arendal, Norway (MH)
Residence: Bergen, Norway
Connecting cities: Oslo, Norway/London, UK/Tokyo, Japan

THE GRANDPEOPLE STUDIO is located in Bergen in the valley that is created by the "seven mountains" – the gateway to the spectacular Norwegian fjords.

Christian Strand Bergheim, Magnus Voll Mathiassen, and Magnus Helgesen are the members of this collective who find inspiration in the forms and processes of nature with which they conceive new graphic ideas. The studio name combines two words which confirm the basis of

their working methods; the importance of teamwork and the objective to create illustration and design with depth – pieces where the surface reflects what's below.

This creative team offers solutions in graphic design, art direction, and illustration for the worlds of fashion, music, advertising, art, and culture. They develop a range of projects from visual identity, promotion, and catalogs to the creation of art and exhibition projects.

For Grandpeople, superficiality is the reflection of what lies below. They believe that design should not stand out for itself but rather for the object it portrays. Their work is characterized by the use of color and abstract organic shapes. They are strongly influenced by music such as black metal, punk, and techno as well as the "positive" seventies aesthetic.

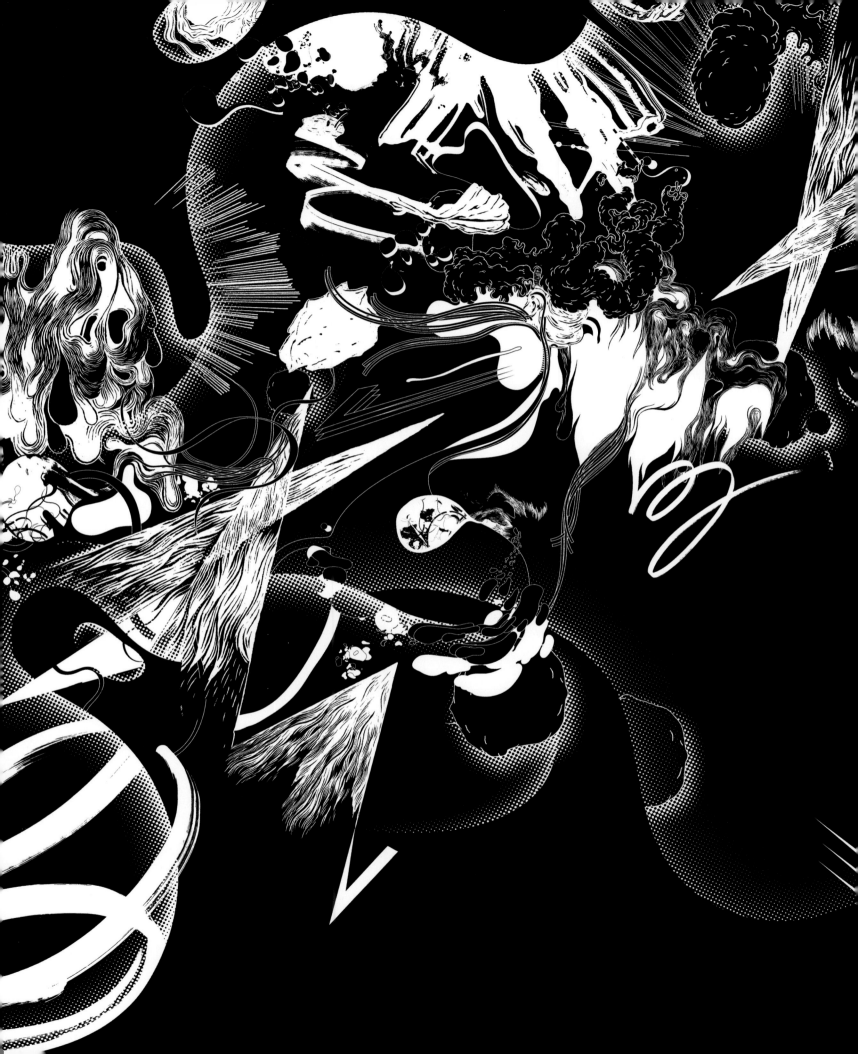

Vagant/Cover and editorial illustrations/Photographs: Magne Sandnes/2007

#4
2007

César Vallejo | Inger Elisabeth Hansen | Christian Bök | Stig Sæterbakken |
Jon Fosse | Rune Christiansen | Gunnar Wærness | Aasne Linnestå |
Mattis Øybø | Friedrich Nietzsche | Ole Robert Sunde | Torild Wardenær

Vagant

TIDSSKRIFT FOR LITTERATUR OG KRITIKK

Vagant/Cover and editorial illustrations/Photographs: Magne Sandnes/2007

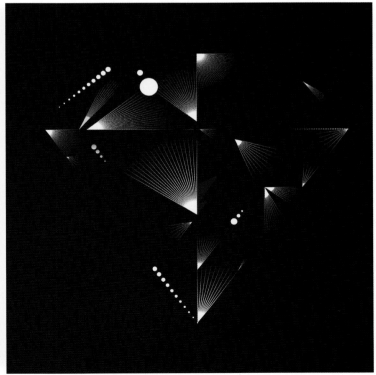

*1000 Beats-1 beat/7"/*Album cover/2007

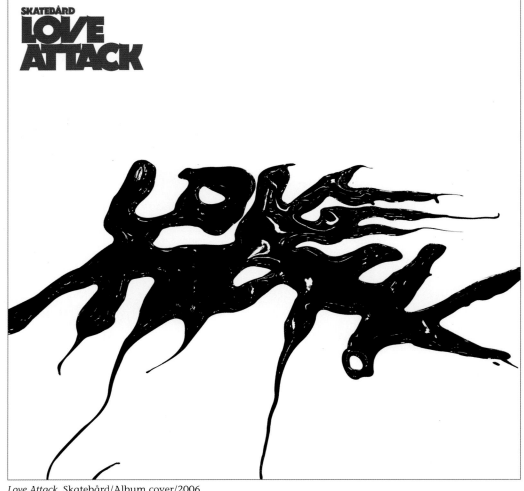

Love Attack, Skatebård/Album cover/2006

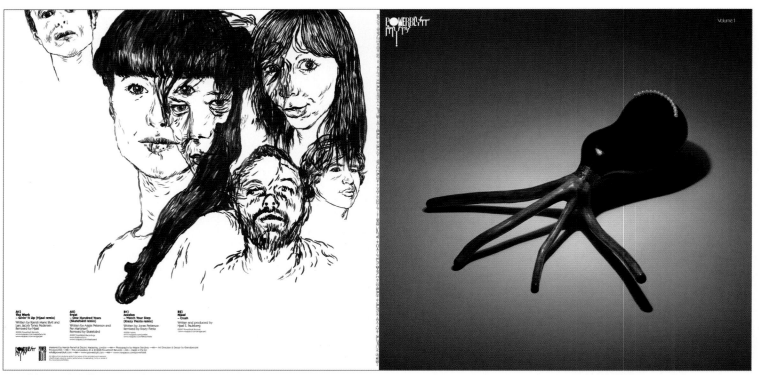

Powerblytt Myths/Album cover/2008

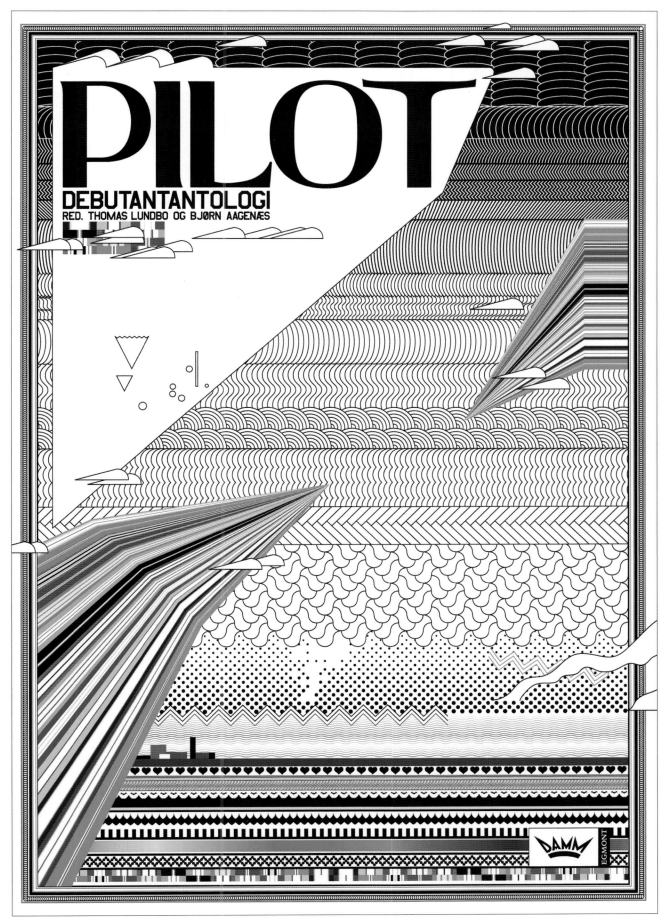

Pilot/Book cover/2007

Strasburg, France (TC)
Paris, France Lons-le-Saunier, France (CV)
Besançon (TC/CV)/Lyon (CV)/Montreuil (TC/CV), France
Perpignan, France (TC)

Helmo

Thomas Couderc and Clément Vauchez
www.helmo.fr
contact@helmo.fr

Birthplace: Perpignan, France, (TC)/Lons-le-Saunier, France (CV)
Residence: Paris, France
Connecting cities: Strasburg, France; Besançon, France; Montreuil, France (TC)/
Besançon, France; Lyon, France; Montreuil, France (CV)

HELMO IS MADE UP OF Thomas Couderc and Clément Vauchez, graphic designers who create posters, books, graphics for museums, images, and some typography.

In 2002, they, along with Thomas Dimetto, created the graphic studio 'La bonne merveille.' They worked together for five years. At the beginning of 2007 they decided to alter the composition as a way of preserving their individual creative liberties – Couderc and Vauchez created the graphic studio Helmo. (Dimetto began to work for Marcel, a French advertising agency.)

'La bonne merveille' is still the name of the work space that they share in Montreuil, Paris, where they welcome other creators to collaborate with on their projects.

Helmo's designers have a great eye for graphics and photography and have developed work for different clients in the worlds of art, culture, and fashion. They have also carried out projects of intervention, as in the case of Noel, an advertising installation for a leading chain store.

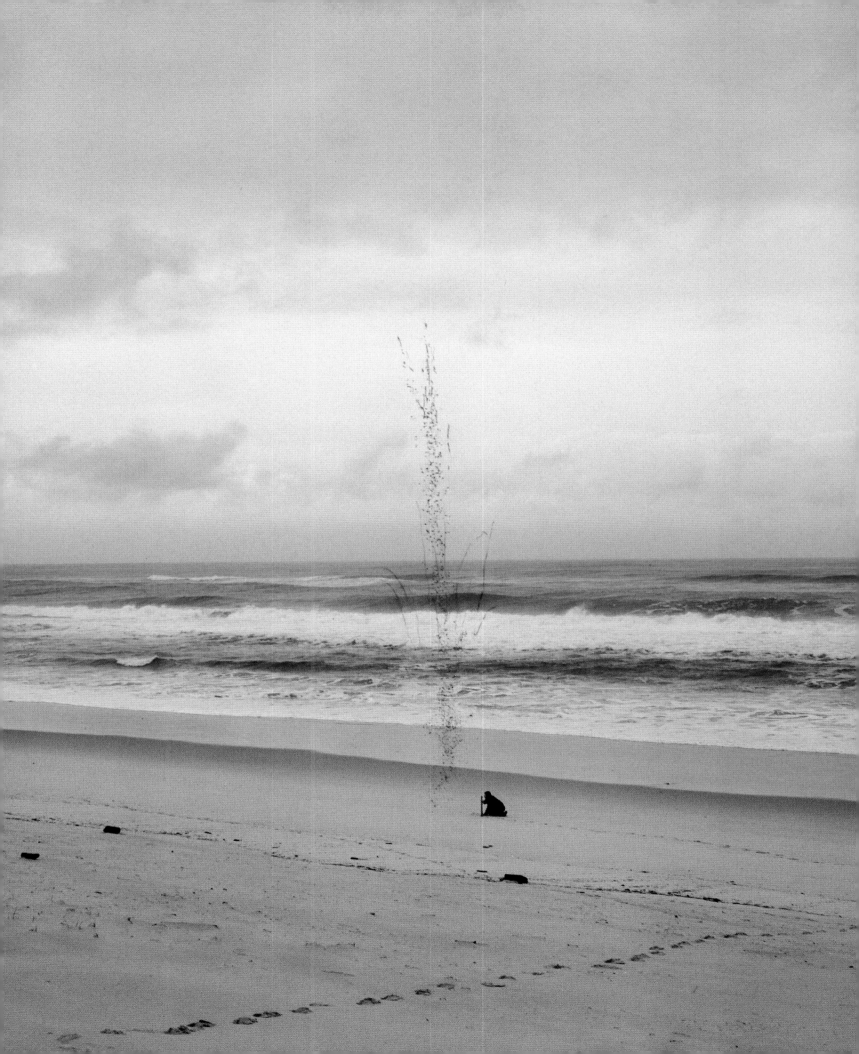

LA VOIX DE
PAUL VEYNE
À PROPOS DE L'ANTIQUITÉ

INTRODUCTION DE LUCIEN JEPHARGNON
UN LIVRE CD ●● 2 CDS AUDIOS

09

LA VOIX DE PAUL VEYNE

LA VOIX DE
BERTRAND BLIER

INTRODUCTION DE ALAIN SARDE
UN LIVRE CD ●●● 3 CDS AUDIOS

32

LA VOIX DE BERTRAND BLIER

LA VOIX DE
JACQUES DERRIDA
À PROPOS DE LA PSYCHANALYSE

INTRODUCTION DE MARTA SEGARRA
UN LIVRE CD ●● 2 CDS AUDIOS

09

LA VOIX DE JACQUES DERRIDA

LA VOIX DE
PAUL GORZ

INTRODUCTION DE DIMITRI POLIAKIRNOV
UN LIVRE CD ●●● 3 CDS AUDIOS

32

LA VOIX DE PAUL GORZ

La Voix de…/Audio CD books project/2007

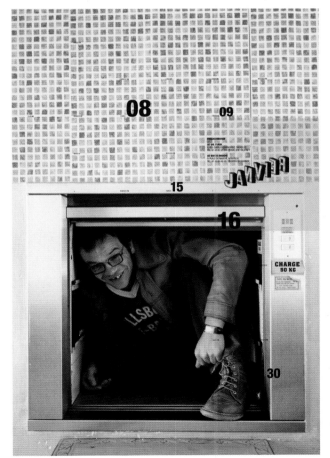

Pin-Up/Poster series for concert hall in Montreuil/Helmo+Thomas Dimetto/2004-2005

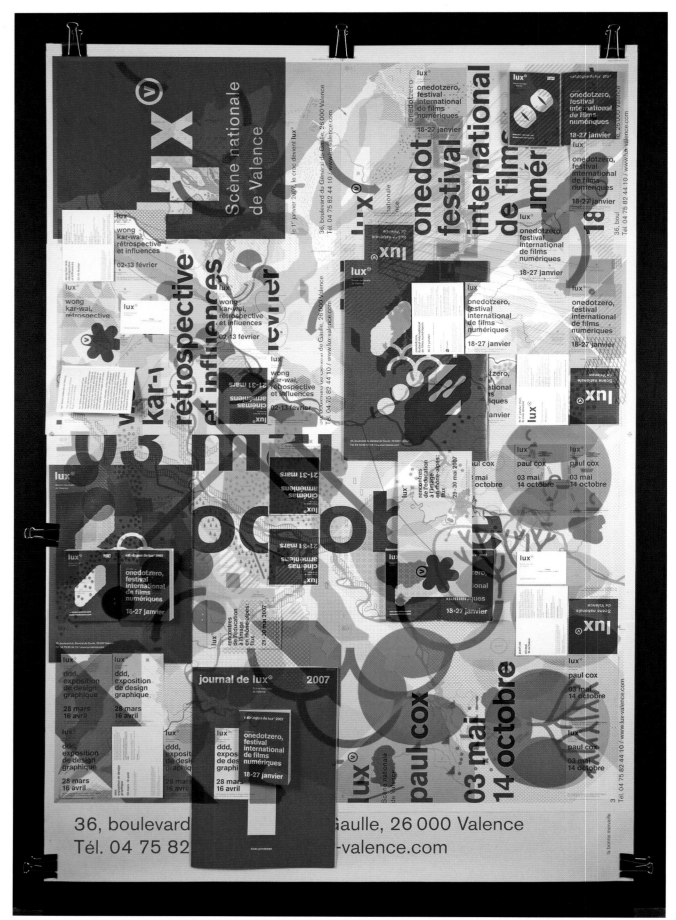

Lux scene nationale de Valence/Visual communication for art center Lux/Cartographic system made in order that people can collect the different documents (posters, flyers, cards, booklets) and re-create the whole map. Cartography as a puzzle/Lux logo: Studio Maji/2007

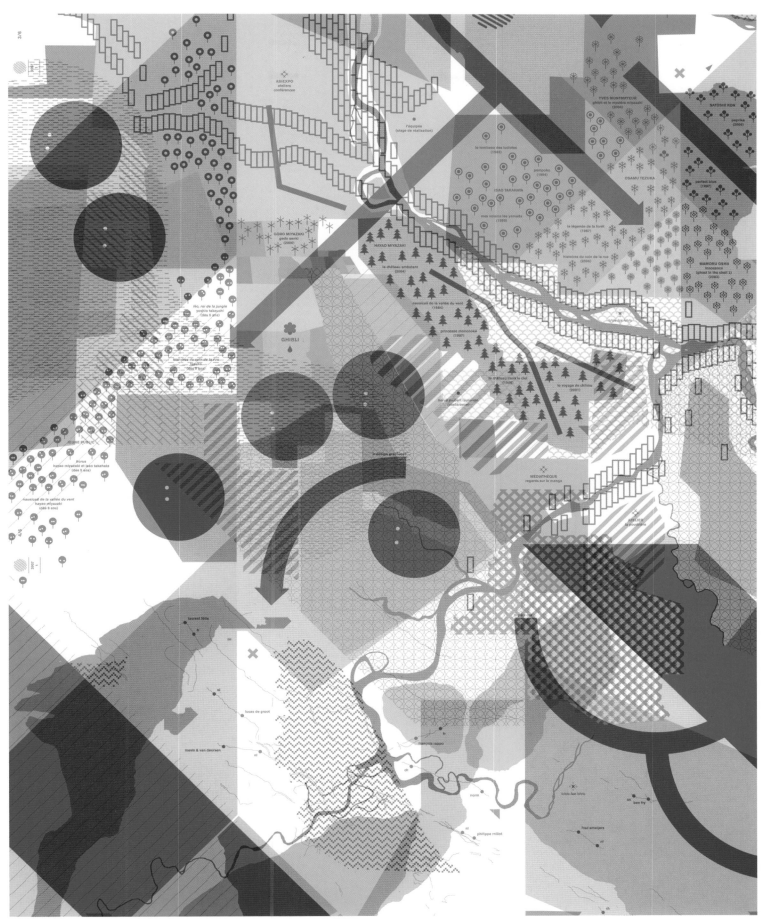

Zoom detail of the Lux map.

JAZZDOR
10.11– 24.11.2006

FESTIVAL DE JAZZ DE STRASBOURG // 21ᵉ ÉDITION
TEL. 03 88 36 30 48 // OFFENBURG 0781/822000 // WWW.JAZZDOR.COM

Jazzdor 06, Strasbourg Jazz Festival/Photography/Photographs: Thomas Couderc, Clément Vauchez and Christophe Urbain/2006

Betes de Mode/Photographic installation for Galeries Lafayette/In collaboration with Thomas Dimetto/Fashion portrait: Laurent Croisier; animal portrait: Christophe Urbain/2006

Berlin, Germany■ Frankfurt/Freiberg, Germany
Hanau, Germany

Hort

Eike König
www.hort.org.uk
contact@hort.org.uk

Birthplace: Hanau, Germany
Residence: Berlin, Germany
Connecting cities: Frankfurt, Germany/Freiberg,
Germany/Berlin, Germany

HORT IS THE NAME of the creative playground based in Berlin and founded by Eike König in 1994. "A place where the words 'work' and 'play' can be said in the same sentence. It is an unconventional workplace. More than a studio, it is an institution dedicated to converting ideas into reality. It is a place to learn, a place to grow and a place that is still growing. It is not an implementation tool for a client. Hort has been created to be inspired by things beyond design."

This studio specializes in the development of visual identity and logos, printed material, webpages, interventions in spaces, photography, and illustration for clients in the worlds of culture, fashion and music. Their core work, however, is in the field of publishing and printing.

They have won many prizes and distinctions, and their work has been published, featured, and exhibited all over the world. They also frequently organize and hold workshops and conferences for design students and professionals alike.

In every project, Hort aims to produce a truly creative and fun message, designed in a way that makes the information easy to understand. For König the most important part of being a designer is to be authentic, not to imitate others and never stop learning. After all "the only constant is change."

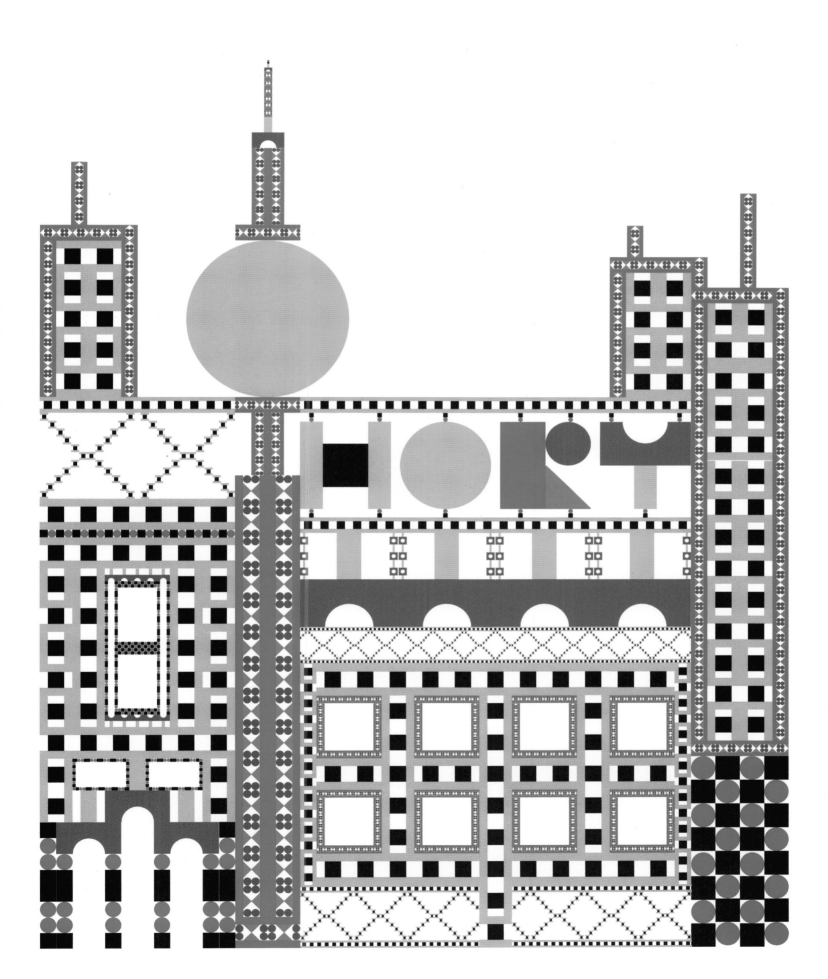

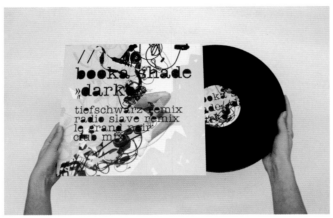
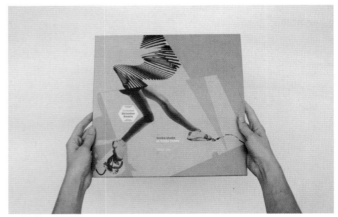
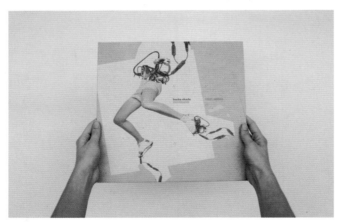
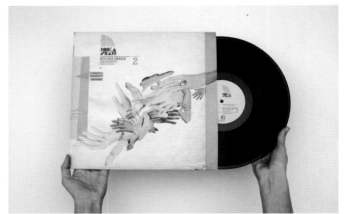

Booka Shade/Art direction and design/Album cover/Collage/2005-2007

Planetary, Booka Shade/Album cover and sleeve/Projection on objects, photography/2008

Tickle, Booka Shade/Album cover/2007

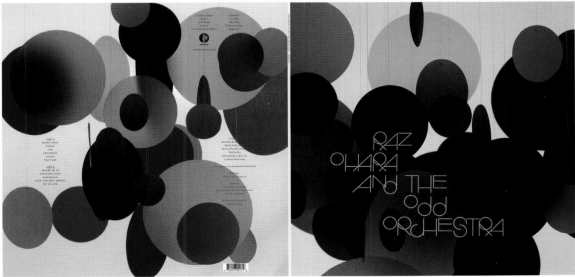

Raz O'Hara and the odd orchestra/Album cover/2007

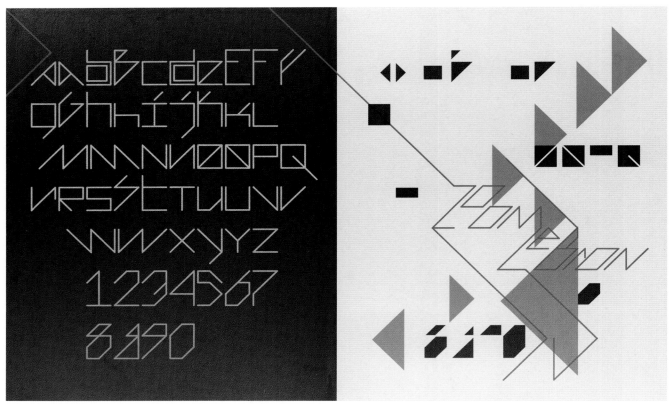

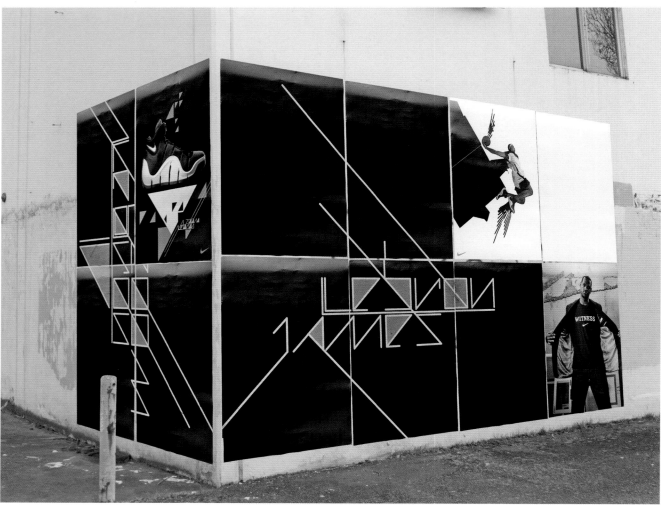

Visual Center for LeBron James/Visual Communication/Art Director for Nike: Michael Spoljaric; art direction and design: Hort/2006

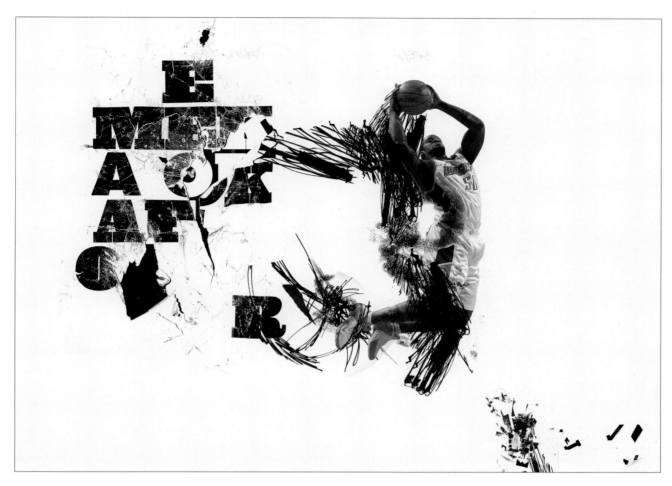

Make History/Book/Xerox, photography of type, illustration/Art director for Nike: Michael Spoljaric; art direction and design: Hort/2005-2006

Hayashi/Visual identity and shop design/2007

Hayashi/Visual identity and shop design/2007

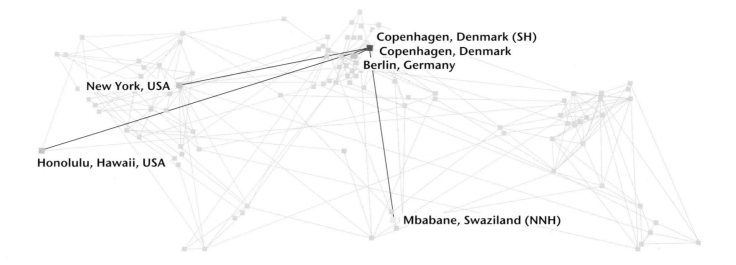

Copenhagen, Denmark (SH)
Copenhagen, Denmark
Berlin, Germany

New York, USA

Honolulu, Hawaii, USA

Mbabane, Swaziland (NNH)

Hvass&Hannibal

Sofie Hannibal and Nan Na Hvass
www.hvasshannibal.dk
info@hvasshannibal.dk

Birthplace: Copenhagen, Denmark (SH)/Mbabane, Swaziland (NNH)
Residence: Copenhagen, Denmark
Connecting cities: Honolulu, Hawaii, USA/New York, USA/Berlin, Germany

THIS YOUNG DESIGN COMPANY is located in Copenhagen and comprises two childhood friends, Sofie Hannibal and Nan Na Hvass.

This duo, made up of a graphic designer and illustrator, has developed different projects for the music industry, such as the album cover for the Danish band Efterklang. They have also created art installations, photography, T-shirts, as well as numerous flyers and posters for a wide range of events and spaces in the Danish cultural scene.

They are both still visual communication students at the Danish School of Design, and they confess to only dedicating about half of their time to commercial projects.

Their work has been reviewed in publications such as *Creative Review*, *Computer Arts*, *Print*, *FORM* and the Chinese magazine *Zing*. They have also been included in the book *YCN 0809*, a compilation of emerging creative talents in design and visual communication, and have participated in numerous art exhibitions and shows. They won a

Grammy for their work with the band Mirador DID as well as two nominations at the Danish Music Awards.

Their designs and illustrations are abstract in style and awash with color, creating captivating imagery that fluctuates nicely between the complex and the simple.

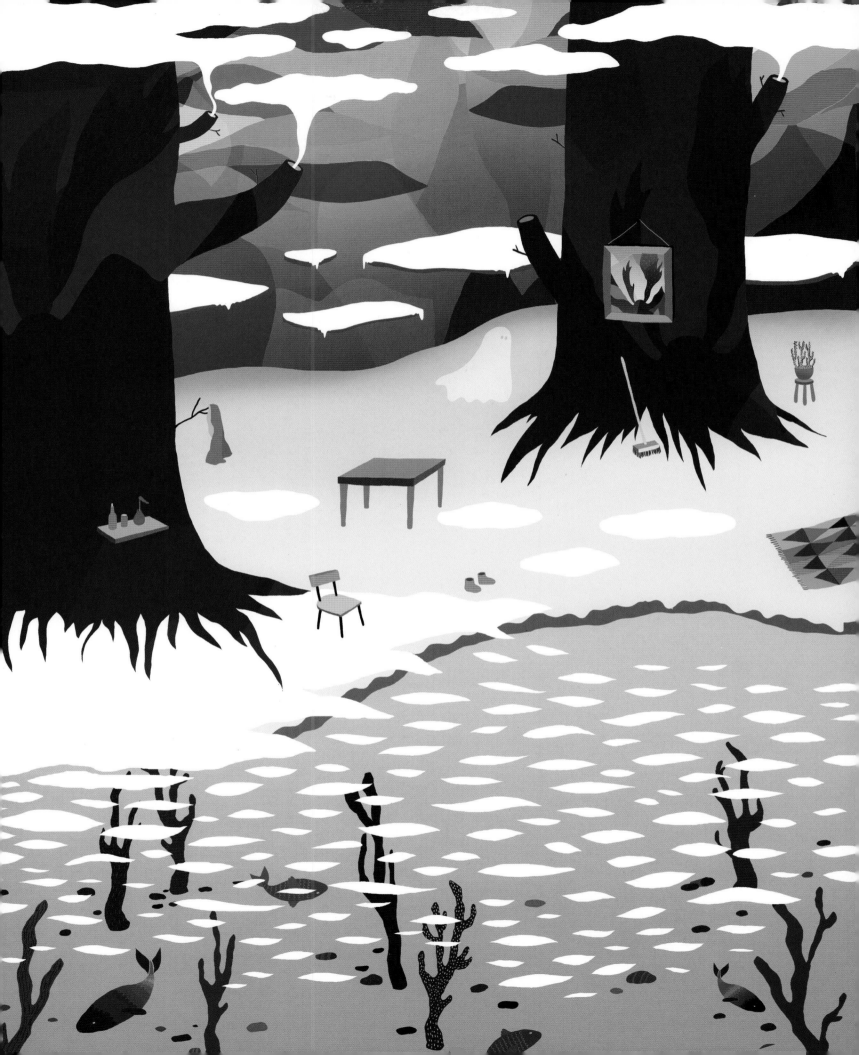

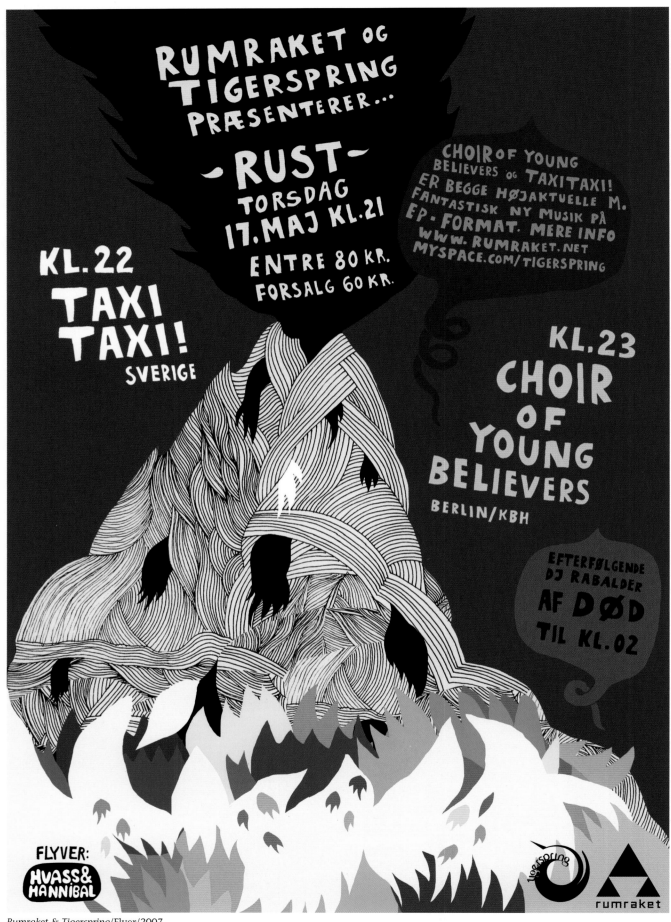

Rumraket & Tigerspring/Flyer/2007

Mikado/Set design for *Turboweekend*/Press photos/Painted wooden sticks, outfits and room/Photo: Brian Buchard/2007

Dark clouds/Set design for *Turboweekend*/Press photos/Laminated wood, outfits and room/Photo: Brian Buchard/2007

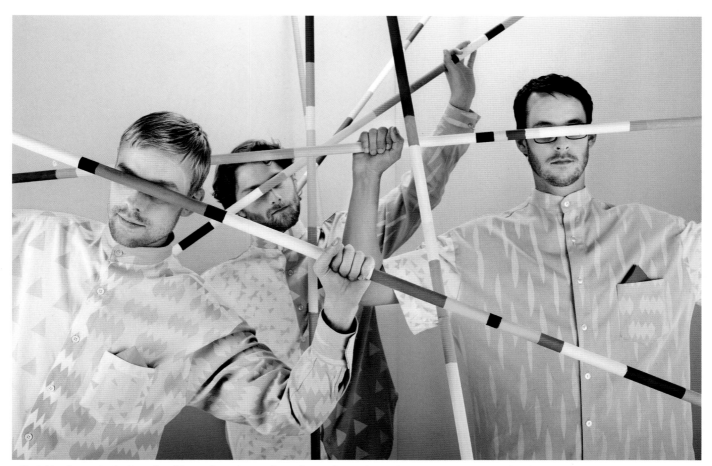

Mikado/Set design for *Turboweekend*/Press photos/Painted wooden sticks, outfits and room/Photo: Brian Buchard/2007

TaxiTaxi!/Album cover/Paper, pen and photoshop/2007

The new generation/Flyer/2007

Night Shift/*Turboweekend*/CD cover/Photography and digital drawing/Photography: Brian Buchard/2007

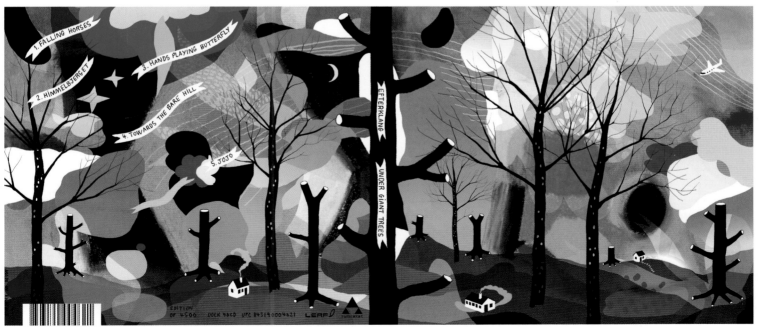

Under Giant Trees/Album cover for Efterklang/Paper, pen and photoshop/2007

Duisburg, Germany Berlin, Germany
Cologne, Germany

New York, USA

Ice Cream For Free

Oliver Wiegner
www.icecreamforfree.com
oli@icecreamforfree.com

Birthplace: Duisburg, Germany
Residence: Berlin, Germany
Connecting cities: New York, USA / Cologne, Germany

ICE CREAM FOR FREE (ICFF) is the design studio in Berlin founded in 2005 by Oliver Wiegner. He graduated with a degree in communication design from Wurzburg University in Germany and since 2007 has formed part of the Flashforceone collective, an audiovisual design laboratory, also in Berlin.

ICFF has become a multidisciplinary team who focus their efforts on the development of printed, interactive,

visual, and motion graphics projects. Their work has been reviewed in magazines such as *IdN*, *Experimenta*, *Shift*, *Computer Arts* and *Bastard*. They have also created work for publications such as *Wired* and have been featured in books such as *Colors & Graphics*, *Latex for Fun*, *Semi-Permanent 06*, and *Neuland*. In 2006, they were part of the exhibition "What makes Berlin addictive?" – a show involving artists from Berlin, which took place in Shanghai.

This collective finds inspiration in street art and in the Berlin and International artistic scene. Collages predominate in their work, created from strange images found on the street and at flea markets.

The name of this group is derived from a play on words from which statements such as "I scream for free" and "Eyes cream for me" can be created.

ICE
CREAM
FOR
FREE

Dog/Horse/T-shirt/Print on fabric/2007

Licht/Poster/Print on uncoated paper/2006

tiger, koletzki & meind/Album cover/Print on coated cardboard/2008

never met them ep, Pawas/Album cover/Print on coated cardboard/2007

moonlight ep, Lützenkirchen/Album cover/Print on coated cardboard/2008

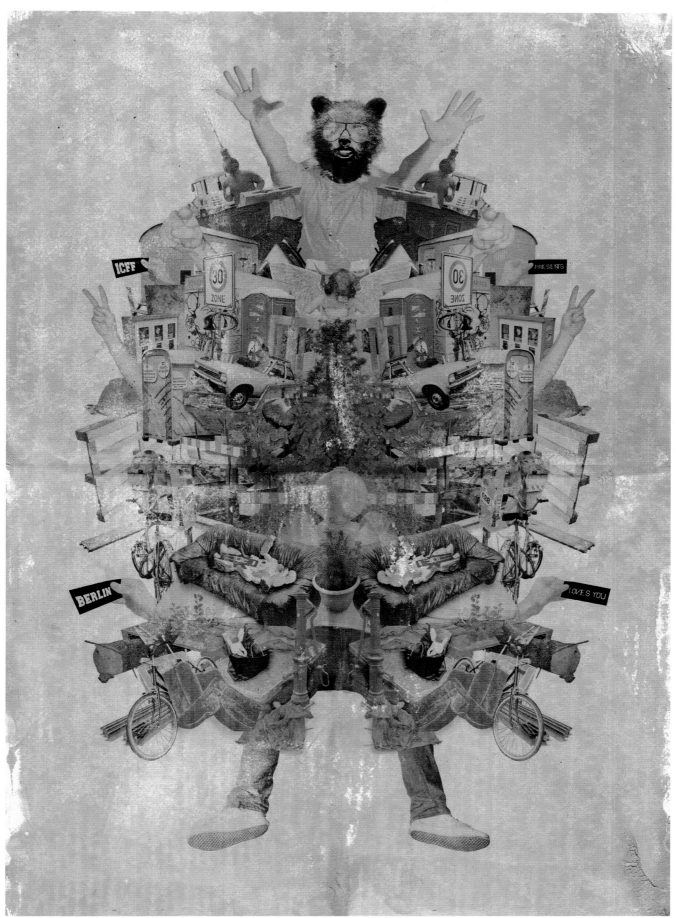

What makes berlin addictive?/Poster/Print on uncoated paper/2006

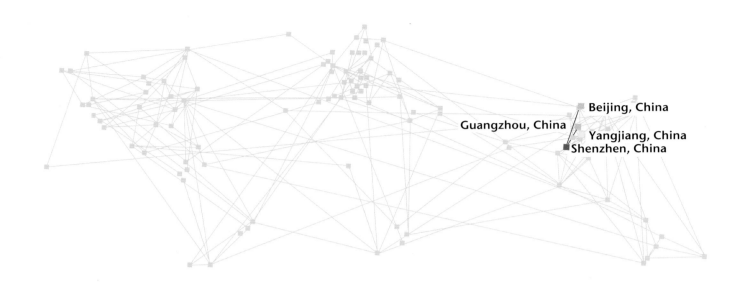

Beijing, China
Guangzhou, China
Yangjiang, China
Shenzhen, China

Imagine Wong

www.iamimagine.com/www.zitype.com
imaginewong@gmail.com

Birthplace: Yangjiang, China
Residence: Shenzhen, China
Connecting cities: Guangzhou, China/Beijing, China

THE ZITYPE WORKSHOP STUDIO was founded by the designer Imagine Wong in the spring of 2008 in Shenzhen in the south of China. It is a platform which aims to delve into the possible connections which exist between design, publications, exhibitions, art, theater, and typographic investigation.

It works in close collaboration with art galleries, media groups, publishing houses, theaters, museums, and corporate firms. Wong, the creative director, is a graphic designer, art director, and curator. She was born in 1982 and after graduating with a degree in art and design from Shenzhen University she began her professional career at the Alternative Archive studio. In 2007, she worked as art director for the Chinese magazine *Phoenix Lifestyle*.

Some of her projects have been included in renowned publications such as *3030 New Graphic Design in China* and *1000 Works of 100 Designers* and reviewed in magazines such as *Idea*, *Computer Arts*, and *Pingmag*. In her role as curator she has organized the exhibitions "Global Warming Design" and "Turning Design" held in China. In 2008, Wong was also one of the curators for the show "70/80," an exhibition about new Hong Kong designers, which also took place in Shenzhen.

上
中
下

a o e

i u ü

b p m f

g k h j q x zh ch sh

an en

ang eng ing ong

iong

iong

kǒu

口

rén

人

shǒu

手

Global Warming/Book/2007

The Tales of Nantou/Book/2008

The Pit/Poster/2006

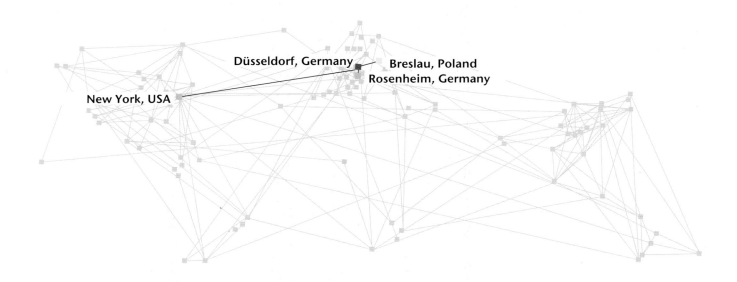

Düsseldorf, Germany

Breslau, Poland
Rosenheim, Germany

New York, USA

In Graphics We Trust

Sebastian Onufszak
www.ingraphicswetrust.com
onufszak@ingraphicswetrust.com

Birthplace: Breslau, Poland
Residence: Düsseldorf, Germany
Connecting cities: Rosenheim, Germany/ New York, USA

SEBASTIAN ONUFSZAK LIVES and works in Düsseldorf. Born in Poland, in 1978, this visual artist develops graphic projects for printed, interactive, and motion graphics media.

Having graduated with degrees in applied science and graphic design, he has worked since 2002 as an independent creative director and designer for a wide variety of national and international clients. In addition to his commercial work, he is also renowned for his live experimental visuals for musicians such as Funkstörung, Mouse on Mars, Michael Fakesch, among others.

His explosive, hallucinatory illustrations veer between order and chaos with an aesthetic that combines the seeming psychedelic look of the seventies with a touch of glam. His work has been featured in publications and exhibitions across the globe, amongst which include, In Graphics We Trust, in Leipzig, Germany; Freaky People in St Petersburg, Russia; Studioline, in Paris, France; Club Spotting, in Florence, Italy; and Synth Eastwood, in Berlin, Germany.

He is currently creative director for the German cinema and animation studio Parasol Island. He is also a founding member of the artistic collective Propagandasburo along with Timo Bose and a group of collaborators, designers, and musicians such as Markus Hofko (The Rainbowmonkey) who adds music to the majority of their projects.

Financial Times Wrap paper/Vector illustration/2007

String Control/Digital vector illustration/2008

GRAPHIC DESIGN IS MY RELIGION

AND I AM ITS PROPHET.

My Religion/Magazine illustration/2006

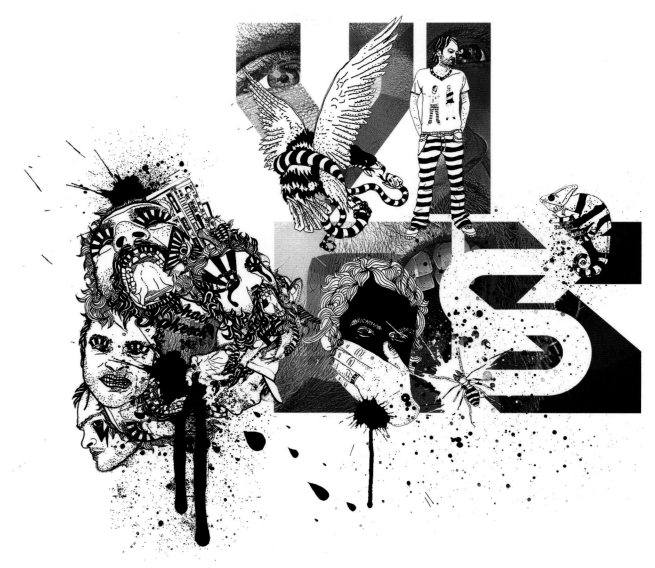

Vidos, Michael Fakesch/Package and CD cover/Drawing/2008

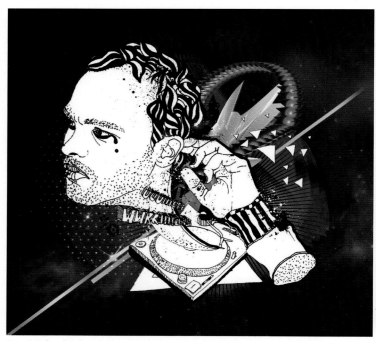

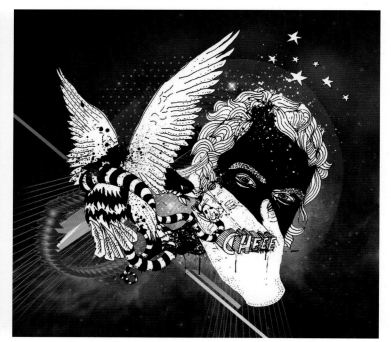

Dos, Michael Fakesch/Package and CD cover/Drawing, collage/2007

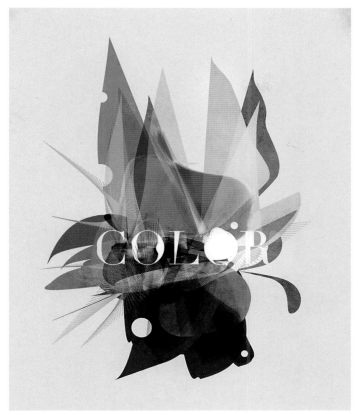
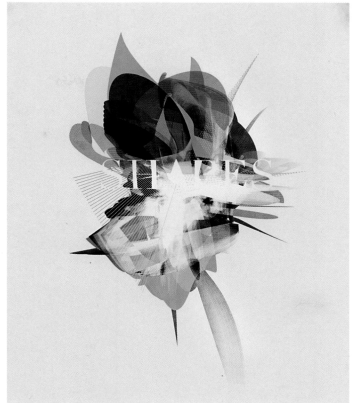

Destruct2Graf/Posters/Digital vector illustrations/2007

Indie Reznik/Flyer, poster/2007

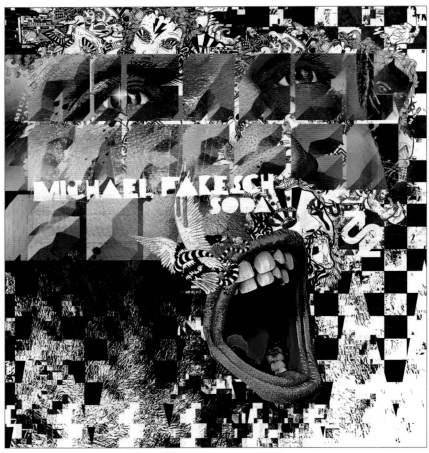

Soda, Michael Fakesch/Package and CD cover/Drawing/2008

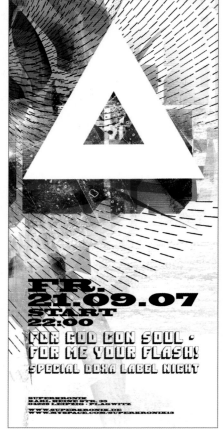

Superkronik/Flyers/2007

You Do Voodoo/Magazine illustrations/Drawings/2008

Gods of LSD/Anti-Drugs Campaign/Computer Collage/2007

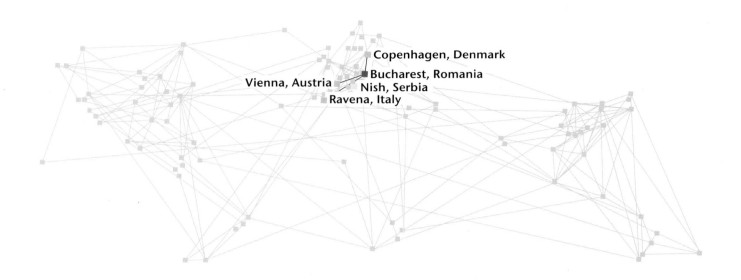

Copenhagen, Denmark
Bucharest, Romania
Vienna, Austria
Nish, Serbia
Ravena, Italy

It's Everyday

www.itseveryday.ro
mail@itseveryday.ro

Birthplace: Nish, Serbia
Residence: Bucharest, Romania
Connecting cities: Copenhagen, Denmark / Vienna, Austria / Ravena, Italy

THE IT'S EVERYDAY DESIGN collective comprises a wide range of nationalities, with designers from Serbia, Switzerland, Denmark, Spain, United Kingdom, and, of course, Romania.

They specialize in the development of Web design projects and declare that they "love getting their hands dirty, printing, branding, and nearly everything else – if we are asked nicely." They are responsible for HardComics publishing house, the first of its kind in Romania,

and they began the *Omagiu* editorial project (www.omagiu.com), the first Romanian magazine on contemporary art and culture, which was acclaimed at the Colophon international competition where it was named one of the best European magazines.

The work of this group has been selected to participate in various publications such as: *We love magazines*, *Web Design: Flash Sites*, and *Web Designing*, among others.

In an interview for *Shift* magazine, the group expressed its interest in designing a brand strategy for Romania as a country, as it believes that when people think of their country they only think of "gymnasts and orphans." There is no available information about the new generation of visual artists who are developing valuable and innovative projects throughout the creative disciplines.

British Council/Wall mural for Brit Cafe/2006

Loyalia/Direct letter for newly-launched mail HR company/2006

Humanitas/Redesigning Plato's Republic for hip young things/2007

Fat Govno/Typeface/2008

EL CAPITAN/Menu for favourite posh eaterie, just outside Bucharest/2007

Neenah/Madison, Wisc., USA

Park Ridge, Utah, USA

Oakland, Calif., USA

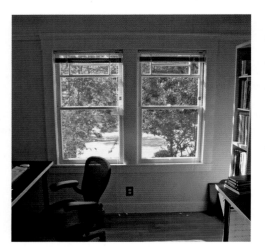

Jason Munn

www.thesmallstakes.com
jason@thesmallstakes.com

Birthplace: Park Ridge, Utah, USA
Residence: Oakland, California, USA
Connecting cities: Neenah and Madison, Wisconsin, USA

THE STUDIO OF JASON MUNN, The Small Stakes, is located in Oakland, California. His posters are already emblematic in the American independent music scene having worked with musicians such as the Pixies, Cat Power, Sufjan Stevens, Death Cab for Cutie, and Animal Collective, among others.

Since 2003 this designer has worked for various national and international clients in different print media, including everything from book covers, posters, and album art, to T-shirts and illustrations. His work has been highlighted in publications such as *Print*, *Communication Arts*, *Computer Arts*, *Etapes*, and *Creative Review*. He has also participated in numerous exhibitions, and his work forms part of the permanent collection of the Modern Art Museum of San Francisco.

His work stands out thanks to his skilful construction of elegant visual metaphors of great purity and simplicity. He uses shapes and colors to transmit an idea where the conceptual process of each piece plays an important role in the execution.

The classic studios of Paul Rand and Saul Bass as well as more contemporary offerings such as Patent Pending and Aesthetic Apparatus serve as the designer's greatest influences.

BROKEN SOCIAL SCENE

MANCHESTER ACADEMY FEBRUARY 14 £8.50

Broken Social Scene/Poster/2006

Death Cab For Cutie, Hurricane Katrina Benefit Show/Poster/2005

NOISE POP AND ANOTHER PLANET ENTERTAINMENT PRESENT

TREASURE ISLAND MUSIC FESTIVAL

MODEST MOUSE • SPOON • BUILT TO SPILL • THIEVERY CORPORATION • GOTAN PROJECT • M.I.A. • KINKY
DJ SHADOW & CUT CHEMIST • CLAP YOUR HANDS SAY YEAH • AU REVOIR SIMONE • ZION I • M.WARD
TWO GALLANTS • GHOSTLAND OBSERVATORY • FLOSSTRADAMUS • SEA WOLF • EARLIMART
DEVIL MAKES THREE • STREET TO NOWHERE • TRAINWRECK RIDERS • FILM SCHOOL
DENGUE FEVER • HONEYCUT • WEST INDIAN GIRL • MOCEAN WORKER • KID BEYOND

SEPTEMBER 15 & 16, 2007

Treasure Island Music Festival/Poster/2007

The Books/Poster/2007

Nada Surf/Poster/2008

College Night, San Francisco Museum of Modern Art/Poster/2006

Modest Mouse/Poster/2007

Cat Power/Poster/2004

Pixies/Poster/2004

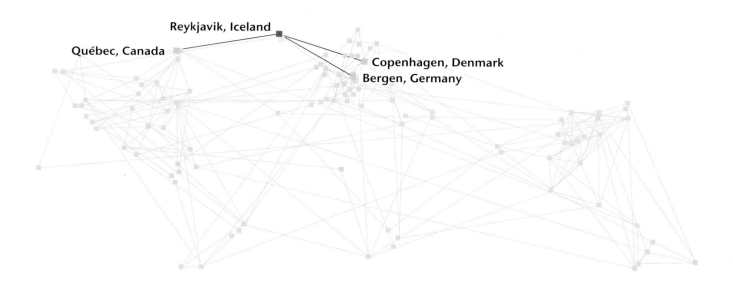

Reykjavik, Iceland

Québec, Canada

Copenhagen, Denmark
Bergen, Germany

Jónas Valtýsson

www.jonasval.com
jv@jonasval.com

Birthplace: Reykjavik, Iceland
Residence: Reykjavik, Iceland
Connecting cities: Bergen, Germany/Québec,
Canada/Copenhagen, Denmark

REYKJAVIK IS THE MOST northern capital in the world: during winter there are only four hours of solar light and during the summer the nights are as bright as the days. It is also home to the graphic designer and photographer Jónas Valtýsson.

He graduated from the Icelandic Art Academy and lives and works in the city of Reykjavik. However he admits that his heart remains in a place called Mosfellsbær on the west coast of Iceland "where the mountains see everything and the trees keep secrets."

For this designer, his greatest passion is the development of projects for the music industry. He states that his love of music is what led him to dedicate himself to design and photography. His main objective is to search for formal and stylistic beauty.

"I've just graduated from university so I don't have a studio as yet. My apartment is basically where I carry out my projects. It can prove disastrous when I'm cooking pancakes, making collages, and working with images on the computer, all on the same table. But it is great – home sweet home."

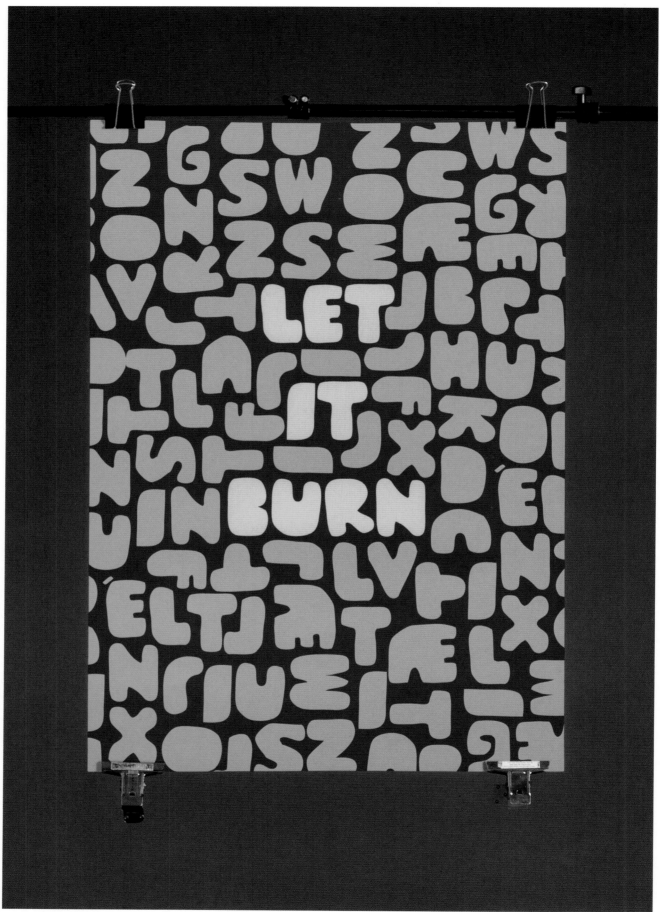

Skar/Typeface/2006

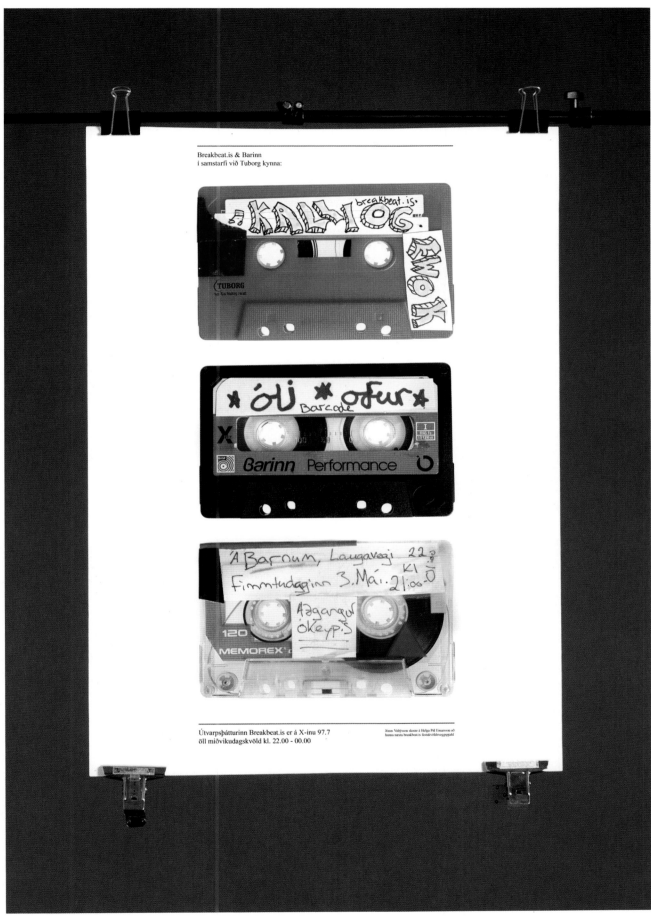

Breakbeat/Poster/2007

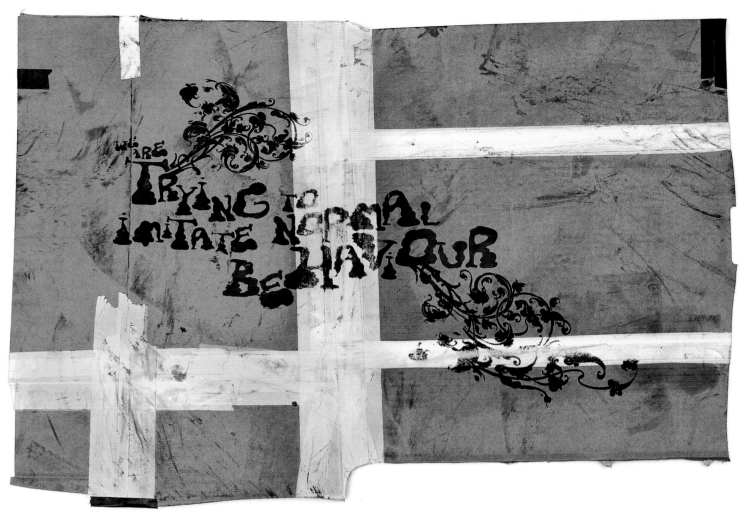

Elephantiasis/Typeface/2006

Eulogy for evolution/CD cover/2006

Phonebook/Phonebook cover/2007

Béton Brut/Poster/2008

Heterocera/Poster/2006

Béton Brut/CD Cover/2008

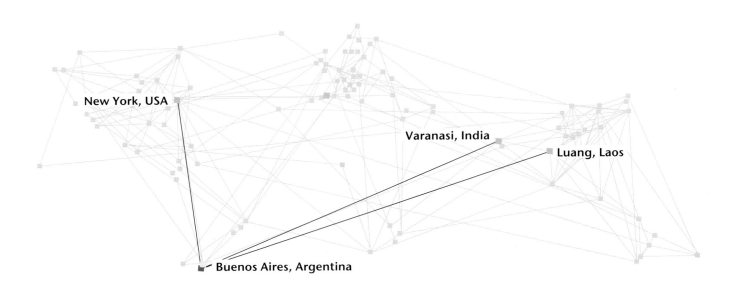

Juan Pablo Cambariere

www.rarosobjetos.com.ar
info@rarosobjetos.com.ar

Birthplace: Buenos Aires, Argentina
Residence: Buenos Aires, Argentina
Connecting cities: New York, USA/Varanasi, India/Luang, Laos

"I AM 35 AND I LIVE AND WORK in Buenos Aires. Despite frequent economic troubles, Buenos Aires is a marvelous place in which to live. It's a city full of... should I say everything?

"Everything is also what I do in my one-man studio – I design, I take photos, I illustrate, I answer the phone, and do any thing else that needs doing. This does not mean that I am an expert in all these areas but, understanding my limits, I manage to develop decent work. – Necessity is the mother of self-invention.

"Since 1997 I have been in charge of the design of 'No,' a weekly supplement for the national newspaper *Página 12*. Working for a newspaper gives me good training as I have fixed deadlines every day. I usually have no longer than three hours to create the cover page – from discussing the idea to producing the final artwork.

"I love posters but printing costs are very high in Argentina. Therefore I began to work with stencils – a technique which has allowed me to express my feelings directly on the street, without censure.

"I have completed courses in graphic design and fine arts (sculpture). As a combination of both disciplines I am currently working on a project called 'Easy on power,' which involves a system of wooden puppets."

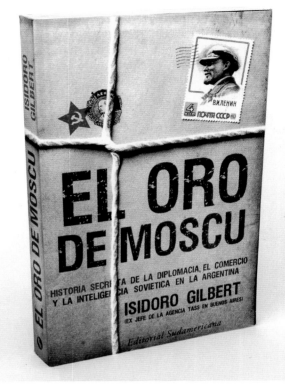

Lived lives/Book cover/2005

Gold from Moscu/Book cover/2007

Adding and abetting/Book cover/2008

Power/Book cover/2008

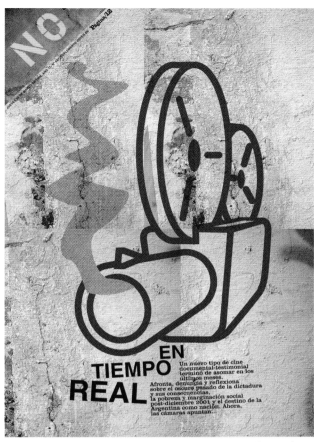

Documentary denounce films/Cover for newspaper supplement/2005

Mixed blood rock/Cover for newspaper supplement/2006

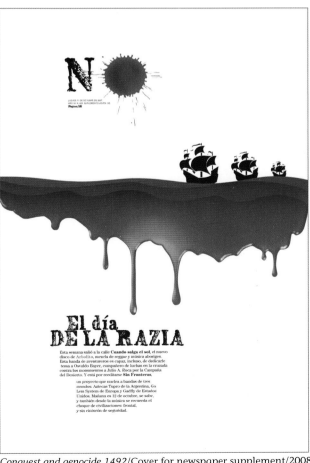

Conquest and genocide 1492/Cover for newspaper supplement/2008

Pforzheim, Germany (CJ)
Tübingen, Germany (TW)

Berlin, Germany
Leipzig, Germany

jungundwenig

Christopher Jung and Tobias Wenig
www.jungundwenig.com
info@jungundwenig.com

Birthplace: Pforzheim, Germany (CJ) /Tübingen, Germany (TW)
Residence: Berlin, Germany
Connecting cities: Leipzig, Germany

JUNGUNDWENIG IS THE CREATIVE studio of Cristopher Jung and Tobias Wenig. This design duo met when they were studying at the Visual Arts Academy in Leipzig in 1999. They began working together in 2004, specializing in design for books and magazines and art for albums, cinema, and multimedia for clients on the arts and culture scene.

When developing their projects, the designers are greatly influenced by their most immediate surroundings. They find inspiration in the works of people such as Cyan, Günter Karl Bose, and Markus Dreben, as well as the outstanding Leipzig typographers Jan Tschichold and Walter Tiemann.

As well as creating seductive images of short duration, this creative team endeavors not to forget its roots. It is worried by the fact that formal questions form the main body of critical discourse, while content and purpose are, unfortunately, not questioned in the same way.

jungundwenig are also passionate about music and find most satisfaction in the smallest of things – "a letter that resembles an animal, an almost empty page with only two or three elements on it, a pleasantly colored surface... it could be anything."

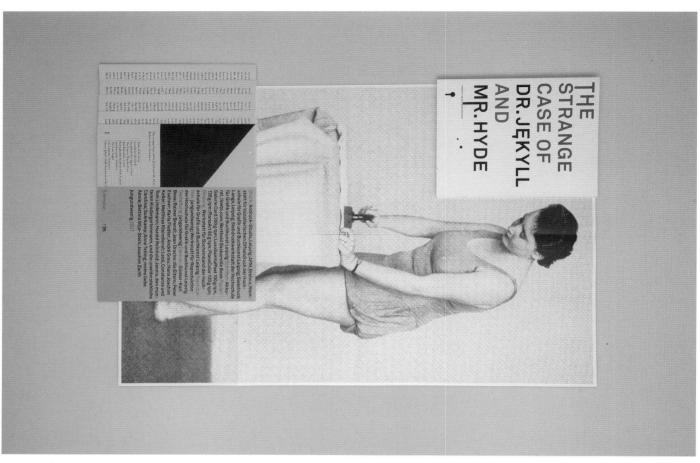

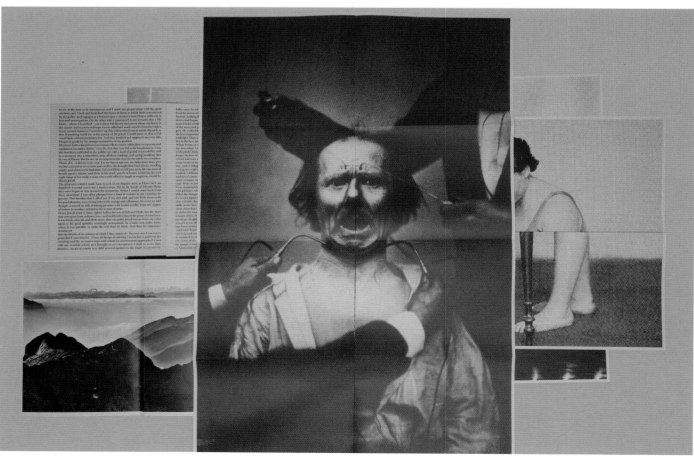

Dr. Jekyll and Mr. Hyde/Book/2007

Giardini di mirò/Album cover/2006

Giardini di mirò/Album cover/2006

VVZ2/Book/2005

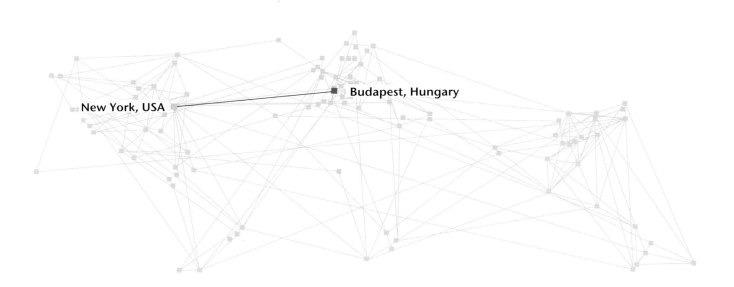

New York, USA — Budapest, Hungary

Karoly Kiralyfalvi

www.extraverage.net
hello@extraverage.net

Birthplace: Budapest, Hungary
Residence: Budapest, Hungary
Connecting cities: New York, USA

EXTRAVERAGE IS THE BRAND that identifies the products and the design of Karoly Kiralyfalvi, an independent visual artist/graphic designer who lives and works in Budapest.

He is passionate about drawing and computers and has been interested in the visual arts since he was a boy, influenced by his father who was an artist, a poet, and a sculptor. In 2001, he began to design printed projects and websites for different local and international studios and clients. His work has been included in the books *Los Logos*, volumes 3 & 4, *Play Loud*, and *Graphicum*, a recent compilation of Hungarian contemporary design. He has also had work reviewed in magazines such as *IdN*, *ROJO*, and *Computer Arts*.

His inspiration comes from his own past and also day-to-day experiences. Music, nature, certain magazines, and websites are key reference points in his visual language. The influence of urban art is also apparent – embodied in customized spray cans, skateboards, and sneakers.

Extraverge believes that it is paramount for a designer to maintain a fresh approach and to work with different clients and themes. His aesthetic style, according to the artist himself, "is rooted in the seventies' aesthetic with a little contemporary make-up."

Coming Strong/Digital print/2008

Escape the City Limits/Vinyl on wood/2008

This Ain't no Halfsteppin/Vinyl on wood/2008

Coming Correct/Citylight poster/2008

Trust the KDU/Digital print/2008

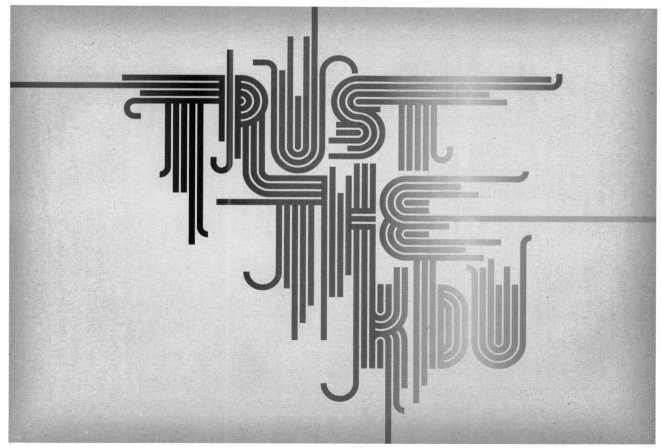

Trust the KDU/Digital print/2008

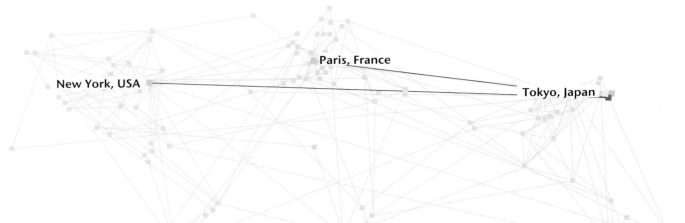

New York, USA

Paris, France

Tokyo, Japan

Kashiwa Sato

www.kashiwasato.com
info@samurai.sh

Birthplace: Tokyo, Japan
Residence: Tokyo, Japan
Connecting cities: Tokyo, Japan/New York, USA/Paris, France

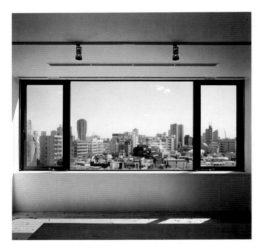

SAMURAI IS THE STUDIO of Kashiwa Sato, one of the most prolific designers in Japan. He is a Tama Art University graduate and has been working independently since the year 2000, specializing in the development of projects in graphic design, visual identity, video, art direction, advertising, and industrial design.

In the role of creative director Sato develops a whole strategy for every project with the assistance of a team of four designers. He was born in Tokyo in 1965 and can count among his merits the Tokyo Art Directors Club Grand Prix, a gold medal from the Type Directors Club of Tokyo and the Mainichi Design award.

His work has been critically acclaimed both locally and internationally. He has also published the monographic books *All About Kashiwa Sato* and *Ultimate Method for Reaching the Essentials*.

According to Sato, his work is characterized by its powerful visual inventiveness and a defined language. His precise artistic control in each stage of the process is fundamental. He endeavors to create pieces that draw attention to the product in the same way as they question each other.

2007.02.11 SUN AM07:03

2007.02.11 SUN AM07:03

2007.02.11 SUN AM07:03

2007.02.11 SUN AM07:03

Issey Miyake/Poster/2006

Issey Miyake Féte/Catalog/Creative director: Kashiwa Sato; graphic designers:
Ko Ishikawa, Gen Eto, Yoshiki Okuse; illustrator: Kashiwa Sato/2006

2008 New Year Cards/Greeting cards/Creative director: Kashiwa Sato; graphic designers: Yoshiki Okuse and Kashiwa Sato/2007

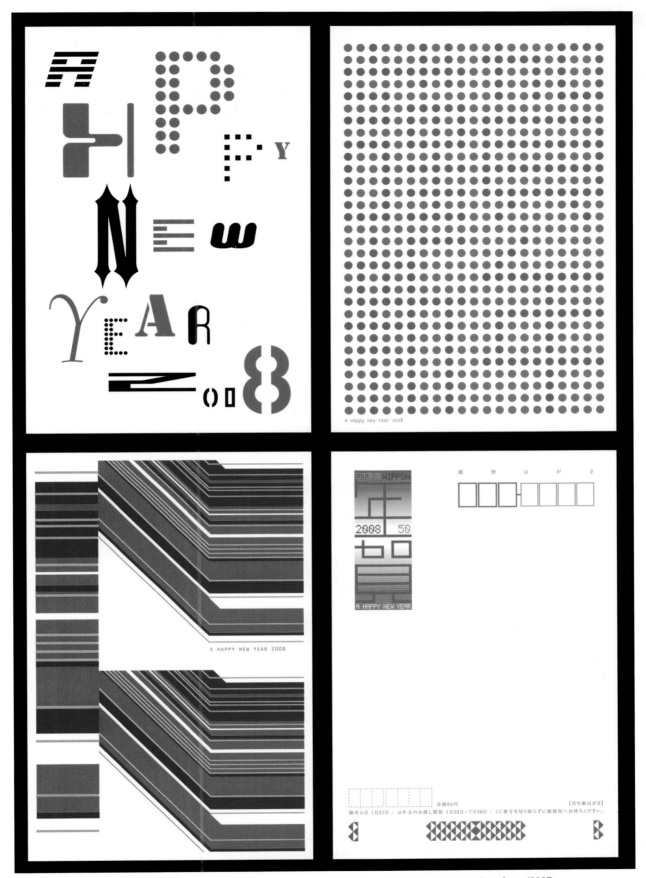

Uniqlo/Bottles/Creative director: Kashiwa Sato; graphic designers: Ko Ishikawa, Gen Eto, Tomoatsu Kasahara/2007

Uniqlo/Bottles/Creative director: Kashiwa Sato; graphic designers: Ko Ishikawa, Gen Eto and Tomoatsu Kasahara/2007

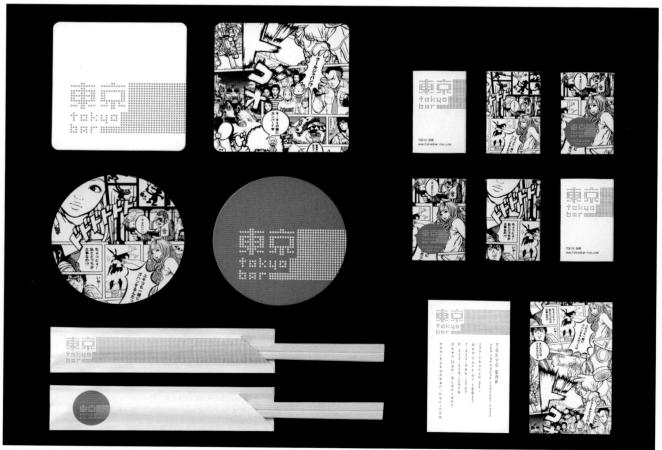

Tokyo Bar/Visual identity/Creative director: Kashiwa Sato; graphic designer: Gen Eto/2007

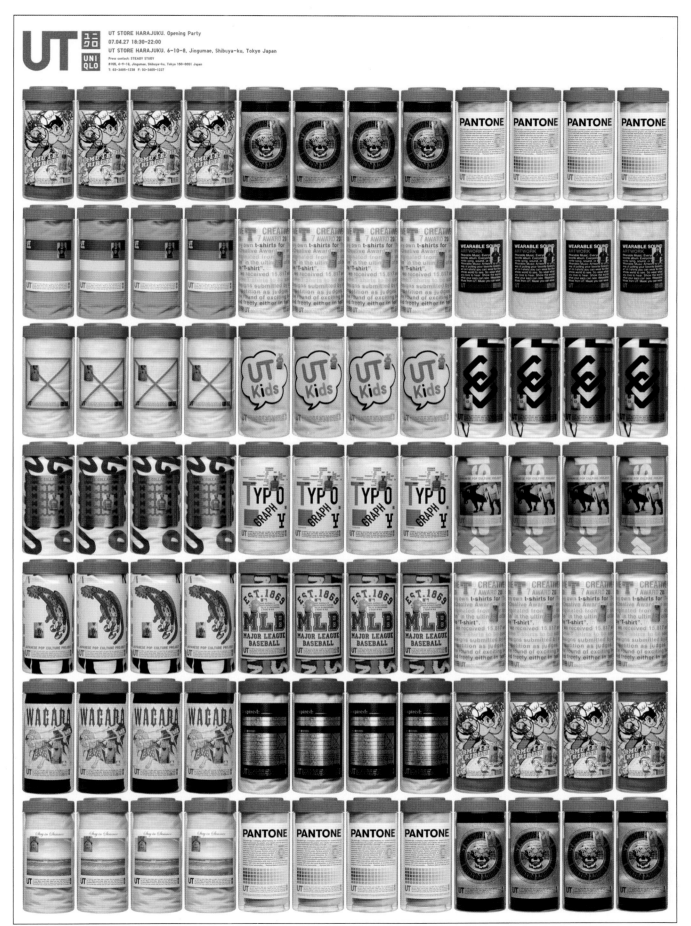

Uniqlo/Packaging/Creative director: Kashiwa Sato and Markus Kierztan; graphic Designers: Ko Ishikawa, Gen Eto and Tomoatsu Kasahara/2007

Tokyo, Japan

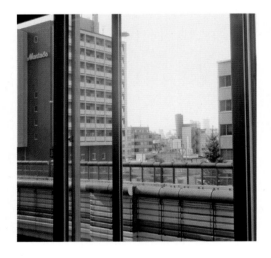

Kazunari Hattori

hattori@flyingcake.com

Birthplace: Tokyo, Japan
Residence: Tokyo, Japan
Connecting cities: Tokyo, Japan

KAZUNARI HATTORI LIVES and works in Tokyo. He graduated with degrees in music and fine arts from National University and currently works developing visual projects for diverse media, including editorial and advertising design, packaging design, and visual identity.

The work of this renowned designer and art director, considered one of the most promising figures in contemporary Japanese graphic design, has been recognized on various occasions with international prizes such as the Tokyo ADC Award, the Member's Award and the Tokyo TDC Member's Prize. In 2007, he received the Grand Prix at the TDC Annual Awards.

In addition, since 2003 he has worked as art director for the bi-monthly magazine *Ryuko Tsushin*. He is particularly passionate about this project, and he participates in each stage of the process, from the conceptualization to the production, with the objective of constructing images that are relevant to the time when they were produced.

For this visual communicator, the typographic work is of the utmost importance and in spite of not considering himself a specialist in the field, he admits that he enjoys playing intuitively with the text – finding a certain mystery and seductiveness in the letters, which takes them beyond their function of mere signs.

Flag/Posters/Experimental printing exhibition/2007

Mayonaka/Magazine cover/2008

Kewpie Half (calorie-off mayonnaise)/Print advertisement/1999

Kewpie Half (calorie-off mayonnaise)/Print advertisement/2004

Ryuko Tsushin/Magazine cover/2002

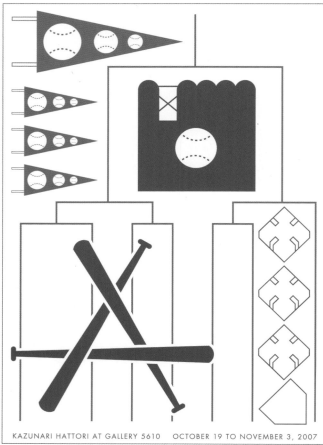

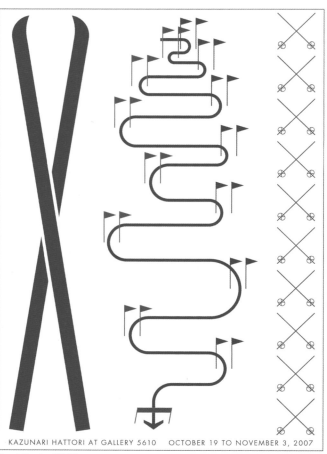

KAZUNARI HATTORI AT GALLERY 5610 OCTOBER 19 TO NOVEMBER 3, 2007

Sport/Poster/2007

KAZUNARI HATTORI AT GALLERY 5610 OCTOBER 19 TO NOVEMBER 3, 2007

Sport/Poster/2007

here and there vol.7/Poster/2008

Kazunari Hattori Exhibition/Poster/2004

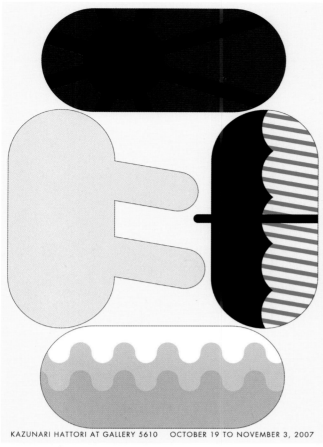

Weather Forecast 1/Poster/2007

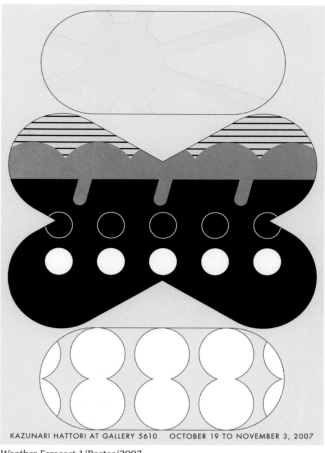

Weather Forecast 1/Poster/2007

Gekkan-Hyakka/Magazine cover/2008

Gekkan-Hyakka/Magazine cover/2008

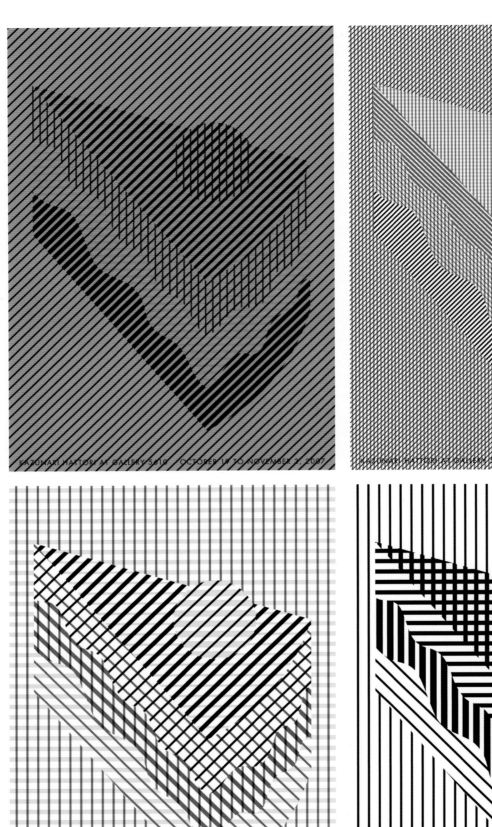

Cake/Posters/2007

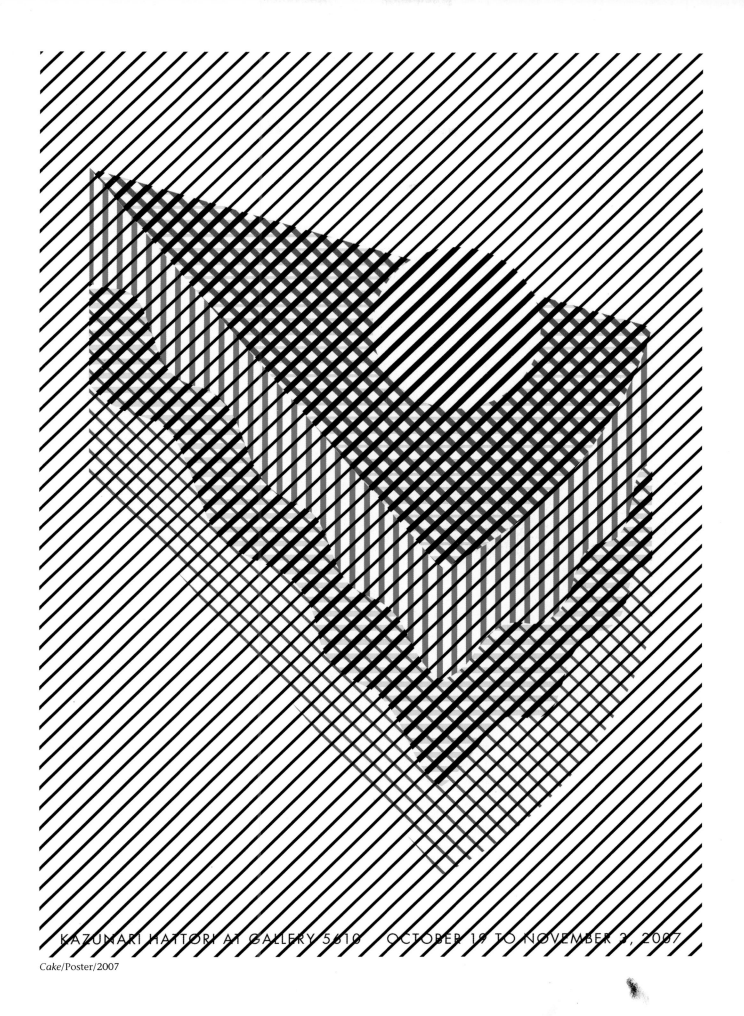

Cake/Poster/2007

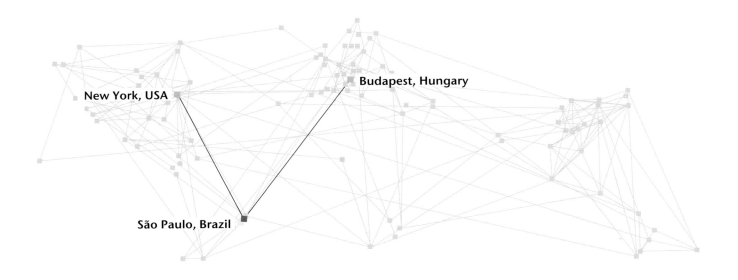

New York, USA

Budapest, Hungary

São Paulo, Brazil

Kiko Farkas

www.kikofarkas.com.br
estudio@kikofarkas.com.br

Birthplace: São Paulo, Brazil
Residence: São Paulo, Brazil
Connecting cities: New York, USA/Budapest, Hungary

THE CREATIVE SPACE of the renowned Brazilian designer Kiko Farkas, Máquina Estudio, is located in the metropolitan São Paulo – the city that never stops.

He is an architect, designer, and illustrator, and his work has been published in international magazines such as *Print*, *Novum*, and *Communication Arts*. He has also participated in numerous exhibitions which include, The Colorado Poster

Biennale, The Warsaw Poster Biennale, The Toyama Poster Triennial and the Brno Poster Triennial, among others.

In 2004, he held his first solo exhibition with an impressive series of posters designed for the São Paolo State Symphonic Orchestra – a large scale project which involved creating 67 posters in record time. Also in 2004 he won a national competition for creating a tourism-based identity for Brazil.

His work shows a clear predilection for geometric shapes, the use of patterns, and series, which, when repeated, create rhythms and harmonies. It has an almost fractal aesthetic that is fluid and effective in communicating the desired message.

OSEPS/Poster/Marker pen/2006

OSEPS/Posters/Illustration/2007

OSEPS/Posters/Digitized keys/2006

6ª Bienal de Design Gráfico

ADG/Poster/Marker pen/2002

O destino das bolas de futebol é fazer gols e a bola Fura-Redes, como o nome indica, era a maior especialista do país na quantidade e na qualidade dos tentos assinalados. Gols olímpicos, e de efeito, de folha-seca, de letra, de bicicleta, de placa, incomparáveis.

Por isso mesmo tornou-se conhecida e aclamada como Esfera Mágica, Goleadora Genial, Pelota Invencível e Redonda Infernal, pelos locutores enlouquecidos ao microfone, quando a viam atravessar o campo, de passe em passe, de finta em finta, para marcar mais um tento sensacional.

Durante um tempo mais ou menos longo, Fura-Redes e Tranca-Redes, ex-Cerca-Frango, dominaram os estádios brasileiros, empolgando multidões nas festas de tentos maravilhosos e de defesas deslumbrantes. Ocupavam as manchetes dos jornais, as telas das televisões e dos cinemas, obrigavam os locutores a criarem expressões novas, ainda mais grandiloqüentes, aumentativos colossais para descrever os feitos da bola e do goleiro.

Depois de varar as redes, aumentando o placar da sutra humilhante aplicada na equipe adversária, a Redondinha vinha, redondinha, acolher-se nos braços de Bilô-Bilô, aconchegar-se em seu peito. Por mais de uma vez aconteceu Tranca-Redes beijar Fura-Redes e então, no estádio, o numeroso público delirava. Parecia um milagre e assim era: milagre de amor não tem explicação, não necessita.

A bola e o goleiro/Book/Japanese brush and digital color manipulation/2008

Helsinki, Finland

New York, USA

Kokoro & Moi

Teemu Suviala and Antti Hinkula
www.kokoromoi.com
info@kokoromoi.com

Birthplace: Helsinki, Finland
Residence: Helsinki, Finland
Connecting cities: Helsinki, Finland/New York, USA

FORMERLY KNOWN AS Syrup Helsinki, Kokoro & Moi is a multidisciplinary design consultancy. It was created in 2001 by Teemu Suviala and Antti Hinkula, both graduates of the Institute of Design at the University of Lahti. They specialize in visual identity design, creative direction, art direction, graphic design, and interactive design.

Kokoro & Moi work for local and international clients who range from large multi-nationals to small companies and public and cultural institutions.

They have blossomed thanks to their innovative work, their passion for excellence, and their dedication to each of the projects with which they are involved. They believe strongly in being original and in the power of good design in brand strategies. They seek equally to go

beyond the traditional barriers of design and incorporate digital elements, thus broadening their horizons as designers.

Their colorful designs are set against atmospheres that are seemingly taken from the world of comics. Suviala and Hinkula say that their creative process is similar to sampling electronic music. They mix their own images, instead of sounds, in a style that transcends the conventional aesthetic canons of beauty.

YE LADS OF GRACE
AND SPRUNG FROM
WORTHY STOCK

GRUDGE NOT TO
B R A V E M E N
CONVERSE WITH
YOUR BEAUTY

IN CITIES OF
CHALCIS, LOVE,
LOOSER OF LIMBS

THRIVES SIDE BY SIDE
WITH COURAGE.

We Were Escalator Records 2.3/CD packaging/2008

We Were Escalator Records 2.2/CD packaging/2008

Bon Bon Kakku/Promotional material, 2008

Talo/Logo/2007

Global Local/Logo/2005

Bon Bon Kakku/Fabric design/2008

Bon Bon Kakku/Fabric design/2008

Escalator Records/Logo/2006

The Crash: Selected Songs/CD packaging/2005

New York Magazine/Illustration/2006

Nord Magazine/Illustration/2006

Oslo, Norway
Warsaw, Poland
Ostrava, Czech Republic
Prague, Czech Republic
Brno, Czech Republic

Kolektiv.info Studio

www.kolektiv.info
kolektiv@kolektiv.info

Birthplace: Ostrava, Czech Republic
Residence: Prague, Czech Republic/Ostrava, Czech Republic
Connecting cities: Oslo, Norway/Brno, Czech Republic/Warsaw, Poland

KOLEKTIV.INFO STUDIO is the name of the studio comprising the designers Lukas Kijonka, Michal Krul, and Jan Košátko. This creative team, with operational bases in two different Czech cities, Prague and Ostrava, develop projects for commercial and corporate clients as well as for musical and cultural institutions.

This recreational, daring and non-conformist collective works is mainly in the area of printed matter and publications. They design advertising campaigns, ads, books, flyers, and posters.

Colors, geometry, photography, and music are essential elements in its work. The studio members participate actively in the underground music scene in the Czech Republic, creating visual sessions for events and festivals as well as their own music.

"Kolektiv.info Studio is a trio, three is a base, and three is a team. Graphic design, music, new media, and the rediscovery of old media is what we do.

We began in an industrial village in the provinces and have grown and presented our work on glossy paper in glazed publications which lie on tables in the metropolitan bookshops."

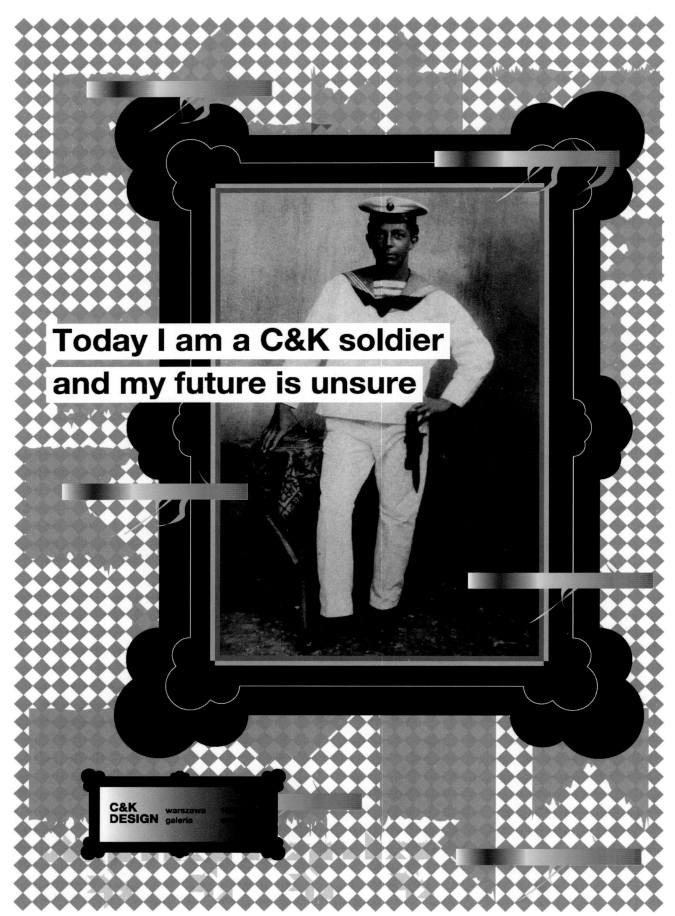

Today I am a C&K soldier
and my future is unsure

C&K
DESIGN warszawa
 galeria

C&K Design/Poster for Warsaw exhibition/2008

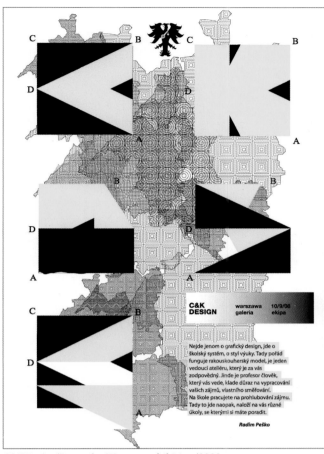

C&K Design/Poster for Warsaw exhibition/2008

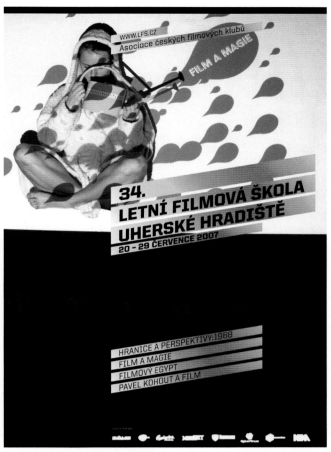

Summer Film School/Posters/2008

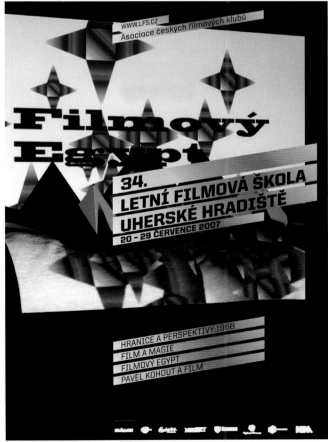

Summer Film School/Posters/2008

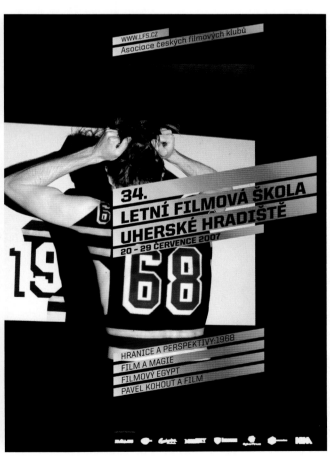

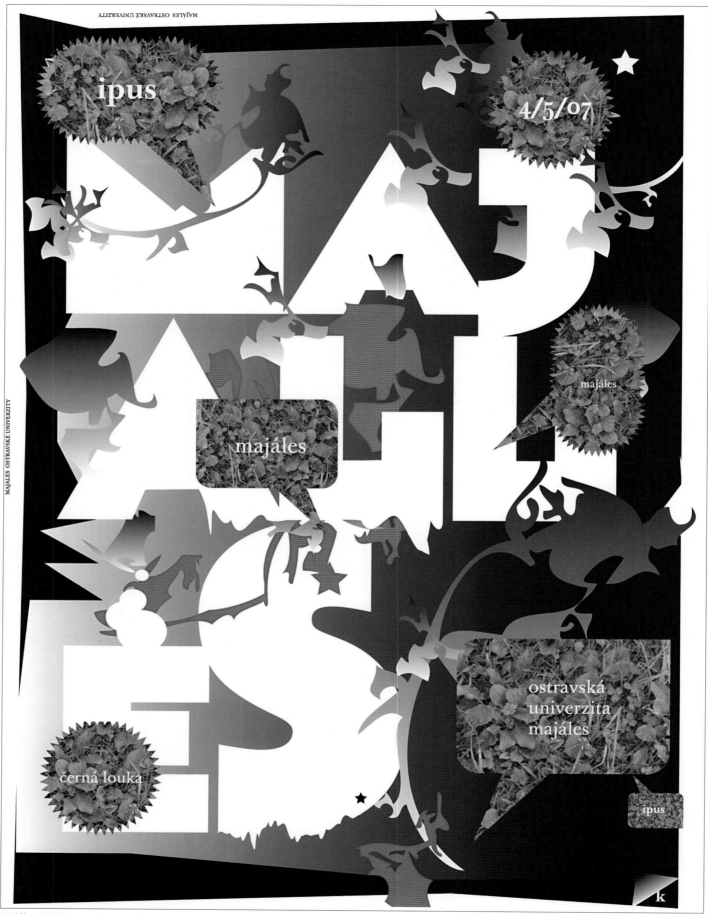

Majáles 2007/Poster for music festival/2006

Majáles 2007/Posters for music festival/2006

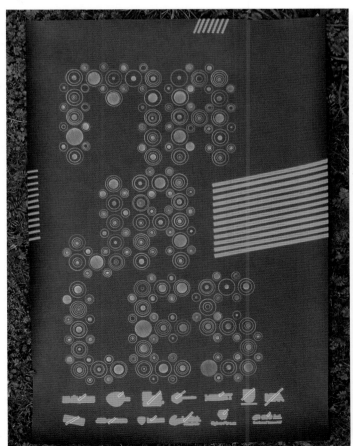

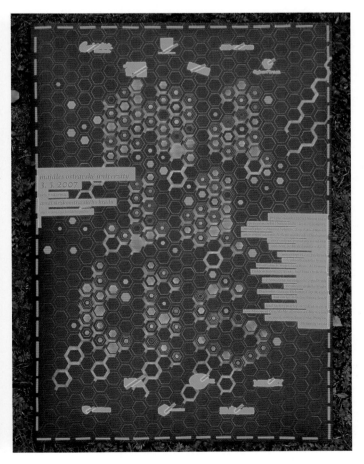

Majáles 2007/Posters for music festival/2006

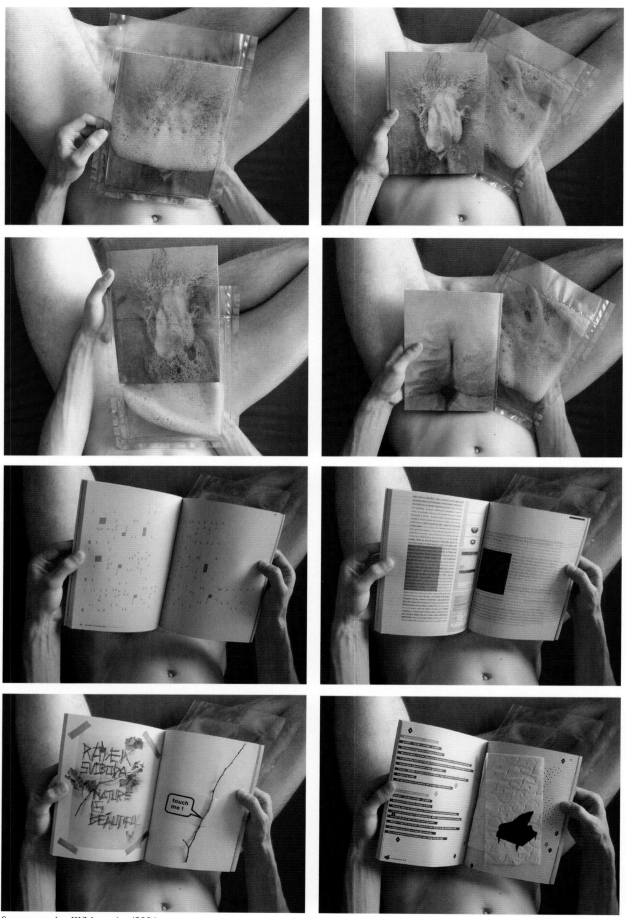

Soap magazine III/Magazine/2004

Holiday posters/Poster/2005

Holiday posters/Poster/2005

Holiday posters/Poster/2005

NUova parties/Poster/2008

London, UK
Trenčín, Slovakia
Paris, France

Orlando, Fla., USA

La Boca

www.laboca.co.uk
eatme@laboca.co.uk

Birthplace: London, UK
Residence: London, UK
Connecting cities: Paris, France / Orlando, Florida, USA / Trenčín, Slovakia

LA BOCA, THE DESIGN STUDIO of Scott Bendall and Alain de la Mata, is located on the legendary Portobello Road in London's west end. Founded in 2002, this creative team introduces themselves as one of the best examples of the new generation of graphic designers in the United Kingdom.

They specialize in the development of graphics for the music, film, and fashion industries. Their visual work covers a wide spectrum, from limited-edition record covers and cinematographic posters to large scale advertising campaigns for national and international clients.

"Inspired," "cosmic," "insane," and "surrealist" are just some of the adjectives with which this "precariously balanced" independent circus, led by three designers and a creative editor, describe themselves.

Their work possesses a provocative flavor, evident in their designs for the record label DC Recordings, which have been exhibited in various galleries in Paris and Ambers. Some of their projects have also been reviewed in periodicals such as *Computer Arts*, *Graphics International*, *Grafik*, and *Groove*, among others, and have been included in the book *Super Sonic Visuals* published by Die Gestalten Verlag in 2007.

Aimee Tallullah is Hypnotised, The Emperor Machine/Album cover/2004

Interrupted Time, White Light Circus/Album cover/2007

Signal Failure, Padded Cell/Album cover/2005

Vertical Tones & Horizontal Noise Part 3, The Emperor Machine/Album cover/2006

Sunburnt Eyelids, Kelpe/Album cover/2005

Sea Inside Body, Kelpe/Album cover/2004

Rocket Ride, White Light Circus/Album cover/2006

Death Before Distemper, Volume 2/Album cover/2008

The Art of Rock/Wad magazine/2008

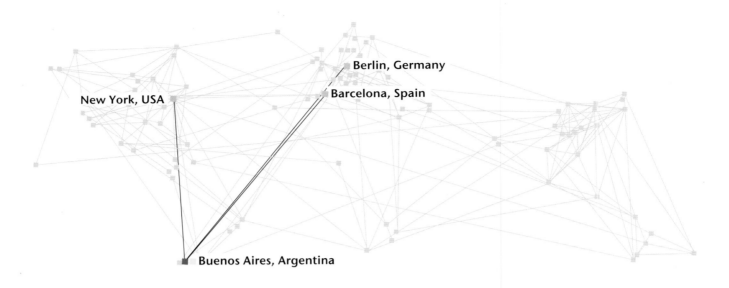

Berlin, Germany

New York, USA

Barcelona, Spain

Buenos Aires, Argentina

Laura Varsky

www.lauravarsky.com.ar
lv@lauravarsky.com.ar

Birthplace: Buenos Aires, Argentina
Residence: Buenos Aires, Argentina
Connecting cities: Berlin, Germany/New York, USA/Barcelona, Spain

LAURA VARSKY LIVES and works in Buenos Aires. She graduated as a graphic designer in 1999 and since then has given typography classes at the university there.

Since 1996 she has been working independently. Her first steps were in the underground independent music scene. She gradually specialized in album design and printed material, given her passion for the relationship between graphics and the musical universe. In 2003, she began

to experiment with illustration. In 2004, she published *Verdesolar*, a book of poems by Victoria Viajera that she illustrated, and she coauthored *Peleonas, mentirosas y haraganas*, published by Ediciones del Eclipse. In 2006, she received a Latin Grammy for the art direction of the Café de los Maestros album.

She is a great admirer of the avant-garde work of the twentieth century and finds inspiration in the work of artists such as

Beardsley, Mucha, Klimt, Josef Hoffmann, Margaret and Charles Rennie Mackintosh, and Hundertwasser, among others.

She admits that she especially enjoys projects for children in which she creates more space for play and it is not necessary to establish a literal relationship between the image and the text.

Canción de tomar el té/Personal project/Ink and digital/2005

ESTAMOS INVITADOS TÉ. La TETERA es de porcelana a tomar el TÉ. -lana PERO NO se ve*

LA leche. TIENE FRÍO y la abrigaré, le pon- dré un sobretodo mío largo HASTA LOS PIES * CUIDADO CUANDO BEBAN, se les va a caer la NARIZ DENTRO de la TAZA Y ESO NO ESTÁ BIEN * dás de UNA TOSTADA se escondió la miel, La MANTECA muy ENOJADA La retó en INGLÉS *. MAÑANA se lo llevan PRESO a un CORONEL por pinchar a la mermelada con un alfiler * PARECE QUE el azúcar SIEMPRE negra fue y de un susto se PUSO blanca TAL COMO LA VEN, *. UN PLATO timorato SE CASÓ ANTE AYER a su esposa La cafetera La trata de usted * LOS pobres coladores TIENEN MUCHA SED PORQUE el agua se les ESCAPA cada 2 por 3 *

canción de TOMAR EL TÉ

de María Elena Walsh

The ugly duckling/Illustration/Ink and digital/2004

Peleonas, mentirosas y haraganas/Book design/Illustrations: Christian Montenegro/2007

Felicidades/CD cover/Illustration: Christian Montenegro/2007

La verdad interior/CD cover/Illustrations/2006

Miau!/DVD cover/Illustration/2006

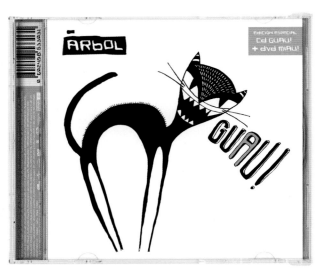

Guau!/CD cover/Illustration/2004

Guau!/CD cover/Illustration/2004

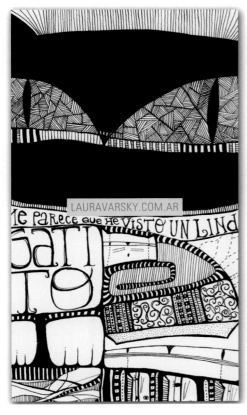

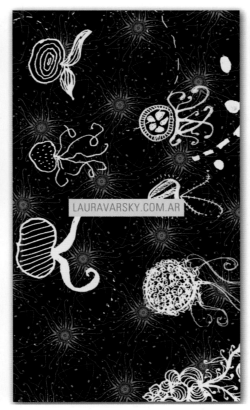

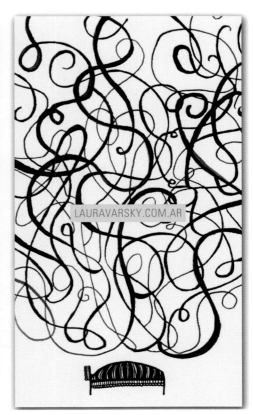

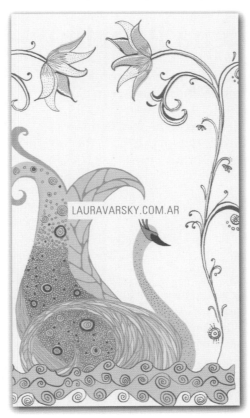

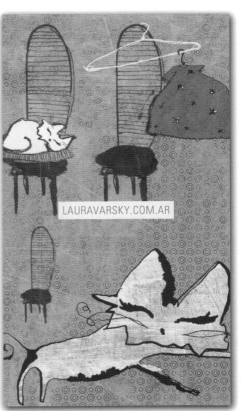

LV/Personal cards and illustrations/2006

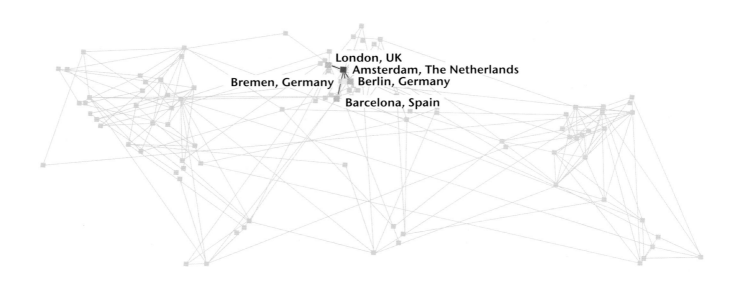

London, UK
Amsterdam, The Netherlands
Bremen, Germany Berlin, Germany
Barcelona, Spain

Lena Panzlau

www.lenasbuero.com
mail@lenasbuero.com

Birthplace: Bremen, Germany
Residence: Amsterdam, The Netherlands
Connecting cities: Barcelona, Spain / Berlin, Germany / London, UK

LENA PANZLAU IS A YOUNG independent graphic designer who was born in Bremen. She currently lives and works in Amsterdam. Since 2006 she has worked independently developing commercial and personal projects.

The portfolio of this visual communicator includes projects for clients in different areas. Her work ranges from corporate design to editorial design, catalogs, posters, flyers, interior design, and projects for digital media. With a touch of irony and a sense of humor, experimentation with 3D typography is evident in the majority of her work. She also pays great attention to the packaging.

She graduated from the Gerrit Rietveld Academy in The Netherlands and from the Kunst-hochscule art school in Berlin. She also forms part of a network of multidisciplinary visual artists who are adamant in eliminating the traditional boundaries which have, until now, kept art and design apart. Many of her projects have been developed within this collective.

She says that she loves working with everything that can touch and be touched. She considers her work to be conceptual, intelligent, and always attractive.

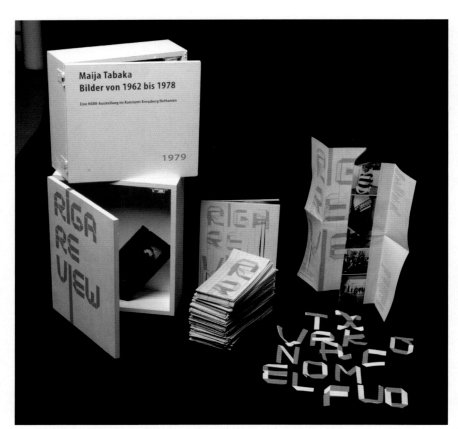
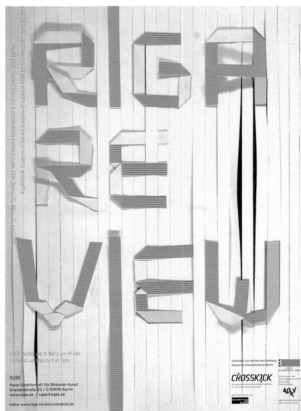

The Riga Review Project/Graphic and exhibition design (for a Berlin-Riga artist exchange and exhibition at the NGBK Gallery-Berlin)/In collaboration with Lena Roob/2007

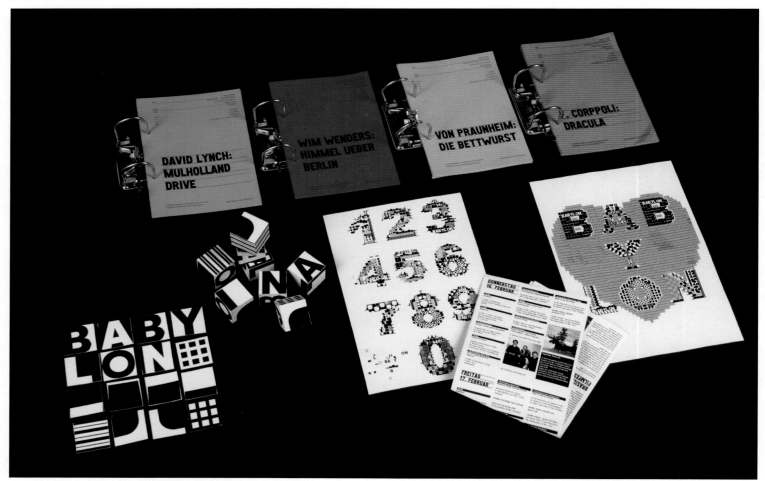

Berlin Babylon/Corporate identity for an arthouse-cinema/2007

True Type Series – Berlin/Exhibition/2008

Lorenskog, Norway (Clay)

London, UK | Amsterdam, The Netherlands
Berlin, Germany

Paris, France Blerick, The Netherlands (van den Brandt)

Lesley Moore

Karin van den Brandt and Alex Clay
www.lesley-moore.nl
mail@lesley-moore.nl

Birthplace: Blerick, The Netherlands (KVDB)/Lørenskog, Norway (AC)
Residence: Amsterdam, The Netherlands
Connecting cities: London, UK/Berlin, Germany/Paris, France

LESLEY MOORE, THE GRAPHIC DESIGN agency founded in 2004 by Karin van den Brandt and Alex Clay, is located in Amsterdam, otherwise known as the "Venice of the north" because of its canals and unique architecture. Their portfolio includes a wide range of projects from the development of visual identities to art direction and design for printed media and exhibitions.

Together with Herman van Bostecen and the Dutch studio De Designpolitie, van den Brandt and Clay are also part of the Gorilla collective, a group which publishes a graphic column on the front page of one of the main Dutch newspapers *De Volkskrant*. It involves a critical and scathing visual interpretation of everyday life. These series were honored in 2007 by the Dutch Design Awards, the European Design Awards and Red Dot Design Award, among others.

In 2009, the studio received the European Design Awards prize for their work on redesigning *Mark* magazine, a bi-monthly publication on architecture, from the same publishing house as *Frame* magazine.

The name of the studio, Lesley Moore, is a play on words which the designers have created from the Goethe's famous quote "Less is more" – the motto taken by Mies van der Rohe also.

VOID

VOID Nº 2
by Lesley Moore & Annouck

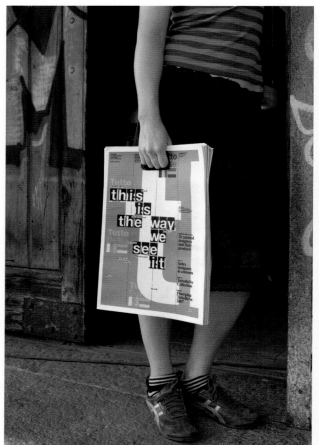
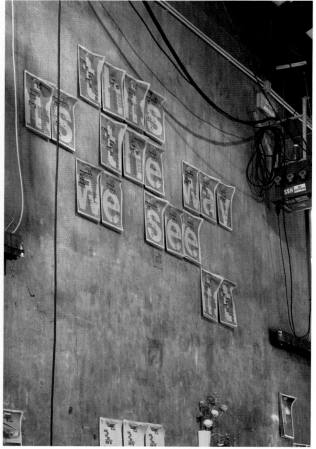

Tuttobene presentation/Newspaper/Exhibition by Lesley Moore & Silke Spinner/Photography: Alberto Ferrero/2007

the ideal stencil letter for lazy dogs

The wall is the landscape/Exhibition lettering for interior designer Robbert de Goede/Stencil/2005

Mark – Another magazine/Magazine art direction and design/2007

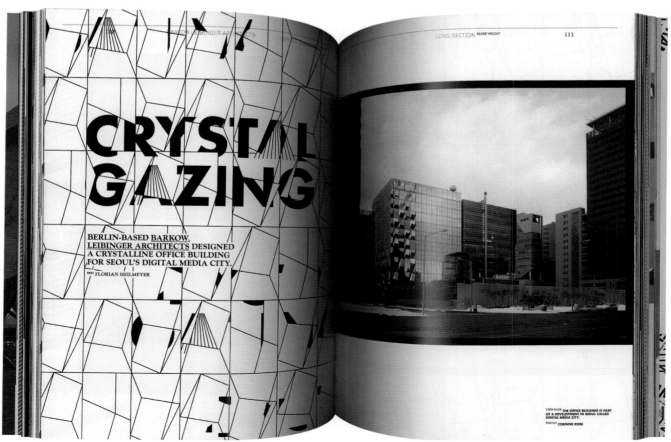

THIS PAGE THE OFFICE BUILDING IS PART OF A DEVELOPMENT IN SEOUL CALLED DIGITAL MEDIA CITY.

PHOTO CORINNE ROSE

Mark – Another magazine/Magazine art direction and design/2007

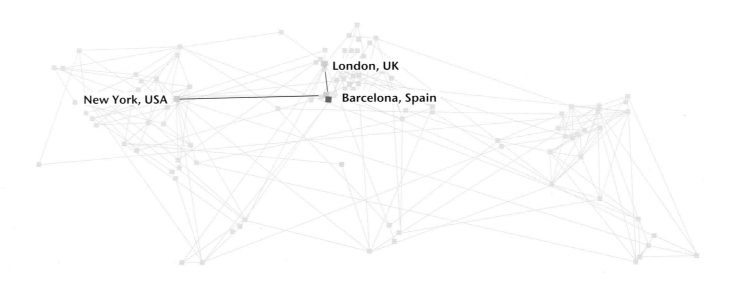

Losiento

Borja Martínez
www.losiento.net
borja@losiento.net

Birthplace: Barcelona, Spain
Residence: Barcelona, Spain
Connecting cities: Barcelona, Spain/London, UK/New York, USA

LOSIENTO IS THE NAME of the agency founded by designer Borja Martínez in Barcelona in 2005. It is dedicated to the development of commercial and personal projects, each as important as the other, since Martínez considers that experimentation is vital for design.

This creative agency has worked for various local and international clients on printed projects and publications, environmental graphics, interventions in space, art direction for the fashion industry, music projects, corporate communication, brands and visual identity, packaging design, and signage. In 2006, it was selected for the Laus prize for its design of The Pinker Tones album.

Its philosophy is about humor and having fun. The graphic execution should be precise on every project and the final product impeccable. The search for excellence is fundamental in order to achieve optimal results.

In his personal projects, Martínez works with experimental graffiti, using materials such as glue and sand. He also works with 3D typography, made with mirrors or food. Combined with reactive photographs, his work transmits powerful messages to highlight global inequalities and the problem of climate change.

Losiento translates to "I feel it" but it also means "I'm sorry."

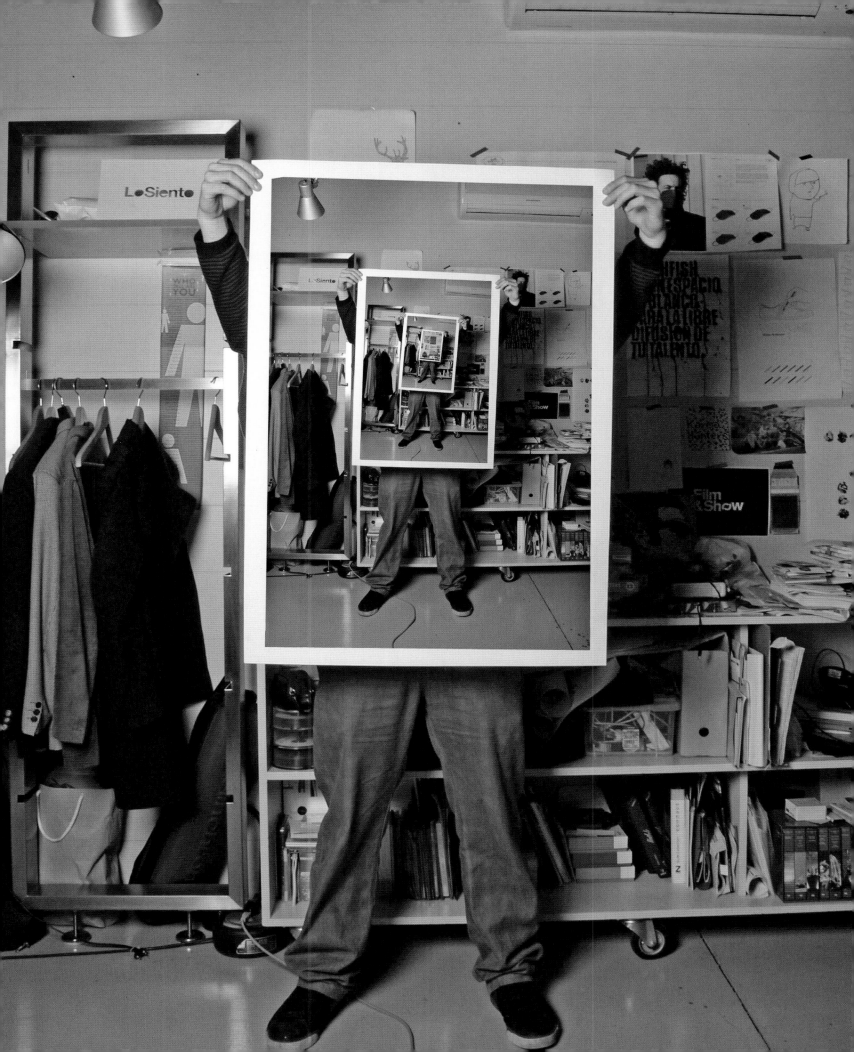

More Colors, The Pinker Tones/CD cover/2007

Crushed Faces/Crushed paper balls portraits/2008

Mag Roll/Magazine rolled typeface/2007

Bazaar/Sand stencil/2006

Wild Animals, The Pinker Tones/CD cover/2008

08

CÈLINE FELGA
CHRISTOPH MERTENS
EQUIPO FALSO
FLAMINIA PELAZZI
GIANNI CANDIDO
NACHO ALEGRE
NINABOY
WADO
THE WHITE APE

radart
Finding new talents

WADO
CRISTOPH MERTENS
DANILO ROJAS
EQUIPO FALSO
FLAMINIA PELAZZI
GIANNI CANDIDO
NACHO ALEGRE
THE WHITE APE

Radart/Logo and poster design/2008

Puig/City scents kit/Welcome pack kit for Puig International Meeting that contains four scents from different places of Barcelona/2007

Existence exit/Public space intervention/Vinyl-adhesive/Using adhesive vinyl to change the meaning of subway signage and symbols/2006

Poeldijk, the Netherlands (Barendse)
The Hague, the Netherlands
Arnhem/Utrecht, The Netherlands
Bergen op Zoom, the Netherlands (DN)

Midland, Texas, USA (Powers)

Ciudad Quezón,
Philippines (Castro)

LUST

**Thomas Castro, Dimitri Nieuwenhuizen, Jeroen Barendse
and Daniel Powers**
www.lust.nl
lust@lust.nl

Birthplace: Ciudad Quezón, Philippines (TC)/Bergen op Zoom, The Netherlands
(DN)/Poeldijk, The Netherlands (JB)/Midland, Texas, USA (DP)
Residence: The Hague, The Netherlands
Connecting cities: Arnhem, The Netherlands/Utrecht, The Netherlands

THIS DESIGN TRIO FOUNDED the LUST studio together in 1996 in The Hague. Their work includes projects for traditional and printed media, interactive media and motion graphics, typography, and other personal work.

They are constantly searching for and locating new areas for graphic design for the development of software and new audiences. For them, design is a process. Each piece of work is based on a concept that is the result of extensive investigation.

Their work methodology involves a design based on processes and generative systems. This enables them to develop an analytical system, which leads to the creation of something that will possibly design itself.

This studio often works with urbanism and architectural firms, publishing houses, music groups, galleries, and both public and private artistic and cultural institutions. They also conduct workshops and courses around the globe.

Castro, Barendse, and Nieuwenhuizen are professors at different Dutch academies. Since 2000 they have sponsored De Program, an international summer workshop for students and professionals in The Hague. They have also co-organized, since 1998, the Zefir7 series of conferences and have received an investigation grant from the Metropolitan University in Leeds.

CARTOGRAFIE VAN EEN WERELDZEE

NOORD ZEE

21

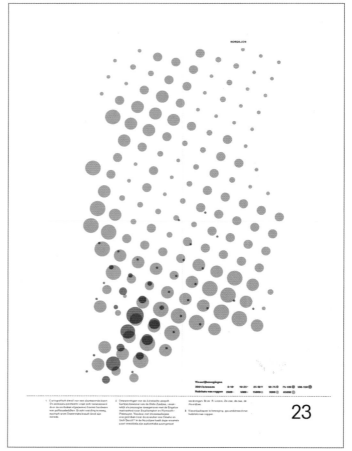

23

The North Sea: Cartography of One of the Worlds Great Seas/Map and Atlas/Self initiated project with Steven van Schuppen and
Jan de Graaf (ed.)/2004

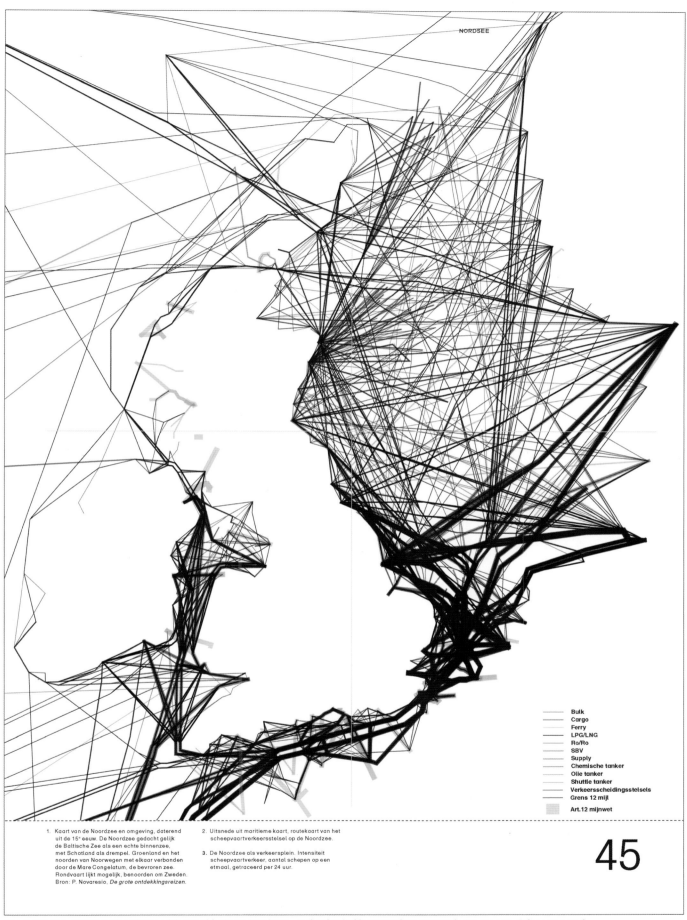

NORDSEE

Bulk
Cargo
Ferry
LPG/LNG
Ro/Ro
SBV
Supply
Chemische tanker
Olie tanker
Shuttle tanker
Verkeersscheidingsstelsels
Grens 12 mijl

Art.12 mijnwet

1. Kaart van de Noordzee en omgeving, daterend
 uit de 15ᵉ eeuw. De Noordzee gedacht gelijk
 de Baltische Zee als een echte binnenzee,
 met Schotland als drempel. Groenland en het
 noorden van Noorwegen met elkaar verbonden
 door de Mare Congelatum, de bevroren zee.
 Rondvaart lijkt mogelijk, benoorden om Zweden.
 Bron: P. Novaresio, *De grote ontdekkingsreizen.*

2. Uitsnede uit maritieme kaart, routekaart van het
 scheepvaartverkeersstelsel op de Noordzee.

3. De Noordzee als verkeersplein. Intensiteit
 scheepvaartverkeer, aantal schepen op een
 etmaal, getraceerd per 24 uur.

45

The North Sea: Cartography of One of the Worlds Great Seas/Map and Atlas/Self initiated project with Steven van Schuppen and
Jan de Graaf (ed.)/2004

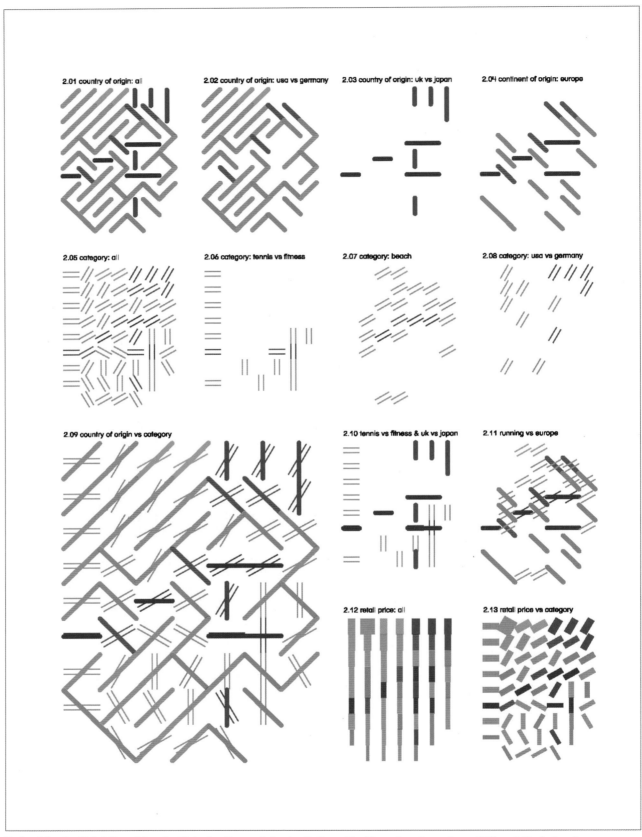

Design Atlas for Global Shoes/Ideas for Outsoles, Uppers & Lacing Patterns/For Margeting, Inventing a Different Marketing Language, André Platteel/2003

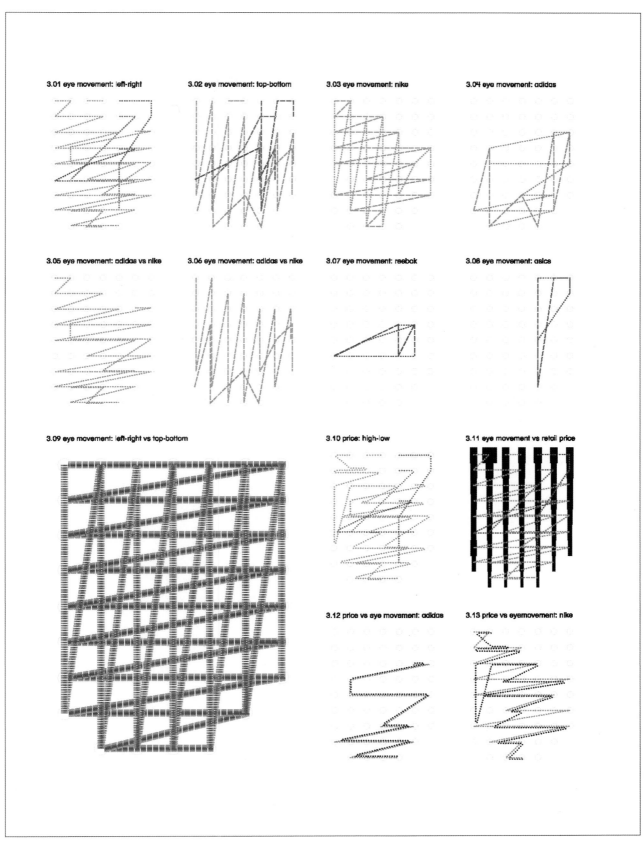

3.01 eye movement: left-right 3.02 eye movement: top-bottom 3.03 eye movement: nike 3.04 eye movement: adidas

3.05 eye movement: adidas vs nike 3.06 eye movement: adidas vs nike 3.07 eye movement: reebok 3.08 eye movement: asics

3.09 eye movement: left-right vs top-bottom 3.10 price: high-low 3.11 eye movement vs retail price

3.12 price vs eye movement: adidas 3.13 price vs eyemovement: nike

Design Atlas for Global Shoes/Ideas for Outsoles, Uppers & Lacing Patterns/For Margeting, Inventing a Different Marketing Language, André Platteel/2003

Mondriaan Stichting Jaarverslag

2004

At Random? Networks and cross-pollinations, Museum De Paviljoens, Almere/Invitation series/2008

Amsterdam, the Netherlands (Klaverstijn)
Amsterdam, the Netherlands
Berlin, Germany
Berlin, Germany (Bois-Reymond)
New York, USA
Paris, France

Machine

Paul du Bois-Reymond and Mark Klaverstijn
www.ourmachine.com
we@ourmachine.com

Birthplace: Berlin, Germany (PBR)/Amsterdam, The Netherlands (MK)
Residence: Amsterdam, The Netherlands
Connecting cities: New York, USA/Berlin, Germany/Paris, France

IN 1996, PAUL DU BOIS-REYMOND and Mark Klaverstijn commenced their work together with the name of Dept. Today, known as Machine, this collective currently has its base in Amsterdam. These designers work on a wide range of projects – many linked to music – and have developed album art, logos, typography, posters, visuals for live shows, and even webpages. In addition to their commercial projects, they also work independently on their own personal creations.

For Machine, the difference between art and design is not important and it endeavors to approach each project with the same attitude, although this may vary depending on the nature of the project. They specialize in combining text and images and in this way search to explore the possibilities of typography as an image.

Although they blend different media and disciplines, music is their permanent source of inspiration. Their Ourmachine

records project is a record label under which they produce their own music. Ourmachine.com defines itself as a creative, autonomous space, in which to share and experiment with ideas.

As well as working on their first album, du Bois-Reymond and Klaverstijn teach classes in the graphic design department at the Rietveld Academy of Art in Amsterdam.

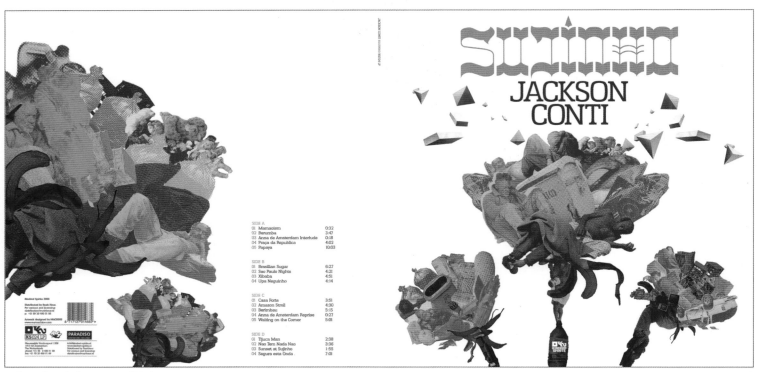

Jackson Conti/Album cover/2008

Build an ark/Album cover/2007

Outsiders

Feat. DJ's:

Mark The Machine & David The Raging Bull

+

Interior Discoration

by Gerrit Rietveld Academie
Architecture Dept. students

+

Cubic Chronicle

Video Installation By
Anne-Jan Reijn

At The:

Bitterzoet
Friday
28.09
2007

Bitterzoet
Spuistraat 2
1012 TS A'dam

Entree: 7,50 Euro
Open: 22:00 hrs
03:00 hrs

Want some get some
better yet take some.

Outsiders
BOLD
BRAVE
BROKE

08.12
2007

BITTERZOET

CHECK:
www.myspace.com/
theoutsiderscrew
• www.davidmoir.nl
• www.ourmachine.com

MACHINE

WELCOME TO PIG CITY

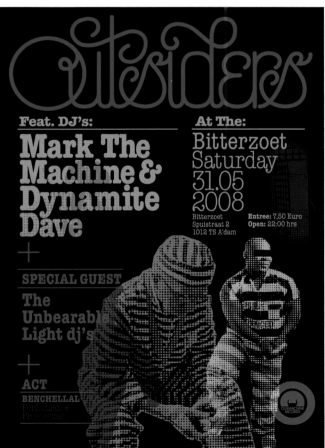

Outsiders

Feat. DJ's:

Mark The Machine & Dynamite Dave

+

SPECIAL GUEST

The
Unbearable
Light dj's

+

ACT

BENCHELLAL

At The:

Bitterzoet
Saturday
31.05
2008

Bitterzoet
Spuistraat 2
1012 TS A'dam

Entree: 7,50 Euro
Open: 22:00 hrs

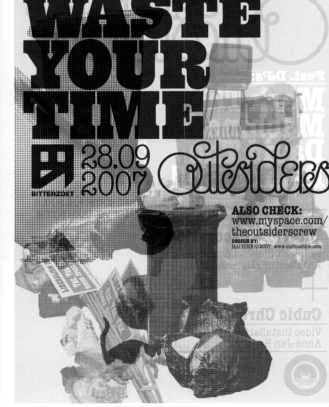

MACHINE INVITES YOU TO
WASTE
YOUR
TIME

28.09
2007

BITTERZOET

Outsiders

ALSO CHECK:
www.myspace.com/
theoutsiderscrew

DESIGN BY:
MACHINE © 2007 www.ourmachine.com

Outsiders/Flyers/2007-2008

Mark magazine/Interior spreads/2005-2006

Mark magazine/Interior spreads/2005-2006

Mark magazine/Interior spreads/2005-2006

Mark magazine/Interior spreads/2005-2006

Cosmic City/Album cover/2008

Versatile/Album cover/2007

Papaia/Album cover/2008

Via Brazil/Flyers/2007-2008

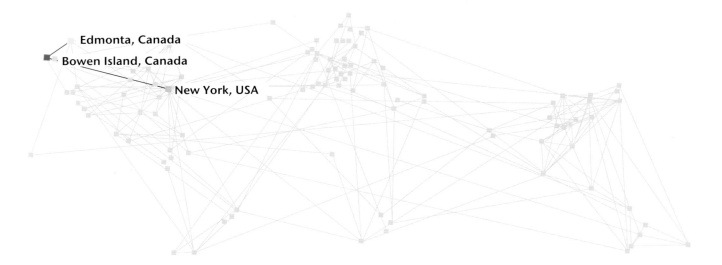

Marian Bantjes

www.bantjes.com
contact@bantjes.com

Birthplace: Edmonta, Canada
Residence: Bowen Island, Canada
Connecting cities: New York, USA

THE STUDIO/HOUSE OF Marian Bantjes is framed by the exceptional scenery of Bowen Island. Bantjes is a graphic artist specializing in the development of typographical characters and ornamental illustration.

This visual communicator, with a strong background in illustration, began her career by working ten years as a typographer. Subsequently she became part of the Digitopolis firm in Vancouver where she designed for cultural, educative,

and corporate organizations. In 2003, she began to develop projects independently and has continued to combine her experience by blurring the traditional boundaries between art, design, illustration, and typography.

This designer has created numerous collections for renowned international brands and publications such as the newspaper *The Guardian* and the magazines *Wallpaper*,* and *Wired*. She is currently part of the board of directors

of the Canadian Society of Graphic Designers and teaches typography classes in the Emily Carr Institute in Vancouver. Her work forms part of the collection of the Cooper-Hewitt National Museum of Design.

She has developed a deeply feminine style of organic inspiration, which she harmonizes with the sensuality of the ornamental patterns, in order to shape her spectacular figures and backgrounds.

Print/Magazine cover and eight interior pages/2006

Print/Magazine cover and eight interior pages/2006

Print/Magazine cover and eight interior pages/2006

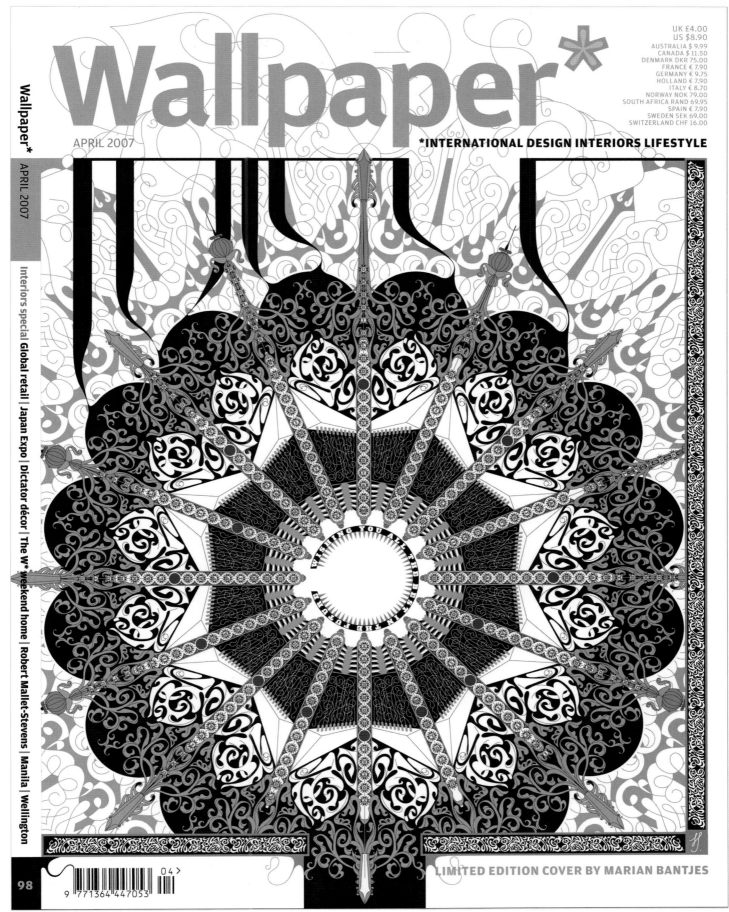

APRIL 2007

Wallpaper*

UK £4.00
US $8.90
AUSTRALIA $ 9.99
CANADA $ 11.50
DENMARK DKR 75.00
FRANCE € 7.90
GERMANY € 9.75
HOLLAND € 7.90
ITALY € 8.70
NORWAY NOK 79.00
SOUTH AFRICA RAND 69.95
SPAIN € 7.90
SWEDEN SEK 69.00
SWITZERLAND CHF 16.00

***INTERNATIONAL DESIGN INTERIORS LIFESTYLE**

Wallpaper*

APRIL 2007

Interiors special | **Global retail** | Japan Expo | **Dictator décor** | The W* weekend home | Robert Mallet-Stevens | Manila | Wellington

98

9 771364 447053 04

LIMITED EDITION COVER BY MARIAN BANTJES

Wallpaper/Magazine cover/2007

$500 Print Design

$500 Advertising

$500 Interactive Design

AWARDS A cash prize of $500 will be awarded to one student from each of the following categories: Print Design, Advertising and Interactive Design. Winning students will also receive a GDC/BC Salazar Student Award Certificate. Winners and honourable mentions will be featured in the Salazar Awards Show, featured publications and the GDC newsletter which is distributed to design firms and ad agencies across Canada. ELIGIBILITY The competition is open to all students who are enrolled in BC academically recognized certificate, diploma or degree graphic design and advertising programs. Students can be at any stage of these programs but must have a signed entry form from an instructor or program director stating that the applicant is enrolled in the named program.

ENTRY FORMS
Available at
http://bc.gdc.net/salazar2007

SUBMISSION SPECIFICATIONS Applicants may submit between 1 to 4 pieces of work. Each piece must be accompanied by a concise description of the problem solved and a rationale of the designer's approach. Use one entry form for each piece. PREPARATION Print submissions must be cleanly mounted on black matte board up to 18" × 24". Pieces larger than 18" × 24" must be photographed or scanned and mounted on black matte boards no larger than 18" × 24". For web or interactive submissions, printed screen captures may be submitted, but they must be accompanied with either the URL to the website or a CD or DVD with the interactive piece on it. DEADLINE Complete submissions must be received by Thursday, May 31, 2007. Drop off between 10 am and 4 pm or send entries to:

Greg Blue
GDC/BC Salazar Student Awards
c/o Langara College
601 West Broadway
Vancouver, BC V5Z 4C2
Phone 604-644-7991

LIMIT OF LIABILITY The GDC/BC is not responsible for any loss or damage that may occur to entries. Applicants are asked to ensure that entries are appropriately documented before submitting to the competition. RETURN OF ENTRIES Students can pick up their entries after June 14, 2007 by contacting Greg Blue at 604-644-7991 or e-mail education@gdc.bc.net. Entries not picked up by June 29th, 2007 will be discarded.

HISTORY OF THE SALAZAR AWARDS The GDC/BC Salazar Student Awards, established in 1985 by the British Columbia Chapter of The Society of Graphic Designers of Canada, was created in honour of Enrique Salazar. Mr. Salazar was one of the founding members of the society and the national representative for the BC Chapter for two years. He was a partner in Salazar Graphics, and taught graphic design at Capilano College until his death in June of 1985. Metropolitan Fine Printers is the founding sponsor of this event.

METROPOLITAN
FINE PRINTERS

THE JUDGING A judging committee comprised of top professionals of the GDC/BC will be reviewing and selecting the winners and honourable mentions. Judging will be based on the strategy and rationales of the pieces as well as the level of visual execution. Judging will be held on Thursday, June 7th, 2007. AWARDS EVENT Winning students and honourable mentions will be promoted to the design, advertising and business communities through an awards evening and exhibit of their work. The event will be held:

June 14th 2007

6 pm and ending at 10 pm
Emily Carr Institute of Art + Design
Theatre: Room 301
1400 Johnston Street
Granville Island, Vancouver

featured speaker

Ian Grais
ReThink Advertising

ENTRY DEADLINE
Thursday May 31 2007

GDC/BC
Salazar Student Awards

AWARDS EVENT
6pm Thursday June 14 2007

Emily Carr Institute of Art + Design
Theatre: Room 301
Granville Island, Vancouver, BC

Society of
Graphic Designers of Canada
British Columbia Chapter

Société des
designers graphiques du Canada
Chapitre de la Colombie-Britannique

POSTER CREDITS Poster design by Marian Bantjes. Typeface is FF Roice, used by special agreement between Marian Bantjes and FontShop for the GDC/BC. Roice was designed by Alex Sholing in 2003, based on his first font, Engine. It comes in five weights: Light, Regular, Medium, Bold and Black; each weight has roman, italic, SMALL CAPS, ITALIC SMALL CAPS (5x4), and an expert set. It sets very loose, as you can see, and has a slightly quirky, friendly feel, which is suitable for both text and display. Available from www.fontshop.com. Printing donated by Metropolitan Fine Printers.

GDC/BC Salazar awards/Poster/2007

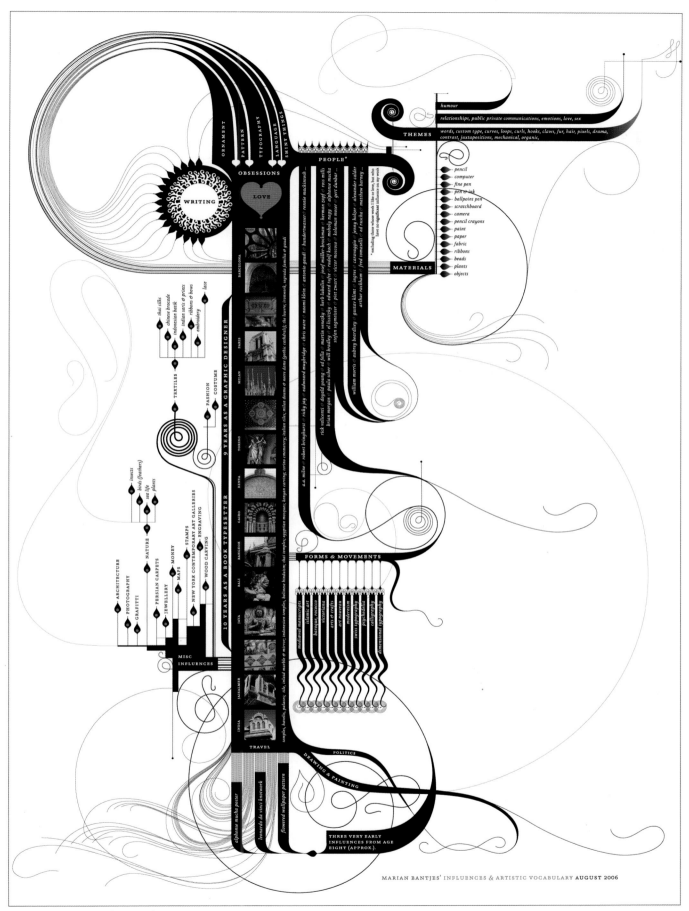

Influence map/Personal project/2006

Knoxville Voice/Illustration design/6ft x 4 ft/2007

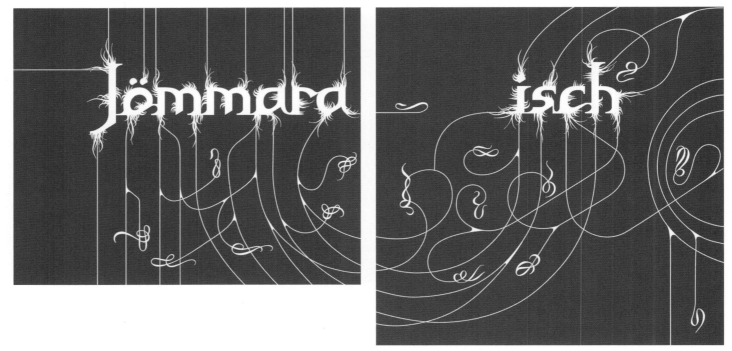

Kunsthaus Bregenz Billboards/Installation/Creative director: Stefan Sagmeister/2006

Saks Valentine/Valentine's day advertisement/2008

Sugar/Type treatment/Creative director: Stefan Sagmeister/2008

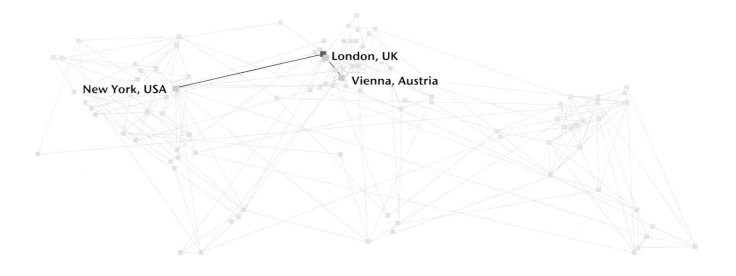

Marion Mayr

www.marionmayr.net
info@marionmayr.net

Birthplace: Vienna, Austria
Residence: London, UK
Connecting cities: London, UK/Vienna, Austria/New York, USA

MARION MAYR HAS HER operational base in London. The work of this graphic designer possesses a surprisingly conceptual coherence and she concentrates mainly on developing projects for printed media with a special interest in typography.

Having graduated with degrees in graphic design and media art from the University of Vienna of Applied Arts, she undertook a master's degree at Central Saint Martins College of Art and Design in London. Since 2005 her work has led to numerous distinctions from important institutions such as the AIGA and the Type Directors Club, among others.

She has worked for different studios and clients as art director and independent designer in London, New York, and Vienna, for names such as Stefan Sagmeister, Saatchi Design, Phaidon Press, Falter Verlag, and Deuticke Verlag.

Recently, she has been constructing small worlds and creating forms for all kinds of content with which she can express her observations, her conscience, and her perception of life. Her global travels have enriched her work with extremely varied influences. Her wholehearted dedication to work and high standards enhances her motivation when taking on new projects. "I hope to be able to maintain this passion."

Hidden Characters/Poster/Hand sewn, japanese paper/2005

Hidden Characters/Poster/Scaled photographed people/2005

Condensed Univers/Puzzle/2004

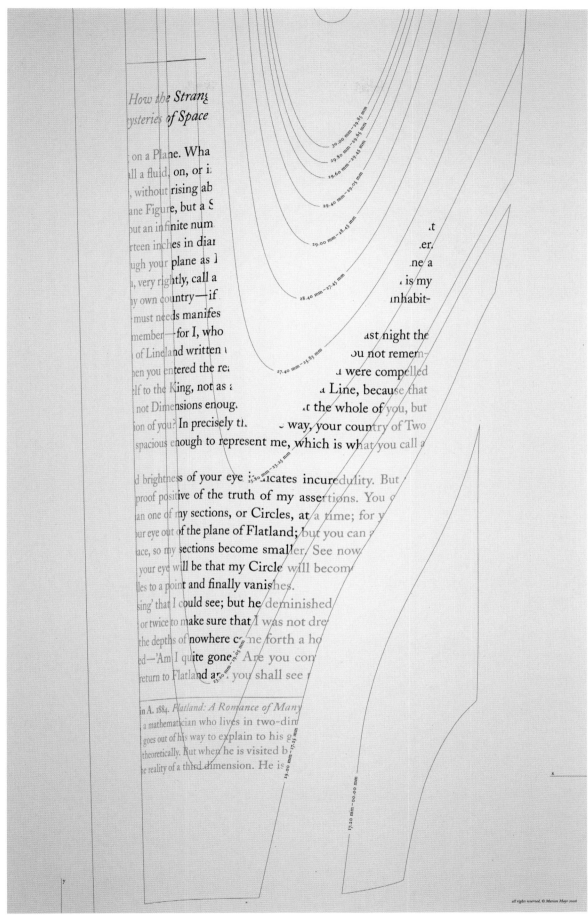

Dissected Matter/Poster/Experimental design on three-dimensional typography/2006

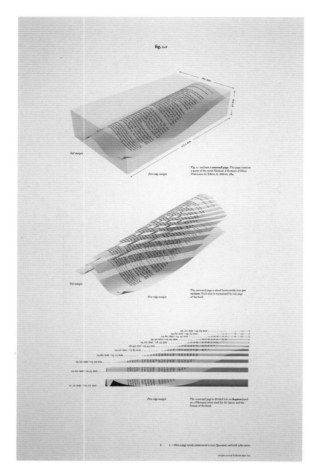

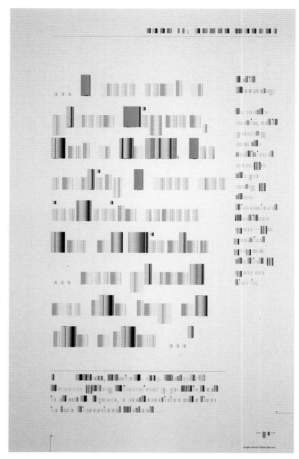

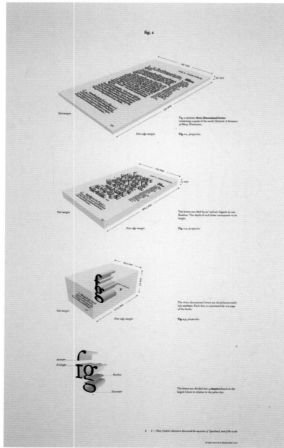

Dissected Matter/Posters/Graphic diagram of the experimental design process/2006

Dissected Matter/Books/The format and layout of the books are based on a Fibonacci series. The books enclose a convexed page and three-dimensional letters/2006

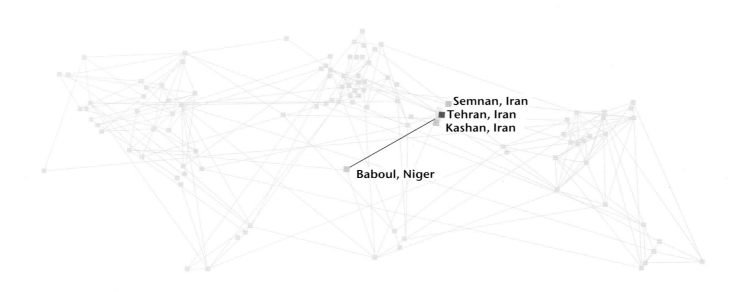

Semnan, Iran
Tehran, Iran
Kashan, Iran

Baboul, Niger

Mehdi Saeedi

www.mehdisaeedi.com
info@mehdisaeedi.com

Birthplace: Tehran, Iran
Residence: Tehran, Iran
Connecting cities: Baboul, Niger / Semnan, Iran / Kashan, Iran

MEHDI SAEEDI LIVES AND WORKS in Tehran. He graduated with a degree in art and design from the University of Cambridge and worked as creative director and graphic designer for different advertising agencies. In 1998, he founded his own studio from where he has developed projects for important cultural institutions in Iran, such as the Tehran Museum of Contemporary Art and the Academy of Art, as well as important musical centers and various companies related to the local cinema industry.

His work has been recognized in national and international competitions, among which include The Islamic World International Poster Biennale, The Kharkov International Eco Poster and Graphic Art Biennale in Ukraine, The Mexican international Poster Biennale, and the Slovakian International Poster Triennial.

A lot of his work has been reviewed in well-known local and international publications and some of his work

can be seen in galleries and museums around the world. In 2004, the Tehran Museum of Contemporary Art published a monographic compilation of his work.

He actively partakes as organizer and commissioner in exhibitions such as the 5th Generation of Iranian Graphic Designers in 2006. He is a member of the Society of Iranian Graphic Designers (IGDS) and since 2005 has worked as professor at various universities in his country.

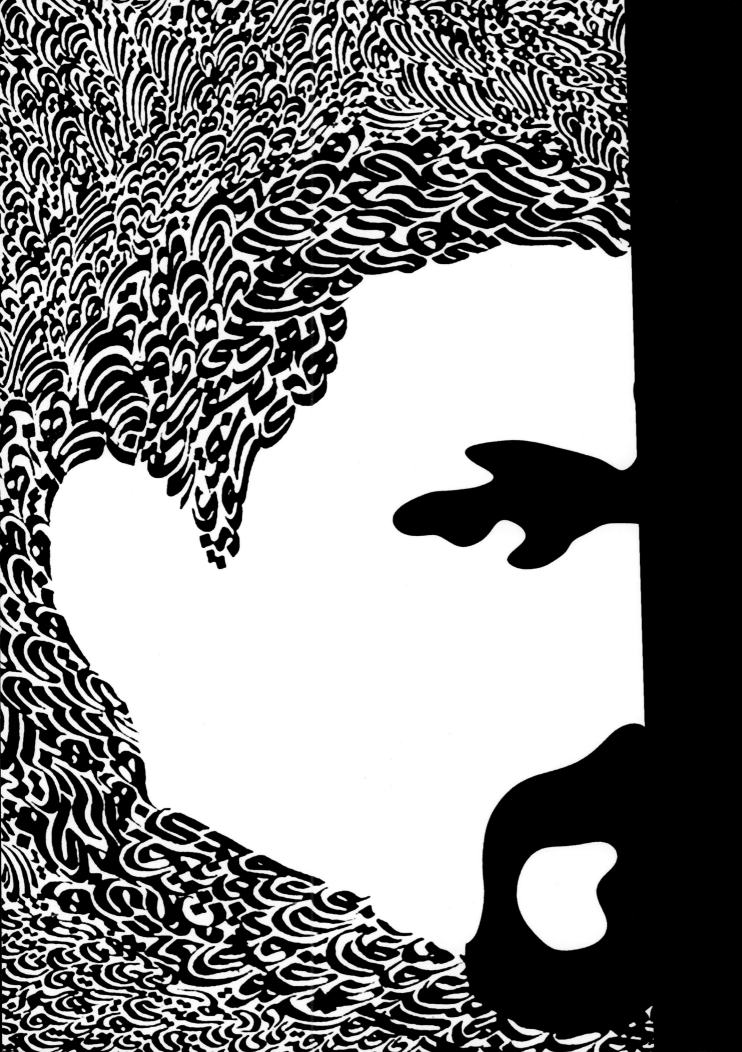

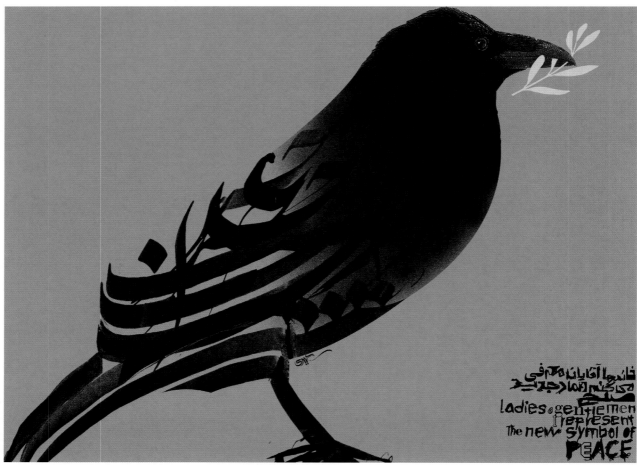

Ladies and gentleman I represent the new symbol of peace/Poster/Screen print/2006

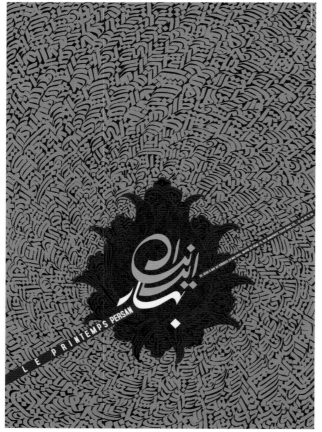

The Iranian Spring/Poster/Offset/2004

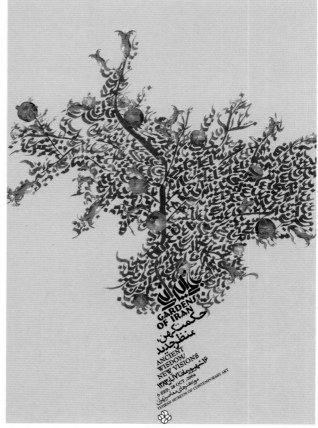

Gardens of Iran/Poster/Digital print/2004

دفتر امور هنر های تجسمی وزارت فرهنگ و ارشاد اسلامی با همکاری انجمن صنفی طراحان گرافیک ایران، موسسه توسعه هنر های تجسمی و موسسه فرهنگی هنری صبا با تایید ایکوگراد ایگرام می کند Saba Cultural and Artistic Center میدان فلسطین، خیابان طالقانی شرقی، شماره ۵۳ تلفن: ۶۶۴۹۲۵۰۸-۱۱ دورنگار: ۶۶۴۹۲۵۱۲

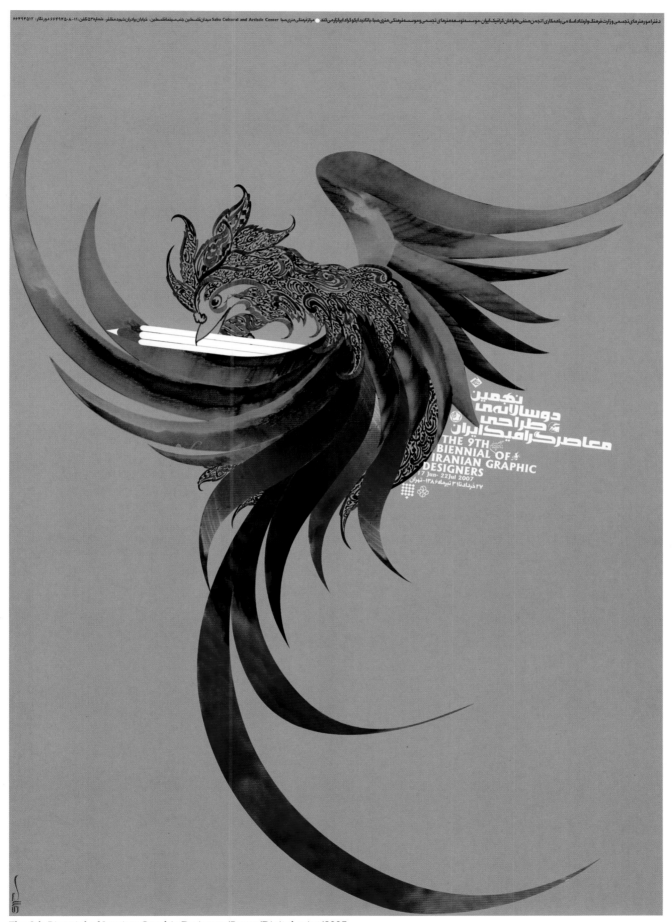

The 9th Biennial of Iranian Graphic Designers/Poster/Digital print/2007

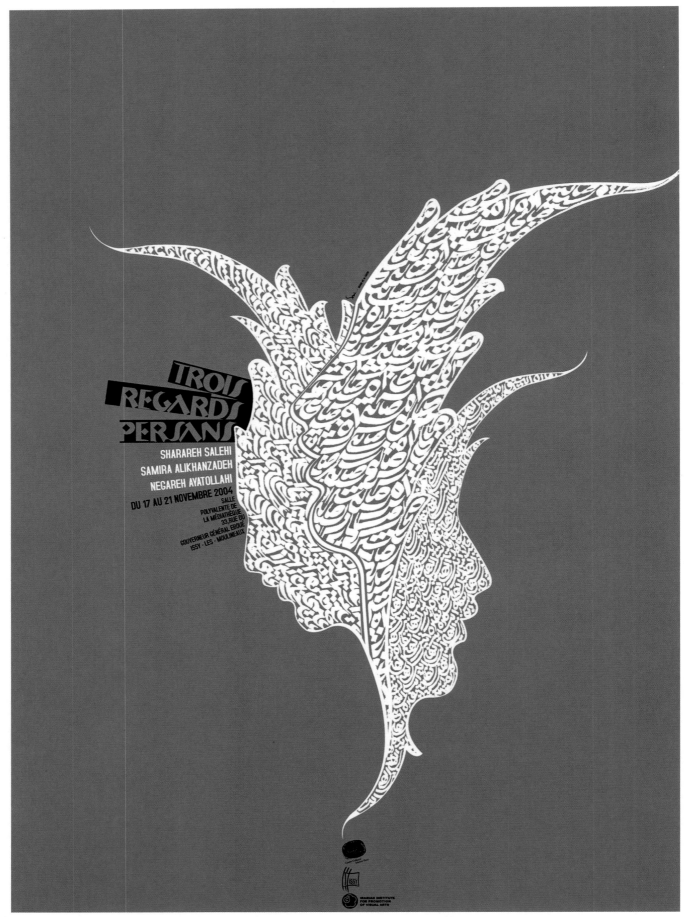

Three Iranian Look/Poster for painting exhibition by three Iranian women artists/Screen print/2004

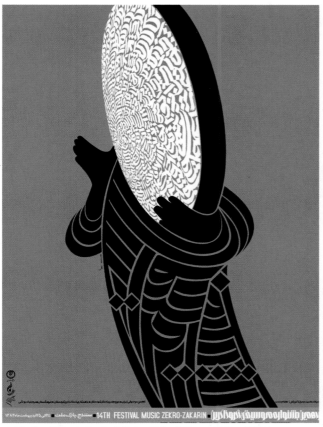

14th Ritual Music Festival (Zekro Zakeri)/Poster/Offset/2004

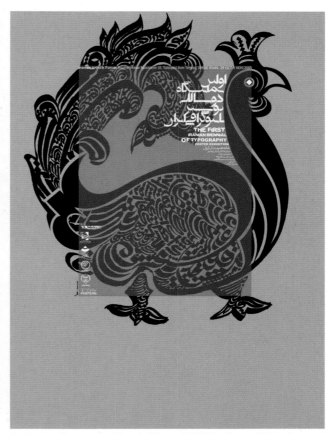

1st Iranian Typography Biennial Poster Exhibition/Poster/Digital Print/2005

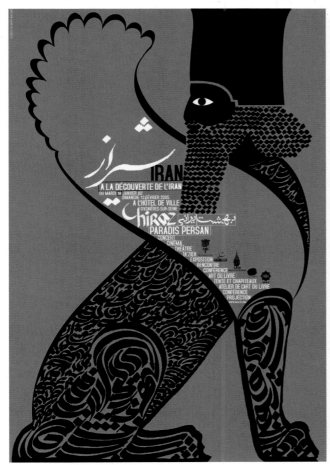

Shiraz, Iranian Paradise/Poster/Offset/2005

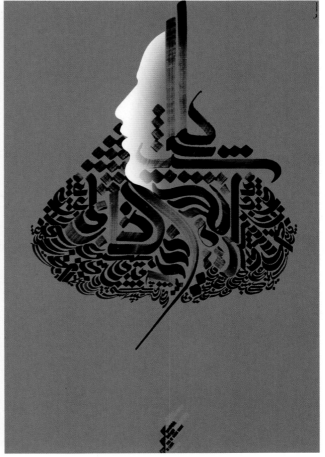

End of dark night is light/Poster/Digital print/2005

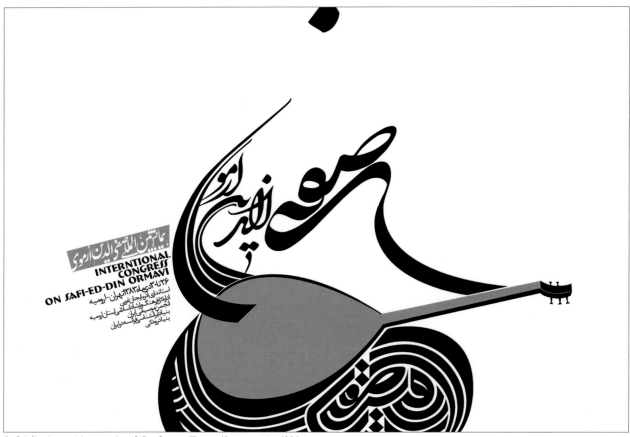

Safi Edin Ormavi International Conference/Poster/Screen print/2004

If you dig a pit for someone else, you fall into it yourself/Poster/Digital print/2006

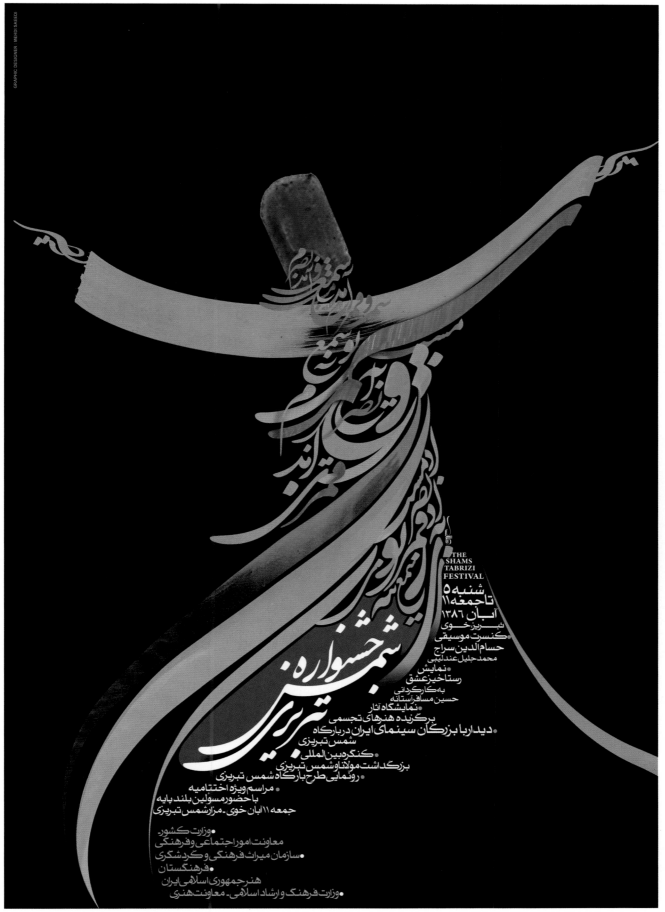

Shamse Tabrizi Festival/Poster/Offset/2008

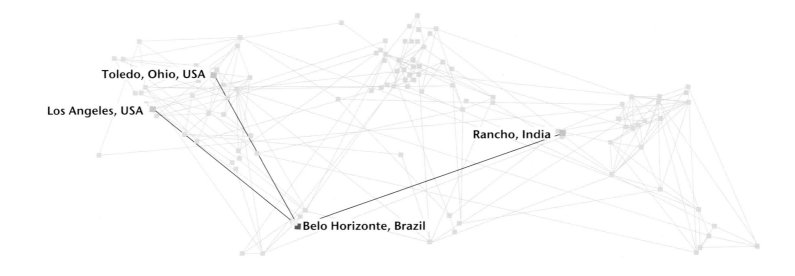

Toledo, Ohio, USA

Los Angeles, USA

Rancho, India

Belo Horizonte, Brazil

Misprinted Type

Eduardo Recife
www.misprintedtype.com/www.eduardorecife.com
recife@misprintedtype.com

Birthplace: Belo Horizonte, Brazil
Residence: Belo Horizonte, Brazil
Connecting cities: Los Angeles, USA/Rancho, India/Toledo, Ohio, USA

BELO HORIZONTE IS THE THIRD biggest city in Brazil, after São Paolo and Rio de Janeiro and serves as base camp for Misprinted Type, the alter ego of the artist Eduardo Recife.

This independent designer, photographer, typographer, and illustrator, who was born in 1980, has developed important commercial projects for publications such as the *New York Times*, *The Guardian*, *Ray Gun*, and *Tokion*, among others. His web-

page offers a varied sample of his work, including his commercial work and also, through Misprinted Type, a selection of his personal projects, among which feature his typographic families which can be downloaded as freeware.

In his collages, Recife digs up vintage images that he processes manually to create textures and stains which give a more human and warm look to his imagery. He is also inspired by graffiti

and grunge typography, designing alphabets and fonts of a great formal beauty.

"I have been drawing since I was a child. At school all my exercise books were filled with drawings instead of notes. I used to tattoo my friends with a black ink pen and draw on any kind of surface when I was bored... I believe this is what I do best... It's a therapy, a hobby and a job that makes me happy."

MIS-

PRINTED
TYPE

sidade

na além ...
me vidas.
dos própri...
amente

Maybe/Print/Digital collage/2005

Handmade/Typeface/Handraw/2008

Panic at the Disco/T-shirt/Digital collage/2007

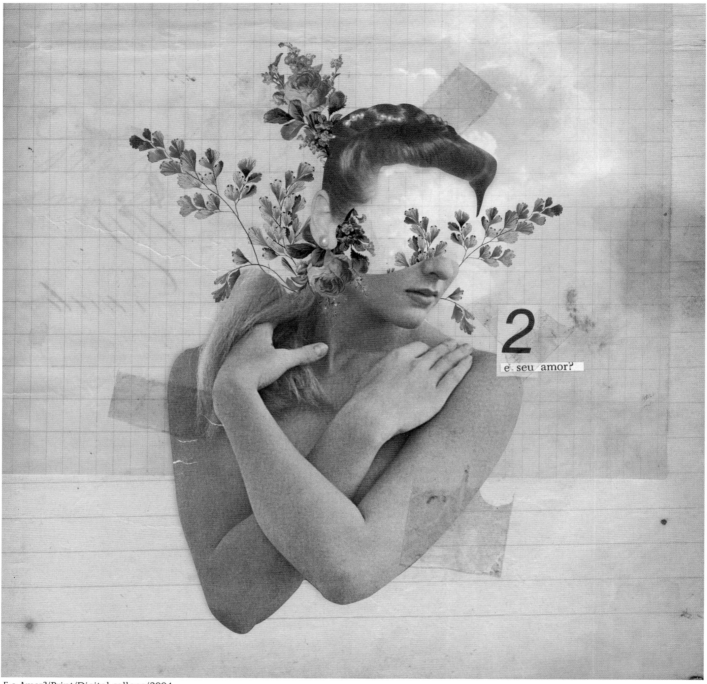

E o Amor?/Print/Digital collage/2004

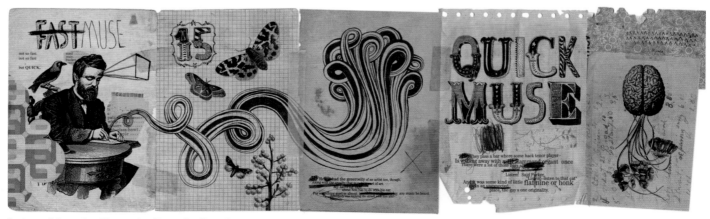

Fastmuse/Magazine illustration/Digital collage/2006

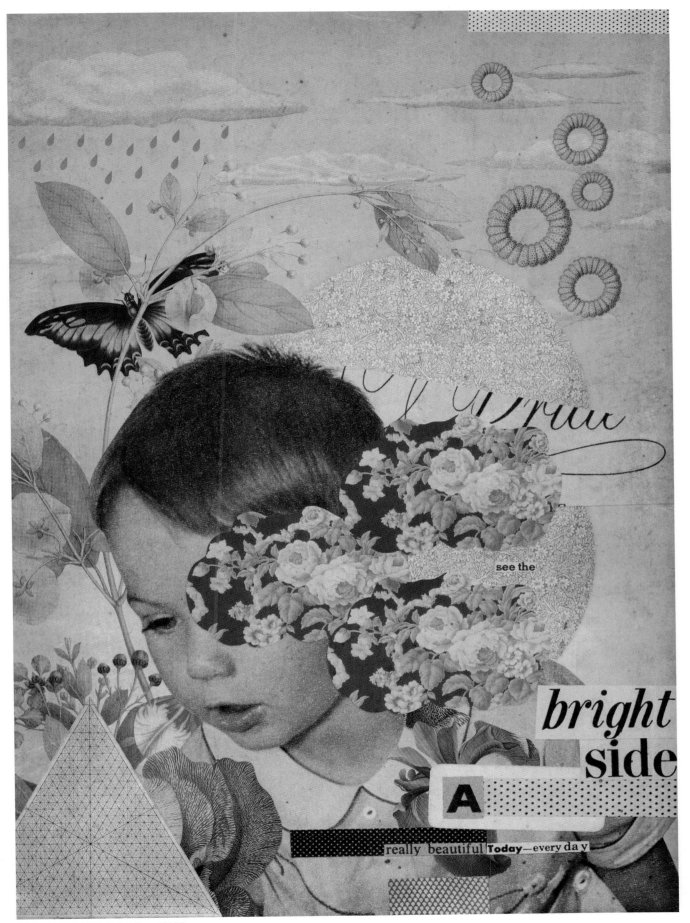

Brightside/Print/Digital collage/2007

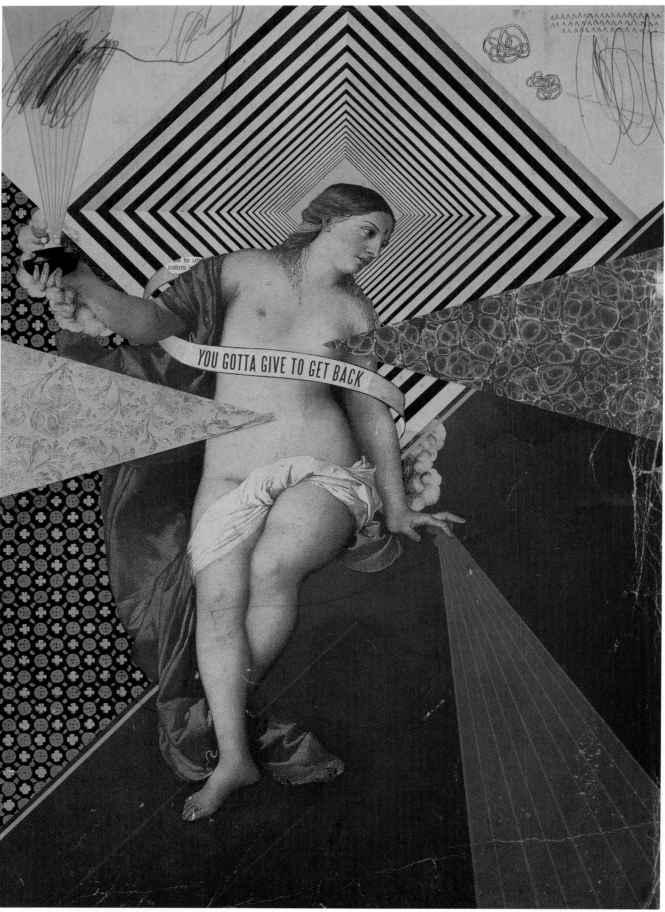

You Gotta Give to Get/Print/Digital collage/2008

Love/Print/Digital collage/2007

Berlin, Germany
Sursee, Switzerland
Lucerne, Switzerland
Horw/Willisau, Switzerland

Mixer

Erich Brechbühl
www.mixer.ch
erich@mixer.ch

Birthplace: Sursee, Switzerland
Residence: Lucerne, Switzerland
Connecting cities: Horw, Switzerland/Willisau, Switzerland/Berlin, Germany

THE SWISS DESIGNER Erich Brechbül began signing his work "Mixer" in 2003. This precocious designer began his career at thirteen when he founded Mix Pictures, an organization that acts as a creation unit in the production of short films and cultural events. After working as a typography apprentice near Lucerne he undertook a work placement in graphic design at the studio of Niklaus Troxler in Willisau. He subsequently settled in Berlin where he is carrying out a work placement at the Metadesign studio.

His work has received many prizes in various international competitions, including the Red Dot Awards, Trnava Poster Triennial, Lahti Poster Biennale, Swiss Poster Award, and Concours internatinoal d'affices in Chaumont, where his work forms part of important international collections. In 2007, he was the youngest member of the Alliance Graphique Internationale (AGI).

Mixer claims he draws his inspiration from theater and music. In addition to his work as a designer, he also organizes musical and artistic events at a cultural forum in Lucerne.

His work stands out for its solid and direct graphic line with minimal elements in order to express his message with clarity. "Good design is even better when it is irritating and surprising. People do not want to be bored."

125 Years MG Harmonie Sempach/Poster/Screen print/2005

125 Years Bourbaki Panorama/Poster/Digital print/2006

War for Peace/Poster/Screen print/2003

Theatersport/Poster/Screen print/2001

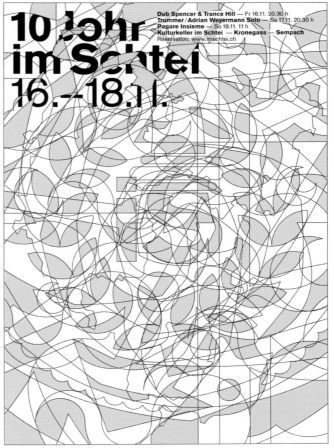

10 Years im Schtei/Poster/Screen print/2007

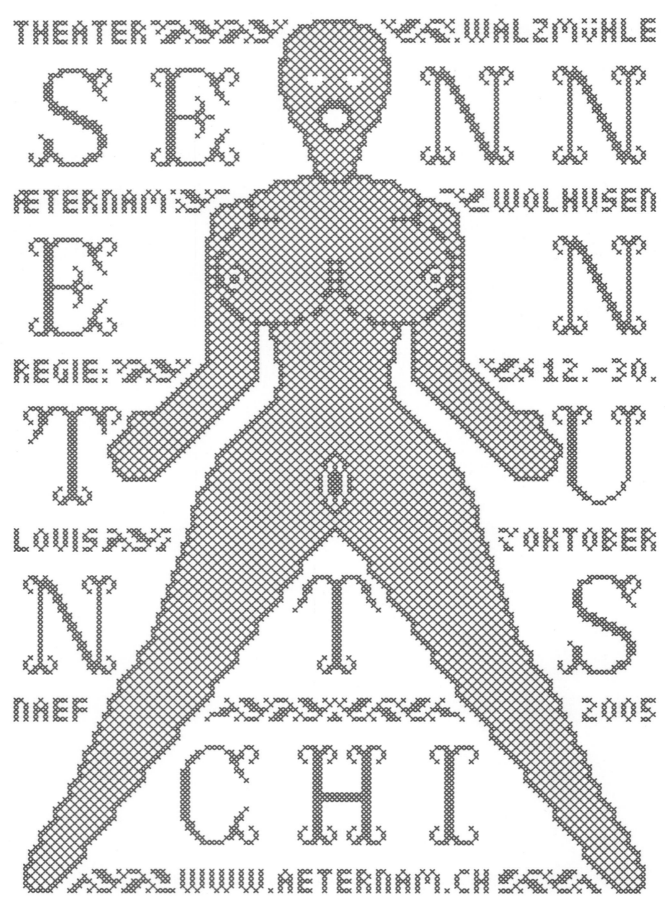

Sennentuntschi/Poster/Screen print/2005

GRAFIK: ERICH BRECHBÜHL [WWW.MIXER.CH] DRUCK: BOSCH SIEBDRUCK STANS

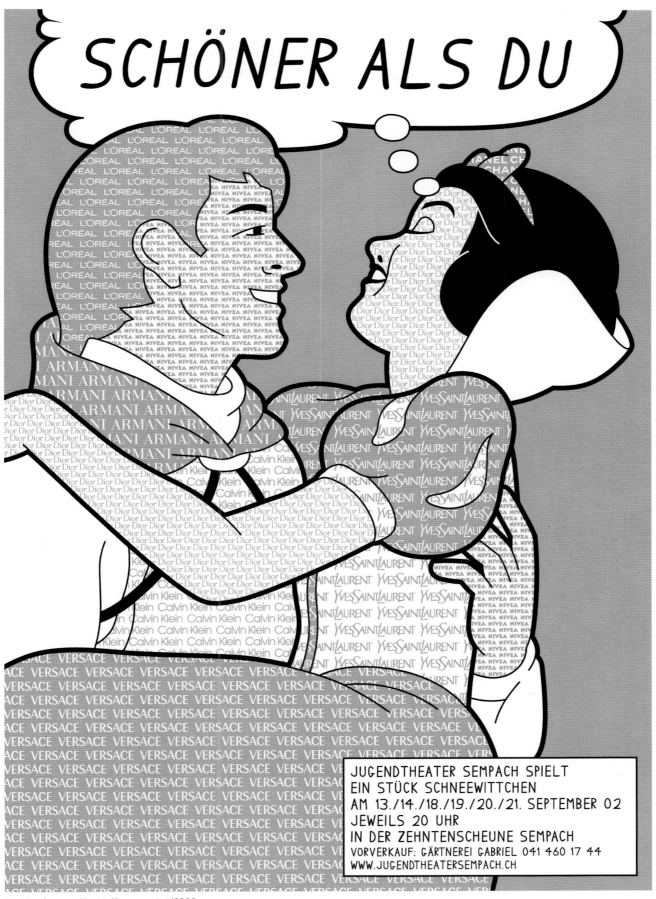

Prettier than you/Poster/Screen print/2002

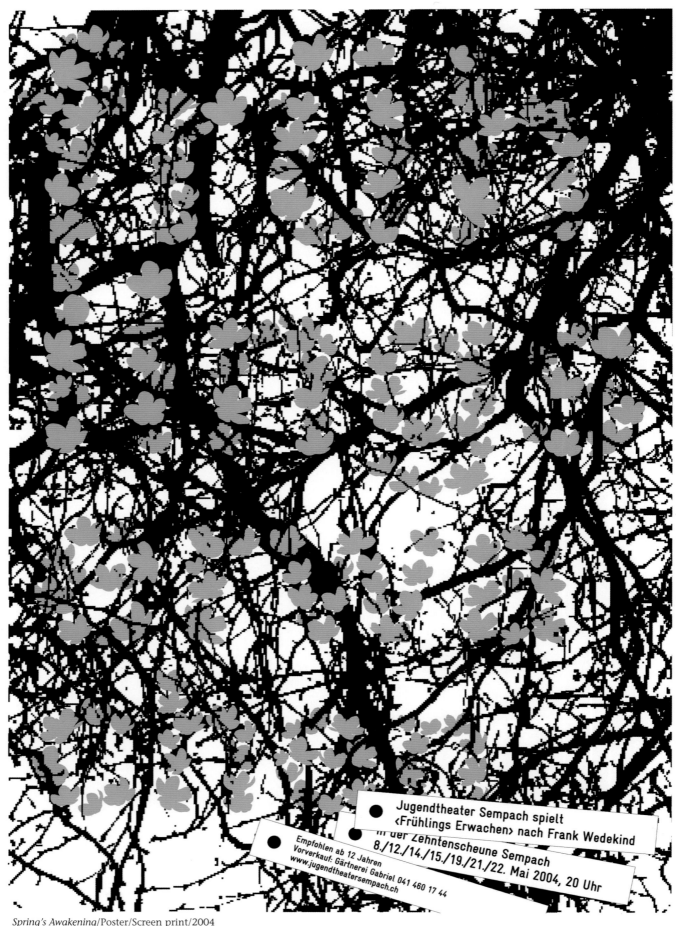

Within the poster image:

Jugendtheater Sempach spielt
‹Frühlings Erwachen› nach Frank Wedekind
in der Zehntenscheune Sempach
8./12./14./15./19./21./22. Mai 2004, 20 Uhr

Empfohlen ab 12 Jahren
Vorverkauf: Gärtnerei Gabriel 041 460 17 44
www.jugendtheatersempach.ch

Spring's Awakening/Poster/Screen print/2004

im Schtei/Poster series/1997-today

Brighton, UK
Venice, Italy
Tehran, Iran
Hong Kong, China
Singapore, Republic of Singapore

Mojoko

Steve Lawler
www.stevelawler.com
steve@stevelawler.com

Birthplace: Tehran, Iran
Residence: Singapore, Republic of Singapore
Connecting cities: Hong Kong, China / Brighton, UK / Venice, Italy

SINGAPORE IS HOME to Steve Lawler. His studio, Mojoko, was founded in 2005 – according to the designer himself – as a personal reaction to the over-excessive use of computers.

Having graduated with a degree in graphic design from Brighton University, in the United Kingdom, he obtained a Fabrica grant in Italy where he worked for two years in the new media department.

Subsequently he developed graphic projects for the fashion industry in Italy until he moved to his current setting.

In his role as creative director, art director, and graphic designer he has worked for important advertising and fashion agencies in Asia, developing commercial as well as experimental projects. He is currently a consultant at Kult, an unconventional agency in

Singapore. In addition, he contributes to the design of publications and teaches workshops and art courses for both children and adults.

He dedicates the majority of his time to design, painting, screen printing, and new media. The rest of his time he spends wandering about and picking up dark pieces of paper from the ground – "one man's waste is another man's painting."

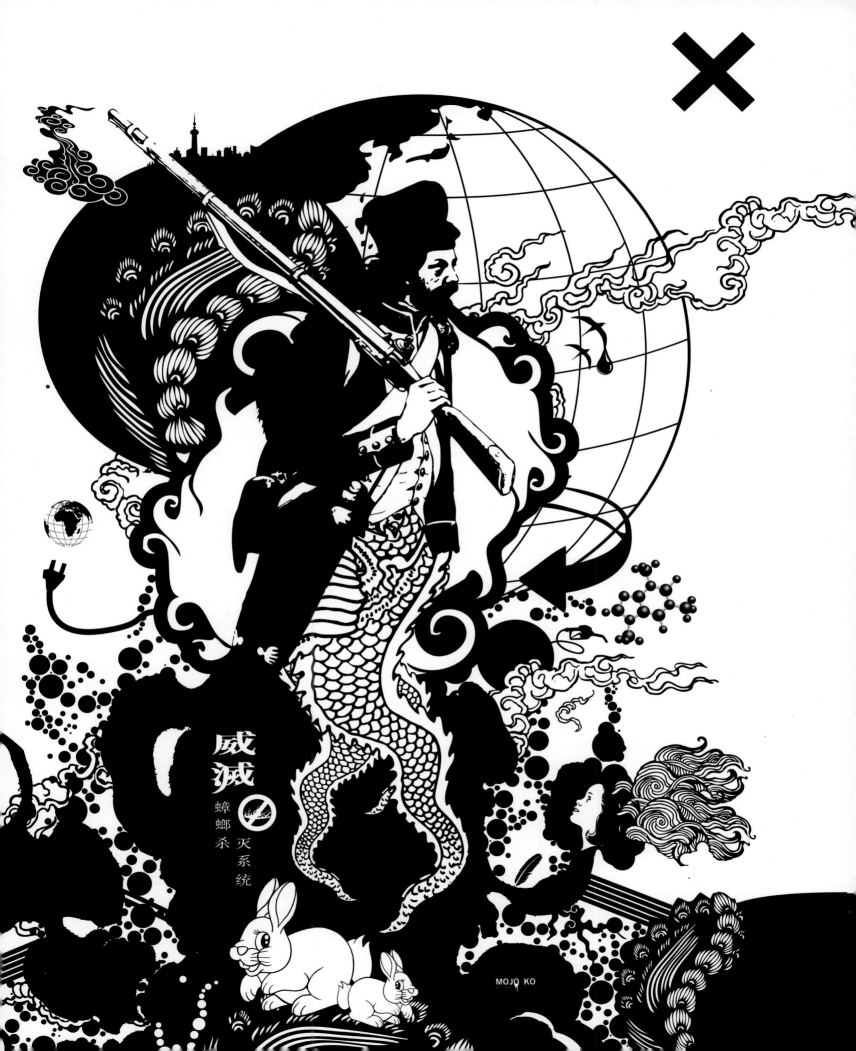

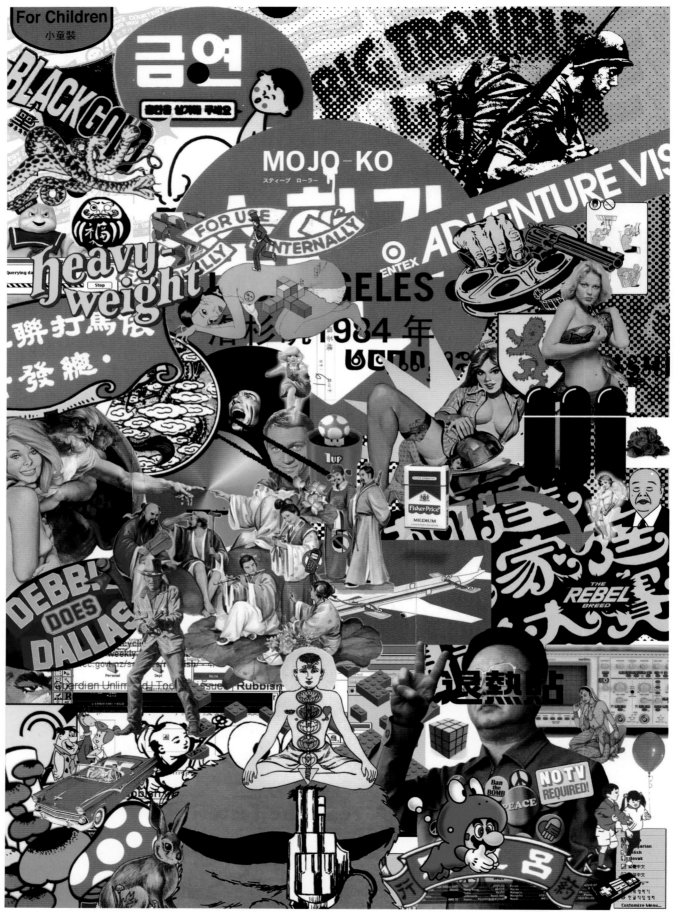

MojokoAsia/Fabric design for Laptop bags/2007

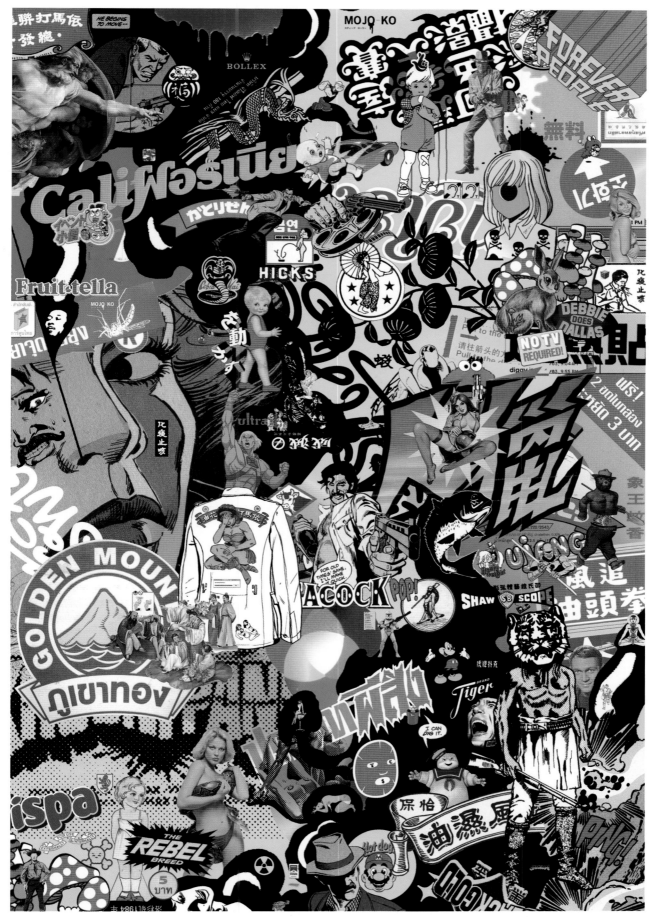

MojokoThai/Digital print/2008

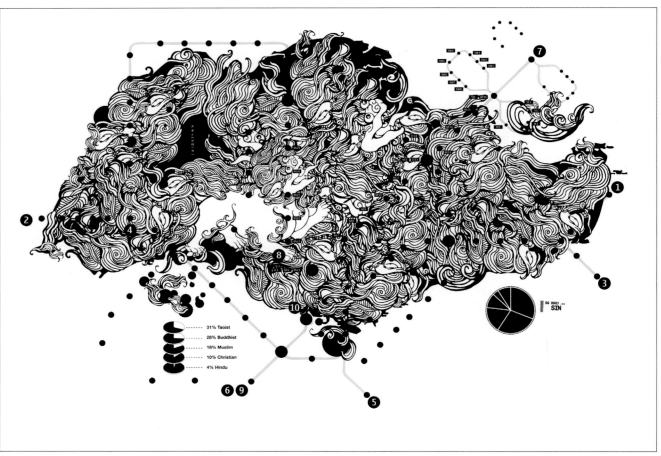

Demographic/Digital/2007

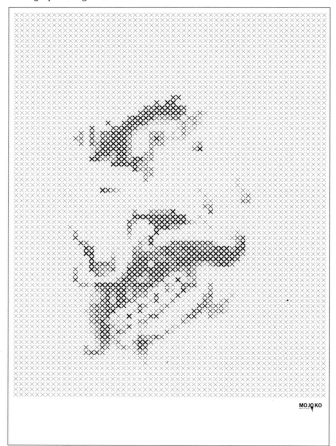

DirtySanchez/Poster/Screen print on canvas/2008

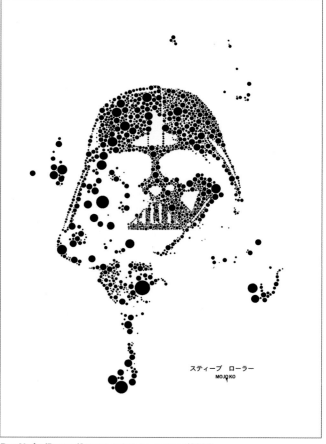

Dot Vader/Poster/Screen print on canvas/2008

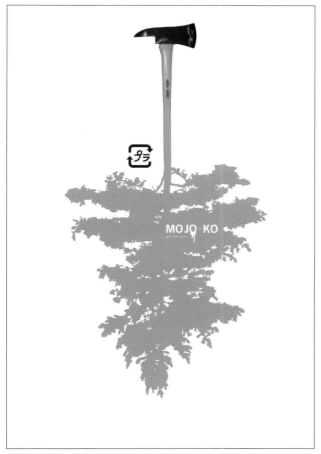

Deforestation/Digital artwork for T-shirt design/2007

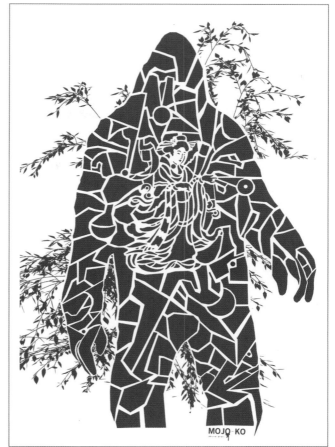

GeishaMonster/Screen print on canvas/2007

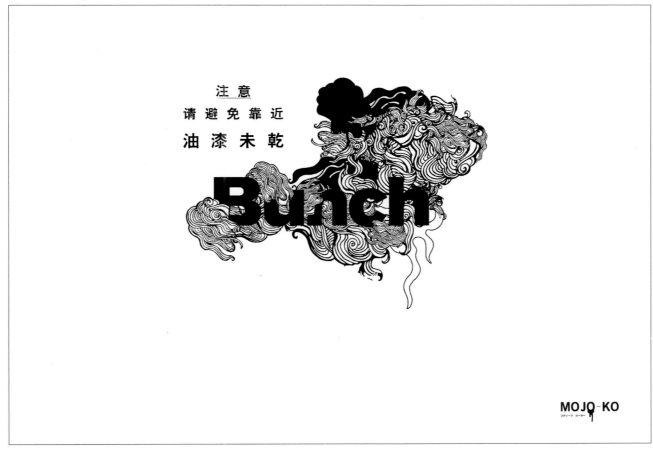

Lawler vs. Bunch/Visual identity/2007

Manchester, UK
Newcastle, UK London, UK (HW)
London, UK
Dortmund, Germany (RD)
Milan, Italy

Multistorey

Rhonda Drakeford and Harry Woodrow
www.multistorey.net
us@multistorey.net

Birthplace: Dortmund, Germany (RD)/London, UK (HW)
Residence: London, UK
Connecting cities: Milan, Italy/Newcastle, UK/Manchester, UK

THIS LONDON-BASED creative group works as much for fashion and industrial design firms as it does for large multinational corporations.

Multistorey has worked on projects of brand, visual identity, art direction, packaging design, exhibitions and events, printed matter, advertising campaigns, and websites. Each assignment is a new challenge for them. In each job they look

for a certain condition and specific solution. It is evident that consistent and functionalist ideas form the basis of all their work.

Rhonda Drakeford and Harry Woodrow are adamant about the importance of design in contemporary society and about the idea that it should never be static. Their work aims to be accessible for all audiences, regardless of the level of visual training. Elitist design is not for

them. Some of their creations have been reviewed in publications such as *Grafik* and the Japanese magazine *+81*.

In addition and increasingly, these designers are moving toward an environmentally sensitive work methodology. They believe that this does not, in any way, detract from creativity and does, actually, make life more interesting.

One Small Step/Corporate identity: letterhead, folder, DVD and case, business cards/2005

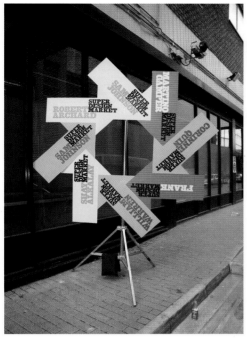
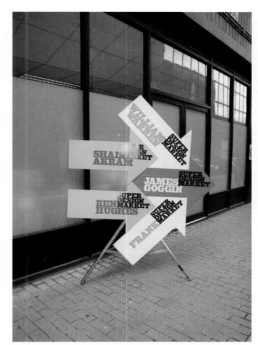
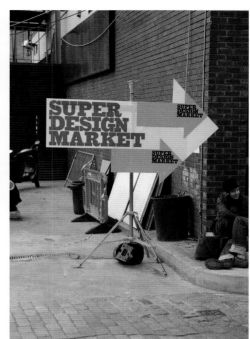

Super Design Market/Exhibition signage/Screen print and vinyl on Correx/2006

Skin+Bones/Exhibition signage/Plastic pins and metallic thread on MDF/2008

New York, USA Rome, Italy Ancona, Italy
 Campobasso, Italy

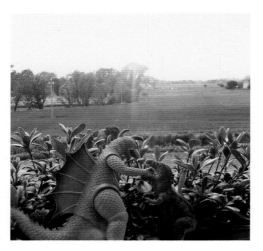

Nazario Graziano

www.ngdesign.it/www.revolverlover.net
me@ngdesign.it

Birthplace: Campobasso, Italy
Residence: Ancona, Italy
Connecting cities: Rome, Italy/New York, USA

DESIGNER NAZARIO GRAZIANO runs NGDesign, a studio specializing in graphic design, illustration, art direction, "...clouds, rain, and rainbows", in the seaport of Ancona in central Italy.

NGDesign has worked with many publications such as *IdN, New York Magazine, Chicago Magazine,* and *Entertainment Weekly,* among others.

The studio's work has been included in the books *Postcards, Musikgraphiks,* and *Spaghetti Grafica* as well as exhibited in shows such as "Attraversamenti" and "This is Rome."

Graziano is founder of the RevolverLover network, a reference website which contains a selection of links to online portfolios. He is also editor of the digital

publication *ANTI,* a magazine made by artists for artists. Created as a thematic series, each edition includes work from different talents from all over the world.

Working with other artists and creating communication networks is the best way to grow, according to this designer, who also believes blogs and free digital magazines are the places to experience the new power of graphics.

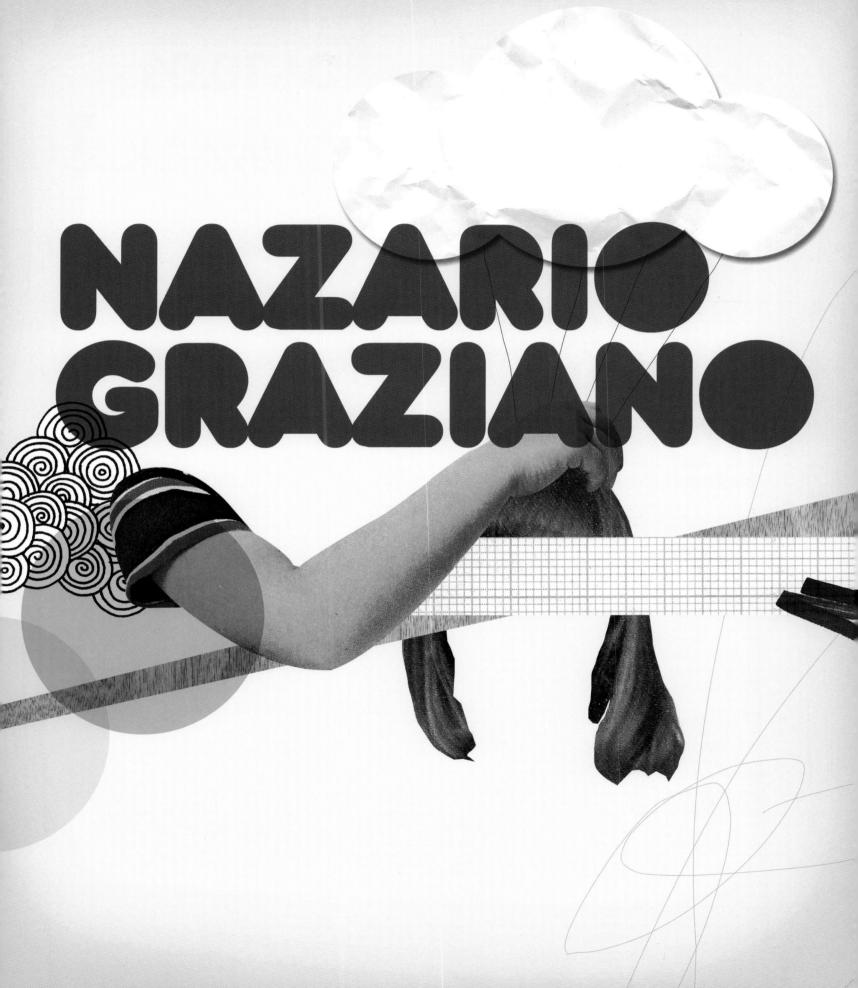

Firewater/Flyers and poster/Art direction/2006-2007

Firewater/Flyers/Art direction/2007-2008

Anticlub/Flyers and poster/Art direction/2007

Cloudhand/Personal project/Print/2007

Toxic.fm/Illustration series for Swiss Radio: Toxic.fm./2007

The Hague, The Netherlands (de Vries)
Paris, France
Barcelona, Spain

Edam-Volendam, The Netherlands (RN)
Amsterdam, The Netherlands
Berlin, Germany

Niessen & de Vries

Richard Niessen and Esther de Vries
www.niessendevries.nl
info@niessendevries.nl

Birthplace: Edam-Volendam, The Netherlands (RN)/The Hague,
The Netherlands (EDV)
Residence: Amsterdam, The Netherlands
Connecting cities: Barcelona, Spain/Berlin, Germany/Paris, France

AMSTERDAM FORMS PART of the great Dutch conurbation of Randstad, one of the largest in Europe. It is here that the studio Nieseen & de Vries, run by the designers Richard Niessen and Esther de Vries, is located. Since 2005 they have developed graphic projects together, specifically for clients in the world of art and culture.

In their work process this creative team favors a close collaboration with their clients and is constantly searching for new ideas that go beyond the simple visual representation. Their methodology involves durability by way of the use of layers instead of one single concept. They also put great emphasis on the selection of materials and printing processes. Their style is characterized by the systematic use of modular elements, which are combined with images and texts displayed in apparent tension.

In addition to her design work, de Vries runs a small publishing house, Uitgeverij Boek, which specializes in the publication of artists' books and art books for children. She has also taught classes in the Real Academy of Art (KABK) in The Hague. Niesson develops his skill as a musician with the band Howtoplays and is a professor at the renowned Gerrit Rietveld Academy in Amsterdam.

 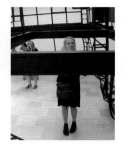

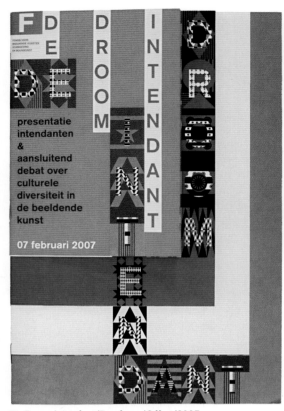
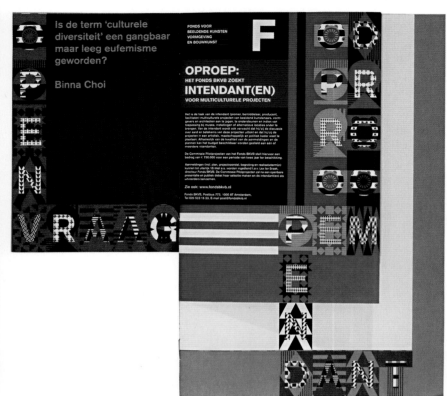

De Droomintendant/Brochure/Offset/2007

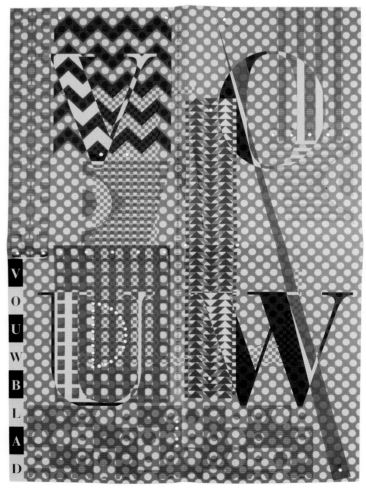

Vouwblad/Promotional poster/Festoon, offset and punching/2007

Intendant Culturele Diversiteit/Letterhead/Offset/2007

Stedelijk Museum Annual Report 2005/Book/Offset/2006

Intendant Culturele Diversiteit/Letterhead/Offset/2007

Stedelijk Museum Annual Report 2005/Book/Offset/2006

Stedelijk Museum Annual Report 2005/Book/Offset/2006

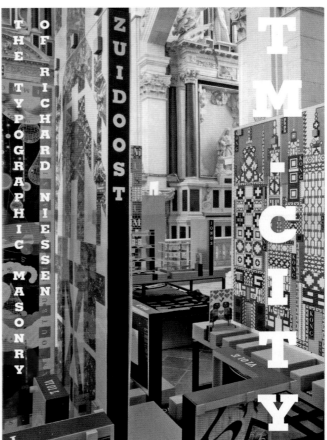

TM-City/Brochure and posters/Offset/2007

Stedelijk Museum New Years Card/Offset/2008

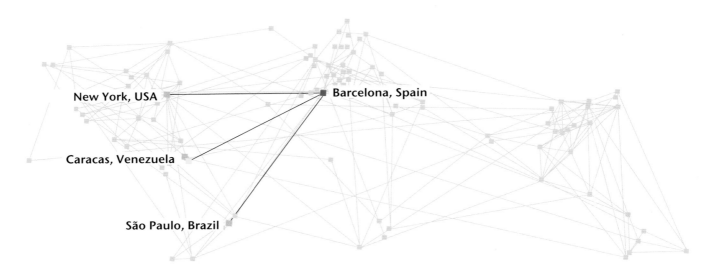

Nodomain

www.no-domain.com
ese@no-domain.com

Birthplace: Caracas, Venezuela
Residence: Barcelona, Spain
Connecting cities: New York, USA / São Paulo, Brazil / Caracas, Venezuela

UNDER THE CREATIVE DIRECTION of visual communicator Joaquín Urbina, the audiovisual and graphic studio Nodomain develop printed and animated projects for important local and international clients. They combine this work with a long list of live visual performances for festivals such as Sónar in Barcelona, Guadalajara, São Paolo, Buenos Aires, and Frankfurt, Sperm in Prague, Bitfim in Hamburg, Mapping in Geneva, DESIGNMAI in Berlin, Full Pull in Malmö, and Número-Projecta in Lisbon, among others.

Their work has been defined as a mix of graphic design and video-art, combined with illustration, animation, and experimentation, blended with advertising and large doses of pop, lo-fi, hi-fi, and improvisation.

Their work has received many distinctions, including the Laus prize given by the Foster in Arts and Design (FAD).

"We all come from a very chaotic city and chaos is a vital part of our creative process. However, within our chaos, each member of the group has his or her own discipline.

"We work on more than two or three projects simultaneously, so we are used to the pressure of deadlines. We establish responsibilities and priorities and we believe in the capacity of each of us to do the work."

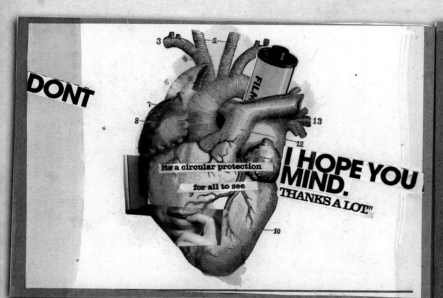

DONT

its a circular protection
for all to see

I HOPE YOU
MIND.
"THANKS A LOT"

TIEMPO

MAESTRO

HIS THING
S TO FUN.

I SENT
IT TO
EVERYONE.

4

the

Women talk
too much on
phone.

say hello to the amphetamine ghost
to show us all

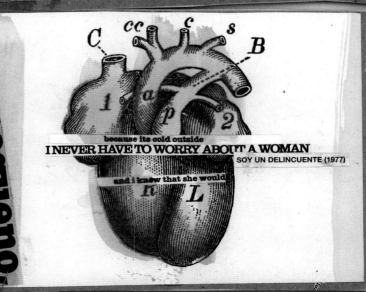

because its cold outside
I NEVER HAVE TO WORRY ABOUT A WOMAN
SOY UN DELINCUENTE (1977)

and i know that she would

Night Of The Brain/Flyer/2007

Espers/Poster/2006

Dntel

Diane

Cluck

Nobody

&

Blank

Blue

Jahbitat

Dimlite

Jueves 6 de septiembre · HORA: **21.00-05.00** · LUGAR: **Sala Becool/Plaza Joan Llongueras 5.** <M> **L5 Hospital Clínic**
BUS: **N0, N12, 6, 7, 15, 32, 33, 34 , 63, 67, 68** · ENTRADA: **15 euros/10 euros after 02.00.** ➤ ___ INFO: lovelyskyboat.com

Dublab/Poster/2006

Cafe Neon/CD cover/2007

The Never Engine, Cristian Vogel/CD cover/2007

Narvik, Norway (Ekhorn)

Oslo, Norway (Ekhorn)

Bath, UK (Forss) · London, UK (Ekhorn)

Pinvin, UK (Forss)

Saint Paul, Minn., USA (Forss)

Non-Format

Kjell Ekhorn and Jon Forss
www.non-format.com
info@non-format.com

Birthplace: Narvik, Norway (KE)/Pinvin, UK (JF)
Residence: London, UK (KE)/Saint Paul, USA (JF)
Connecting cities: Oslo, Norway; London, UK (KE)/Bath,
UK; London, UK; Saint Paul, Minnesota, USA (JF)

NON-FORMAT IS THE STUDIO run by the designers Kjell Ekhorn and Jon Forss with bases in London and St. Paul. They began working together in 1999 designing art for albums. This creative team works on diverse projects, which include art direction and design and illustration for clients in the industries of music, art, fashion, and advertising.

The graphic work of Non-Format has been selected to feature in various publications and has been reviewed in many specialist magazines such as *Creative Review*, *Dazed & Confused*, *Grafik*, *No*, *IdN*, and *Shift*.

In 2007, Die Gestalten Verlag published their monographic book titled *Non-Format Love Song*. The publishing house Pyramid also published an edition in 2006 as part of the Design and Designer series. They are responsible for the redesign and the

art direction of the British magazine *The Wire* as well as being directors of *Varoom*, a periodical specialist publication on illustration and images.

The studio is highly recognized and has received many distinctions from prestigious organizations such as the D&AD, Creative Review Annual, New York Art Directors Club, and the Tokyo Type Directors Club, among others.

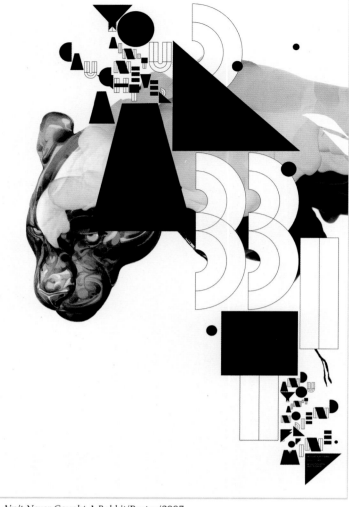

Mega Breakfast, The Chap/Poster/2008

You Ain't Never Caught A Rabbit/Poster/2007

LoAF/Music packaging/2006-2008

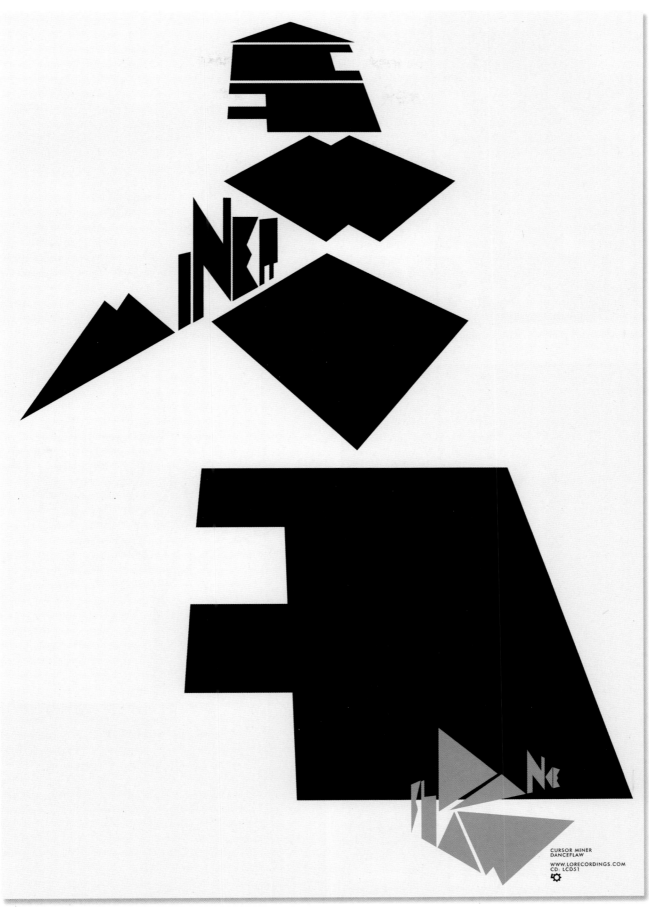

Danceflaw, Cursor Miner/Poster/2006

Hanne Hukkelberg Rykestrasse 68/Music packaging/2006

Prism 1, Stateless/Music packaging/2007

Curiosity, The Economist/Press & billboard advertising/2007

Balance, The Economist/Press & billboard advertising/2008

Bloodstream, Stateless/Music packaging/2007

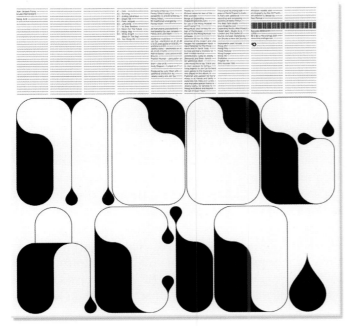

Moog Acid/Music packaging/2007

Oded Ezer

www.odedezer.com
oded@odedezer.com

Birthplace: Tel Aviv, Israel
Residence: Tel Aviv, Israel
Connecting cities: Tel Aviv, Israel/New York, USA/Istanbul, Turkey

ODED EZER WAS BORN IN 1972 and studied visual communication at Bezalel Academy of Art and Design in Jerusalem and at Middlesex University in the United Kingdom, specializing in the typographic aspects of the design of brands and publications.

He is a typography and graphic design professor at the Ramat Gan School of Design and Engineering and at the WIZO design school in Israel. His posters and graphic work have been exhibited and published around the world. He has also received numerous international distinctions from institutions such as the Nagoya Center of Design in Japan, the Type Directors Club of New York, and the Ningbo International Poster Biennale in China, as well as many others. His work forms part of the collections at the Israeli Art Museum, the Museum für Kunst und Gewerbe in Hamburg, and the Museum für Gestaltung in Zurich.

In addition to his commercial work, he also develops experimental artistic projects with typography exploring new forms of communication with characters in Hebrew. These include The Finger project, an imaginary landscape created with letters in Hebrew, and the Now project – in homage to the work of the Israeli visual communicator David Tartakover. He views his creation in terms of "meditation" rather than work.

טיפוגרפיה עברית עכשווית מושפעת משני מקורות

מהכתב העברי לאורך ההיסטוריה // ומצורות הכתבים הלועזיים

מדוע לא להוסיף מקורות השראה נוספים

פניה לשדות אחרים // העתקת העקרונות שלהם לשדה העיצוב הטיפוגרפי // תביא ליצירת צורות חדשות בתחום זה.

Plastica/Poster/B/W process printing/2001

Unimportant & Nothing/Poster/Photograph: Shaxaf Haber/2004

Typography/Poster/B/W process printing/2004

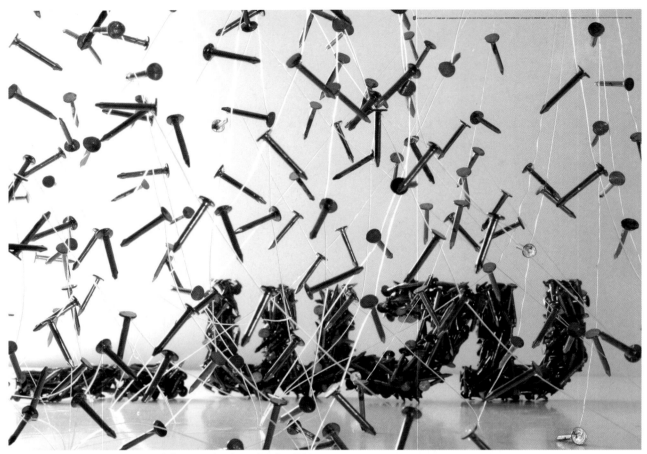

Now/Poster/B/W process printing/Photograph: Shaxaf Haber/2004

The Message/Poster/B/W process printing/2001

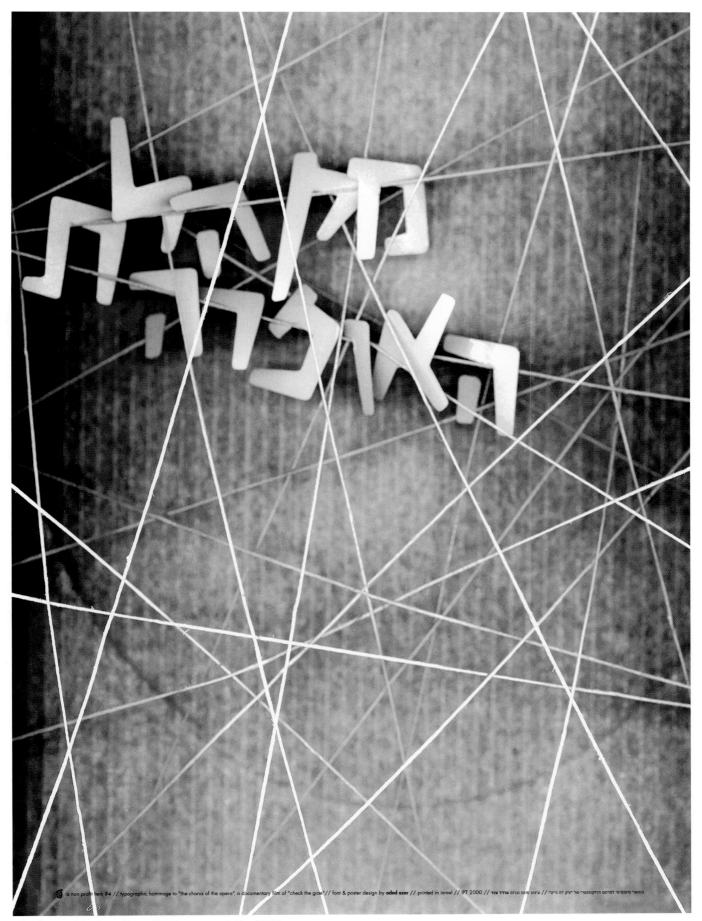

The Chorus of the Opera/Poster/B/W process printing/2000

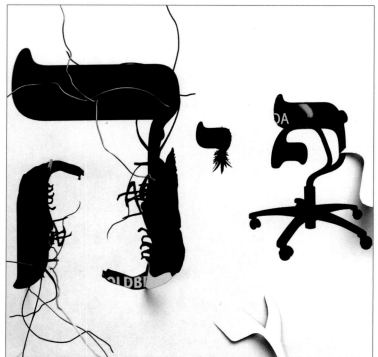

Tybrid/Poster/4 square pannels 1.64x1.64 ft./B/W process printing/2007

Alef/Poster/B/W process printing/2003

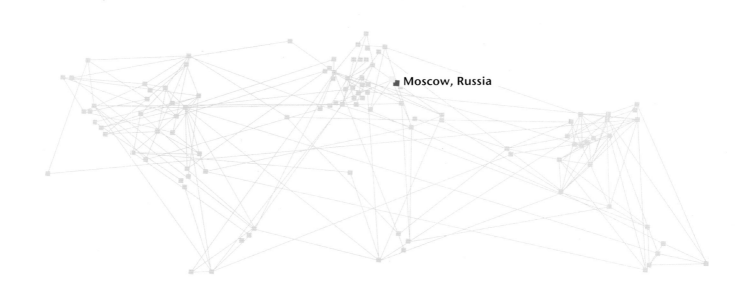

Moscow, Russia

OSTENGRUPPE

Igor Gurovich, Anna Naumova, Eric Beloussov and Dmitry Kavko
www.ostengruppe.com
if@ostengruppe.com

Birthplace: Moscow, Russia
Residence: Moscow, Russia

OSTENGRUPPE IS THE design studio founded by Eric Beloussov, Igor Gurovich, and Anna Naumova in 2001. In 2003, designer Dmitry Kavko joined the team.

The studio develops their work with inspiration drawn from modern functionalist design, undertaking projects of a diverse nature – graphics, television, projects for Internet, video, interior design, furniture design, fashion design, and set design for events. Many of the posters designed by this creative studio have been selected for participation in the Toyama International Poster Triennial, the Brno, Warsaw and Mexico City International Poster Biennales, and the Chaumont International Poster and Graphic Arts Festival. They have received various prizes at international competitions and their work has been published in books such as *Moscow Style*, *The Anatomy of Design*, and *All Men are Brothers*, among others.

OSTENGRUPPE's team has also edited, designed, and published books which include *Golden Bee* for the 7th Moscow International Poster Biennale and *Ein, zwei, drei*, a book which presents a series of posters created by different members of the studio. The group also participates frequently in local and international exhibitions and is invited to give talks and conferences on their work in Russia and abroad.

X+1 Fortepiano concerts/Poster/Design: Eric Belooussov/2007

Artists of game cinema/Poster/Design: Igor Gurovich/2008

We don't play in TV-box/Poster/Design: Anna Naumova/2008

Fiesta/Poster/Design: Eric Belooussov/2008

Russian, German Multimedia Festival/Poster/Design: Igor Gurovich/2008

Deep throat, Voice Festival/Poster/Design: Eric Belooussov/2007

Vladimir Martynov works Festival/Poster/Design: Anna Naumova/2008

White square/Poster/Design: Igor Gurovich/2008

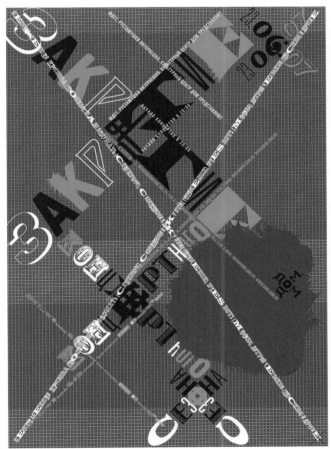

Concert season closing/Poster/Design: Dmitry Kavko/2007

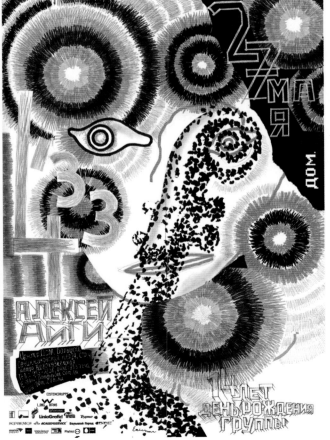

4'33 Band/Poster/Design: Eric Belooussov/2008

London, UK
Copenhagen, Denmark
Berlin, Germany
Szeged, Hungary (Benyi)

Santiago de Chile, Chile (Aguilera)

Melbourne, Australia

Pandarosa

Ariel Aguilera and Andrea Benyi
www.pandarosa.net
info@pandarosa.net

Birthplace: Santiago de Chile, Chile (AA)/Szeged, Hungary (AB)
Residence: Berlin, Germany
Connecting cities: Melbourne, Australia/London, UK/Copenhagen, Denmark

PANDAROSA HAS ITS BASE in Berlin and is formed by the designers, Ariel Aguilera and Andrea Benyi – a duo who began working together in Melbourne, Australia, creating graphics and illustrations for clients from the music and art industries, for the most part.

Their work involves graphic projects, exhibitions, installations, projections, short films, webpages, animations, and interior design. Their projects have

been reviewed in specialist magazines including *Artichoke*, *Grafik*, *Tokion*, and *Frame*. They have also been invited to participate in publications such as *Hidden Track*, *Graphics Alive*, and *Dotmov 2004*. Several of their animation projects have been exhibited at international festivals such as DOTMOV, Japan, Onedotzero, United Kingdom, AMODA, United States Contrast, France, and The Krakow Film Festival, Poland.

They participate frequently in shows and exhibitions in galleries and art spaces, in their role as artists and curators. In this way, they believe they are able to demonstrate the possibility of a co-existence between art and design.

First and foremost the duo develops their ideas and emotions regarding each project. Their aim is to stimulate the imagination rather than just describe visually. Akin to imagination itself, they do not follow trends, but construct images with a purposely random effect.

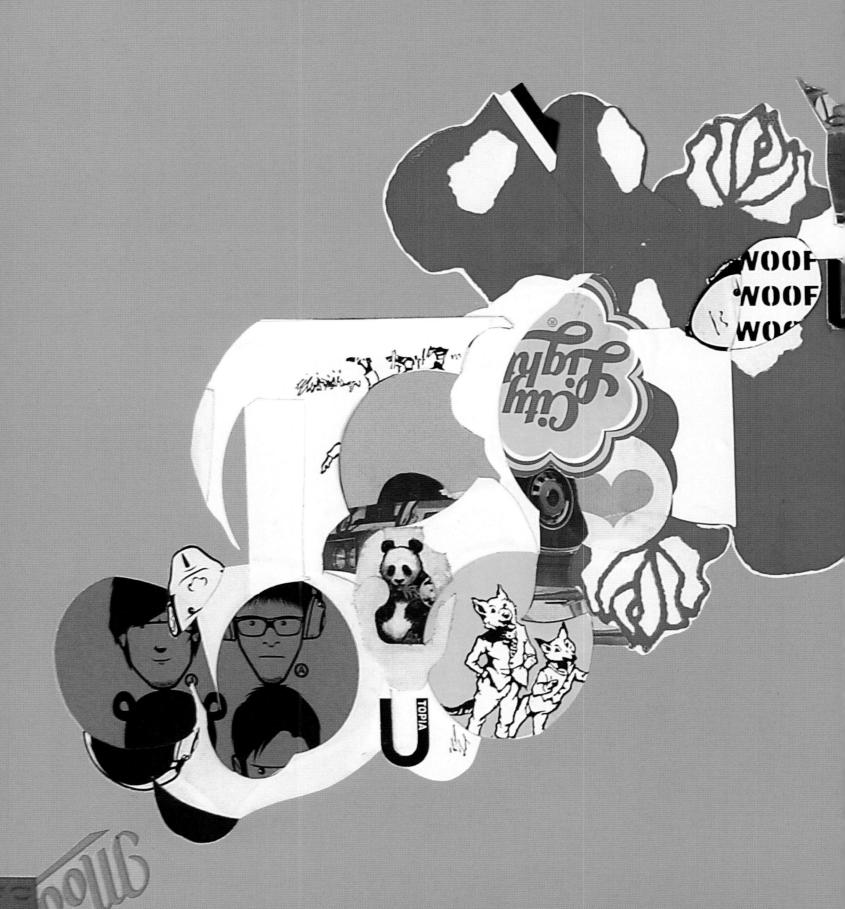

The Brown Kids would stay down there, eating those mysterious grapes from the Secret Vine and telling tales, until they heard Father Brown's truck heading back up the road. Then they would gather their things and rush back over the bridge, up the big hill, past the vines and by the lake back home.

KYN wines/Illustration, label design, playing card set & "Golden" book/2007

KYN wines/Illustration, label design, playing card set & "Golden" book/2007

KYN wines/Illustration, label design, playing card set & "Golden" book/2007

The world of two nocturnal pandas/Exhibition invitation/2008

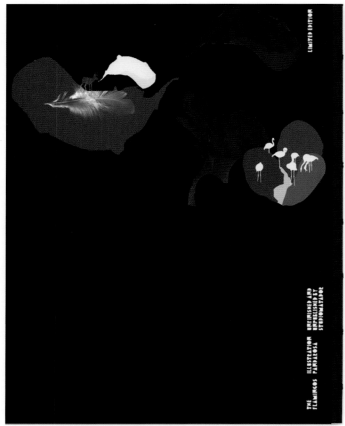

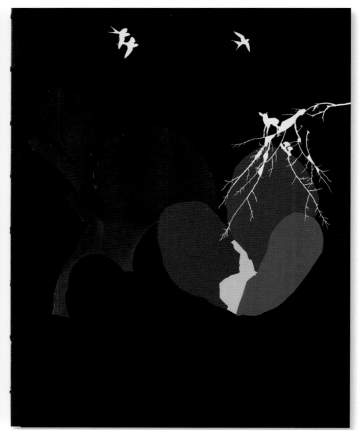

The Flamingos/Illustration/2008

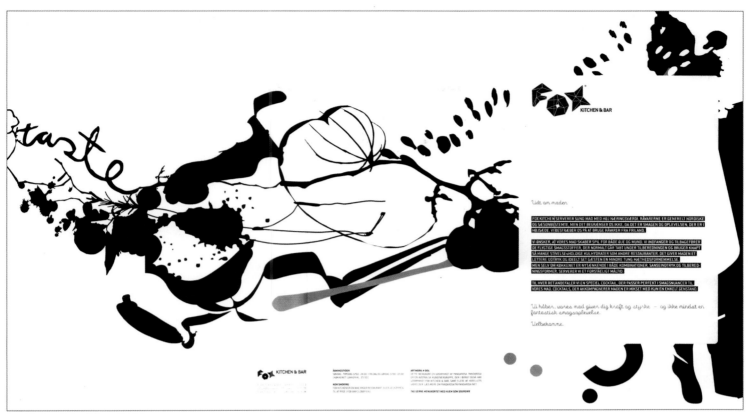

Fox Kitchen & Bar/Menu/2006

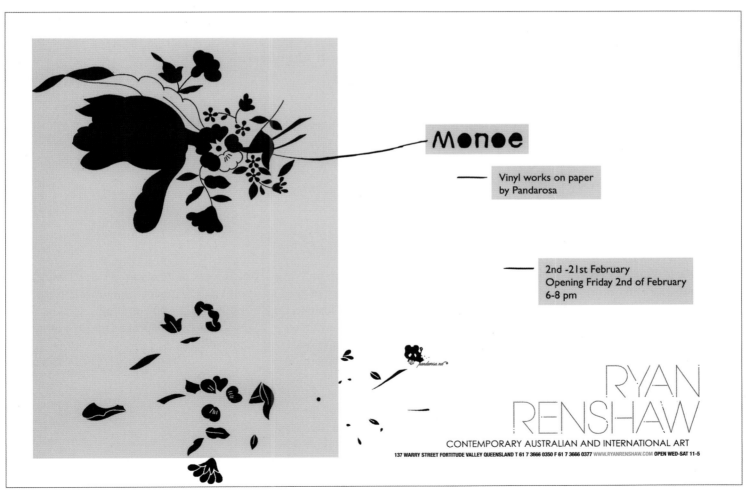

Monoe/Exhibition invitation/2007

Amsterdam, The Netherlands
Göttingen, Germany (Niessler)
Frankfurt, Germany
Berlin, Germany
Hanau, Germany (Altenbrandt)
Tokyo, Japan

Pixelgarten

Adrian Niessler and Catrin Altenbrandt
www.pixelgarten.de
hallo@pixelgarten.de

Birthplace: Göttingen, Germany (AN)/Hanau, Germany (CA)
Residence: Frankfurt, Germany
Connecting cities: Berlin, Germany/Amsterdam, The Netherlands/Tokyo, Japan

THE MULTIDISCIPLINARY space headed by Adrian Niessler and Catrin Altenbrandt in Frankfurt is not a classic design studio – it is more unconventional and fun.

Both designers graduated from the Offenbach University Art School and their projects are often on the cusp of design and fine art. Going beyond these limits is vital for them in order to generate ideas and find new avenues for visual communication.

They specialize in art direction and illustration but also develop projects of installation, animation, and fashion and are set for new challenges. They enjoy combining analogue techniques and digital techniques to create something new and different.

Books such as *Young German Design*, *Tactile*, *Lemon Poppy Seed*, and *Data Flow* have featured their work and their work has also been reviewed in magazines such as *Shift*, *Computer Arts China*, and *Wired*.

The work of Pixelgarten can be found in all kinds of media, from a wall in Berlin built from 1,500 light bulbs, to classic black and white posters for an editorial project.

Um was es nicht geht/Photography, installation/2006

Um was es nicht geht/Photography, installation/2006

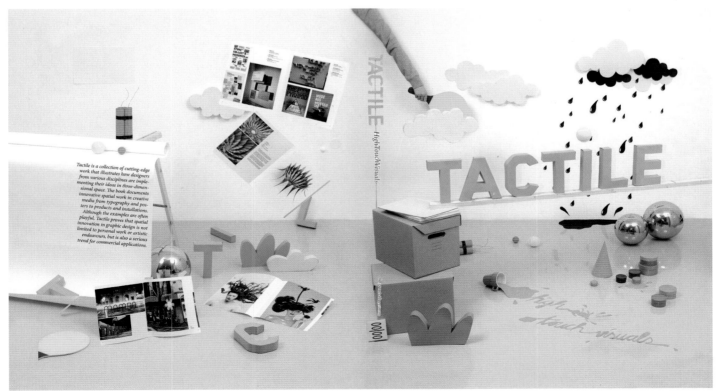

Tactile/Book cover/2007

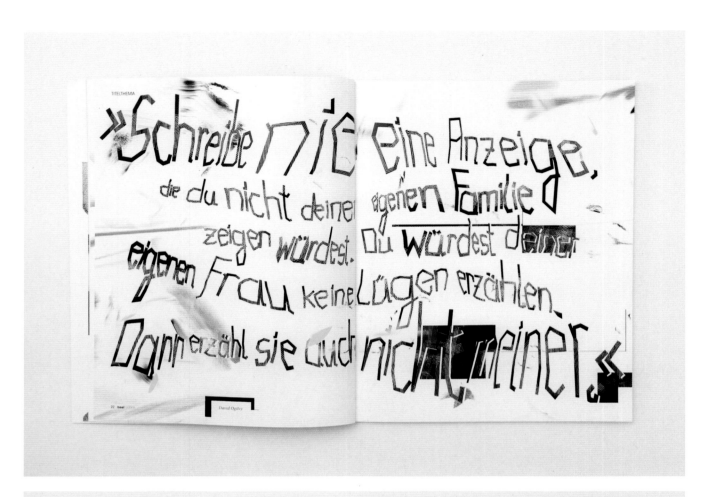

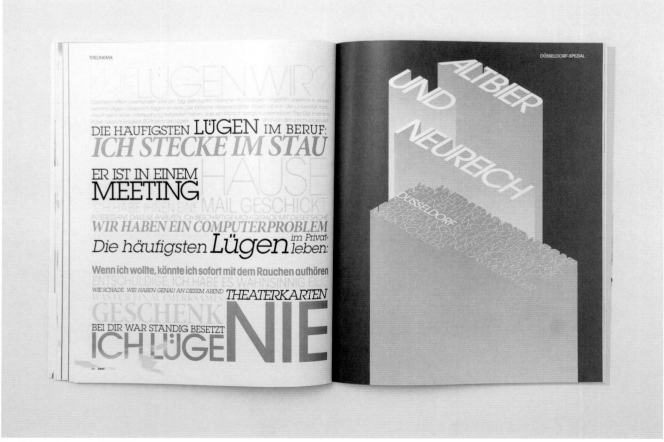

Beef/Magazine spreads/2007

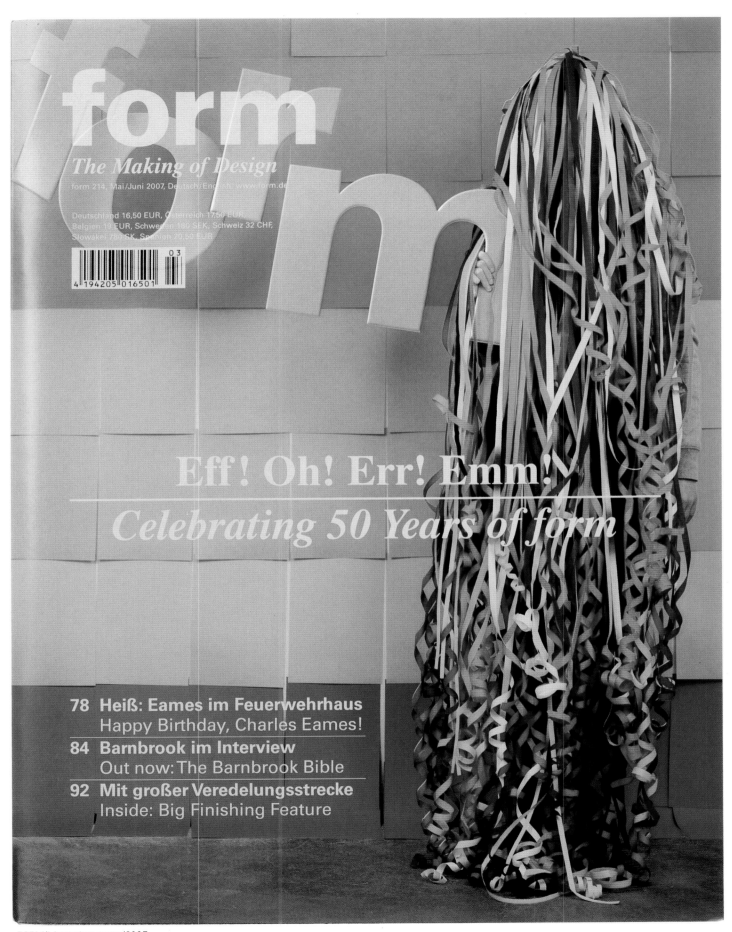

FORM/Magazine cover/2007

FORM/Magazine illustration/2007

Money/Beef magazine illustrations/Still life photography/2008

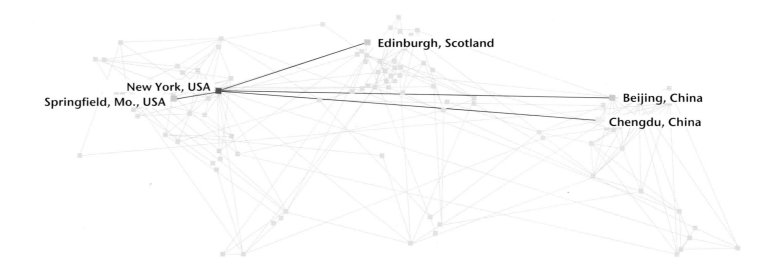

Qian Qian

www.q2design.com
q2design@gmail.com

Birthplace: Chengdu, China
Residence: New York, USA
Connecting cities: Beijing, China/Edinburgh, Scotland/Springfield,
Missouri, USA

QIAN QIAN IS A Chinese multidisciplinary artist, designer, illustrator, and art director. He graduated with a degree in design for digital media from the University of Edinburgh in Scotland and today he lives and works in New York.

His work stands out due to the strong mix of influences resulting from his personal career, whereby he combines and reinterprets his own experiences.

During the creative process he uses graphic design tools to produce the structure and composition of the project and then develops his personal expression through illustration.

In 2005, he organized the exhibition Get It Louder, a large-scale event in China. Considered among the "20 under 30 New Visual Artists" by *Print* magazine, his work has been reviewed and exhibited in

important institutions such as the Victoria & Albert Museum in London and the Lincoln Center in New York.

Qian currently works independently developing his personal projects, as well as working for advertising agencies, although in the future he plans to open his own studio. For this designer, style is nothing more than a viewpoint that moulds itself to each project and moment.

Shadow Play Is Fun!/Poster/2006

Nanxiang Steam Bun/Poster/2006

Shiseido/Illustration/2004.

The Current Group/Poster/2006

Nike Air Riders/Print advertisement/2006

Happy Ending/Illustration/2005

MaoMao/Illustration/2006

FlyingV Boy/Poster/2007

One Show Interactive/Animation/2007

Space Badminton/Illustration/2007

New York, USA
New York, USA (Redman)

Berlin, Germany (R.Alexander, S. Alexander)

Ipswich, Australia Brisbane, Australia
Ipswich (S. Alexander)/ Brisbane (R.Alexander), Australia (Clifford)
Gold Coast, Australia (Maier) Melbourne,
Maffra, Australia (Clifford) Australia (Maier)
Gloucester,
Australia (Redman)

Rinzen

Steve Alexander, Rilla Alexander, Adrian Clifford, Karl Maier and Craig Redman
www.rinzen.com
they@rinzen.com

Birthplace: Ipswich, Australia (SA)/Brisbane, Australia (RA)/Maffra, Australia (AC)/
Gold Coast, Australia (KM)/Gloucester, Australia (CR)
Residence: Berlin, Germany (RA, SA)/Brisbane, Australia (AC)/New York, USA
(CR)/Melbourne, Australia (KM)
Connecting cities: Brisbane, Australia/Berlin, Germany/New York, USA

FIVE MEMBERS, four towns of residence, and three continents: Rinzen has made a name for itself as a result of the special way in which this globally dispersed art and design group works together – from Brisbane to Melbourne and from Berlin to New York.

The studio evolved in the year 2000 as a result of the audio visual remix project RMX, a kind of "exquisite corpse" of a surrealist style, whereby each participant intervenes in the piece before passing it

onto the next player. In their own words: Rinzen is a synonym of play, not work. In 2001, they produced a monographic book published by Die Gestalten Verlag and their projects have been reviewed in international publications such as *Nylon, Relax Magazine,* and *Tokion.*

Their daring, spontaneous work has been exhibited from Mexico to Tokyo, including an exhibition of their posters and album art at the Louvre Museum in Paris and the design of a series of characters for the

Prado Museum in Madrid. They have also created visuals for important electronic music events. Their designs can be found as easily in wallpaper and textiles as on bicycles and toys.

Despite the strong international influences in its work, Rinzen is greatly inspired by the so-called "Australian attitude" – presenting what makes the Australian culture prominent within a contemporary global context.

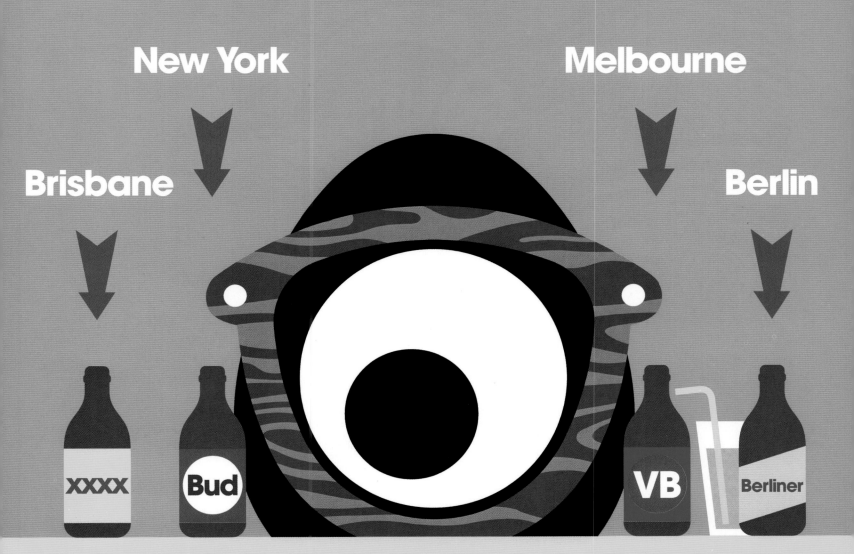

Rinzen/Poster/Screen print/2007

50 Exhibition/Poster/2007

Solar Powered/Posters/Screen prints/2007

BUNJI GARLIN CLAUDE VONSTROKE BOYZ NOISE STRICTLY KEV GRUFF RHYS COMMIX

XLR8R

ACCELERATING M

113
DECEMBER
2007

SWITCH SWITCH SWITCH

SWITCH SWITCH

SWITCH TOPS OUR LIST
OF THE YEAR'S BEST MUSIC, ART, AND CULTURE.

$4.99 US $6.99 CANADA WWW.XLR8R.COM 07

XLR8R/Magazine cover/2007

In the Milky Night/Poster/Wallpaper/2006

Kon/Illustration/2006

In the Milky Night/Poster/Ink on Paper/2006

In the Milky Night/Poster/Digital Print on Canvas/2006

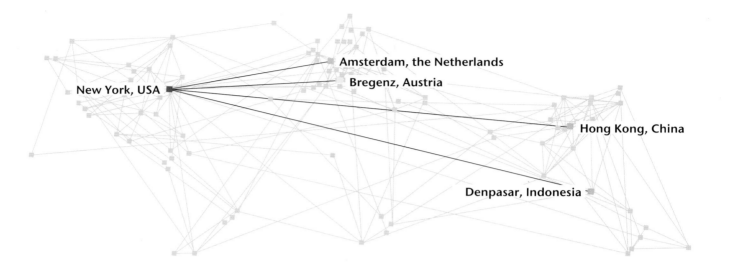

Amsterdam, the Netherlands
Bregenz, Austria
New York, USA
Hong Kong, China
Denpasar, Indonesia

Sagmeister Inc.

Stefan Sagmeister
www.sagmeister.com
info@sagmeister.com

Birthplace: Bregenz, Austria
Residence: New York, USA
Connecting cities: Hong Kong, China/Denpasar, Indonesia/Amsterdam, the
Netherlands.

NEW YORK CITY, the world's third largest urban expanse after Tokyo and Mexico City, is where the renowned designer and art director Stefan Sagmeister has his studio – a creative space that he runs with his business partner, designer Matthias Ernstberger.

Specializing in the development of graphic projects for the commercial, music, and advertising industries, his visuals for figures such as the Rolling Stones, Talking Heads, and Lou Reed are emblematic in contemporary design. He also actively participates in projects of a social nature such as the "True Majority" initiative, a collective of five hundred artists and business people who were against the war in Iraq and who suggested a reduction in military spending and greater investment in education.

Born in Austria in 1962, Sagmeister studied applied arts at Vienna University and went on to earn a master's degree at the Pratt Institute in New York, having obtained the Fulbright grant. His work has been recognized with prizes and distinctions in many international design competitions and has been exhibited in cities such as Zurich, Vienna, New York, Berlin, Tokyo, Osaka, Prague, Cologne, and Seoul. He is also an outstanding lecturer at an international level.

Through his work he explores new ways of portraying ideas. He also experiments with many techniques and materials, where content is always more important than style. His design work is provocative and emotionally strong, thus reaching out to the hearts of his audience.

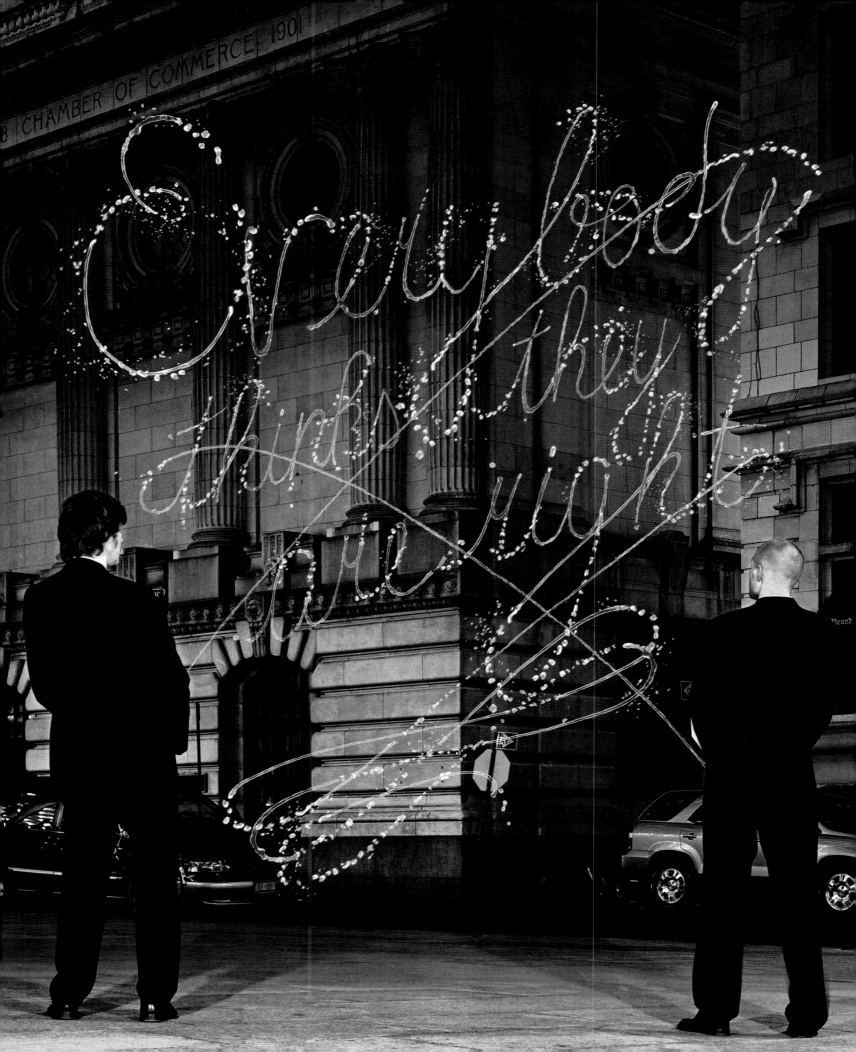

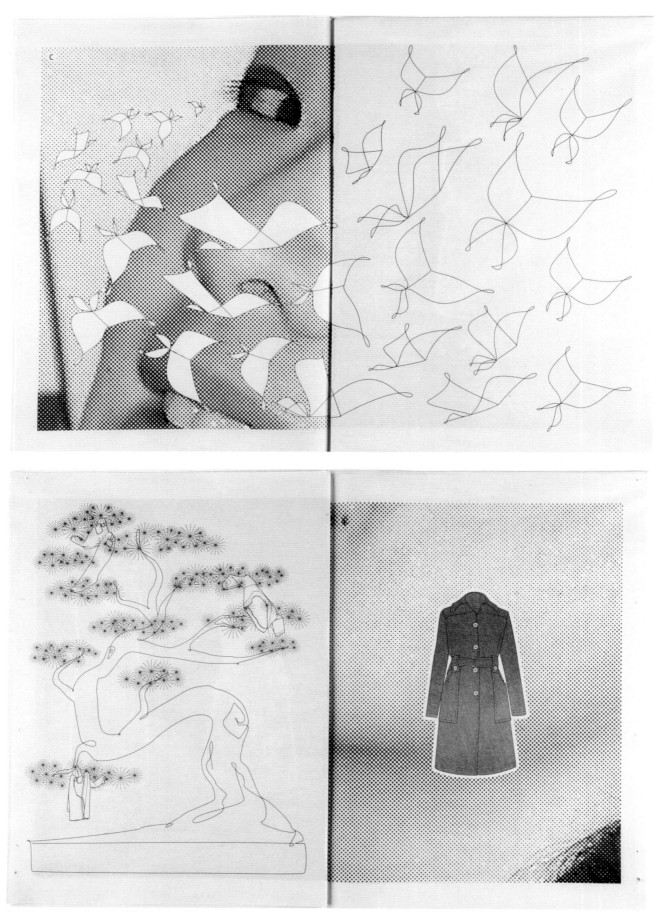

Anni Kuan Spring-Summer 2005/Mailer/Creative director: Stefan Sagmeister; design and illustration: Richard The/2005

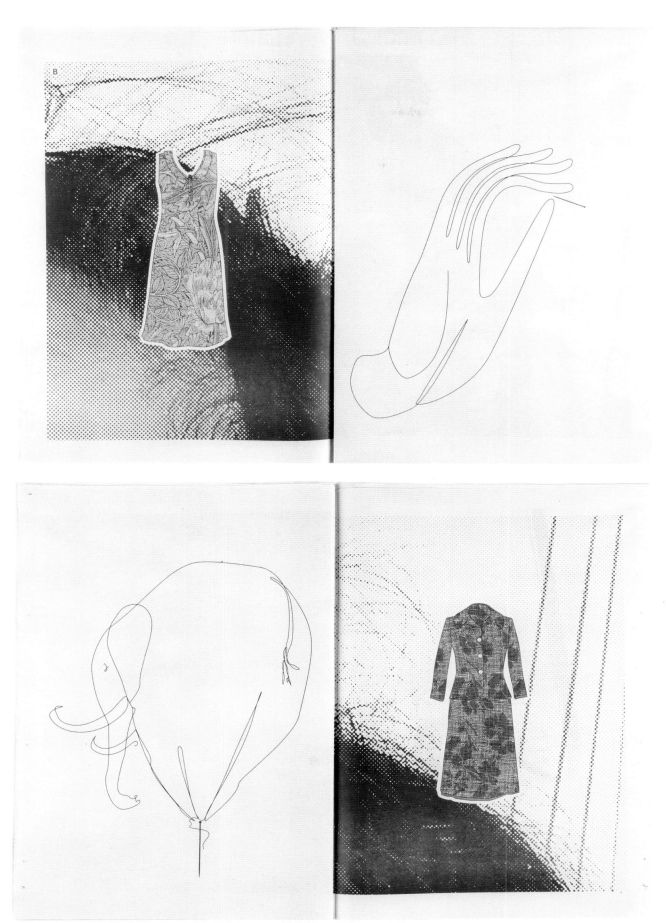

Anni Kuan Spring-Summer 2005/Mailer/Creative director: Stefan Sagmeister; design and illustration: Richard The/2005

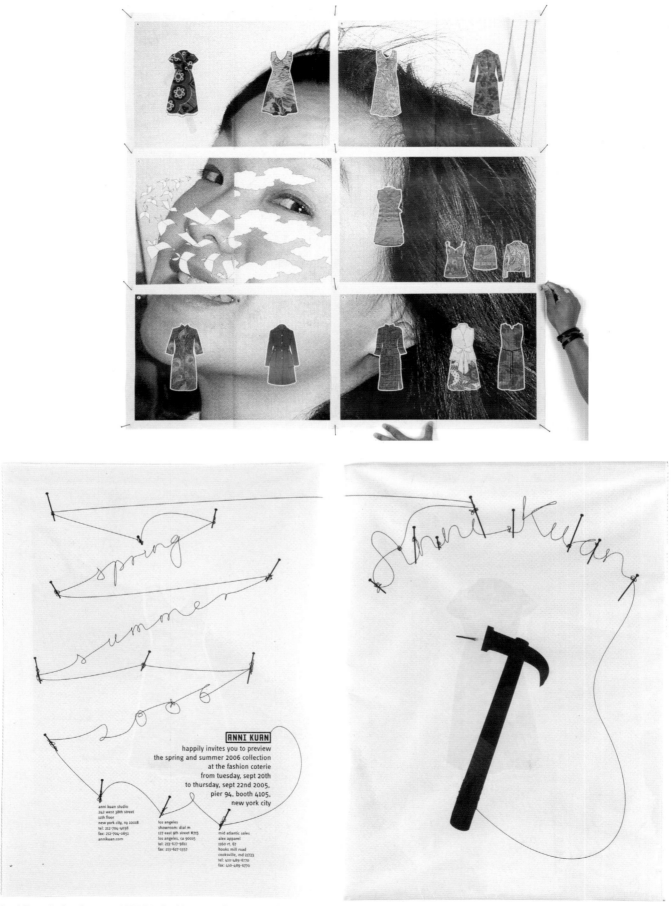

Anni Kuan Spring-Summer 2005/Mailer/Creative director: Stefan Sagmeister; design and illustration: Richard The/2005

Complaining is silly. Either act or forget/Photogram on newsprint paper/Design: Stefan Sagmeister; typography: Matthias Ernstberger, Richard The/2005

Things I have learned in my life so far/Book/2008

Worldchanging. A user's guide for the 21st century/Book/Printed on recycled paper, the book cover yellows over time, allowing the sun to imprint the cover through the die-cut holes of the slipcase/Art direction: Stefan Sagmeister; design: Matthias Ernstberger, Roy Rub/2006

San Francisco, USA

New York, USA

Berlin, Germany
Boulogne-Billancourt, France

Slang

Nathanaël Hamon
www.slanginternational.org
nat@slanginternational.org

Birthplace: Boulogne-Billancourt, France
Residence: Berlin, Germany
Connecting cities: New York, USA / San Francisco, USA

NATHANAËL HAMON IS SLANG. He was born in France, grew up in the United States, and has been living in Berlin since 2000. After graduating with a degree in art history, he worked as art director in advertising, and since 2006 has run his own studio independently. His work includes posters, books, typography, illustration, and album art and recordings.

His creations have been included in various publications such as *Best of Disc Art, Crack: World New Graphic Design*

2007/2008, Logo Design, and *Tres Logos*, among others, and has been reviewed in magazines such as *Lodown Magazine, I/O*, and *Creative Review*. In 2006, he received the Silver Award from ADC Germany for the design of the book *Heimspiel*.

The choice of the word "Slang" is no mere coincidence. According to the designer, this word shares common characteristics with his style of graphic design: freshness, sensibility, a fun element, and the constant reinvention of itself. For Hamon,

"Slang" refers to an informal language that is experienced, felt, and very much a part of life for certain groups of people.

This interest in issues of communities and minorities has led the artist to develop, as a personal project, a series called "Coexistence." He uses flags as graphic elements to encourage reflection on concepts such as cohabitation, tolerance, commitment, and identity.

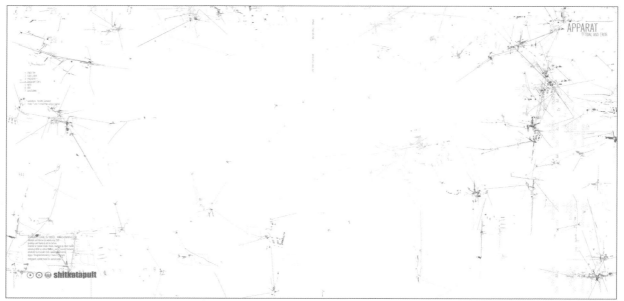

TTTrial and Eror, Apparat/CD cover/Offset/2001

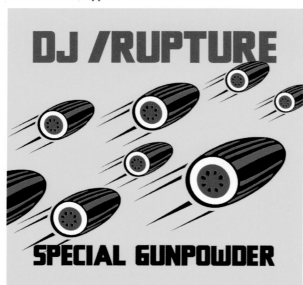

Special Gunpowder, Dj /Rupture/CD cover/Offset/2004

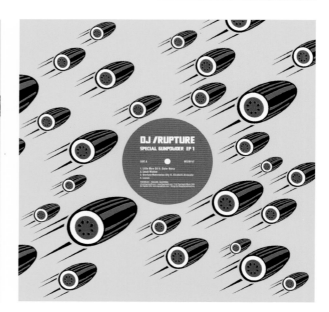

Wintersleep, Anders Ilar/CD cover/Offset/2005

Neurotitan/Poster/Photocopy/2008

Explode, Agf/Delay/CD cover/Offset/Illustration: Kaisa Kemikoski/2004

Shockout Vol.2: Oppositional Ambitions/CD cover/Offset/2008

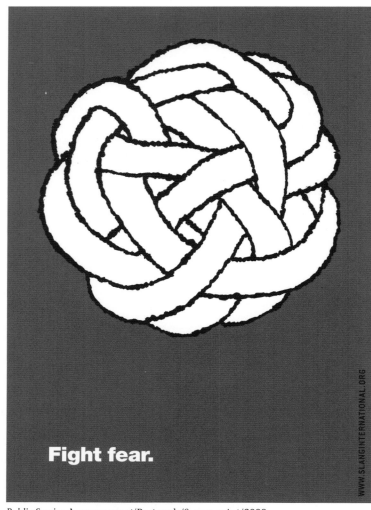

Fight fear.

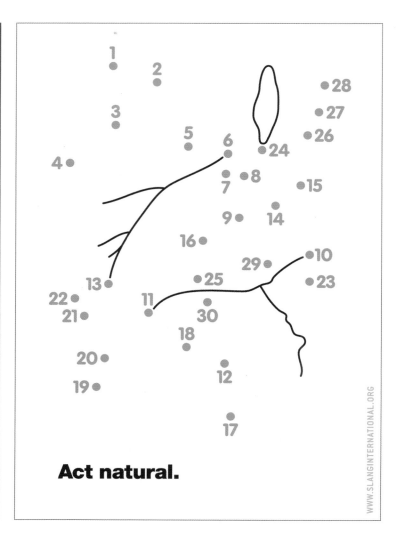

Act natural.

Public Service Announcement/Postcards/Screen print/2008

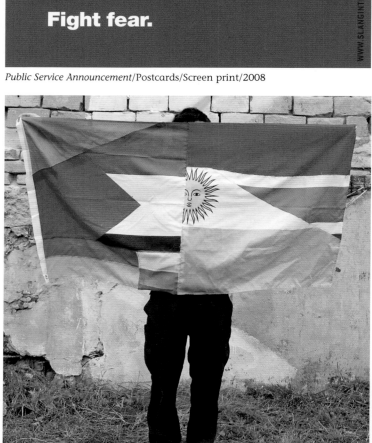

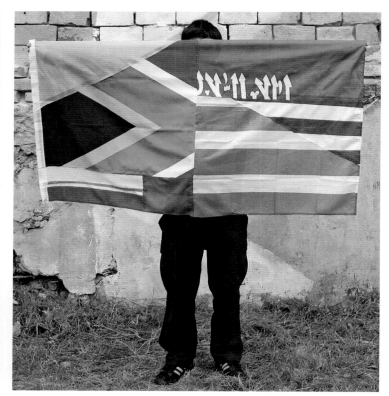

Coexistence 3/Flags/In collaboration with Jaana Davidjants/2007

Home/Poster series/Screen print/In collaboration with Jaana Davidjants/2007

Amsterdam, The Netherlands
Alphen a/d Rijn, The Netherlands (Middlekoop)
Rotterdam, The Netherlands
Berlin, Germany
Zagreb, Croatia
Rochester, N.Y., USA (Frisk)
New York, USA

Strange Attractors Design

Ryan Pescatore Frisk and Catelijne van Middelkoop
www.strangeattractors.com
mail@strangeattractors.com

Birthplace: Rochester, New York, USA (RPF)/Alphen a/d Rijn,
The Netherlands (CVM)
Residence: New York, USA/Rotterdam, The Netherlands
Connecting cities: Amsterdam, The Netherlands/Berlin, Germany/Zagreb,
Croatia

IN 2001, THE DESIGNERS Ryan Pescatore Frisk and Catelijne van Middelkoop founded the Strange Attractors Design studio. With two operational bases, one in Europe and the other in America, the international studio offers innovative ideas and solutions for visual, cultural, and commercial communication.

Both designers are active design researchers and educators and have taught workshops and conferences all over the world, including Zagreb, Split, Moscow, Prague, Berlin, Amsterdam, Rotterdam, New York, and Chicago. They are both invited professors at the Eindhoven Design Academy. Catelijne is also a graphic design professor at the Royal Academy of Art in The Hague.

Their work has been featured in various books and periodicals and is part of the permanent collection at the Boijmans Van Beuningen Museum in Rotterdam.

They were nominated for the Design Prize of Rotterdam and the Design Prize of Germany in 2007.

For Strange Attractors, each design project results in a tailor-made and personalized solution. The studio offers a series of rich experiences and distinct messages as an alternative to what they see as global banality in a context of what they call "neo-modern generic communication."

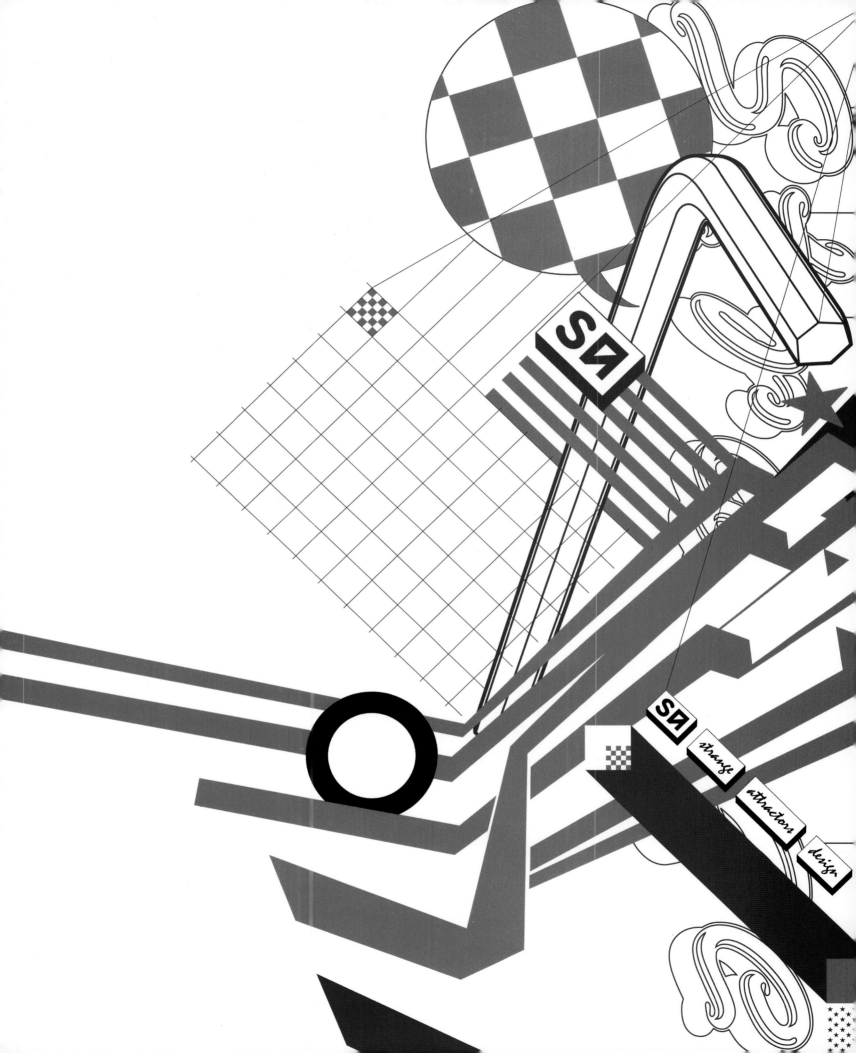

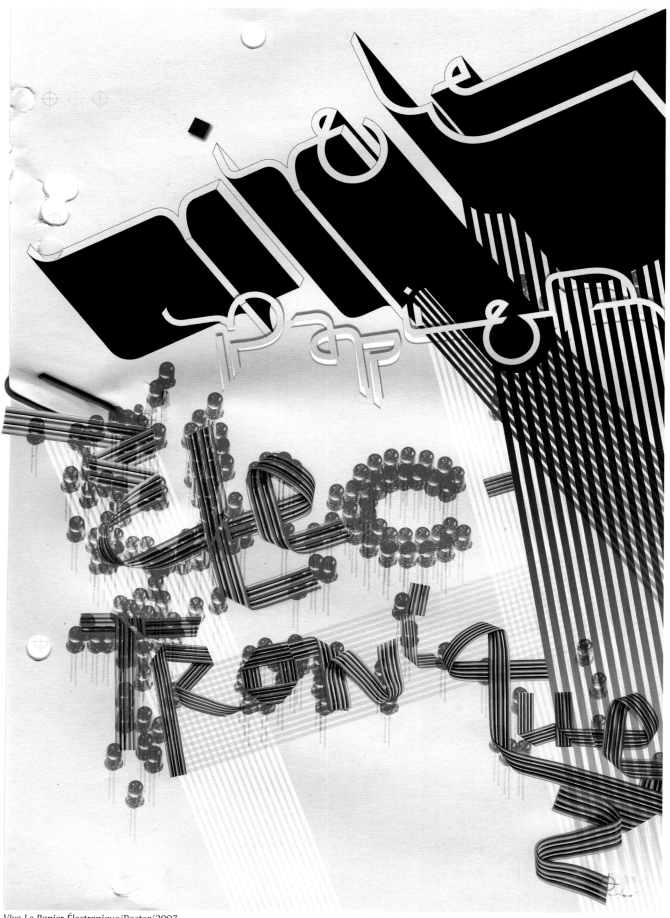

Vive Le Papier Électronique/Poster/2007

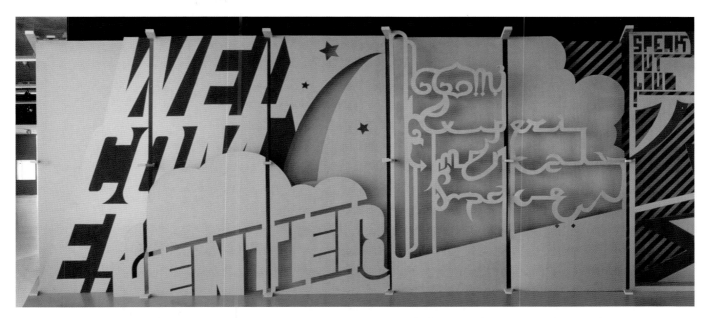

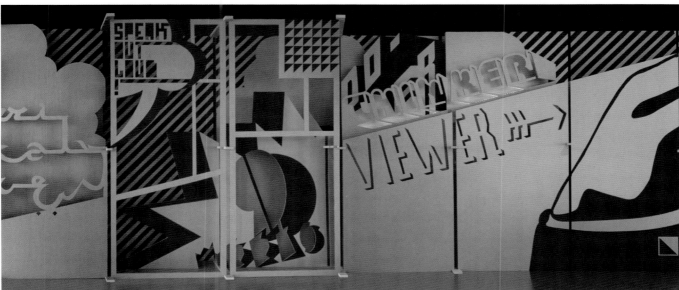

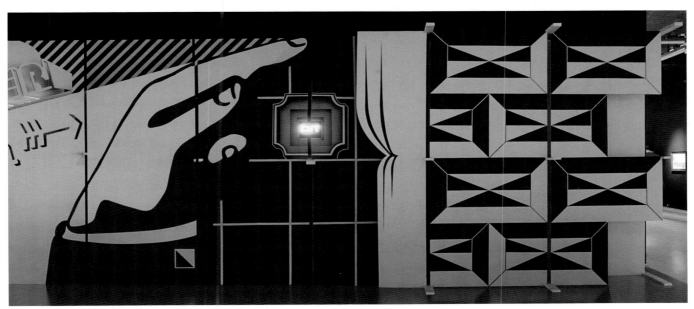

Big Type says more/Typographic installation/2006

"...In the battle between the old and the new, it is not a question of creating a new style for its own sake. But new needs and new contents create new forms which look utterly unlike the old. And it is just as impossible to argue away these new needs as it is to deny the need for a truly contemporary style of typography. That is why printers today have a duty to concern themselves with these questions. Some have forged ahead with energy and creative success: for the rest, however, it seems that there is still almost EVERYTHING to do!"

(P.13-14) *The New Typography*, Jan Tschichold (1928). Translation: Ruauri Mc Lean

(P.76) *The New Typography*, Jan Tschichold (1928). Translation: Ruauri Mc Lean

Chapter 1. Introduction.

"The New Typography, after being violently attacked and often decisively condemned, has now established itself in central Europe. Its manifestations confront modern man at every step. Even its most ardent opponents have eventually had to resign themselves to accepting it"

(P.7) *The New Typography*, Jan Tschichold (1928). Translation: Ruauri Mc Lean

The New Typographers/Visual essay/2005

Yesterday I lost my Helvetica/AIGA lecture invitation/2006

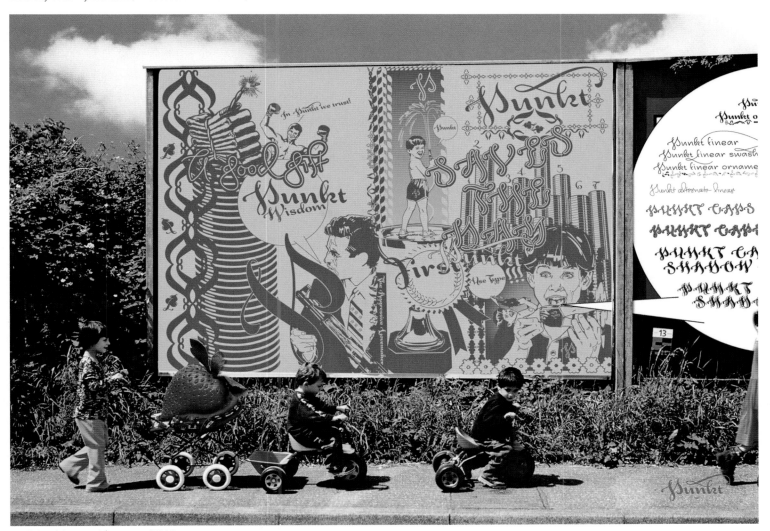

Punkt/Typeface and specimen/2005

Sacramento, Calif.,
USA (Swanlund) Saint Paul, Minn., USA (Swanlund)

San Francisco, The Hague, The Netherlands (JS)
Calif., USA (Sueda)

Eagle Rock, Calif., USA (GS) Raleigh, N.C., USA (Sueda)

Los Angeles, Calif., USA (JS/GS)

Honolulu, Hawaii, USA (JS)

Stripe

Jon Sueda and Gail Swanlund
www.stripela.com
jsueda@sbcglobal.net/gail@stripela.com

Birthplace: Honolulu, Hawaii, USA (JS)/Saint Paul, Minnesota, USA (GS)
Residence: San Francisco, USA (JS)/Eagle Rock, California, USA (GS)
Connecting cities: Los Angeles, California, USA; The Hague, The Netherlands;
Raleigh, North Carolina, USA (JS)/Los Angeles, California,
USA; Sacramento, USA (GS)

THE GRAPHIC SERVICES agency, Stripe, founded by Jon Sueda and Gail Swanlund, is joined by a team of designers, photographers, illustrators, writers, editors, and investigators on each project. The studio has headquarters in Los Angeles and in San Francisco where they generate, organize, calculate, assemble, and dream about words, in order to produce solutions which relate directly to their audiences.

Sueda and Swanlund are California College of the Arts (CCA) graduates. Swanlund is a professor at CalArts where she co-directs the graphic design program. These two designers both share a curiosity and appreciation for all things odd and strange, a passion for intelligent ideas and the pure exuberance of creating – this is a feature of their work.

The work of this graphic studio has been reviewed in specialist magazines, including *Idea, Grafik, Ping,* and *Creative Review.*

They have also been selected to participate in exhibitions at international art spaces and in important publications.

Collaboration is a vital part of their design process. The discussion, friction, and creative energy that is generated during the collaborative process is an essential ingredient, which "gives way to the mysterious and the unknown which then turns into the tangible and visible."

Earthquakes and Aftershocks/Poster/Screen print/2005

Expanded Design Poster. UCLA Design Lecture Series/Poster/In collaboration with Geoff Kaplan (General Working Group)/2001

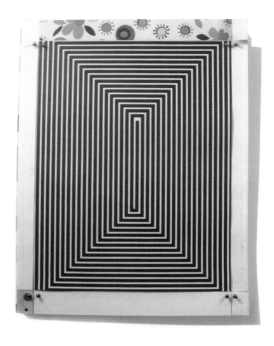

Margaret Kilgallen: In the Sweet Bye & Bye/Exhibition Catalogue/In collaboration with Michael Worthington (counterspace)/2005

Andrea Bowers: Nothing is Neutral/Exhibition Catalogue/2006

RESULT FORMED BEFORE (Receipt) (Of) (Clients) (Problem)/Happening/Installation piece at LACE. Part of group show entitled "Draw a Line and Follow It"/Posters/2007

Graphic Design in the White Cube Poster/International Biennale of Graphic Design Brno, Czech Republic/Poster/2006

Vancouver, Canada

Munich, Germany
Ljubljana, Slovenia
Belgrade, Serbia

Studio 360

Vladan Srdić
www.thesign.org.uk
studio@thesign.org.uk

Birthplace: Belgrade, Serbia
Residence: Ljubljana, Slovenia
Connecting cities: Belgrade, Serbia/Munich, Germany/Vancouver, Canada

STUDIO 360, THE AGENCY of designer Vladan Srdić, is located in the town of Ljubljana. The company offers solutions combining architecture and brand design. His experience in two and three-dimensional design has led him to "create strategic brand development, effective results, and satisfied clients."

The branding department of Studio 360 is devoted to the development of work for advertising, illustrations, packaging, graphics, and Web design.

Their philosophy is to communicate with a sophisticated and fresh style, which always involves double entendres. Every project is important to them and they blend aesthetic principles, shape, and function with the promise of creating powerful concepts and added value for their clients.

The architectural department focuses on the creation of flexible design concepts and investigation into building techniques that offer a better quality of life. Their

philosophy is based on simplicity, attention to detail, and an intelligent use of materials.

This studio's work has been reviewed in important publications and has been awarded numerous prizes in local and international competitions. "Ten years of experience and dedication ensure excellence. We are flexible, quick, and able to produce total solutions for architectural as well as graphic projects."

EYES WITHOUT A FACE

Hot-line/Print advertisement/2000

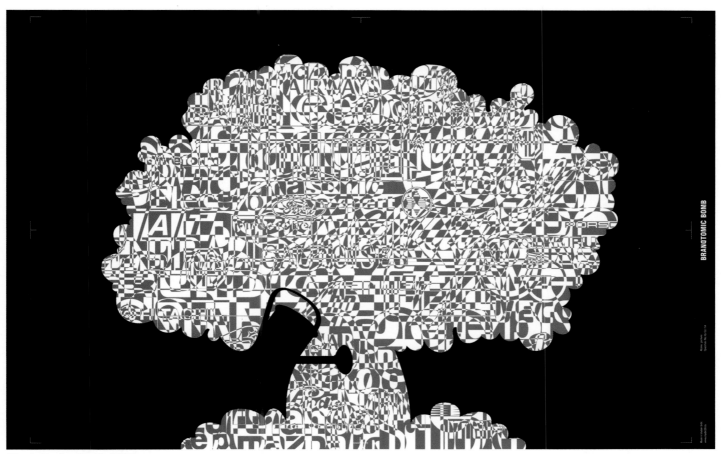

Atomic Gardens/Poster/2005

T-error/Poster/2005

MGLC/Poster/2006

Magdalena/Poster/2005

Trnfest/Poster/2006

Stockholm (Willey)/(Curtis), Sweden

St Albans (Bather)/Southampton(Curtis)/Bristol (Willey), UK Copenhagen, Denmark (Willey)

London, UK

San Francisco, Calif., USA (Bather) Paris (Bather)/(Willey), France

Turin, Italy (Bather)

New York, USA (Curtis) Barcelona, Spain (Curtis)

Studio 8

Zoë Bather, Matt Curtis and Matt Willey
www.studio8design.co.uk
info@studio8design.co.uk

Birthplace: St Albans, UK (ZB)/Southampton, UK (MC)/Bristol, UK (MW)
Residence: London, UK
Connecting cities: Paris, France/San Francisco, California, USA/Turin, Italy (ZB)/Barcelona, Spain/Stockholm, Sweden/New York, USA (MC)/Stockholm, Sweden/Copenhagen, Denmark/Paris, France (MW)

STUDIO 8 IS A RENOWNED London graphic design studio. Its work includes projects of editorial design, exhibitions, signage, corporate publications, webpages, and visual identity development.

Matt Willey and Zoë Bather were creative directors at the studio of outstanding designer Vince Frost before opening their own studio in London in 2005. With an impressive career in the world of visual communication they aim to imbue each project with the richness of their

experience, knowledge, and enthusiasm in order to produce seductive and intelligent creative solutions.

Studio8 is in charge of the art direction and design of the well known biannual magazine *Graphic*. In 2008, they were awarded gold and silver for the best magazine at the Chimera Prize in Poland for their work on the design and art direction of *Futu Magazine*. They received the Platinum Award at the Graphics Poster Annual and at the Design Week

Awards in the Editorial Design category. They can also boast mentions of excellence by the Art Directors Club in New York and the Type Directors Club in New York and Tokyo.

The majority of their work smacks of minimalism, where the chromatic and graphic simplicity strengthens the typographic elements, enabling each piece to communicate its message in a direct and resounding manner.

Hearing level

20dB 30dB 40dB 50dB 60dB

04.19 00.00

'Simple Twist Of Fate'
Bob Dylan

Frequency

250–500 (b, d, e, j, l, m, n, u, v, z)
500–1k (a, i, o,r)
1k–2k (ch, g, h, p, sh)
2k–4k (k, t)
4k-8k (f, s, th)
(c, q, w & x were omitted)

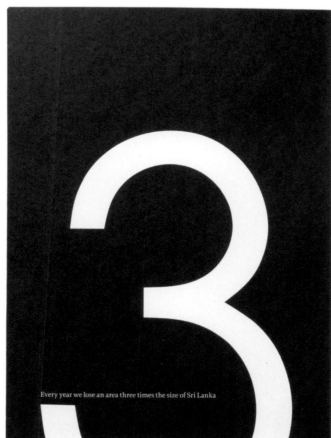

Every year we lose an area three times the size of Sri Lanka

At This Rate/Booklet/Creative directors: Matt Willey, Giles Revell; designer: Matt Willey/2007

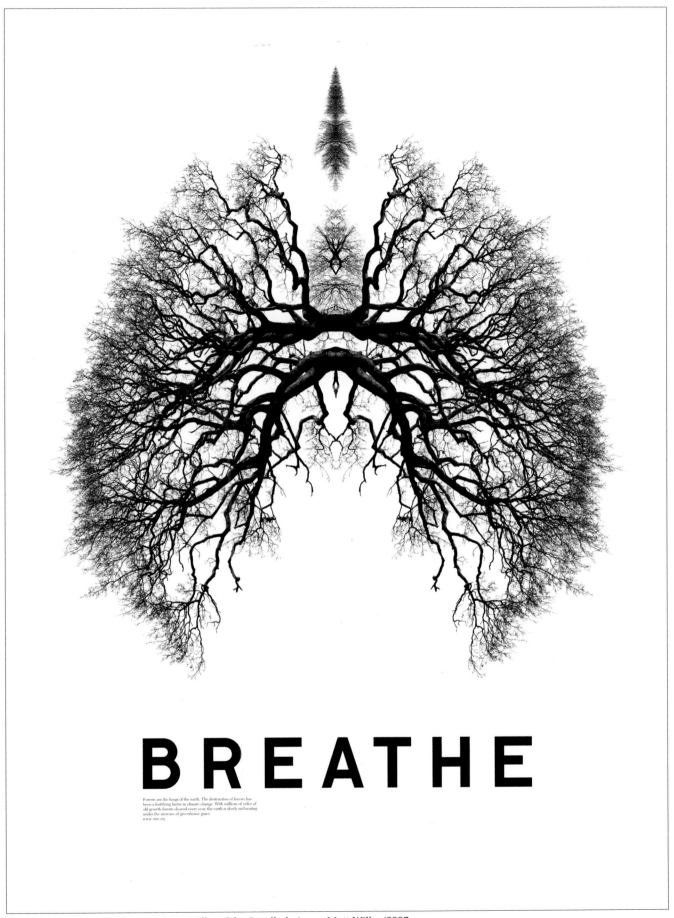

BREATHE

Forests are the lungs of the earth. The destruction of forests has
been a fortifying factor in climate change. With millions of miles of
old growth forests cleared every year, the earth is slowly suffocating
under the increase of greenhouse gases.
www.rm.org

Breathe/Poster/Creative directors: Matt Willey, Giles Revell; designer: Matt Willey/2007

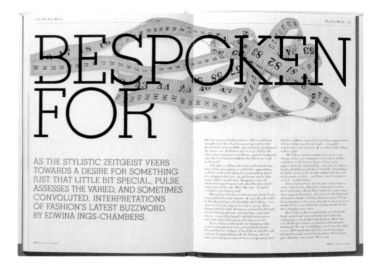

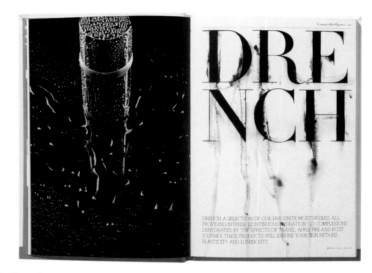

NB Pulse/Book/Art direction and design/Creative directors: Matt Willey, Zoë Bather; designers: Matt Willey, Zoë Bather, Matt Curtis/2007

The Circus Space/Annual Report/Creative directors: Matt Willey, Zoë Bather; designers: Matt Willey, Zoë Bather/2006

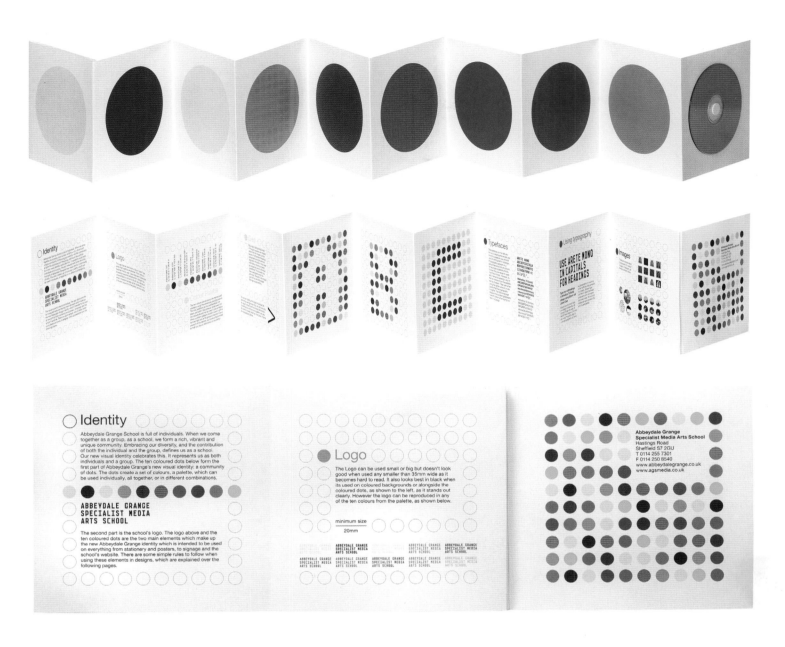

Abbeydale Grange School/Visual Identity/Creative directors: Matt Willey, Zoë Bather; designer: Zoë Bather/2006

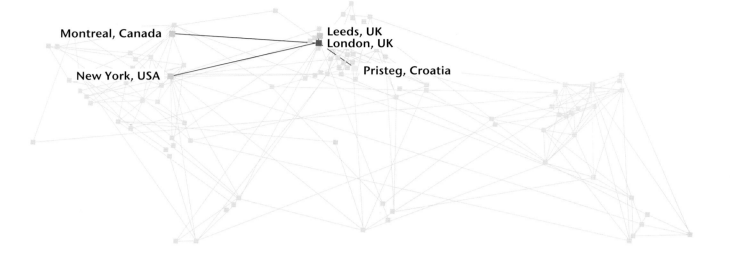

Montreal, Canada

Leeds, UK
London, UK

New York, USA

Pristeg, Croatia

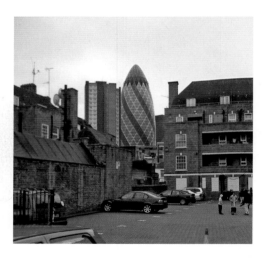

The Luxury of Protest

Peter Crnokrak
www.theluxuryofprotest.com
info@theluxuryofprotest.com

Birthplace: Pristeg, Croatia
Residence: London, UK
Connecting cities: Montreal, Canada/Leeds, UK/New York, USA

PETER CRNOKRAK IS a graphic designer and art director who lives and works in London. In 2007, he established his own studio, The Luxury of Protest, while designing for the Nick Bell Design studio.

His work methodology as a designer is based on analysis and investigation, an approach inherited from his academic background as a graduate of biological science with a doctorate in the field of evolution genetics.

His creations have been reviewed in publications such as *Print*, *Creative Review*, *Grafik*, and *IdN*, and included in compilation books such as *Logo Design 2* (Taschen), *Logos* (Rotovision), and *Data Flow* (Die Gestalten Verlag). He has also participated in diverse collective exhibitions and has been awarded prizes in international competitions such as the European Design Awards, STEP Annual Design, and Coupe Design Annual Competition.

The message this designer portrays depends heavily on the project in question. The majority of his work shows a plural and anti-dogmatic approach, defending his position as author without distinguishing between the design and the art, even when it is a commercial project.

Crnokrak says he finds as much inspiration in music as in politics and considers graphic design to be more effective than poetry.

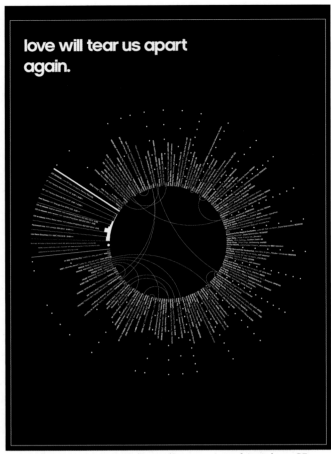

Love Will Tear Us Apart Again/Poster/Screen print, white ink on GF-Smith Plike/2007

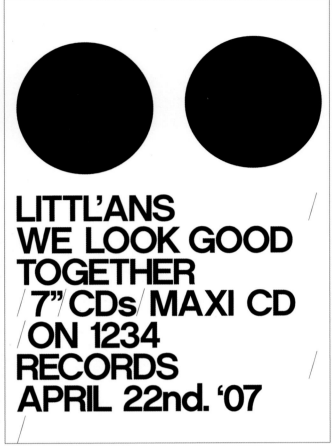

We Look Good Together/Poster/Digital plotter print/2007

2dots – Hiroshima/Poster/Lambda print on glossy duraflex plastic/2007

2dots – Hiroshima/Poster/Lambda print on glossy duraflex plastic/2007

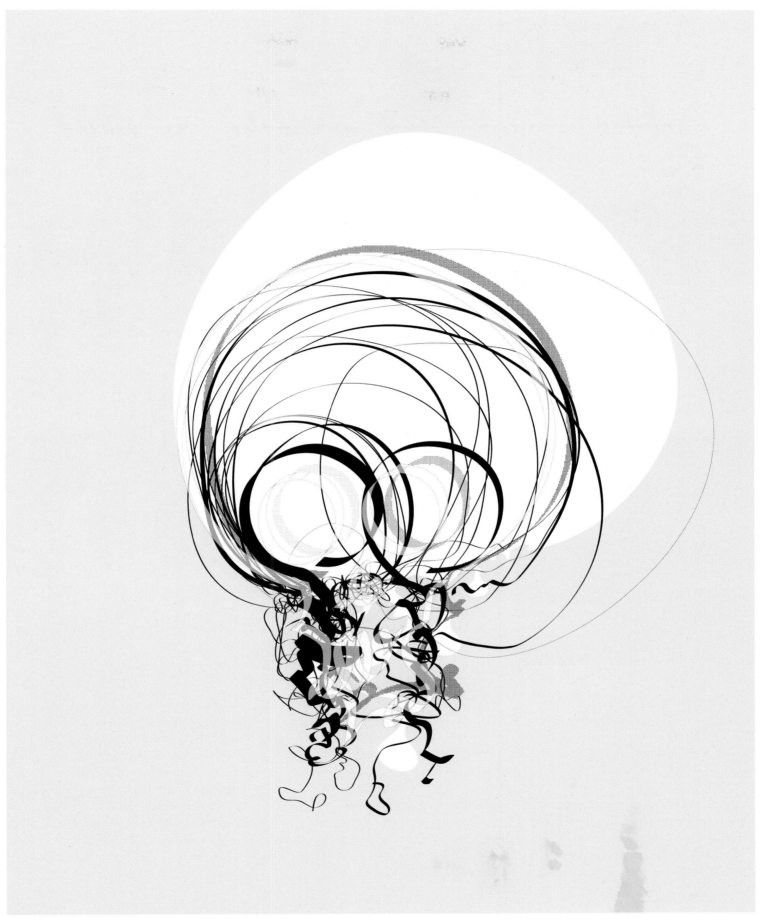

Skulligraphy/Poster/Lambda print on glossy duraflex plastic/2006

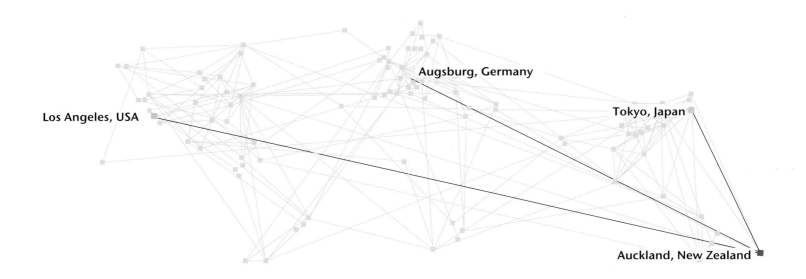

Los Angeles, USA

Augsburg, Germany

Tokyo, Japan

Auckland, New Zealand

The Rainbowmonkey

Markus Hofko
www.rainbowmonkey.de
info@rainbowmonkey.de

Birthplace: Augsburg, Germany
Residence: Auckland, New Zealand
Connecting cities: Tokyo, Japan / Los Angeles, USA

THE RAINBOWMONKEY IS the pseudonym of the visual artist, musician, and independent designer, Markus Hofko. He was born in Germany and currently lives and works in Auckland.

This versatile visual communicator has worked for various clients in the world of art, fashion, and television. He works toward a powerful visual language which is unique in each project. Rather than create his own style as designer, he endeavors to reinvent himself on every occasion, ensuring that each design possesses its own individual characteristics.

One of his personal projects "Pie Paper," a piece carried out in collaboration with Simon Oosterdijk, is a publication about "art, nature, science, and other miscellaneous areas of modern life."

Maintaining the focus on detail and on high standards is essential for this designer. His skills range from sound design to the design of printed materials, 3D design, illustration, and motion graphics. His main objective is to make the world a more colorful place and to unleash the primal instinct that lies within every person. His philosophy is to be fun, narrative, experimental, focused, and microscopic – "to be a primate."

Making Worlds/Exhibition/Diverse print-media/2007

Okyo/Website/Interactive start-page/2007

Making Worlds/Exhibition/Diverse print-media/The keyvisual for this show is a modular world that can be extended or transformed. The backside of the poster-guide can be painted and will then be pasted around town for advertising. The backs of the stackable cards give the opportunity to create own worlds/2007

Wow/Poster/Personal project/2007

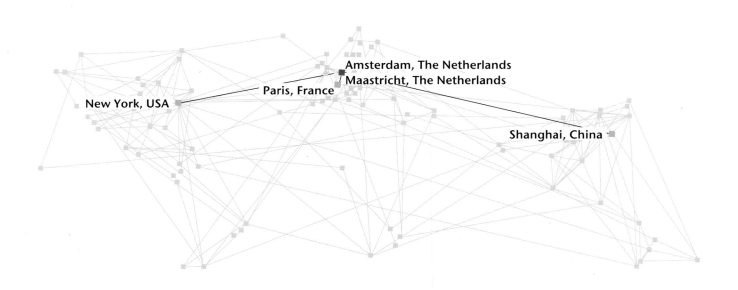

Amsterdam, The Netherlands
Maastricht, The Netherlands
Paris, France
New York, USA
Shanghai, China

Thonik

www.thonik.nl
studio@thonik.nl

Birthplace: Maastricht, The Netherlands
Residence: Amsterdam, The Netherlands
Connecting cities: Shanghai, China / New York, USA / Paris, France

THE DESIGNERS NIKKI GONNISSEN and Thomas Widdershoven founded the Thonik visual communication studio in 2000. This creative duo has been working together since 2003, formerly as Gonnisson en Widdershoven. The name Thonik is formed by joining together the first three letters of the names of the founders.

The building that houses the studio was created by the architecture firm MVRDV. It is a unique construction covered with green painted polyurethane and has been featured in various architecture and interior design magazines.

Thonik specializes in the realization of graphic design projects, mostly in the field of printing. They also develop communication concepts for advertising campaigns with a notably original style and conceptual approach. Their main objective is to build bridges between the aesthetic experience and social reality. Their work shows great strength in both cultural and political spectrums.

This recognized studio forms part of the elite of contemporary Dutch design and their work has been widely acclaimed at a national and international level. They have received many distinctions and prizes, such as the Rotterdam Design Prize in 2007, and their work has been reviewed in numerous books and specialist magazines.

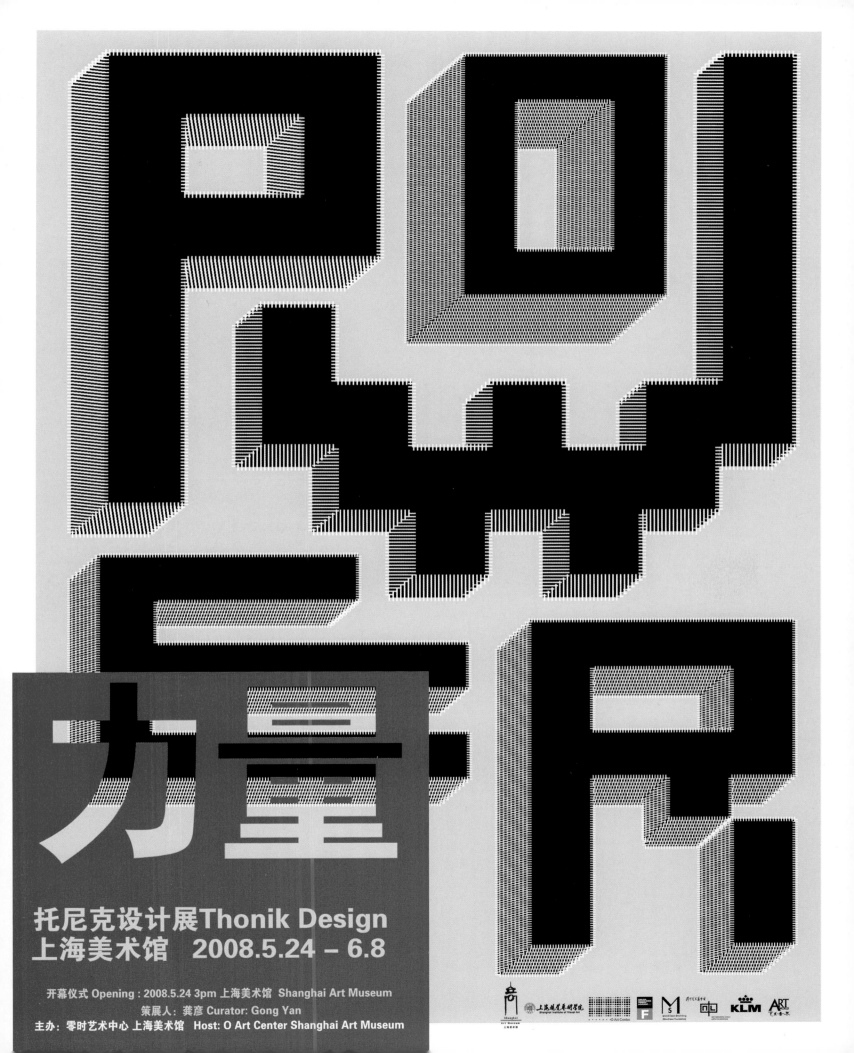

托尼克设计展Thonik Design
上海美术馆　2008.5.24 – 6.8

开幕仪式 Opening：2008.5.24 3pm 上海美术馆 Shanghai Art Museum
策展人：龚彦 Curator: Gong Yan
主办：零时艺术中心 上海美术馆　Host: O Art Center Shanghai Art Museum

POWER Thonik Design/Thonik studio retrospective/Shanghai Art Museum/2008

14/09–23/11/2008

OUT THERE

ARCHITECTURE BEYOND BUILDING

la Biennale di Venezia

11. Mostra Internazionale di Architettura

Venezia **Giardini della Biennale–Arsenale**
orario/opening hours **10.00–18.00**
www.labiennale.org

Out There Architecture Beyond Building/Graphic identity for the 11th International Architecture Venice Biennale/2008

London, UK
Paris, France
Zurich, Switzerland
New York, USA
Culebra, Puerto Rico

Tiziana Haug

www.inthehabit.com
tiziana@inthehabit.com

Birthplace: Zurich, Switzerland
Residence: New York, USA
Connecting cities: London, UK/Culebra, Puerto Rico/Paris, France

SINCE 1998 TIZIANA HAUG has been living in New York. Once she had finished her master's degrees at Central Saint Martins College of Art and Design, in London, and at the Pratt Institute, in New York, she began working for important design studios, such as Point One Percent, The Apartment, and Wolff Olins, as well as developing other projects independently.

She has carried out a wide variety of work, which includes editorial design, typography, graphic interventions in space, textile design, packaging, and webpages.

Her work has been reviewed in an article about up-and-coming talents in *Step Inside Design Magazine*. She was also named a "Young Gun" by the Art Directors Club. She has received numerous distinctions and her work has been published in various magazines such as *Tokyo TDC*, *Grafik*, *New York Magazine*, *V Magazine*, and *Frame*, among others.

Haug feels that her origins influence her work. Although she does not classify her work as typically Swiss, she admits that she has a natural tendency toward order and a minimalist approach in the use of graphic elements. Her company, In the habit, owes its name to her habit of designing every day. Design is part of her daily routine, something which just happens naturally, "like a habit."

ADC Paper Expo/Mailer and poster/Designers: Tiziana Haug and Steve Rura/2007

The 27th Letter/Typeface and posters/2008

Annular/Typeface/Creative director: Stefan Boublil; design: Tiziana Haug;
studio: The Apartment/2005

Sweet/Typographic illustration/2007

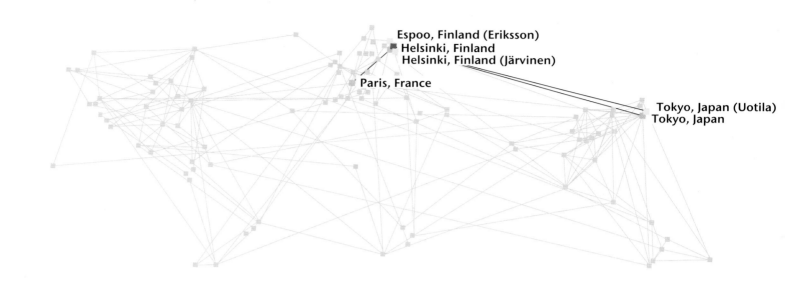

Espoo, Finland (Eriksson)
Helsinki, Finland
Helsinki, Finland (Järvinen)

Paris, France

Tokyo, Japan (Uotila)
Tokyo, Japan

TNOOC

Jonatan Eriksson, Inka Järvinen and Antti Uotila
www.tnooc.com
inkajarvinen@gmail.com

Birthplace: Espoo, Finland (JE)/Tokyo, Japan (AU)/Helsinki, Finland (IJ)
Residence: Helsinki, Finland
Connecting cities: Paris, France/Tokyo, Japan/Helsinki, Finland

LOCATED IN HELSINKI, on the shores of the Gulf of Finland, this independent design triad, which has been working together since 2006, mainly develops design projects for the worlds of art, music, and fashion, working with all kinds of applications from visual identity to illustration.

They all graduated from the University of Art and Design in Helsinki. Jonatan Eriksson is the technological link in the group, "who knows a lot about computers but not much about the real world." Inka Järvinen graduated with degrees in graphic design as well as fashion design and since 2006 has created her own line of T-shirts "Girls of Boredom." In addition to her work as graphic designer and independent illustrator, Antti Uotila is also a musician and forms part of the Finnish electronic music group The Millionaires.

TNOOC creates with an aesthetic that draws inspiration from the avant-garde styles of surrealism, Dadaism, and pop art. They love old science-fiction films and in most of their work they use the collage as a technique and screen printing as a process.

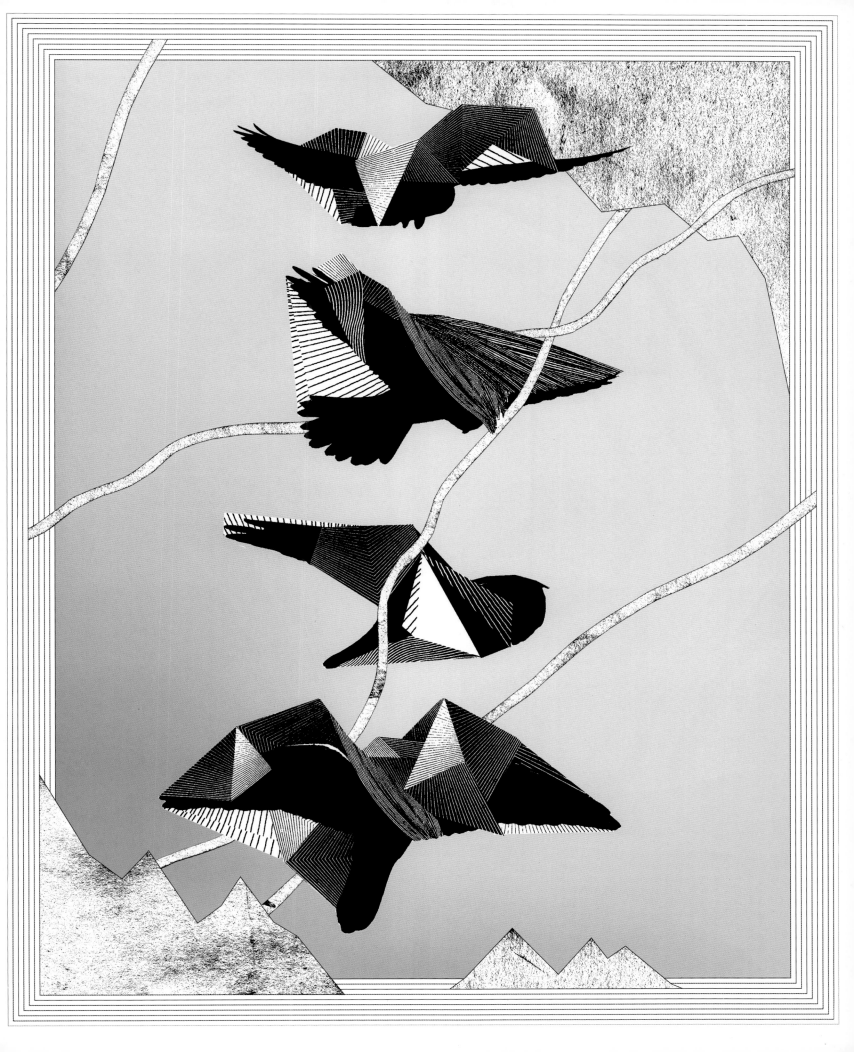

Frisson/Graphic identity for a fashion show/2008

Näytös07/Graphic identity for a fashion show/2007

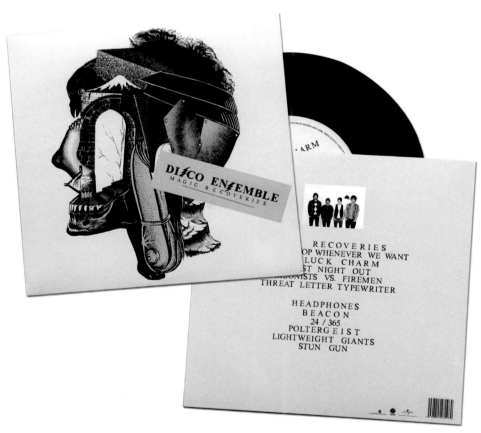

Fortune/Logo/2007

Jännäri/Logo/2007

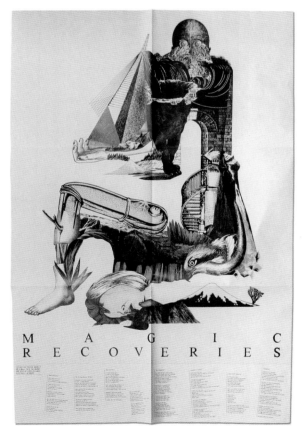

Magic Recoveries, Disco Ensemble/Album cover/2008

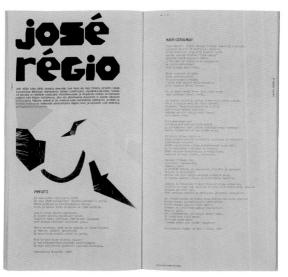

Tuli & Savu/Magazine design and layout/In collaboration with Jaakko Pietiläinen (www.frck.fi)/2007

Most Sexiest Music, The Millioners/CD cover/2007

Vieraalla maalla, Lauluyhtye 5/CD cover/2006

Barendrecht, the Netherlands (ED)
Rotterdam/Breda, the Netherlands
Krefeld, Germany (ML)

Chicago, USA

Sydney, Australia

Toko

Eva Dijkstra and Michael Lugmayr
www.toko.nu
info@toko.nu

Birthplace: Barendrecht, the Netherlands (ED)/Krefeld, Germany (ML)
Residence: Sydney, Australia
Connecting cities: Chicago, USA/Rotterdam, the Netherlands/Breda, the Netherlands

EVA DIJKSTRA AND Michael Lugmayr are Toko, a multidisciplinary studio founded in 2001, originally based in Rotterdam and currently in Sydney – the largest and oldest city in Australia. They specialize in the areas of editorial design; however, they have also carried out projects which include the design of signage systems, visual identity, posters, flyers, and more.

For Toko, a good design implies the correct balance between a good idea and impeccable execution. They prefer not to use artistic references as a model but rather aim to create unique pieces for each project, whether big or small. Typography plays an important part in their work either through experimentation or creating their own fonts.

Their work has appeared in publications such as *Area 2*, *Super Holland Design*, *Tres Logos*, *Around Europe Design*, among others, and they have been featured in many magazines such as *IDEA*, *Etapes*, *Graphik Magazine*, and *Empty*. The collective responsibility the designers hold for the environment is a constant theme and inherent in their design processes. With this stance they aim to benefit from "restrictions" as a way to create truly sustainable design.

Confused Type/Typographic treatments/2007-2008

Designed/Newspaper and cards/2007

Gallery Blik/Posters/Screen print on offset/2005

Aantal werkzame personen en aantal vestigingen naar sector, 2003	werkzame personen*	vestigingen
landbouw, jacht, bosbouw	863	217
visserij	349	6
industrie	8124	612
nutsbedrijven	809	7
bouwnijverheid	6051	940
handel en reparatie	23393	4772
horeca	6636	1648
vervoer/opslag/communicatie	17667	523
financiele instellingen	11223	494
zakelijke dienstverlening	36086	3597

Aantal werkzame personen en aantal vestigingen naar sector, 2003	werkzame personen*	vestigingen
openbaar bestuur/overheid	48968	262
onderwijs	11326	478
gezondheids-/welzijnszorg	29660	1577
overige diensten	13053	1887
extra-territoriale lichamen	451	141
totaal aantal	214659	17161

* een werkzame persoon heeft betaald werk van 12 uur per week of meer
Bron: DSO, L&V

fig. DSO.15 / Aantal werkzame personen naar sector, 2003

Niet-werkende werkzoekenden naar hoogst voltooide opleiding, 2002	aantal	%
basisonderwijs	7691	32,2
Vbo of Mavo	8933	37,4
Mbo/Havo/Vwo	4567	19,1
Hbo/Wo	2677	11,2

Bron: ISEO

Niet-werkende werkzoekenden naar etniciteit, 2002	aantal	%
Turken	3284	13,8
Marokkanen	2246	9,4
Surinamers	2586	10,8
Antillianen	1026	4,3
overige allochtonen	3495	14,6
autochtonen	11231	47,0

Bron: ISEO

fig. DSO.16 / Niet-werkzame werkzoekenden naar hoogst voltooide opleiding, 2002

Aandeel werkzame personen* naar grootteklasse van het bedrijf	grootteklasse 1 wp	2-9 wp	10-49 wp	50-99 wp	> 99 wp
1998	12%	26%	19%	8%	35%
2003	11%	22%	19%	6%	41%

* een werkzame persoon heeft betaald werk van 15 uur per week of meer
Bron: KvK

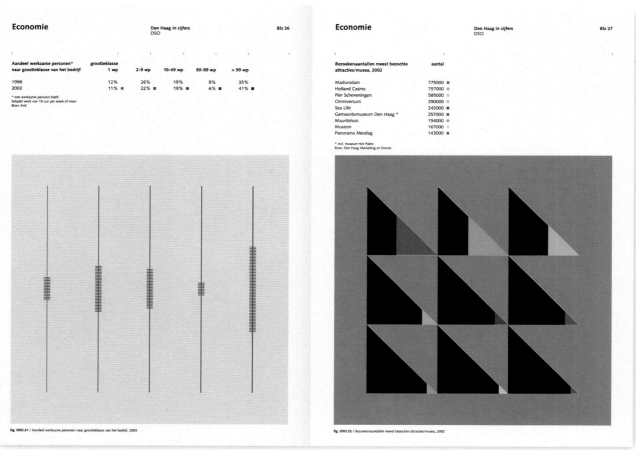

fig. DSO.21 / Aandeel werkzame personen naar grootteklasse van het bedrijf, 2003

Bezoekersaantallen meest bezochte attracties/musea, 2002	aantal
Madurodam	775000
Holland Casino	757000
Pier Scheveningen	585000
Omniversum	290000
Sea Life	245000
Gemeentemuseum Den Haag *	257000
Mauritshuis	194000
Museon	167000
Panorama Mesdag	143000

* incl. museum Het Paleis
Bron: Den Haag Marketing en Events

fig. DSO.22 / Bezoekersaantallen meest bezochte attracties/musea, 2002

DSO/Corporate annual report/2004

Burgerlijke staat	1996	2001	2002	2003	% verandering tov 2002
ongehuwd	207860	220994	230916	235771	2,1
gehuwd	161709	149849	154870	156597	1,1
gescheiden	40339	42745	43849	44216	0,8
weduwe-weduwnaar	32612	28731	28039	27170	-3,1

Bron: bestand Burgerzaken
(bewerking DSO/Beleid/Onderzoek)

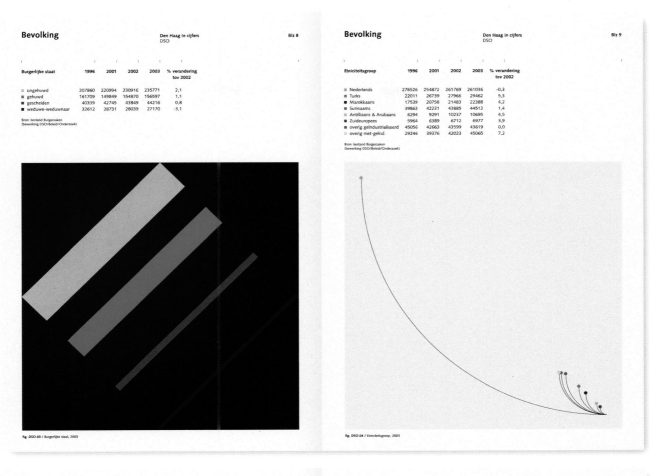

fig. DSO.03 / Burgerlijke staat, 2003

Etniciteitsgroep	1996	2001	2002	2003	% verandering tov 2002
Nederlands	276526	254872	261769	261036	-0,3
Turks	22011	26739	27966	29462	5,3
Marokkaans	17539	20758	21483	22388	4,2
Surinaams	39863	42231	43885	44512	1,4
Antilliaans & Arubaans	6294	9291	10237	10695	4,5
Zuideuropees	5964	6389	6712	6977	3,9
overig geïndustrialiseerd	45056	42663	43619		0,0
overig niet-geïnd.	29246	39376	42023	45065	7,2

Bron: bestand Burgerzaken
(bewerking DSO/Beleid/Onderzoek)

fig. DSO.04 / Etniciteitsgroep, 2003

Huishoudens naar type	1998	1999	2000	2001	2002	2003
eenpersoonshuishouden	107508	107076	108214	109032	110446	111473
samenwonend zonder kinderen	58446	57728	56981	56491	57301	57596
samenwonend met kinderen	42735	42582	42688	42680	45714	46677
eenoudergezinnen	17570	17794	17996	18479	18942	19516
Totaal aantal huishoudens	226259	225180	225879	226682	232403	235262

Bron: huishoudensraming
DSO/Beleid/Onderzoek

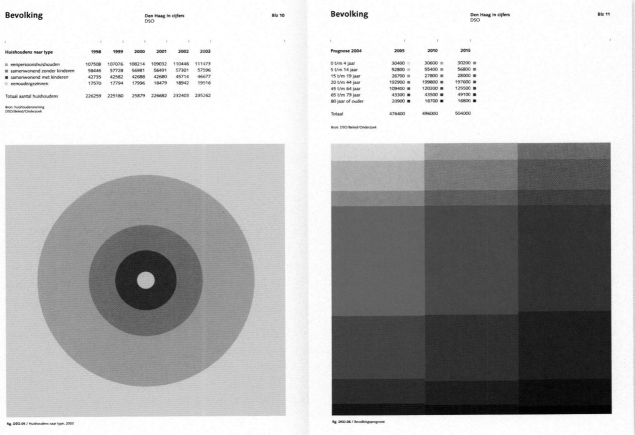

fig. DSO.05 / Huishoudens naar type, 2003

Prognose 2004	2005	2010	2015
0 t/m 4 jaar	30400	30600	30200
5 t/m 14 jaar	52800	55400	56800
15 t/m 19 jaar	26700	27800	28000
20 t/m 44 jaar	192900	199800	197600
45 t/m 64 jaar	109400	120200	125500
65 t/m 79 jaar	43300	43500	49100
80 jaar of ouder	20900	18700	16800
Totaal	476400	496000	504000

Bron: DSO/Beleid/Onderzoek

fig. DSO.06 / Bevolkingsprognose

DSO/Corporate annual report/2004

Ljubljana, Slovenia ■——— Moscow, Russia
Nova Gorica, Slovenia

New York, USA ■

■ Mexico City, Mexico

Tomaž Plahuta

www.tomazplahuta.com
tomaz@eno.si

Birthplace: Nova Gorica, Slovenia
Residence: Ljubljana, Slovenia
Connecting cities: Moscow, Russia/New York, USA/Mexico City, Mexico

THE STUDIO OF TOMAŽ PLAHUTA is situated in the town of Ljubljana, in Slovenia, and is "a welcoming space which seeks to reinvent retro mini-maxi and maxi-minimalist design."

This meticulous designer is a visual communication graduate who believes that following trends does not lead to successful results. He supports the idea of telepathic design and creative communication by using signs and

symbols. In this way the visual experience can be gently and unconsciously absorbed without direct verbal abuse – which is common practice in our least developed societies.

His work has received various distinctions, including the Art Directors Club prize, the Best of the Best of Moscow, and the Slovenia Communication Biennale prize. He has also participated in exhibitions such as the ZGRAF, the Croatian

Communication Biennale, and the Moravian Gallery at the Brno Biennale in the Czech Republic.

Plahuta is adamant about making use of "shamanic expression using the digital crystal ball." He thinks people should follow their interior voice to achieve aesthetic freedom – something uncommon – which is why this designer is here to give help.

Miti po katerih živimo, Joseph Campbell/Book cover/Offset/2007

Miti po katerih živimo, Joseph Campbell/Book layout/Offset/2007

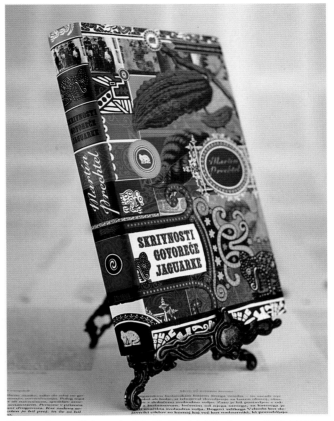

Zgodbe ob kuhinjski mizi, Rachel Naomi Remen/Book cover/
Offset/2005

Skrivnosti govoreče jaguarke, Martin Prechtel/Book cover/Offset/2005

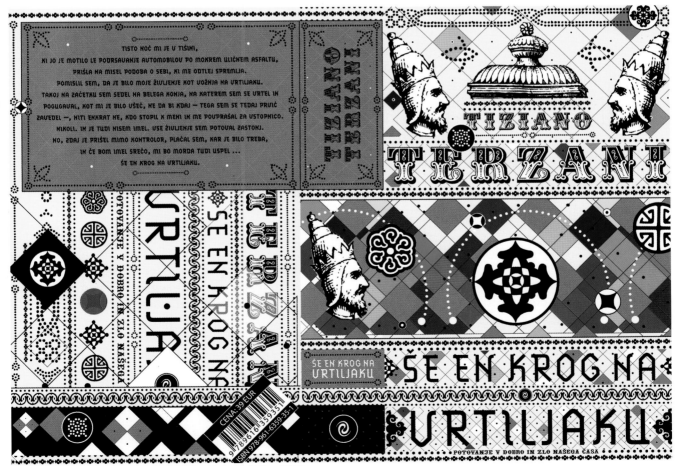

Zadnji krog na vrtiljaku, Tiziano Terzani/Book cover/Offset/2008.

Columbus, Ohio, USA (Labenz)
New York, USA
Tel Aviv, Israel (Rub)
Tel Aviv, Israel

Topos Graphics

Seth Labenz and Roy Rub
www.toposgraphics.com
dear@toposgraphics.com

Birthplace: Columbus, USA (SL)/Tel Aviv, Israel (RR)
Residence: New York, USA
Connecting cities: Columbus, USA/Tel Aviv, Israel/New York, USA

TOPOS GRAPHICS IS THE STUDIO of Seth Labenz and Roy Rub located in Brooklyn, New York. It was founded in 2005 and specializes in creating ideas for printing, visual identity design, signage, packaging, and typography. Regardless of the type of client, its objective is to develop each project from its conception to the end product with the same focus and careful attention to detail.

Topos Graphics has developed projects for various clients and has contributed to publications such as *Metropolis Magazine*, *New York Magazine*, and the *New York Times*, among others. It has also worked for important publishing houses such as Chronicle Books, Penguin USA, and Rizzoli.

In 2008, Labenz and Rub were included in *Print* magazine's "20 under 30" – its annual review of new visual artists.

The name Topos Graphics has a special meaning for this design duo. Someone once asked them about their work and when they replied that they were "typographers" the interlocutor understood that they were "topographers." This amused them and was actually not so far from the truth since the idea of "place" is a recurring theme in their work. In most of their projects the notions of home, place and geography are apparent and suggested in many ways.

40°N
42' 52.64"

73°W
57' 46.53"

Give/Holiday card/Screen print/2007

Collective Memory/CD cover/Offset lithography/2007

Spam Design/E-mail attachment/SPAM® Modeling and photography/2008

Silver Lining/Holiday card/Scratch-off-stamping, foil-stamping/2007

Cadin+Karen/Wedding invitation/Screen print on Gampi Paper/2007

Montreal, Canada (Freyer) London, UK Berlin, Germany (Rucki)
Amsterdam, The Netherlands (Rucki) Frankenber (Freyer)/Emmerich (Rucki), Germany
 Paris France (Noel) Montbéliard, France (Noel)
New York, USA (Freyer) Milan, Italy (Noel)
 Athens, Greece (Freyer) Beirut, Lebanon (Rucki)

 Guangzhou, China (Noel)

Troika

Conny Freyer, Sebastien Noel and Eva Rucki
www.troika.uk.com
studio@troika.uk.com

Birthplace: Frankenberg, Germany (CF)/Montbéliard, France (SN)/Emmerich,
 Germany (ER)
Residence: London, UK
Connecting cities: Montreal, Canada; Athens, Greece; New York, USA (CF)/Milan,
 Italy; Paris France; Guangzhou, China (SN)/Berlin, Germany;
 Amsterdam, the Netherlands; Beirut, Lebanon (ER)

TROIKA IS THE MULTIDISCIPLINARY studio, founded in 2004, by Conny Freyer, Sebastien Noel, and Eva Rucki, who met during their studies at the Royal College of Art in London. Of different professional backgrounds, they all come from the world of graphic and visual communication, art, industrial design, and installation art.

This group creates captivating and visually demanding images for each of their projects. They work with a wide range of media, from the design of printed material to 3D design. By combining art and design in their processes they reveal their love of simplicity, diversion, and their desire to "provoke."

Troika have been invited as lecturers and teachers for various academies and educative institutions in America and Europe. Publications such as *I.D.*, *Grafik*, *Creative Review*, *Icon*, *The Guardian*, *Dazed & Confused*, *Wired*, and *Blueprint*, have featured the work of this creative team. They have also participated in important international exhibitions such as "Design and the Elastic Mind" at the Modern Art Museum in New York, "Volumes" in Luxemburg and the itinerant "Get it Louder" in the People's Republic of China.

Digital By Design/Book/Written and designed by Troika, published by Thames and Hudson/2008

All the Time in the World/Electro-luminescent World Clock/Animated Lcd Display/ British Airways/photo © Alex Delfanne/Curated by Artwise Curators 2008

Firefly Font/Typeface/photo © Alex Delfanne/Artwise Curators 2008

All the Time in the World/Electro-luminescent World Clock/Animated Display/British Airways/photo © Alex Delfanne/Curated by Artwise Curators 2008

SMS Memory Wall/Interactive projection/BBC Electric Proms/2007

SMS Memory Wall/Flyer/BBC Electric Proms/2007

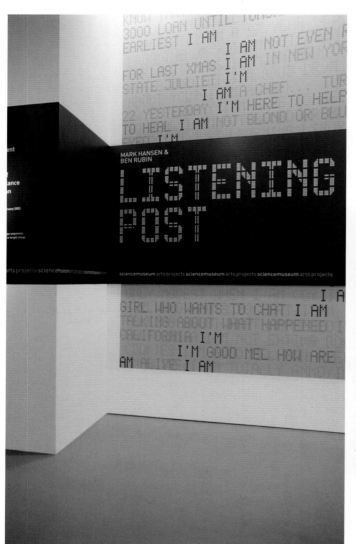

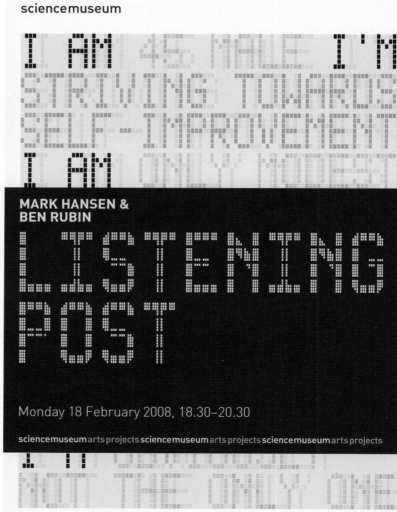

Listening Post/Graphic identity and exhibition design/Science Museum/2008

A magnetic soundscape

Contemporary Patrons Group Exhibition/Poster/Royal Academy/2005

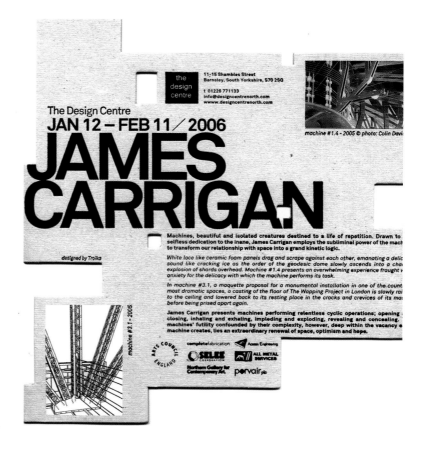

MA Fine Art Show/Exhibition catalogue/
Central Saint Martins College/2005

James Carrigan Solo Show/Invite/2006

MA Fine Art Show/Exhibition catalogue/Central Saint Martins College/2005

Moscow Style/Book/Published by Booth-Clibborn/2005

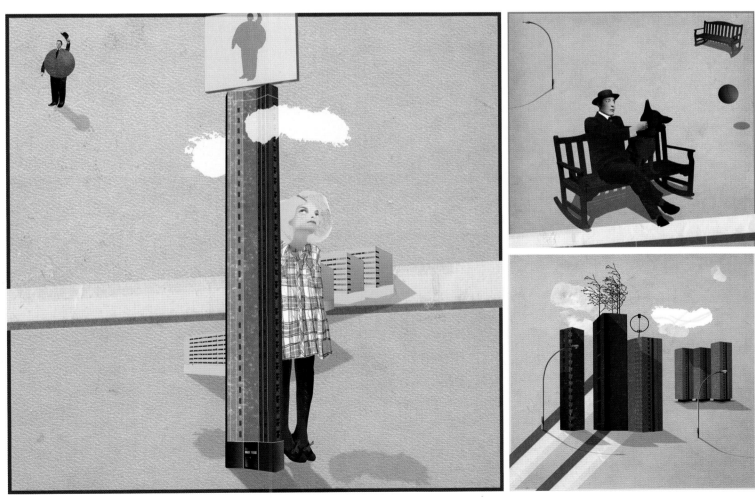

Greyworld/Book illustrations/2005

The Hague, The Netherlands (Lorenz) Hanover, Germany (Lorenz)
Frankfurt, Germany (Lorenz)
Saragossa, Spain (Asensio) Barcelona, Spain
Barcelona, Spain (Asensio)

Twopoints.net

Martin Lorenz and Lupi Asensio
www.designby.twopoints.net
info@twopoints.net

Birthplace: Hanover, Germany (ML)/Saragossa, Spain (LA)
Residence: Barcelona, Spain
Connecting cities: The Hague, The Netherlands; Frankfurt, Germany (ML)/
Barcelona, Spain; Saragossa, Spain (LA)

THE BARCELONA-BASED visual communication agency Twopoints.net specializes in the coordination, creation, development, and implementation of visual identity projects.

Founded in the year 2000 by Martin Lorenz, Twopoints.net began life in The Hague, The Netherlands, as a platform for personal projects and work combining creative talents from diverse fields and locations. One such project is The One

Weekend Book Series, a document call to "graphic tourism" which involves producing a book in the space of forty-eight hours. Lorenz and another invited artist have a weekend to discover a new town and record it in a book, in the style of a visual diary without the use of a computer.

Their work has won various prizes and is frequently reviewed and mentioned in specialist publications. As well as

offering graphic design services, the agency also coordinates and conducts a series of educative workshops for design and visual communication students. The agency's members have also been invited as professors and lecturers by the Escola Superior de Disseny Elisava and the Instituto Superior de Diseño (IDEP), both in Barcelona.

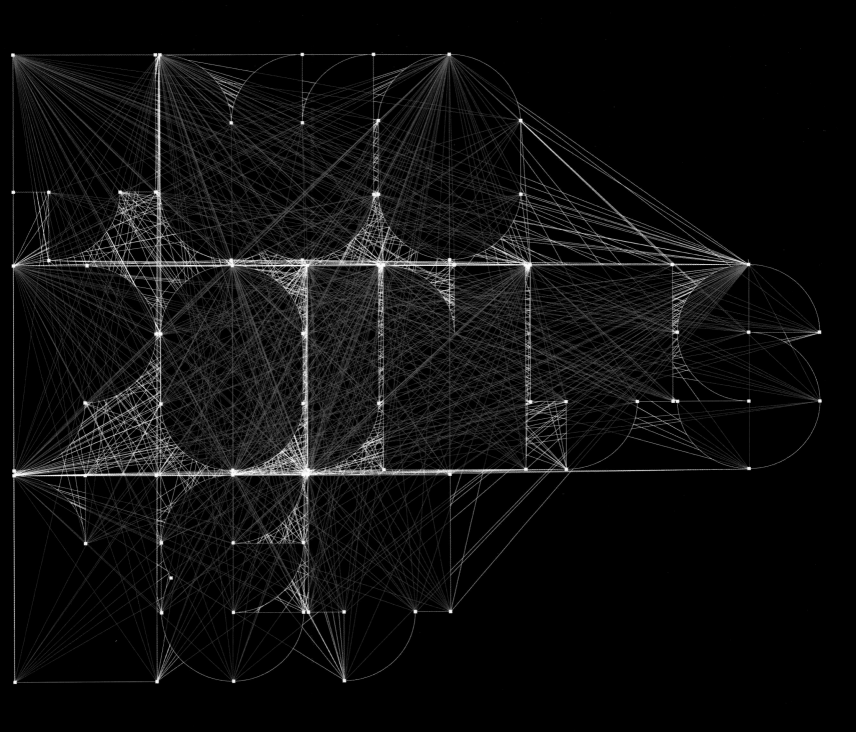

Palau de la Música Catalana/Posters/2007

Get Involved/Posters/2007

Visual/Magazine cover/2007

The One Weekend Book Series/Book/In each book M. Lorenz and a guest artist are given 48 hours to experience a city, document it and create a visual diary without the use of computers/2003-on going

Each year about 13 million hectares of the world's forests are lost due to deforestation.

Cada año, unos 13 millones de hectáreas de los bosques del mundo se pierden debido a la deforestación.

Each year, commercial fishing worldwide wastes more than 16 billion pounds of fish and kills hundreds of thousands of sea turtles, marine mammals and seabirds.

Cada año, la pesca comercial mundial malgasta más de 16 mil millones de libras en desechos de pez y mata centenares de millares de tortugas del mar, así como aves y mamíferos marinos.

Worldwide are conveyed daily approximately 80 million Barrel crude oil. Whether the worldwide coal supplies, oil supplies or gas supplies will last 10, 15 or 100 years, nobody seems to know.

Diariamente, aproximadamente 80 millones de Barril petróleo crudo son transportados por todo el mundo. Nadie parece saber si los suministros mundiales de carbón, petróleo o gas durarán 10, 15 o 100 años.

In the year 2050, at least one-third of the world population will live with chronic or always recurring fresh water deficiency. Already today more than 50 countries suffer from significant water shortage.

En el año 2050, al menos una tercera parte de la población del mundo vivirá con un problema crónico o recurrente de deficiencia de agua dulce. A día de hoy, ya más de 50 países sufren significativamente de la escasez de agua.

DesignPolitics/Illustration/2007

Recipe «Tortilla de patatas»
or Martin teaches Kasper how to do a «Tortilla de patatas».
Barcelona, 2006

Step one:

- Peel 5 medium sized potatoes
- Cut them into small cubes
- Fry them in a lot of olive oil until they are done

Step two:

- Mix six eggs
- Add fried potato cubes
- Add salt

Step three:

- Remove oil from pan
- Add this time only a little olive oil
- Wait until it is hot
- Add the egg-potato mix
- Once the egg starts to stiffen shake the pan a little sideways,
 so the tortilla doesn't stick
- Turn down the heat
- When the bottom half of the tortilla has become stiff,
 cover the pan with a plate,
 turn it upside down and
 slide the tortilla back into the pan

Buen provecho de parte de:

y:

typisk

Tortilla Poster/Poster/2006

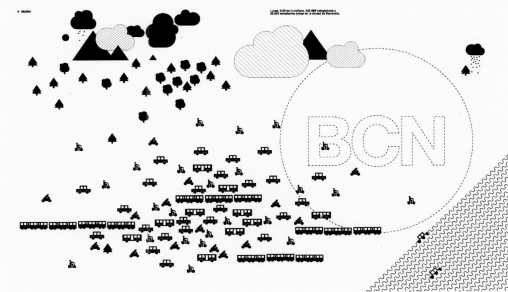

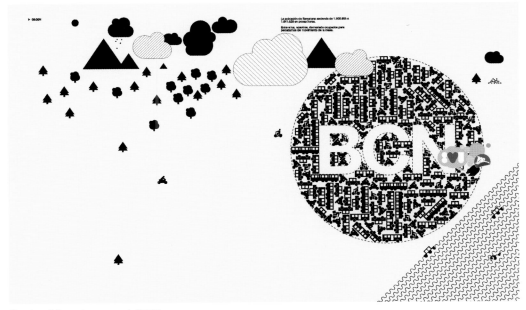

Creators/Magazine spreads/2006

London, UK
Amsterdam, the Netherlands
Berlin, Germany

Moscow, Russia
Togliatty, Russia

Vadik Marmeladov

www.vadikmarmeladov.com
vadikmarmeladov@gmail.com

Birthplace: Togliatty, Russia
Residence: Moscow, Russia
Connecting cities: London, UK/Berlin, Germany/Amsterdam, The Netherlands

VADIK MARMELADOV IS a young graphic designer who lives in Moscow. His most important project is his own life and this is exactly how he introduces himself commercially – as his own studio.

He develops graphic design pieces for traditional media and experimental projects created for new media. One of his most original pieces is the current series "My Time Machine," a graphic project

which seeks to explore, what the artist calls, the archeology of the cliché. In 2008, this designer formed part of the selection for the "The New Easy" show, an exhibition commissioned by Lars Eijssen, which reflects on contemporary aesthetics. According to Eijssen "a New Easy work is one that looks as though it has been created in three minutes, demonstrating the genius of the artist who knows how to escape from a depressing world with no hope."

He is currently responsible for the Art Direction of *LAM* (Look at Me) magazine, an HTML publication that specializes in the trends in fashion, art, and music in Moscow. It has become a reference point for the emerging scene of artists, designers, and photographers from this city.

LAM magazine/Digital magazine illustration/2008

Another Collusion With My T/Magazine illustration/2008

W.E.S.D./Branding/2005

Hairy Gift/Magazine illustration/2008

LAM magazine/Digital magazine illustration/2008

Hairy Gift/Magazine illustration/2008

Vier5

Marco Fiedler and Achim Reichert
www.vier5.de
contact@vier5.de

Birthplace: Pforzheim, Germany (MF)/ Neckarsulm, Germany (AR)
Residence: Paris, France
Connecting cities: Paris, France

PARIS, CONSIDERED TO BE ONE of the most beautiful and glamorous cities in the world, is the setting for Vier5 studio comprising the designers Marco Fiedler and Achim Reichert, a duo who started working together in 1999 in Frankfurt, Germany.

This creative team endeavors to avoid visually empty phrases, substituting them with creative, individual statements that are developed according to the media and type of project. They create each one of their pieces with a classic notion of design, using it as a way to draft and construct new forward-looking images in the field of visual communication.

Much of their work has been commissioned by clients from the world of art and culture – including the Museum of Decorative Arts in Frankfurt, Documenta in Kassel, the Bordeaux School of Fine Art, and the Brétigny Center of Contemporary Art. One of their most well known projects is the publication *Fairy Tale*, a photographic magazine of a thematic nature, designed and published by them.

The use of seemingly hand-created typography stands out in their daring yet simple graphic language. Their *pixeled* shapes refer to a computer aesthetic – a type of digital doodle which has become the emblematic signature of their designs.

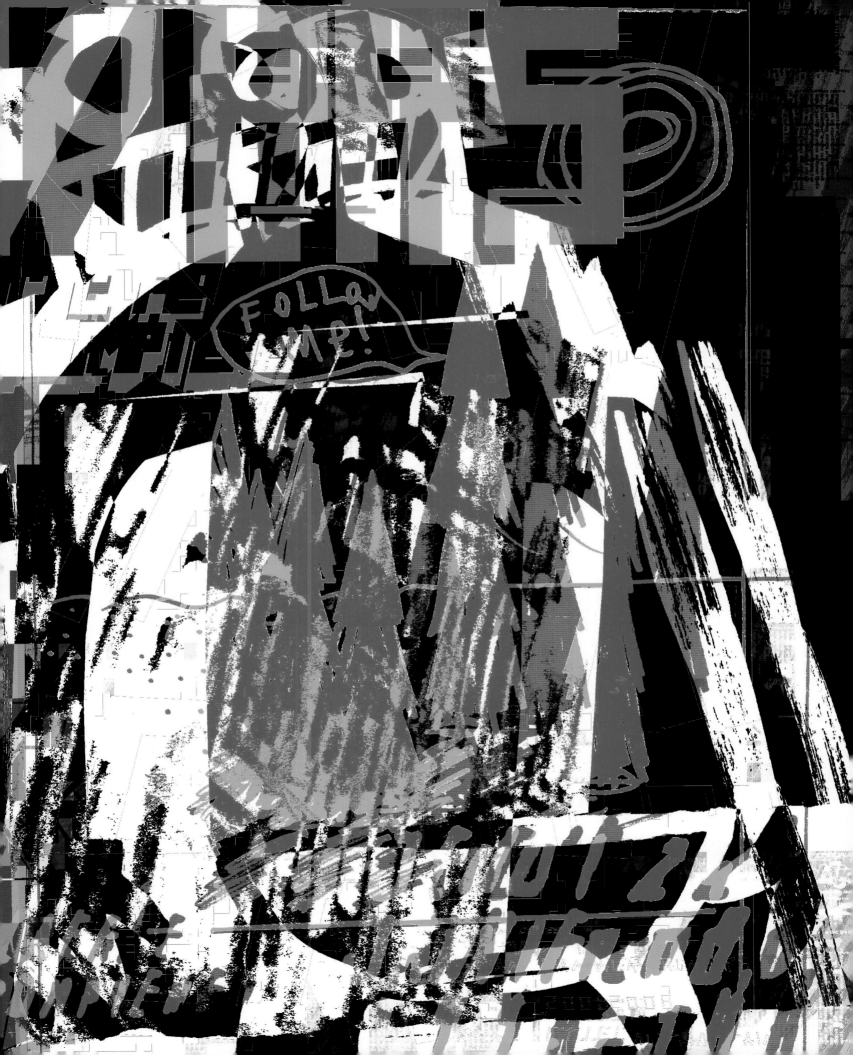

SKY LINE

BY ANTIE PETERS

FAIRY TALE: issue architecture and interiors/Textbook, lay-out/Offset/2008

Track Bike Gazelle Champion Handel Reynolds 531,
Prototype for Bicycle Lock by Wolfgang Brauer,
Bag from Whole Foods New York with Crown Cap.
From documenta 12 from VIER5.
Chain of Leaves by the Nursery Teacher of Helena Kleinfeld.

8

NAVY-WHITE STRIPE , BLUE-WHITE STRIPE OR LIGHT-BLUE CHECK

BY SABNE REITMAIER

9

FAIRY TALE: issue architecture and interiors/Textbook, lay-out/Offset/2008

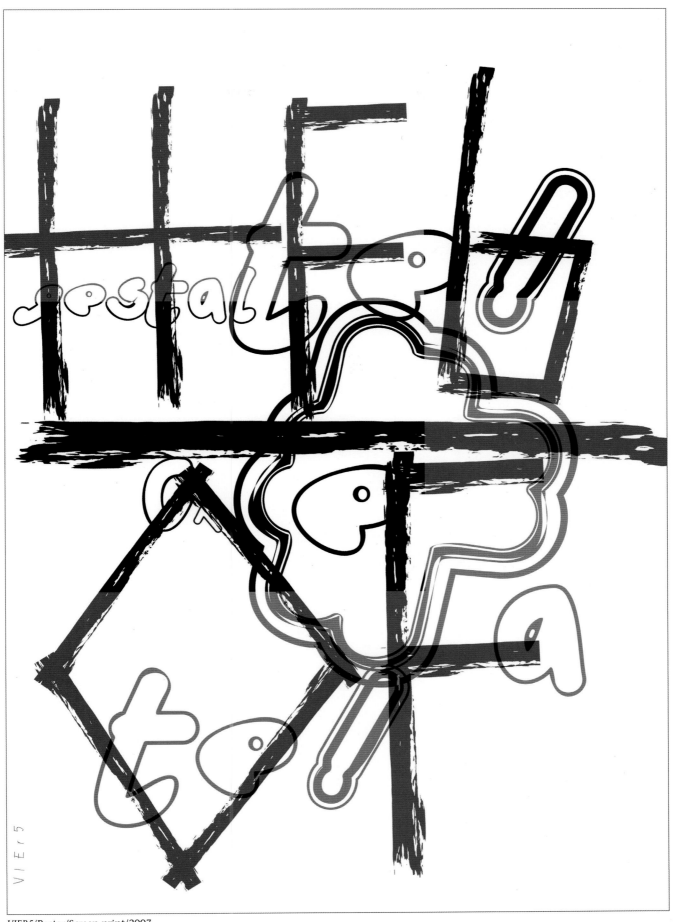

VIER5/Poster/Screen print/2007

VIER5/Posters for the Centre of Contemporary Art in Bretigny for the exhibition of Nashashibi Skaer and Cyprien Gaillard/Offset/2008

VIER5/Posters for the Centre of Contemporary Art in Bretigny for the exhibition of Nashashibi Skaer and Cyprien Gaillard/Offset/2008

VIER5/Poster for the Ecole des Beaux Arts in Bordeaux for the lecture of Vier5/Screen print/2008

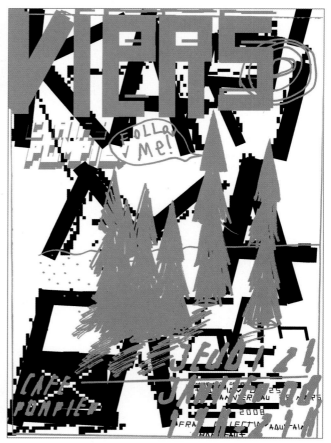

VIER5/Poster for the Ecole des Beaux Arts in Bordeaux for the lecture of Vier5/Screen print/2008

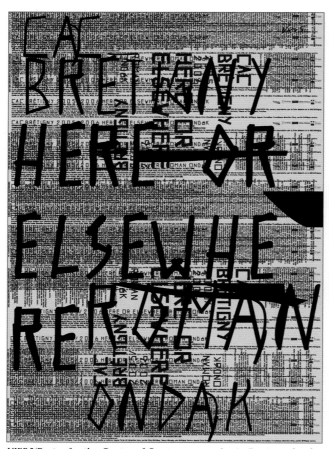

VIER5/Poster for the Centre of Contemporary Art in Bretigny for the exhibition of Roman Ondak/Offset, Screen print (black)/2006

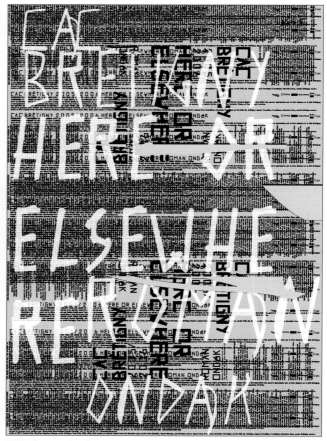

VIER5/Poster for the Centre of Contemporary Art in Bretigny/Offset, Screen print (white)/Studio version/2006

VIER5/Poster for the Centre of Contemporary Art in Bretigny/Offset/2007

Moscow, Russia
Vitebsk, Byelorussia
Treviso, Italy
Hong Kong, China Shanghai, China

Vladimir Dubko

www.vladimirdubko.com
mailbox@vladimirdubko.com

Birthplace: Vitebsk, Byelorussia
Residence: Shanghai, China
Connecting cities: Treviso, Italy / Moscow, Russia / Hong Kong, China

AFTER GRADUATING WITH a degree in communication design, Vladimir Dubko worked for two years in the interactive department at Fabrica – the center of investigations in Italy. Here he experimented with diverse disciplines and developed commercial projects and personal illustration work. Subsequently, he moved to Moscow where he worked in advertising as art director. He currently works in Shanghai where he designs for important brands in the fashion industry.

Dubko has worked on various publications such as the German magazine *Vorn* and the Moscow magazine *Fashion Collection*. Some of his projects have been reviewed in publications such as the magazines *Step* and *Beef*. He has also participated in exhibitions and art spaces in Moscow, Stockholm, San Francisco, and the Pompidou Center, in Paris, among others.

His work recreates a fun yet sophisticated stylish blend, which demonstrate the designer's interest in the world of fashion, in which he hopes to continue to develop. His biggest motivation is curiosity, and he firmly believes in design as a "great field in which to explore the world."

OVS Live More!/Four parts magazine inside cover illustration/2007

ProSays' Twinkle/Advertising campaign image and type design for a cosmetic brand/In collaboration with www.tommylidesign.com/2008

Beef magazine, Aussteiger/Editorial illustration/2007

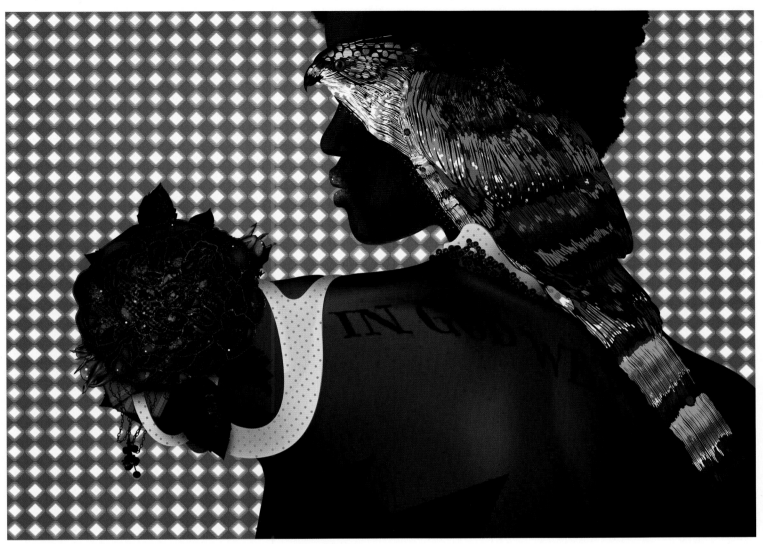

LEDs, Birds, Roses/Artwork from a self-initiated project Count 2 Nine/2007

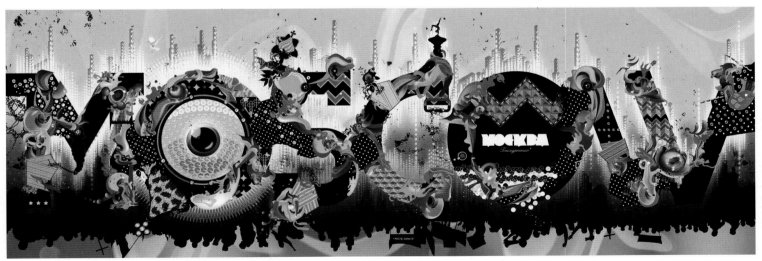

Moscow, OVS Live More!/Cover illustration and type design/2007

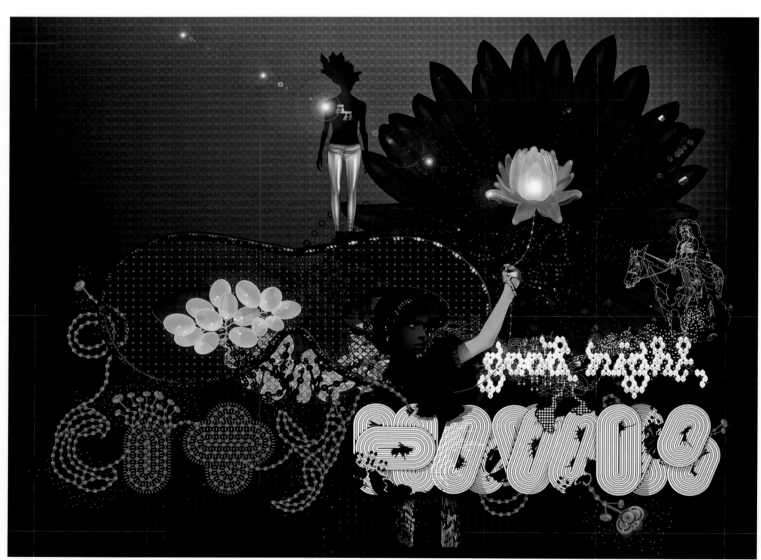

Good Night, City Hawks!/Artwork from a self-initiated project Count 2 Nine/2007

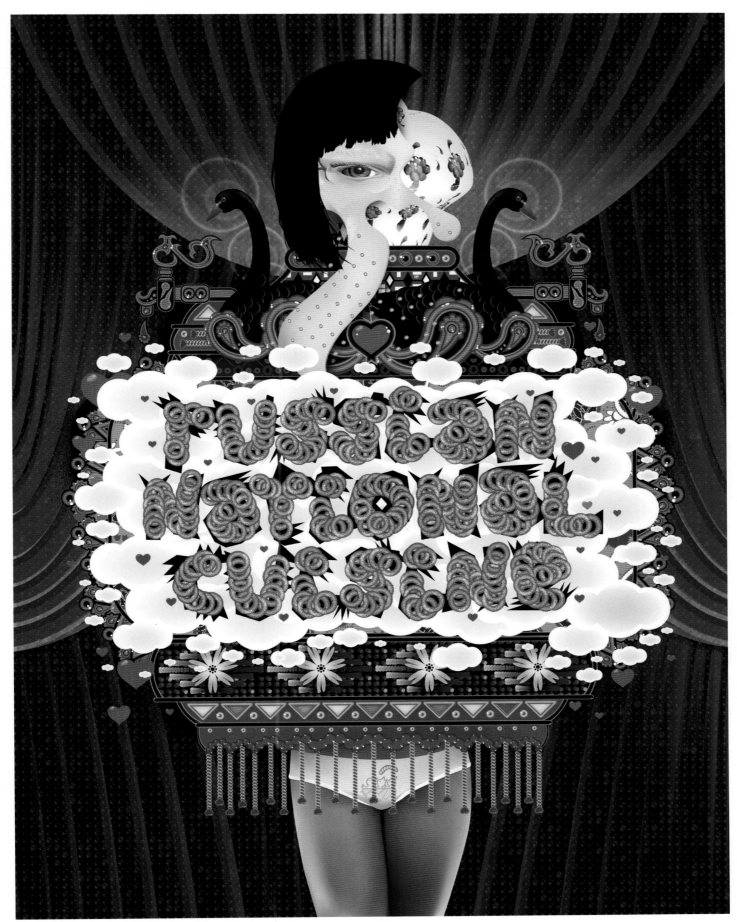

Russian National Cuisine, OVS Live More!/Editorial illustration/2007

Wabisabi

Ryohey *wabi* Kudow and Kazushi *sabi* Nakanishi
www.homeinc.jp/wabisabitop.html
wabi@homeinc.jp

Birthplace: Hokkaido, Japan
Residence: Sapporo, Japan

SINCE 1999 THIS STUDIO and its team of designers have developed projects for clients in areas as diverse as advertising, cinema, and industrial design.

Ryohey Kudow and Kazushi Nakanishi, who are childhood friends, base their work on the Asian philosophy of *Wabisabi* – a Japanese aesthetic term with notions of fleetingness, impermanence, beauty, and imperfection, combining minimalism with the warmth of nature in order to achieve harmony.

Their carefully illustrated graphic work reflects the influence of the tradition of Asian aesthetics based on simplicity and the use of lines. These designers have created outstanding posters for prestigious institutions such as the Association of Graphic Designers of Japan (JAGDA) as well as visual identities and logos for the Art Directors Club and the Copy Writers Club in Sapporo.

Some of their pieces have been awarded with prizes by the Art Directors Club in New York as well as by the International Toyama and Taiwan Poster Biennales. Their work has been exhibited in shows such as Dotmov 2005, Tree of Life, and SOSO. The duo currently work as art directors for the design agency Home, as well.

Sightseeing/Poster/2008

Calibonsai/Poster/2005

Taki/Poster/2005

Design Bussan Japan/Book/2008

hormons/Personal project/2006

hf05 sb/hormon

HORMON/Typeface/2006

Bear's kingdom, Hokkaido/Original typeface/2006

CORD/Original typeface/2006

Map showing connected cities:

London, UK

New York, USA

Los Angeles, USA
San Diego, Calif.,USA

Orlando, Fla., USA

WeAreNøtYøu

www.wearenotyou.com
me@wearenotyou.com

Birthplace: San Diego, California, USA
Residence: Los Angeles, USA
Connecting cities: London, UK / New York, USA / Orlando, Florida, USA

THIS STUDIO WAS CREATED by Jarred Eberhardt in Los Angeles in 2007. Its main focus is on branding, printed material, typography, and Web design projects.

Eberhardt works mostly for the extreme sports industry, although he admits that his creativity knows no bounds and he is comfortable with any field, from clean, traditional corporate design to more daring and experimental terrain. He is a strong believer of the power of the imagination and views design itself as a process.

"WeAreNøtYøu eats, sleeps, and drinks CMYK and RGB. WeAreNøtYøu is not a big studio. WeAreNøtYøu hopes to work with you soon. WeAreNøtYøu believes in the all powerful moustache. WeAreNøtYøu loves Los Angeles but hates L.A. WeAreNøtYøu prefers Burt Reynolds to Steve Gutenberg. WeAreNøtYøu likes the cinema and the music that you would laugh at. WeAreNøtYøu tries to do each thing as though it were being done for the first time. WeAreNøtYøu prefers working on rainy days. WeAreNøtYøu believes that week days are the thinking person's weekend. WeAreNøtYøu will never abandon you, it will never deceive you, and it will never run from you, nor leave you stranded. WeAreNøtYøu loves Tom Waits and Wu-Tang. WeAreNøtYøu were classed as number one by their mothers. WeAreNøtYøu has something up its sleeve. WeAreNøtYøu is different. WeAreNøtYøu is glad not to be you."

The Lady Vanished/Poster/2006

1978/Album cover/2008

Static Movement/Posters/2007

Static Movement/Posters/2007

Remission/Book cover/2008

WEST COAST DIRTY SOUTH
FREESTYLE GHETTO HOUSE
HARDCORE BAMABOUNCE
GOLDEN AGE HORRORCORE
TURNTABLISM MEMPHIS
GRIME MAFIOSO NEO SOUL
REGGAETON SNAP HYPHY
BACKPACK EAST COAST
CHOPPED & SCREWED JAZZ
NEW SCHOOL MIAMI BASS
BALTIMORE CLUB G FUNK
NERDCORE NU METAL
INSTRUMENTAL ACID RAP
OLD SCHOOL NEW JACK
BRAZILIAN FUNK GANGSTA
CHICANO CRUNK ELECTRO
ALTERNATIVE TWO STEP
RAPCORE GHETTO TECH
POLITICAL MIDWEST MOBB
ABSTRACT POP RAP RAGGA
PORNOCORE UK GARAGE
SOUTHERN TRIP HOP
COUNTRY BOUNCE

{∅} We Are Nøt Yøu™

Them Beats/Poster/2008

The Hague, The Netherlands
Paris, France (Bohner) ■ Prague, Czech Republic (Macháček)
Lausanne (Macháček)/(Bohner), Switzerland

Welcometo

Adam Macháček & Sébastien Bohner
www.welcometo.as
mail@welcometo.as

Birthplace: Prague, Czech Republic (AM)/Paris, France (SB)
Residence: Lausanne, Switzerland; Prague, Czech Republic (AM)/Lausanne,
 Switzerland (SB)
Connecting cities: The Hague, The Netherlands/Lausanne, Switzerland

ADAM MACHÁCEK AND Sébastien Bohner are Welcometo – a team of graphic designers, typographers, and illustrators who work together, although they live in Lausanne and Prague respectively.

Macháček graduated from the Academy of Art, Architecture and Design of Prague and Bohner graduated with degrees in design and communication from the Ravensbourne College of London. They first met during an internship at the renowned Dumbar studio in The Hague in 2002 and joined forces to develop projects together two years later.

They work mostly on printed and editorial projects, although they have also developed visual identity work, interventions in space and textile design. This duo has contributed to numerous publications such as *Communication Arts*, *Font*, and the Czech magazine *Komfort*.

Their graphic work stands out for its powerful visual and versatile style. The nature of the job dictates whether their work is fun, geometric, and colorful or requires a greater purity and a monochrome aesthetic, showing extreme care and attention to detail. Together they also carry out personal projects as artists and as curators, participating in and/or organizing exhibitions in important spaces such as the Moravian Gallery in Brno and the Academy of Art, Architecture and Design in Prague.

The Moravian Gallery/Bulletin/Sewn paperback/Offset/2007

The forming of the Moravian Gallery collections

From the history of the graphic design collection and the Brno Biennial

History of the graphic design collection of the Moravian Gallery in Brno

Historie sbírky grafického designu Moravské galerie v Brně

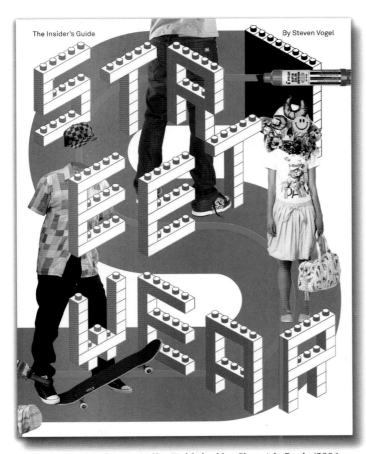

Streetwear/Book cover/Offset/Published by Chronicle Books/2006

Streetwear/Book spreads/Offset/Published by Chronicle Books/2006

Milan Houser Litky/Poster/Screen print/2008

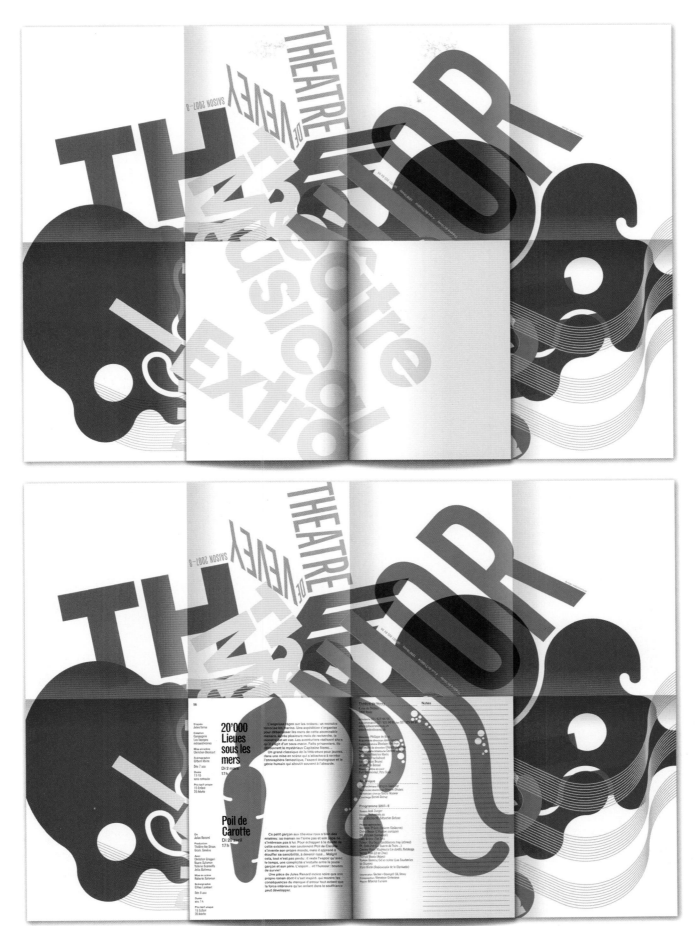

Program Théâtre de Vevey 2007-08/Program/The cover of this programme is a folded poster stapled to the booklet/Offset/2007

The Moravian Gallery/Bulletin/Sewn paperback/Offset/2006

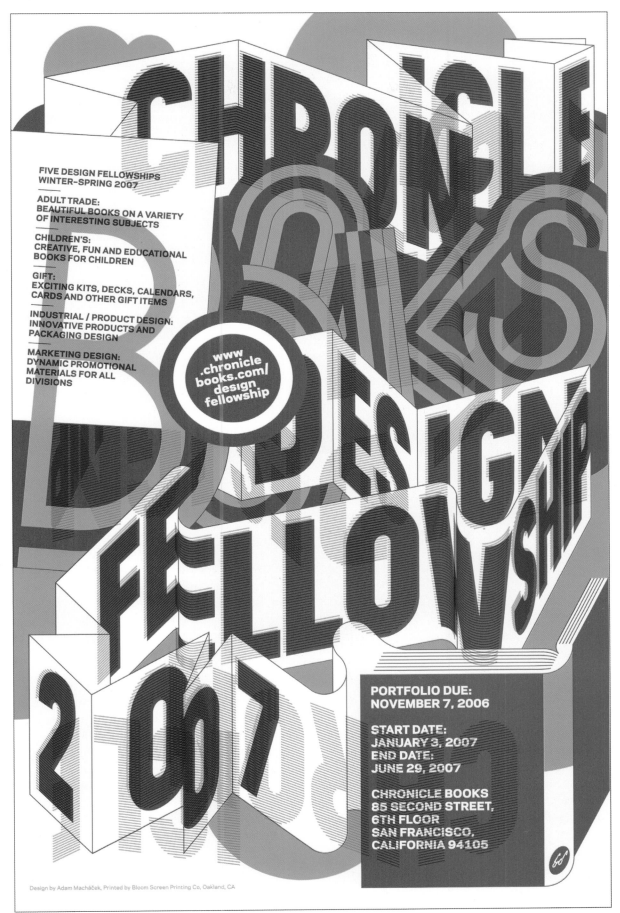

Chronicle Books Design Fellowship/Poster/Screen print/2006

Lillestrøm (EF/AGR/TN), Norway Lillestrøm (EF/AGR), Norway
London (AGR), UK Oslo (ML/TN), Norway
Oslo (EF/AGR/TN), Norway Oslo, Norway

Baton Rouge, La., USA (EF)

Yokoland

Espen Friberg, Aslak Gurholt Rønsen, Martin Lundell and Thomas Nordby
www.yokoland.com
info@yokoland.com

Birthplace: Lillestrøm, Norway (EF and AGR)/Oslo, Norway (ML and TN)
Residence: Oslo, Norway
Connecting cities: Baton Rouge, Louisiana, USA; Lillestrøm, Norway; Oslo,
Norway (EF)/Lillestrøm, Norway; London, UK; Oslo, Norway
(AGR)/Oslo, Norway; Stockholm, Sweden (ML)/Lillestrøm,
Norway; Oslo, Norway (TN)

THEY SPECIALIZE IN editorial design, but they have also developed various applications ranging from the design of signage systems, murals, set design, and exhibition design to short films, music videos, title sequences, and websites. Yokoland also works for the commercial sector on advertising and visual identity projects.

This creative group participates frequently in collective and solo exhibitions. For the last seven years they have also been the in-house design studio for the Metronomicon Audio record label, a musical project initiated by Friberg and Gurholt Rønsen. In 2006, they launched their monographic book *Yokoland: As we go up we go down* published by Die Gestalten Verlag.

They endeavor to keep an open mind and not to worry unnecessarily about defining limits between the different disciplines in which they partake. They do not believe in just one philosophy and their work can be as conceptual as it can purely aesthetic. They do, however, admit to having a tendency to make things more complicated – "instead of solving problems, we create them!"

A Traveller's Guide to

YOKOLAND

E. BETTLER

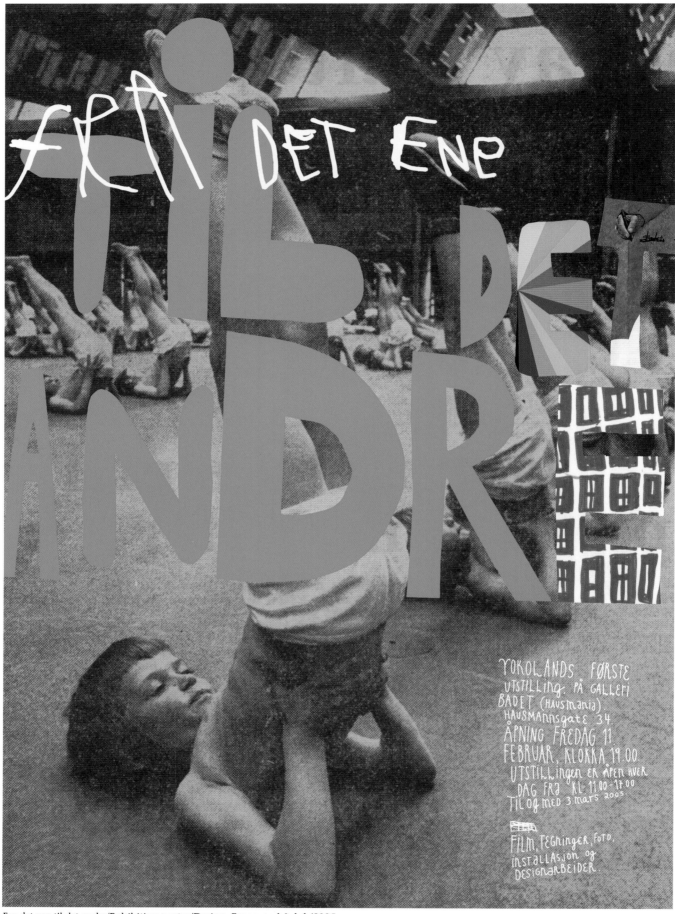

Fra det ene til det andre/Exhibition poster/Design: Espen and Aslak/2005

Anachronism

Pronunciation: &-'na-kr&-"ni-z&m
Function: *noun*
Etymology: probably from Middle Greek *anachronismos*, from *anachronizesthai* to be an anachronism, from Late Greek *anachronizein* to be late, from Greek *ana-* + *chronos* time
1 : an error in chronology; *especially* : a chronological misplacing of persons, events, objects, or customs in regard to each other
2 : a person or a thing that is chronologically out of place; *especially* : one from a former age that is incongruous in the present

Anachronisma: Center of the Universe/CD cover/Design: Aslak/2006

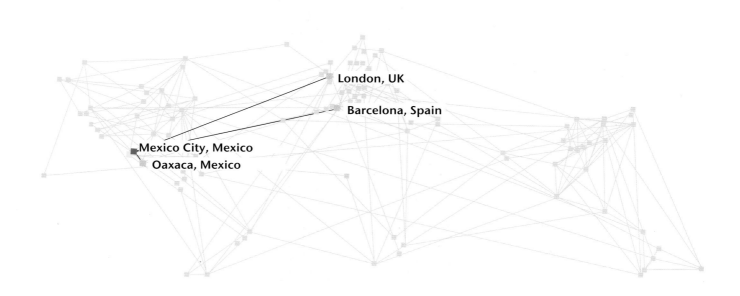

London, UK

Barcelona, Spain

Mexico City, Mexico
Oaxaca, Mexico

Zoveck Estudio

Julio Carrasco and Sonia Romero
www.zoveck.com
valiente@zoveck.com/sonaja@zoveck.com

Birthplace: Mexico City, Mexico
Residence: Mexico City, Mexico
Connecting cities: Barcelona, Spain/London, UK/Oaxaca, Mexico

AFTER DRIFTING FROM various advertising agencies to publishing houses and other people's studios, Julio "The Brave" Carrasco and Sonia Romero decided to create their own studio in 2004 in Mexico City.

Zoveck defines itself as a design studio that generates ideas and concepts for multimedia, advertising, and printed media. Their philosophy is based on discovering the magic in each project, their enjoyment, and giving their creations soul. They experiment with things they like and are passionate about, and things they have grown up with and which they experience every day.

From an aesthetic viewpoint, this duo of designers admit to being heirs of the Fonacot generation – a name identifying a series of lower-middle class housing units in which visual excess predominated, as well as an accumulation of decorative baroque elements and all things kitsch. They admit that they often find inspiration in memories of baptisms and teenage party decorations.

As an active agent on the Mexican cultural scene, the studio participates frequently at exhibitions in art spaces as well as organizing and teaching workshops and educational courses for students and professionals alike. Their work has been included in publications such as *Latin American Graphic Design* and the specialist magazine *Étapes*.

To be lucky with women/Book/Collage/2005

To dream of your husband-to-be/Book/Digital collage/2005

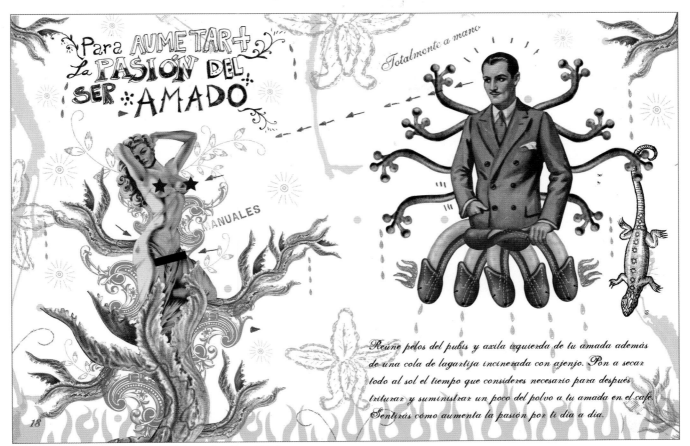

To increase a loved one's passion/Book/Digital collage/2005

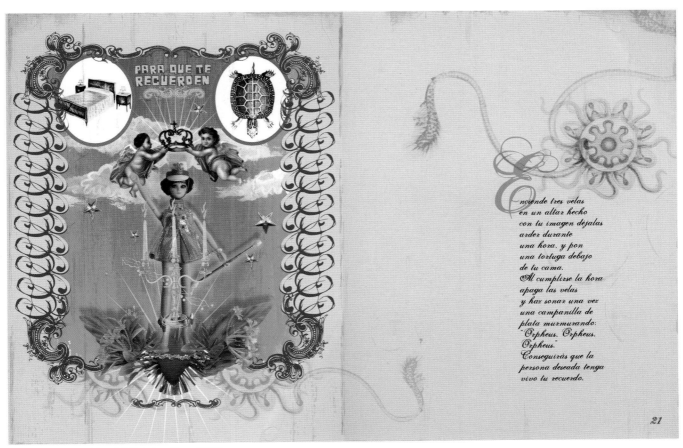

To be remembered/Book/Digital collage/2005

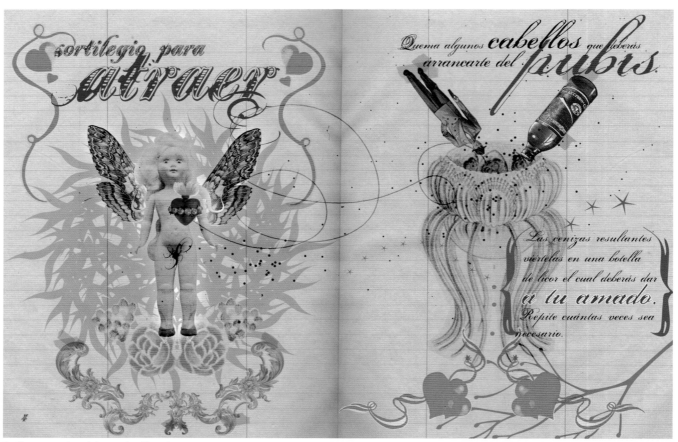

Spell to attract/Book/Digital collage/2005

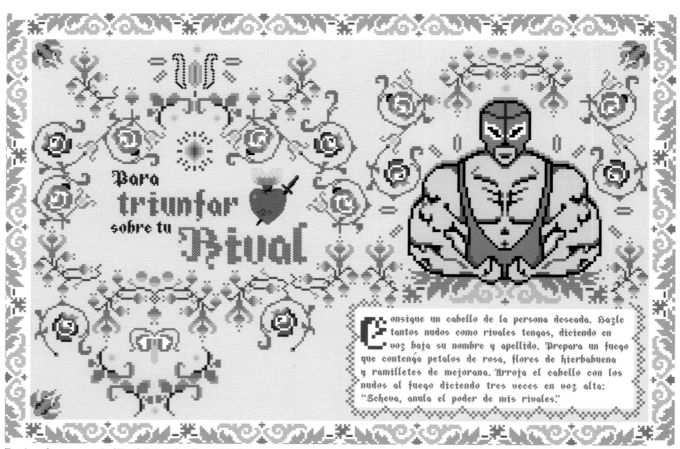

To triumph over your rival/Book/Digital collage/2005

To ensure love and devotion/Book/Digital collage/2005

To ensure love/Book/Digital collage/2005

London, UK — Moscow, Russia
Barcelona, Spain
Madrid, Spain

Zunge Design

Protey Temen
www.zungedesign.ru
protey@zungedesign.ru

Birthplace: Moscow, Russia
Residence: Moscow, Russia
Connecting cities: Madrid, Spain/Barcelona, Spain/London, UK

ZUNGE DESIGN FORMS a small studio located in Moscow and boasts renowned designer Protey Temen as creative director. This studio, founded in 2001, specializes in identity design, printed material, editorial design, and the development of visual concepts.

In each project this *atelier* seeks a balance between bright colorful solutions and an effective commercial approach. Its designs have earned various honors at international competitions such as the Krakow Eco Poster and Graphic Arts Triennial, the Warsaw International Poster Show, and the Sofia Poster Triennial.

In addition to his commercial work, as creative director, where he explores different forms of saturation of visual surroundings, this designer simultaneously develops personal projects such as the "Dobrotarizm" series which could be translated as "Happyism," which began in 2007 as a reflection on human emotions and the possible manipulation of these emotions. For Temen, graphics based on childlike drawings are his main source of inspiration.

The work of this designer has been shown in exhibition spaces such as Fabrica, the DOM Center in Petrozavodsk, The Zverevskiy Center of Contemporary Art, and the Central House of Artists in Moscow.

Amelia's Magazine/Magazine cover/2007

Earl Grey Smokers/Poster/2002-2003

Earl Grey Smokers/Poster/2002-2003

Earl Grey Smokers/Poster/2002-2003

Tramplin Festival/Poster/2008

Icons of the Dobrotarism/Posters/2007

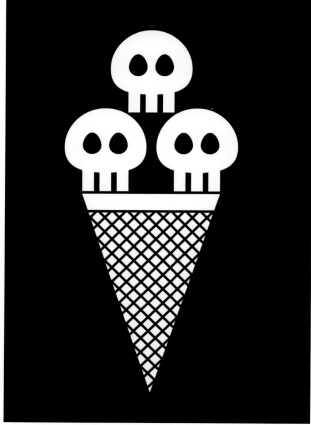

Ice creams of my dreams/Posters/2007

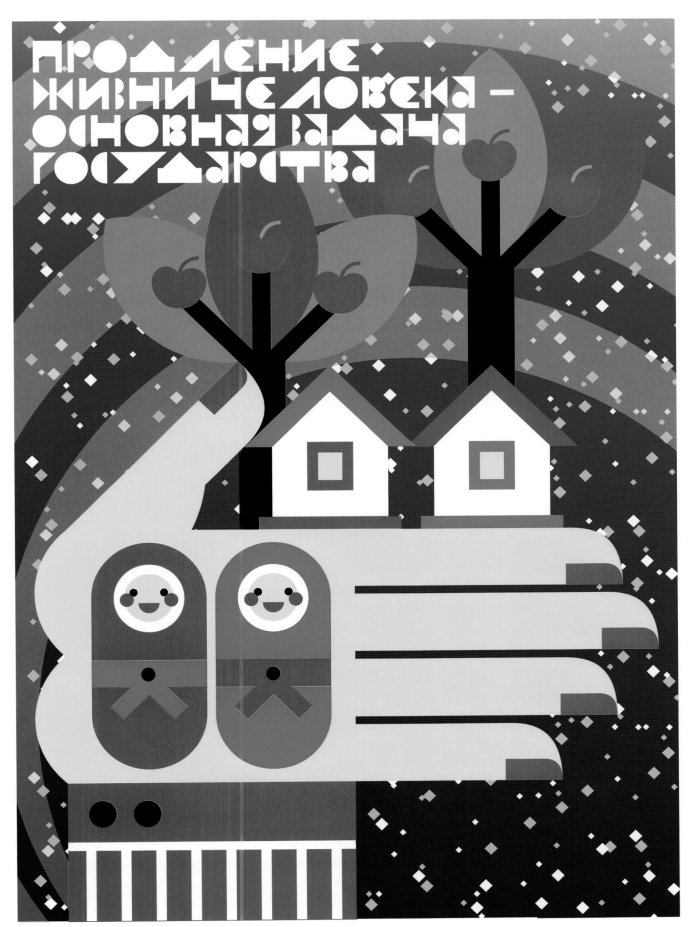

Science Against Aging/Poster/2007

atypica

Atypica/Magazine cover/2008

Warm Feelings for Norilsk/Posters/2008

Zunge goes Arma/Poster/2007

Idle conversation/Poster/2007